The Engine of

Visualization

The Engine of
Visualization

꿎

THINKING THROUGH

PHOTOGRAPHY

Patrick Maynard

Cornell University Press

ITHACA AND LONDON

First published 1997 by Cornell University Press
First printing, Cornell Paperbacks, 2000

Printed in the United States of America

Library of Congress Cataloging-in-Publication Data

Maynard, Patrick, 1939–
The engine of visualization : thinking through photography /
Patrick Maynard.
p. cm.
Includes bibliographical references and index.
ISBN 0-8014-3365-7 (cloth: alk. paper)
ISBN 0-8014-8689-0 (pbk.: alk. paper)
1. Photography—Philosophy. 2. Visualization. I. Title.
TR183.M4 1997
770'.1—dc21 97-23981

Cornell University Press strives to use environmentally responsible suppliers and
materials to the fullest extent possible in the publishing of its books. Such materials
include vegetable-based, low-VOC inks and acid-free papers that are recycled, totally
chlorine-free, or partly composed of nonwood fibers. Books that bear the logo of the FSC
(Forest Stewarship Council) use paper taken from forests that have been inspected and
certified as meeting the highest standards for environmental and social responsibility.
For further information, visit our website at www.cornellpress.cornell.edu.

1 3 5 7 9 Cloth printing 10 8 6 4 2

1 3 5 7 9 Paperback printing 10 8 6 4 2

For Olga Maynard, writer

Contents

Illustrations

Preface

Photography is an increasingly popular topic; there are in print many useful and interesting books, monographs, articles, journal series, and pamphlets devoted to aspects of the subject, and many more are to be expected. Further, photography is so implicated in other aspects of modern life that the volume of writing about it in works devoted to other topics is increasing. Yet amid this growing plenty there are obvious shortages, the omission of entire topics. This book addresses one—perhaps the simplest and most surprising—of these. In the many technical works, excellent historical studies, and attempts to explain its artistic or social meaning, writers on photography have forgotten to say what it is. This book is an attempt to do that in an elementary but useful way.

Perhaps scholars and other writers have neglected to say what photography is because they have assumed that we already knew. That in some sense we do not know should by now be clear, considering the strange assortment of ambivalence, confusion, ambiguity, mysteriousness, paradox, and heated argument which has characterized thought and discussion about photography since it was presented to the public and put immediately to use over 150 years ago, and which is projected into the future by common observations, the press, and savants with each new development. As photography evolves rapidly and ingeniously in invention and application, people's general conceptions of it and the terms in which they discuss it are remarkably inarticulate, hardly serviceable. In a way, of course, this is a typical philosophical

situation. Philosophers frequently point out the inadequacy and unfortunate effects of our everyday conceptions of mental events, our explanations of behavior, freedom, responsibility, reasonableness, knowledge, causality, etc. But photography, as opposed to these very hard, possibly perennial problems, which have taxed many deep and brilliant minds—some of whom even doubt the possibility of their resolution—is something recent, something people have invented. Given few basic ideas and information accessible to everyone, only a little research and a modest philosophical effort to think the matter through would seem to be required.

The thesis of this book is therefore very simple. It says that what photography is, is a kind of technology. Technologies, of course, have uses; they amplify our powers to do things. Accordingly, my emphasis is not so much on things as on activities, on what we do with things. Which of our powers does photo-technology amplify? Several, a few of which, usually unidentified, can be singled out for basic investigation, as they seem to underlie the multitude of functions discussed in the growing literature on the subject. I focus on two (though others enter the discussion): our powers to imagine things, and our powers to detect things (with "things" understood very generally to include not only objects but states of affairs, etc.). But if photography has several basic functions, it is necessary to develop a point that would be embarrassingly obvious if it were not so widely overlooked. The point is that photography, like many tools, can perform various functions *together*. Furthermore, when photography is doing more than one thing for us, its functions do not merely combine; they interact in useful ways. Thus my project involves setting these points out for photography in nontechnical language and providing preliminary applications of that exposition—all of which, I hope, readers will easily and profitably connect to the more specialized accounts of various kinds of photographic literature, thought, and activity.

As though my basic thesis were not simple enough, I have approached the functional account of photography through an intermediate step. It seems useful to consider photography as a family of technologies for extending our powers to put marks on surfaces—if I may stretch the term "marks" to include impermanent physical states such as projections on screens—and then assign to these marked surfaces the functions discussed. This two-step treatment has (among others) the advantage of keeping the account concrete as well as simple.

The procedure of the book is to some extent "historical," although it is

hardly intended as a history of the topic. I usually introduce a given issue by going back to the earliest days of photography and coming forward from there. There are several reasons for this. First, in order to present photography as technology, one must consider it as a kind of historical phenomenon. Perhaps an effective way to keep our thoughts steadily open to the future of a fast-changing field is to run them back and forth between past and present, so that what we say will not be unnecessarily confined to local situations and so soon prove obsolete.

The second reason is that in a historical approach lies strength. The historical literature on photography often seems to me to offer the best developed, the most informative, indeed the most interesting and suggestive of ideas. It is also the most accessible to the non-expert. There are excellent general histories of photography from various points of view, and the literature of more specific historical investigations grows rapidly. The story of photography is an absorbing one, highly relevant to everyday life, constantly elaborated by new research (more than I have been able to cite). There are, besides, fine anthologies that include essays from the whole history of photography. Having taught university courses from four such anthologies, I think of this book as a possible companion to any of them and thus have keyed the account to them all: *The Camera Viewed,* ed. Peninah R. Petruck; *Classic Essays on Photography,* ed. Alan Trachtenberg; *Photography: Essays & Images,* ed. Beaumont Newhall; *Photography in Print,* ed. Vicki Goldberg.

An argument from anthologies can be no better than what is in them: thus the third reason for working from history. It is often pointed out that photography was born full-grown, and something similar might be said about the thinking and writing on the subject. One often finds nineteenth-century figures dependably clear, farsighted, interesting, and articulate in their observations on photo phenomena; I have found in their ideas and formulations starting points for most of my discussions. To some extent, therefore, this book may be read as a gloss on a few observations by William Henry Fox Talbot and Lady Elizabeth Eastlake.

Those are the reasons for a simple treatment of photography by one not expert in any aspect of it, through a thesis about technology from one who knows little technology, with historical references by one who is no historian. My hope is that more knowledgeable people will improve on it. Philosophers should note that, given the project of this book and its intended audience, I have left formulations simple. When writing about such topics

as causality, I have had occasion to remind myself of what Gwendolen Fairfax says to Cecily Cardew: "This is not the moment for German scepticism."

The chapters of the book are arranged as follows. Chapter I introduces what it means to think of photography as technology—as surface marking to serve several functions—and, by briefly considering the narrow limits of many "philosophical" approaches to photography, recommends this way of thinking. Chapter II provides an analytic and then a longer historical account of photography as a technology for marking surfaces. As photography is here treated as a family of technologies for such a purpose, Chapter III is a necessary summary and nontechnical account of how technologies in general amplify certain powers and thereby typically filter, even suppress, other powers. Chapters IV and V look into the two main activities that photo-technologies are here held to extend (and thereby to filter)—our activities of imagining and of detecting—and the close interaction of those activities which is so typical of photography yet so confusing to commentators.

The rest of the book deals with the initial applications and developments of these ideas and addresses perhaps the two most common areas of puzzlement about photography: photo fidelity and photographic art. Chapters VI, VII, and VIII attempt to treat the first in terms developed by the earlier chapters. Chapter VI also provides an elementary, even naive, account of photo-optics as it bears on this topic, placing it in wider contexts; Chapter VII offers some preliminary work on the influential but unexamined idea of "photographic seeing"; Chapter VIII sketches a wider context for the account of basic photo functions in Chapters IV and V. Finally, although this is not primarily a book about aesthetics, Chapter IX attempts first to clarify and then to begin to resolve some basic issues concerning photography as a fine art by thinking them through from the standpoint of photography as an amplifier of our powers.

Although it is typical of writings on photography to take advantage of illustrations, I have kept these to a minimum. Among my reasons were the difficulty of locating sources and the cost of securing permissions; they cannot object to economies in these matters who have not attempted to do this job themselves. The main reason, however, rests with the object of the book as stated. Since I regard it as a "primer" dealing with basics, which should apply to all cases, it seemed most effective to rely on a few cases, returning to some through diverse discussions, the better to show the wealth of interesting aspects that most good photographs present. I want to encourage read-

ers to connect this treatment with the many fascinating collections of photographs already in print, to test it against them, and to relate these observations, conceptualizations, and distinctions to other commentaries. Only in this way is the book likely to be useful.

I have drawn heavily on the works and encouragement of others. The general functional approach to images is inspired by the views of E. H. Gombrich. My consecutive thinking about photography began in an invitation to address the American Society of Aesthetics on that topic. Teaching philosophy and visual arts courses at the University of Western Ontario and the University of California–Berkeley, and addressing various groups—including the University of Michigan's Philosophy and Art History Departments and the University of Toronto's Semiotic Circle—kept the thinking going. The focus on technology derived from Duke University's invitation to take part in its Festival of Art, Science, and Technology. I am grateful to the sponsors, good angels, and audiences at these and other places for their interest and their observations. Travel and research were funded by the Deans of Arts of the University of Western Ontario, and by two grants from the Social Sciences and Humanities Research Council of Canada. For most of the library research I was able to depend on the holdings of the University of Western Ontario.

A few words can have effect, such as those of encouraging interest from Cheryl Bauer and Paul Feyerabend. Richard Wollheim remarked that it was time for me to write a book, and I usually try to do as he counsels. I was early prompted by Joel Snyder's idea that I might usefully write on a topic in which I felt relatively inexpert; explicit acknowledgments to his ideas occur in the text. I hope the discussion at the close of Chapter VIII enhances the work of Alan Trachtenberg, who tellingly encouraged both the historical approach and my writing of this book. Chapter VI, on shadows, for all its shortcomings, I like to think of as the continuation of a radio talk by Frank Oppenheimer. An invaluable practical editing conference with David Hills and Kendall Walton set the writing going, and both gave precious time to offer detailed comments on various drafts.

Some of these acknowledgments reveal a laborsaving technique for the writer: cultivate over long periods the friendship of the best thinkers in your field, dear friends who are also the kindest people, it being unnecessary to steal from those who give freely. In fact, I am pleased to consider that here I

preside at a conference of thinkers, some of whom have not exchanged ideas before. My thoughts about technology were focused by Clifford Hooker's explicit formulation of technologies as amplifiers of our powers. This book could be understood as a working out of his idea. Were he not half a world away, his observations would have greatly improved everything I hazard about engineering, and more. David Sanford was of great help and encouragement to my earlier thinking about the Chapter V material; I wish there had been time to put the full manuscript before that philosopher.

As Chapters IV and V make clear, Kendall Walton's theory of representation has been crucial to carrying out this enterprise. The publication of his *Mimesis as Make-Believe* may well mark 1990 as the year in which we were first presented with something that could be unreservedly called a theory of representation and thus of depiction, where by "theory" I mean a systematic account that can be used to explain phenomena in clear terms, to situate them within wider contexts, to solve old problems, to match the distinctions we observe and the tendencies we exhibit, and to begin to tell us why representation should be so important to us. I doubt that the job of saying what photography is could be accomplished without that theory, so badly needed and so long in coming. Walton had begun to work out the implications of his approach for photography; the *Mimesis* book and an earlier paper sorted out the strands of depiction and what is here called "detection," and were explicit about their interactions. It remained to think through these insights, to give them extended formulation, historical basis, and application. This book is one attempt to do so.

To deal with the issue of photographic art in Chapter IX, I faced the seemingly daunting task of saying not only what photography is but what art is, as well, and applying this conception to particular works in order to understand why problems should come up for artworks that are photographs of things. In my specific comparisons between photographs and drawings, I have relied greatly on the theories and vocabulary of John Willats, as they appear now in his *Art and Representation: New Principles in the Analysis of Pictures*. I had also the benefit of Willats's comments about my applications of his terms, though for tactical reasons I have not developed these as fully as he might. Willats also guided my drawing of the Chapter VI diagrams. Finally, the approach to pictorial artistic meaning in terms of "thematization" derived, like the earlier idea of "imaginative projects," from Richard Wollheim.

This book was written quickly (some may say too quickly) but not quickly enough. It is dedicated to Olga Maynard, who did so much to motivate and sustain its production. My last typewritten letter from her, typically fluent and impeccably produced, urged me in the most practical terms to work steadily and not to let writing time slip away. She appended a handwritten note about the recent production of an opera composed by an old family friend: "Such joy!" she wrote, "when a friend has such success!" This book need not, however, be dedicated to Professor Maynard's memory. Her own books, with her hundreds of articles and recorded lectures, preserve that for an international public. Her many students, her colleagues, and some of the finest dancers and choreographers of the time—in their testimonies but above all in their work and their own teaching—continue that memory. Of a beloved friend she wrote, "Wearied of obituaries in this decade, I prefer to celebrate his memory than to mourn his loss. He would have had it so; Joffrey is the choreographer of *Remembrances*. He left us attended by two handmaidens. On his right was Terpsichore, the muse of Dance, whom he had served well. And, on his left, Mnemosyne, she who presides over Memory, and ensures that Robert Joffrey shall not be forgotten." Should ever in the following text an apt phrase or analogy occur, or an idea lead to unexpected connections, let that be tribute to Olga Maynard, on behalf of her children and grandchildren.

PATRICK MAYNARD

London, Ontario

PART ONE

❧

PHOTO TECHNOLOGIES

CHAPTER I

❧

Photography as Technology

Technologies of Photography and Photography as Technology

The simple theme of this book is that what we call "photography" is a *technology*. More accurately, it is a branching family of technologies, with different uses, whose common stem is simply the physical marking of surfaces through the agency of light and similar radiations. If the idea of photography *as* technology seems unfamiliar, the technology *of* photography is surely very familiar. Even those not disposed to call photography a technology will admit that from what may be called its first inventions in the 1830s through its several reinventions, the importance of photography has depended not only upon its social uses but also upon a series of remarkable technological innovations, a series still showing no limit. To illustrate this, let us set aside, for the moment, major photo-technological inventions—the latent image, the negative-positive process, dry plates, roll film, miniature cameras with fast lenses, "tripack" color film, motion pictures, television, and the highly technical innovations of our time—and consider instead only a few mass-market technical developments from just one decade in the recent history of amateur photography: those in the miniature camera market beginning in the late 1970s.[1]

By that time film-exposure automation, with electronically controlled

[1] My chief source for this information is John Wade, *The Camera: From the 11th Century to the Present Day* (Leicester: Jessop, 1990).

shutters, was well in place, and LED (light-emitting diode) indicator displays were common in cameras, as they were in many everyday appliances. Then, thanks to the newly evolved micro-chip, tiny computer processors found a niche in camera bodies—again, as in domestic appliances and automobiles—which consequently began to shrink in size. Owing to such technological miniaturization and to the introduction of new lightweight materials, the single-lens reflex, or mirror, camera (SLR), with its through-the-lens viewing and light-metering system and interchangeable lenses, became smaller and lighter. The even smaller, flatter, non-reflex 35-mm "compact" camera—often equipped with electronic flash—came to a position of dominance in mass consumer markets. Some may recall how the tiny 110 film format, popular from about 1972, went down with the 126, with the ill-starred film disk, which had arisen only in 1982. During the decade, "automation"—indeed programmability—in the words of a famous book on technology, truly "led the way." Full automation for light exposure did not amount to what is called "point and shoot"; there was still the question of automatic *focus*. This too was ingeniously addressed during the decade, most easily for compact cameras without interchangeable lenses, as the microelectronics could be positioned right in the fixed-glass optics; however, "body-integral" autofocus systems for SLRs were on the market by the late 1980s.

Thus the outline of a mini-history of *one* line of popular photo-technological development for a general market. It is no part of my brief presentation to say that this development was autonomous, or that it basically involved "solving problems." I do not even call it progress, or imply that it answered anyone's "needs." Setting the account in the context of widening mass, popular, consumer markets, fairly affluent and increasingly mobile—as well as within a production and distribution network increasingly global—is a reminder from the outset that, technologically, necessity is by no means the mother of invention. In fact, the idea of necessity is a poor way of understanding human technological initiatives generally and poorer still in the context of modern popular consumer markets.[2] Given their market applications, photographic inventions of the kinds listed seem more often the mothers of (perceived) necessities. This is the place of modern advertis-

[2] A theme to which I shall return. Lynn White Jr. comments on both the falsity and the origin of the adage that necessity is the mother of invention in "Cultural Climates and Technological Advance in the Middle Ages" (1971), in Lynn White Jr., *Medieval Religion and Technology: Collected Essays* (Berkeley: University of California Press, 1979), p. 222 and n 18.

ing, in which photo processes, as we all know, serve as an "engine of visualization," affecting conceptions, quickening desires.

None of this implies that producers and promoters have the power simply to impose "necessities" on a given market. History shows that many technological initiatives simply fail to interest potential users. For example, during the decade surveyed, new versions of the panoramic camera and of stereo photos—much heralded versions of which seem to recur periodically—attracted buyers for only short periods. The four-lens camera of the early 1980s, which produced three-dimensional effects without viewing apparatus, did not seem to attract buyers. Holograms likewise fell short of initial expectations. Again, some observers say that the popularity of the small 110-film format had been due mainly to its automatic loading method, so that for the 35 mm compact to overwhelm the 110 was just a matter of making the simple process of loading film even simpler. Nor did all the changes occur in cameras themselves. During the same decade, *color* prints began to dominate color slides in the popular market, and black-and-white printing suffered successive demotions (which may be tracked through our family photo albums) from standard to default, option, specialty or "custom" (more expensive and not so fast)—a plunge similar, though rather less dramatic and final, to that of vinyl sound recordings after compact disks appeared. While listing such high-technology advancement in certain markets, we might also note that throwaway cameras came into vogue at about the same time, following the trails of the disposable ballpoint marker of the mid-1950s and razors of the mid-1970s.

Some will hold that this little review of the technologies of photography during a single recent decade has left out the most significant photo-technological innovation: *electronic* film recording, or EO, as it is sometimes called (for "electro-optic"). It was precisely during this decade that small video camcorders became a main photo market, so that "photography" was no longer exclusively the *chemical*-optic technology it had been since its inception. By the end of the decade the still-video camera had appeared, opening in principle—if not in sales—a new chapter in the history of camera technology, not only because it retraced for still photography the path from chemical surface receptors (notably silver halides) to *electronic* surface receptors but because that path was now through a directly *digital* system. According to some observers, of all the changes mentioned, that was the largest. Earlier in the decade the miniature central processing unit (called a CPU) in

the camera works had permitted digital control of the *input* processes—that is, of the optical and the chemical image formations (a later chapter looks at the relationship of these two kinds of images). By the end of the decade there was digital *output* as well. This is output that is easily integrated with other computing digital systems, which were meanwhile busy about their own graphic capacities for image-*making,* as opposed to image-*taking.* The potential of computers for smooth transitions between these taking-pictures and making-pictures operations appeared great, especially as the decade ended with the rise of the personal computer market.

Here is a point at which we should observe a technological fact that usually passes unappreciated in discussions and prophecies of this sort. If something called photography seemed about to be transformed by fast-developing computer technologies, these technologies were themselves functions of a photographic technology and could not exist without it. The reason is simple: personal computers were made possible by the emergence in the early 1970s of microprocessors, tiny solid-state structures that depend, crucially, upon the process of microfabrication of computer chips, which is itself a "photolithographic" technology. That variant of what might be called a classic photo-technology is necessarily a chemical, not an electronic, process. Without photo-technological miniaturization, computer circuits would simply be too large, too slow, too undependable, and far too expensive to have any of the uses I have indicated. Far more than photography relies on electronic and digital technologies, those technologies rely on standard chemical photography.

This observation carries us from the topic of ("merely") technologies *of* photography (such as autofocus devices) to that of photograph*ic* technologies (such as those for making microchips) and thereby to photography *as* technology. If those photographic technologies are to be considered part of what we mean by "photography," then there is photography that does not consist in making photographs—at least not as we ordinarily understand those terms. That photography may be a technological way of *doing* things might suggest that even in the more familiar or "traditional" case of making photos, photography could also be understood in terms of doing things. The question would then be, what sorts of things are we doing? The following chapters give detailed answers to this question. Yet this way of considering photography seems to stand in marked contrast with that to which we are most accustomed.

"Photography" and Photographs

My sample of some technical developments affecting popular and professional still photography in a recent decade was intended neither to introduce a detailed history of photo-technology nor to predict its future history. Rather, it was to remind us how much photography is a creature of technology, a product of nineteenth-century industrial society which continued transformation right through twentieth-century technological society. Yet might we not say the same about almost everything else during recent decades? And is this trend not likely to continue, for better or for worse? As the inventor of the first mass photo system, George Eastman, once remarked, whoever "thinks he has done everything he can do has merely stopped thinking."[3]

One reason for choosing the decade from the late 1970s to the late 1980s was that a year near its end, 1989 (the very year in which every major photographic company marketed a still-video camera), also marked the 150th anniversary—the sesquicentennial—of public announcements of "photography." Now it happens that, for all the generally acknowledged—even insisted on—current importance of photography and of photo-media, this anniversary was not a much observed event: not one to compare with the following stress-filled fifth centennial of Europe's discovery of America, or the demicentennial of D-Day. On the other hand, it might be said that photography's anniversary did receive more attention than did that of one of the noblest of inventions, the bicycle, or of that most successful of all linguistic expressions, "OK"—also from the year 1839.

It was remarkable to note, in the little that was printed and broadcast about the photo anniversary, how unclear it appeared what the occasion was an anniversary of. The overall impression was of the inception of a sort of remarkable kind of *thing*, "photographs," rather like a rain of meteorites. One everyday way of thinking of photography seems to be as simply a way of producing photographs; an engagingly simple dictionary definition of photography would be "the taking of photographs," while a definition of "photograph" would be "picture made with a camera."[4] A more careful version of the same conception might read: "photograph: Picture, likeness, tak-

[3] George Eastman, quoted by Bob Schwalberg in his column, "Critical Focus," *Popular Photography,* September 1989.

[4] *Thorndike-Barnhart Comprehensive Desk Dictionary,* ed. Clarence L. Barnhart (1951).

en by means of chemical action of light on sensitive film on basis of glass, paper, metal, etc. . . . Hence photographER, photographY, . . . photograph-IC."[5] Although more circumspectly here, a thing is still taken as basic and a process conceived in terms of producing that thing. By the term "likeness," we are not so restricted to "pictures" in the usual sense of that term, and we also get clear of cameras, which are not always necessary to photography (and which, in any case, had prephotographic life), and begin to specify the essential elements of light and sensitive surfaces. One might wish, however, to specify both these elements rather more generally: "light" might be expanded to include X-rays, and provision made for nonchemical, electro-optic photo forms such as television.

In keeping with this dictionary approach, what was mostly pondered at photography's anniversary was the nature and significance of these peculiar "things" and what *they* do to us—rather more than what *we* do with them. These objects "froze events" or "captured moments"; they were poignant reminders; they had become the leading visual artform; they sold products, policies, and politicians; they constituted a "ghostly scrim of media images" through which people try to glimpse reality: a dark and suspect "mirror," we were warned.[6] Such preoccupation with the nature and uses of photographs, proved somewhat awkward, however, for the actual objects have historically presented rather different "objects" from one generation to another. When we get to moving picture photography, it begins to be awkward to speak of photos as things at all, and one is more likely to take refuge in such terms as "images," or "moving images." The awkwardness becomes all the more acute with television, an EO technology that does not even produce, like cinema, separate things called photographs but seems photographic, nonetheless. Finally, if the journalists and other observers covering the sesquicentennial event had read the *history* of photography and considered its contemporary importance in just the areas they were emphasizing—of art, advertising, ideology, private use, and technical employment—they might have been rather less inclined to focus on a stream of objects, photographs, which in 150 years had broadened from an initial few feeder trickles of diverse sources to a rush that engulfs us.

[5] *Concise Oxford Dictionary of Current English,* ed. H. W. Fowler and F. G. Fowler, 5th ed. (1964). The 6th edition entry (1976, ed. J. B. Sykes), "Picture taken by means of chemical action of light or other radiation on sensitive film," loses "likeness" but by "other radiation" admits X-ray and other kinds of photography.

[6] Richard Lacayo, "Drawn by Nature's Pencil," *Time,* 27 February 1989, pp. 62–65.

After all, the term "photography" itself is, like "lithography" (a resembling technique invented not forty years earlier, and to which it was joined), the name not of a class of things but of a kind of productive process, which frequently but not always issues in things of diverse use and interest. To be sure, the popular accounts from 1839 and the next few years were full of wonder about the things produced—how they appeared, what they showed—but they were also enthusiastic about the processes that produced them. This was just as well, given that some of the early examples of things produced were very small, nondescript in appearance, and at best mistaken for productions by manual or printing systems—rather like early dot matrix computer printing as compared with typewriting. The early advertising for photography and daguerreotypy (if we keep these systems at first distinct), their scientific and commercial promotions, and certainly their *patents,* of course, stressed their physical means of production. Early inventors and promoters such as William Henry Fox Talbot were prudent to draw attention not so much to a new class of objects as to the diverse uses of a new set of technological procedures. Talbot was, after all, inventing and patenting photographic *procedures,* not photographs. It was Oliver Wendell Holmes Sr. who twenty years later coined the rather misleading phrase "mirror with a memory." Talbot's famous book displaying his invention was called, more appropriately, *The Pencil of Nature,* emphasizing photography as a means by which *we do* many valuable things. In this he proved not only a fine inventor but a sound prophet.

By contrast, almost all writing about photography in our own times tends to begin with the alleged nature of the product rather than with its production and use. Photography itself is taken as the productive process for producing photographs. Typically, such writing, with its tendency to label that product "the photograph" or "the photographic image," conjures with the strangeness of its effect upon us—even with the alleged strangeness of its "being." By investigating its nature, we are to find explanations of its use and importance.

"Reputable Opinions"

Pioneering the treatise form as we know it, Aristotle recommended that it is usually good to begin with a survey of what he called "reputable opinions" (*Topics* 1.100b). Even in a field such as photography which has lacked systematic treatment, we have much to learn from what thoughtful people

have already stated. Further, as Aristotle went on to say, a good account should be shown to square with such perceptions (or the best of them) even where it attempts to correct them (*Nicomachean Ethics* 6.1098b, 1145b). There being a dearth of actual philosophical studies about photography, I will be drawing testimony from a variety of influential shorter, general pieces, beginning with some widely read prefatory notes to cinema theories and briefly reviewing a few other standard sources.

André Bazin's famous essay of 1945, "The Ontology of the Photographic Image,"[7] attempted the sort of project just outlined. Its title names a kind of thing (thus "reification") in the singular ("the photographic image"), and wonders about the category of this thing's being (thus "essentialism," with the suggestion of metaphysics). In this essay, as elsewhere, Bazin treats photography as a mechanical process for making pictures of things and for transferring the "reality from the thing to its reproduction." Thus, "the photographic image," he writes, "is the object itself." Photography is to be understood in terms of images produced in a certain way, and these were all assumed to be *photographs of* things. For Bazin, photography is exceptional among ways of depicting things, in the satisfactions it brings by its very means. This approach was followed, for example, in 1971 by Stanley Cavell, a philosopher influenced by Bazin's ideas but understandably uneasy about the paradoxical equivalence of image and object. In his own book on film art, Cavell comes straight to my present point: "We do not know what a photograph is. . . . We might say that we don't know how to think of the *connection* between a photograph and what it is a photograph of," and he reflects on "how mysterious these things are."[8] This reifying approach he continues through a search for the sort of thing a photograph "reproduces," parallel to the sounds a recording reproduces. The conception of photography is thus through that of photographs. Photographs are considered a puzzling sort of thing, to be addressed in terms of their relationships to other things: notably the relationship of being a photograph *of* other things. This is not only a common but a standard conception. Alas, slight progress has been made in *explaining* the relationship "photograph of."

[7] André Bazin, "The Ontology of the Photographic Image," in *What Is Cinema?* trans. Hugh Gray (Berkeley: University of California Press, 1967), 1:12; rpt. also in *The Camera Viewed: Writings on Twentieth-Century Photography*, ed. Peninah R. Petruck (New York: Dutton, 1979), and in *Classic Essays on Photography*, ed. Alan Trachtenberg (New Haven, Conn.: Leete's Island Books, 1980).

[8] Stanley Cavell, *The World Viewed* (New York: Viking, 1971), p. 19.

Some influential theorists almost provide exceptions to this predominant thing-mindedness. A third modern film theorist, Siegfried Kracauer, is also something of an exception to the approach to photography via the nature of photographs. To be sure, Kracauer's introduction to his 1960 book on cinema speaks of "the nature of the photographic medium" and its "specific properties," but he works at such topics quite effectively through an analysis of the early and recent *histories* of our ideas of it.[9] For example, according to Kracauer, since photography's (not "the photograph's") inception, people have stressed its powers to "record and reveal" what is photographed. Naive early formulations of those powers must be tempered by the perception that "photographs do not just copy nature but metamorphose it." This leaves photography open as well to artistic "formative" operations (a discussion to which I return in detail in Chapter IX). Kracauer also argues explicitly against perhaps the most harmful false dichotomy in the history of talk about photography, pointing out that its realist recording powers are fully consistent with its being highly interpretive, even self-expressive. His famous, controversial insistence on maintaining cinema's connection with "physical reality," however, still emphasizes what it produces photographs *of.*

Such was true of an even earlier writer, Walter Benjamin, whose avowedly technological approach to still photography and film during the 1930s would become very influential some decades later; his is perhaps the most influential of our reputable opinions. Benjamin provides the rare case of a modern writer on photography who treats the technologies of photo reproduction centrally and relates these (though all too briefly) to the printing press and to sound recording. His famous, elusive essay of 1936, "The Work of Art in the Age of Mechanical Reproduction," set out to provide general "concepts" for the theory of art through sweeping and often misleading historical generalizations about the use of images.[10] These include the prophe-

[9] Siegfried Kracauer, *Theory of Film: The Redemption of Reality* (Oxford: Oxford University Press, 1960), chap. 1, "Photography." The book is, strangely, out of print, though the introductory chapter is reprinted in Petruck, *The Camera Viewed*, 2:161–87, and in Trachtenberg, *Classic Essays*, pp. 245–68.

[10] Walter Benjamin, "The Work of Art in the Age of Mechanical Reproduction" (1936), trans. Harry Zohn, in *Illuminations*, ed. Hannah Arendt (New York: Harcourt Brace Jovanovich, 1968). The situation with Benjamin's 1931 "Short History of Photography," trans. Phil Patton, *Artforum* 15, no. 6 (1977): 46–51, is rather different. There, seeking "insights into photography's basic nature" he refers to "the broad spectrum of the new technology," discusses the appearances of different kinds of early picture-taking processes, and writes of "the technology for reproduction" allowed by photography.

cy that photo-reproductive technologies would remove the "aura" of unique-
ness from original works of art, a prediction falsified by postwar affluence
and travel technologies, which allowed millions of people to go to original
artworks and bring reproductions of these works to themselves. This avowed
Marxist's technological approach, however, yielded an essay distinctly about
kinds of things, rather than about the work that people do with a technolo-
gy or even about the ways in which that work became organized and indus-
trialized. Benjamin's much cited terms "aura," "authority," "authenticity" are
all static adjectives describing things, and his thesis about the age of me-
chanical reproduction constitutes another, very influential, example of ad-
dressing the relationship between two sets of alleged *things:* originals and
"reproductions" of them, and the changes allegedly wrought in the former
by the latter. His way of thinking leaves out, for example, the normal use
people make of photographic reproductions: to discover originals, learn
about them, imagine seeing them, even indirectly perceive them, as we do
by listening to sound recordings. Benjamin's use of the term "reproduction"
is in fact so broad as to include photographs of nature (which do not entail
loss of the subject's "authenticity"), not just of works of art; photography is
then once again considered simply in terms of pictures that are *photographs
of* things. We are not informed what it is to be a photograph of something.

Among somewhat longer pieces—meditative, unindexed monographs—
is an interesting and quite influential pair: Susan Sontag's *On Photography*
from 1977,[11] followed in 1980 by Roland Barthes' *Camera Lucida.*[12] Sontag,
who was to write appreciatively of both Benjamin and Barthes,[13] collected
a set of essays on the subject of what she termed "photographed images." By
that she meant throughout, and with scarce exception, (still) photographs of
things. While a good deal of her discussion concerns—in an influential way
to which I shall return—*art* photography (rather, American art photogra-
phy), the "theoretical" beginning and ending of her book are about "images,"
in relation to what she repeatedly terms "the real" or "reality." Citing Plato's
Allegory of the Cave, Sontag too understands photography basically in terms

[11] Susan Sontag, *On Photography* (New York: Penguin, 1977), based on a series of *New York Re-
view of Books* essays that worked toward a "theoretical" statement on the subject.
[12] Roland Barthes, *La chambre claire* (Paris: Gallimard, 1980), trans. Richard Howard as *Camera
Lucida: Reflections on Photography* (New York: Hill & Wang, 1981).
[13] For her estimate of Barthes on photography, see Susan Sontag, "Writing Itself: On Roland
Barthes," *New Yorker,* 26 April 1982, pp. 122–41.

of the relationship between two kinds of entities: images and reality—as the producing of photographs of things—and offers many perceptions about what "photographs are" or tend to do. One has to wait for her very last, not so influential, pages to find her qualifying this approach with an interesting contrast of Chinese and "capitalist" photographic *practices*—the ontology of photos presumably being the same in Beijing as in New York.

As for Barthes, there could scarcely be a clearer instance of the tendencies under review than his melancholy investigation. Hardly a sustained account of photographs themselves, his monograph is actually reductive to the subjects photographed, taken substantively: usually people or details of them and their attire. Unlike Sontag, who at least makes some reference to photo-technology, Barthes explicitly puts that aside on page 3 to investigate unabashedly what he terms "Photography's" (interchangeably, "the Photograph's") "essence." Like Bazin and Cavell before him, Barthes wonders about what he calls the ontology of a strange object, the photo. Since his and Bazin's discussions, much has been written about the so-called ontology of photographs (although this is not yet a generally recognized branch of philosophical metaphysics), and Barthes too accounts for it entirely in terms of a photo's relationship to what it is a photograph of, what he calls its "referent." Thus the distinctive nature of the photographic image consists in its being "literally an emanation of the referent" (80), "co-natural" with (76) though not a "copy" of it (88), and our poignant experience of this as "that-has-been" constitutes its greatest interest for us. Where the moment of the composition of the picture seems an undeniable factor in the appeal of a photograph, Barthes counts that as "luck."

Finally, one might consider John Berger's *Another Way of Telling,* although (speaking of lack of technological interest) it may be difficult to repose confidence in a book that remarks, "The camera was invented in 1839."[14] Berger speaks throughout, generally, of "a photograph," and finds photography "a strange invention" (85). His basic premise is that "photographs quote from appearances" rather than "translate from" them, as do ordinary pictures of things. This has to do with the physical way in which photos are made. Since they are taken at a moment, they can provide only incomplete quotes, out of temporal and spatial context. "This produces a discontinuity," he claims, "which is reflected in the ambiguity of a photograph's meaning." Therefore

[14] John Berger and Jean Mohr, *Another Way of Telling* (New York: Pantheon, 1982), p. 99.

"all photographed events are ambiguous" except to those whose personal knowledge can restore "the missing continuity." The fact of this inherent ambiguity is usually obscured by verbal glosses. "The expressive photograph," however, can present meaning in the relationships of what it shows in an instant (128). Although he discusses different uses of photography, commenting that their "truthfulness" varies with the context of use (98), the thesis of this critic of positivism is based upon the unexamined assumption that the nature of photographs can be derived from the way in which they are, allegedly, made: because they are "taken in an instant," they can capture appearances at an instant, whence they inherit their characteristic and troubling ambiguity, as appearances at instants are ambiguous. Thus, "the only time contained in a photograph is the isolated instant of what it shows" (95). If we are being phenomenological, none of this makes much sense against our experience of some of the most "photographic" of photographs, such as an amateur's telescopic view of the Horsehead Nebula, or closeups of bark, dew-bedropped spider silks, butterfly wings, or a darkfield macro of two pregnant waterfleas.[15] Nor does it jibe with standard printed photography of package contents, and so on.

With some exceptions, such a survey of reputable "philosophical" opinions shows a tendency to consider photography in terms of its products, photographs, and then to consider some significant relationship that these products bear to some other thing or things and thereby to discover the meaning all this has for us. These other things are, typically, what the photos are photographs of, or—in the case of the more "philosophical" accounts—what is called "reality," "the real," "the world," "the real world," and so on.[16] In other words, we find an all too familiar syndrome of theoretical puzzlement. It begins with "reification," the conception of a topic in terms of substantives, "things"—in fact, *two* kinds of things and thus a "dualism," to boot: on one side there is "the photograph" (click); on the other, "reality" (THUD). Next comes "essentialism," a search for the essences (drawn from impressions of a few instances) of one or the other member of this pair of things, as well as for an essential relationship between them, from which per-

[15] See, e.g., William J. White Jr., *Close-Up Photography,* Kodak Workshop Series (Rochester, N.Y.: Silver Pixel Press, 1984).
[16] Sontag, *On Photography,* p. 158. In the first thirteen pages of the book she uses "real" thirty-six times and "reality" twenty times.

ceptions are to flow. Cavell's puzzle presents that succinctly: "We don't know how to think of the connection between a photograph and what it is a photograph of." Here is a place to note that in the decades immediately following the books just described, many thinkers on the subject turned from the alleged nature of the photograph to that of the other relational term, the world, or reality itself, wondering about photography's power to determine its nature.

If these three labels—reification, dualism, essentialism—are perhaps too strong for describing both common conceptions and printed meditations regarding photography, they at least indicate the directions of the more usual kind of thinking. For example, "essentialism" may be too strong a term, as none of these accounts actually specifies the assumed essence of its topic. It is questionable whether any can even be said to make an effort to do so. Photography is understood in terms of photos, and photos are invariably understood relationally as being *of* things. Remarkably, one looks in vain through all that literature to discover any attempt to define or to explain the relationship "—— is a photograph of ——." One looks in vain even for any effort to mark the difference between being a *photographic picture* of something and being a *photograph* of it, although we daily see photographic pictures that are by no means photographs of what they depict.

Turning away from opinions—"reputable" and less so—one finds recent writing about photography better characterized by its number of excellent histories: more books and articles, more research, more extended consideration of photography than among the occasional essays of philosophes and philosophers. One might expect also to find more technological treatment, more awareness of the various kinds and processes of photography, certainly more concern with their uses, for a history of photography could scarcely avoid the history of technologies of photography. This is largely true, although one "history of photography," published just before the sesquicentennial, opens as follows: "I was told once that more photographs exist than bricks. . . . Photographs, like bricks, are everywhere. Can there be anyone left who has not seen a photograph? . . . From snapshots to billboards, from the cradle to the grave, we give and receive through images on a daily basis. . . . Technology has played a secondary role in photography's visual history—for all their micro-chip sophistication today's cameras are close relatives of the humble wooden apparatus made for William Henry Fox-

Talbot . . . by his village carpenter."[17] One could hardly find a clearer exposition of the tendency under review: to consider photography in terms of a sort of thing, like bricks, and to cast photo-technologies into the background of our conceptions and concerns.

Most photo histories, however, are not like that—not even this one. Subsequent chapters will draw consistently on these histories for our investigations, but let it suffice here to say that "technologies of photography" does not necessarily comprehend "photography as technology." Almost every history of photography emphasizes its technological history, but none presents it in terms of technology. A striking symptom of this is that such histories are nearly devoid of reflection upon the nature and history of technologies generally and never seem to bring insights there to bear on their subject matter.

Photo-ready?

We have considered representative evidence that those with the most theoretical perspectives on photography in recent times have typically approached it through consideration of the *nature* of an apparently puzzling, even disturbing, new kind of thing, and that this approach has shaped their accounts in characteristic ways. It remains to make a case that they should have done otherwise, or to see how they might have done.

It is understandable that so many writers have followed that conception. Photographs, or photographic images, form an important class of modern artifacts. The approach to photography via photographs, rather than to photographs in terms of photography, however, has proved a common pitfall of most thoughtful treatments of the subject. If we begin with attention to certain products of photography called "photographs," we are as likely as these writers to experience failure of memory. We will simply not remember a host of familiar cases, and this will constrict our data. Even if not so blatantly as Barthes, who in *Camera Lucida* wrote, "I resolved to start my inquiry with no more than a few photographs, the ones I was sure existed *for me*" (8), we

[17] Peter Turner, *History of Photography* (New York: Exeter Books, 1987), p. 7 (the hyphenation of Talbot's name is a mistake, which Turner does not continue). Actually, Turner's history is very much written around and informative about technological innovations, which he seems to understand well; his is one of the few histories that keeps photography in a context of other technologies and industrialization throughout.

are likely to follow the tendency to remember just one or very few kinds: family snapshots, works of art or their reproductions, historical portrayals, advertising images, news pictures, movie stills, police file pictures. Combining reification and essentialism, we are then likely to be tempted, as are various of these writers, to generalize from our sense of such partial, favored data regarding the nature of something called "the photograph," leaving it to readers to ask, *which* photograph?

As we shall see, photographs themselves are of rather different natures, uses, appearances, and have been produced and valued in these different ways from their first inventions. Besides underestimating this diversity, the usual "photographs" approach to photography falls short in its ability to help us understand *new* kinds of photo imagery as they appear. A significant example is the present bafflement of many in the face of digital EO photography: a sign that they were thinking about familiar, habitual objects rather than from sufficiently useful principles. Furthermore, we have reason to expect photo-technologies to continue to produce new kinds of photographs or, better, new kinds of photography and new uses of it. As these occur, they will be better understood in terms of some general principles. For example, we know that all modern technologies tend to diversity. Thus television was developed from work on radar: an example of what might be called "root diversification." Again, microcomputers, developed independently of cameras, revolutionized camera control systems: such might be called "application" or "transfer." Application may also be interactive: hence "hybridization." As image-taking systems are further joined to digital processing systems—including image-generating ones—hybrid forms will appear. These are typical of many technological developments, and unlike mules, such hybrids often prove fertile, even of other forms. As Aristotle remarked following a survey of opinions: "These thinkers evidently grasped . . . vaguely, and with no clearness, but as untrained people behave in fights; for they . . . often strike fine blows, but they do not fight on scientific principles, and so these thinkers do not seem to know what they themselves say" (*Metaphysics* 1.985a).

The lack of principles shows up in most treatments of photography that attempt to be general. There is not only a partiality to certain examples and a tendency to overgeneralize from them, not only an inability to help us understand new examples as they appear, but also a tendency to isolate photography from related, even closely related, phenomena. Operating without principles, we are likely to think of a narrow field of objects and activities—

not a good philosophical situation. We are also likely to overlook important connections to photographic processes that do not link subjects to photographs of them and to overlook, as well, interesting and relevant connections to nonphotographic *imaging* techniques. We are thereby likely to say things that will soon prove obsolete in a quickly developing technological environment. For example, use of the term "photography" in most discussions has not yet caught up with later familiar techniques such as electrophotographic imaging processes, in xerography and nonimpact printing, and electronic photography—including, besides television and the still-video cameras mentioned, medical CRT (cathode-ray tube) systems, those used for remote sensing, and so forth. Yet new processes and applications appear regularly (and are, incidentally, exploited by artists). Part of my argument is that even when we choose to narrow our consideration of photography to certain examples, we will much better understand them if we first think about photography in a more general sense and within a wider field of relationships.

We may summarize this discussion with a consideration that is, literally speaking, graphic. We considered before a simple dictionary definition of "photography" as "the taking of photographs," and of "photograph" as "a picture made with a camera." This account is immediately in trouble if we go up the same page to "photoengraving," which the same dictionary defines as a "process by which plates to print from are produced with the aid of photography."[18] Cameras are not essential to the process of photoengraving, which often, in any case, operates without "pictures." Even writers who would set out to interpret the nature and significance of photography usually forget to notice the photo-reprographic processes by which the very texts of their own books and articles are not only illustrated but printed. Thereby they overlook that most important *re*invention of photography, around the beginning of the twentieth century (which electronic imaging's development may never rival in importance): the *ink,* or relief-impact, press-printing systems without which even "the photograph" today would have a diminished historical significance. In short, given their neglect of such photo processes, although some of these authors' own writings are made "photo-ready," typically the authors themselves are not.

[18] *Thorndike-Barnhart Comprehensive Desk Dictionary* (1951).

Defining "Photography"

Nothing in the preceding discussion establishes that we could not develop an insightful, principled approach to photography centered on an account of photographs—that is, if we could provide an adequate account of photographs. My thesis is, first, that an account of these "things" which is useful to understanding photography requires taking them in terms of our own activities with them, and, second, that these activities—if they are to be understood, in turn—must always be kept in the wider contexts of like but nonphotographic activities. Next, because all these activities will be presented technologically, we must do more than draw attention to photographic technologies; we must develop a principled, technological (but not too technical) conception of photography itself.

Fortunately, developing such a conception does not require inventing it. It already exists as another version of everyday ideas about photography and can be seen in dictionary entries that run a different path from those considered above. For example: "Photography: the art or process of producing images on a sensitized surface (such as film) by the action of radiant energy and esp. light."[19] This approach is also in accord with some of the existing technical accounts of photography. One of the best among older standard treatises in the field states: "Photography is the science of obtaining images of objects by the action of light on sensitive surfaces. . . . The two sciences of optics and chemistry form the basis of photography, the former being concerned with the production of the image in the camera, the latter with the composition and treatment of the sensitive surface which reproduces the image cast upon it by the lens."[20]

All parts of this style of account will be valuable to our conceptions: the emphasis on sensitive surfaces (see Chapter II) and on images. Therefore, for the present we can agree with one principled everyday understanding and define photography as a "science"—but better as an "art or process": that is, as a technological family comprising ways of doing things. We can charac-

[19] *Webster's Ninth New Collegiate Dictionary* (1983).
[20] C. B. Neblette, *Photography: Its Principles and Practice,* 2d ed. (New York: Van Nostrand, 1930), p. 1. This standard, first published in 1927, founded a series upon whose latest edition I depend heavily: *Imaging Processes and Materials: Neblette's Eighth Edition,* ed. John Sturge, Vivian Walworth, and Allan Shepp (New York: Van Nostrand Reinhold, 1989).

terize photography in terms of technologies for accomplishing or guiding the production of *images* on sensitized *surfaces* by means of *light* (broadly understood), without necessarily understanding such images as "photographs." Procedures, structures, materials will then be photograph*ic* when they have a place in such technology, whether or not they themselves work by light (which, in the case of some parts of camera engineering or development chemistry, they certainly do not). Putting "photography" before "photographs" in the order of inquiry means that photographs in the ordinary sense are themselves photograph*ic* because they are pictorial images produced by such processes. Therefore, to understand these objects better, we will need (first) to understand photo-technology better and (second) to understand a kind of "picture" better.

Doing this in a principled way should soon take us beyond even the best dictionary entries. For example, we will need to say what is meant by the use of light in forming an image, given that such radiation is, after all, causally necessary to forming images in painting, sculpture, tapestry. A first approximation, to be defended later, is that in the case of photography it is the radiation that *forms* the image, whereas in painting it is not. For the present, then, it is enough to say that etymology proves a guide: John Herschel's 1840 term "photography" has stood the test of time better than have many of the products to which it applies. The first part of the word means light (and related radiations); the second part means *marking*. Photography is technology by which light is directed to make physical states that we call images. Our sources neglect to state what such "images" are. Paradigmatically, they are *markings,* although photo-technology has significantly extended them to less permanent states than implied by a strict definition of that. These markings—or quasi-markings—occur, as our dictionary says, on special *surfaces.* Such surfaces, in the case of the more transient markings, are *screens,* of which there is a variety.

Photography thus conceived will include, but not be limited to, technologies for making certain kinds of pictures. Contrary to the foregoing sources, only some images marked on surfaces by light are there to be treated as pictures. Many are not, some could never be. Furthermore, only some of those that are pictures are pictures *of* (see Chapter IV), *depictions* of things and events, photographic "pictures of" overlapping with another class called "photographs of" them. Pictorial uses of photographic markings may well

be paramount, as all our sources tend to assume, but because they do not constitute photography, not even they will be correctly understood *as photographs* unless they are taken in something like the wider technological context considered here. In short, to understand photographs, we will first have to understand photography.

ঝ

Making Our Marks

Photographic "Images"

First, "Things"

Since conceiving of photography in terms of things—photographs—is so appealing to theorists, historians, artists, and dictionaries, we might as well begin there with our photo-technology approach. Now a philosophical consideration of photographs as things should include at least a general consideration of the kinds of things to which they belong. It should have been clear to the writers cited, in the midst of their insistence on thinking of photography in terms of pictures (or "images"), that the objects of their interest are first of all of the general class of *marked surfaces:* that is, of (1) surfaces that (2) have been marked—in this case by light.

The fact and significance of that might have been clear all along for a number of reasons. (1) Most people think of photography in terms of pictures, and "marked surfaces" (often declared to be "flat") is the most common way of thinking of pictures. (2) The most clichéd expressions for photographs, such as Holmes's "mirror with a memory" (1859), imply this. Daguerreotypes have mirrorlike surfaces and, according to Holmes, "the photograph has completed the triumph, by making a sheet of paper reflect images like a mir-

ror and hold them as a picture."[1] Further, since several sources have a theme of supposed links of photographs to death, this might have reminded them of the common nineteenth-century linkage connoted by (3) *shadows,* shadows cast upon surfaces. Next, (4) they might have considered that still photographs are most often seen today in conjunction with *print,* on a variety of surfaces—including some, such as cans, that are not flat. Other sites of photographic images, movies and TV, should remind them (5) of *screens,* which—whether used for light reflection/transmission or for electronic display—are not permanently marked by their images but are physically affected by them in a way analogous to marking; we will extend the term "marked" to include them. (6) If the writers themselves take pictures, they might have reflected on how they feel when the processor returns to them *un*marked surfaces. Overwhelmingly, (7), if they have done historical reading about photography, they should have recalled that the people who invented and reinvented it confronted the challenges of getting light to make permanent, controllable marks upon surfaces of various kinds. Finally, (8) the use that many of these writers make of the term *image,* as in "photographic image," has surface implication.

These are a sampling of easy but overlooked clues and leads, the development of *any* of which should long ago have led to a far better understanding of photo phenomena than generally obtains today. Since I devote whole chapters of this study to separate examination of two of these clues, depiction and cast shadows, here is a place to look more closely at the others, in connection with technologies of marking—beginning with the last one, "images."

"A Stain Designedly Traced"

"Image" is not a precise term, even in the present context. Yet if we want to think about photography in terms of things, this is as good a word as any for keeping the account broad as well as relevant to the present historical situation of rapidly multiplying "imaging technologies." The goal of this chapter is therefore to find photography's general place among imaging tech-

[1] Oliver Wendell Holmes, "The Stereoscope and the Stereograph," *Atlantic Monthly* 3 (June 1859), rpt. in *Photography: Essays & Images,* ed. Beaumont Newhall (New York: Museum of Modern Art, 1980), p. 53.

nologies. A philosophical account of photography that hopes to have actual relevance to the modern world should do no less. "Image" is an expression with certain immediate advantages, since, as noted, it includes but is not limited to pictures and would therefore include but not be limited to *depictions* (among them, photographs) of things. By beginning with the term "image" we may be able to proceed in the kind of order that photo theorists have consistently lacked—holding off, for example, the tormented topic of *representation* until we are in place to deal with it (Chapter IV). Perhaps what has for the longest time, and most obdurately, stood in the way of our understanding photography is the assumption that photography is essentially a depictive device and that its other uses are marginal. Ironically, it is this very assumption that has prevented us from understanding it as an important depictive means, where it is one. In this chapter and the next three, I shall simply forestall discussion of photography as a depictive device. (If philosophers are to be good lovers, they will simply have to learn to wait.)

The images under discussion are not mental images, nor are they mirror images. They are usually physical states of surfaces of which people make mental (that is, cognitive) use. They take energy and expense to produce, often space and care to preserve. They are subject to destruction by fire; they deteriorate physically through oxidation or magnetic influence. Often far too numerous, some present a serious solid waste problem. There is a multitude of procedures and technologies for making such images, and more are being developed. The ongoing modern invention, the engineering challenges of such images, photographically, is easy to state: it is that of effecting rather minute changes in the surfaces of objects of various sorts, by means of electromagnetic radiation. At least for chemical photography, our approach was well indicated by an excellent nineteenth-century writer, Lady Elizabeth Eastlake—two years before and more matter-of-factly than Holmes's fanciful, misleading "mirror with a memory."[2] Lady Eastlake wrote that our photographic interest lay in a "stain designedly traced upon the prepared substance [by means of light], not in the thing portrayed."[3] We can assume

[2] Alan Trachtenberg has pointed out that the mirror metaphor for daguerreotypes was common, and has argued that Holmes's coining of the phrase signals rather the end of the metaphor, as Holmes turned attention to the "disembodied" image of the new paper processes; see Trachtenberg, "Photography: The Emergence of a Keyword," in *Photography in Nineteenth-Century America*, ed. Martha A. Sandweiss (New York: Harry N. Abrams, 1991), pp. 37–38.

[3] Elizabeth Eastlake, "Photography," *Quarterly Review* 101 (1857): 442–68; rpt. in Newhall, *Photography: Essays & Images*, quotation p. 84R.

that she meant substances on surfaces of things. Let us therefore consider surfaces.

Technical definitions of "surface" occur in various disciplines: mathematical, physical, psychological, and others. Here we need only an everyday conception of surfaces, which nevertheless varies considerably with context. There has been little systematic study of surfaces.[4] A drawing surface, for example, may be toned, well-calendered, smooth or toothy, hard, semitransparent, vellum-finished, kid. For painting, ordinary glass provides a smooth, impermeable surface, whereas frosted glass, also impermeable, holds paint better. A kitchen counter surface may be too far from the cooking surface, be made of arborite, be clean or cluttered. The surface of the sea may be quiet, warmer than the depths, covered with small sailing craft; that of the earth may be of lighter rock, mostly under water, inhabited with life, open to cosmic rays. Such ordinary cases remind us that surfaces have, besides topological characteristics, a multitude of physical characteristics: they may have depth, permeability, transparency, rigidity, etc. The whole history of photography, a late technology, occurs within an epoch where the physical bearer of the image is almost all surface. We tend to forget that this has not always been true of painting, which has often been done on things with independent identities: cups, walls, fabrics, human bodies.

We will be treating images in relation to *marks*—not boundary markers but, in another familiar meaning of the word, discontinuous physical states of the surfaces of things, notably but not exclusively those that have appeared on the surface due to some action of agencies off the surface. "Marks" would include skid, tooth, and water marks but also birth marks. As it is the state of physical surfaces that actually concerns us, I will extend the normally more limited term "mark" in several ways. The first direction allows the term to encompass *cast shadows:* real physical states of surfaces though not usually considered to be parts of them in the same way as marks, they include the fugitive shadow projections that make up cinematic images on screens. The related second extension is to emission screens, such as TV: what we see are not really marks on the screen, but again they are real physical states of the screen. (By significant contrast, we will not be calling *mirror* images—including highlights—marks, as they are not physical states of surfaces, although they depend upon the existence of such states.) Part of the defense

[4] The philosophical literature is tiny, perhaps the only book devoted to surfaces of this sort being Avrum Stroll, *Surfaces* (Minneapolis: University of Minnesota Press, 1988).

for extending the meaning of "mark" is the continuity of technology and purpose that connects traditional handmade marks with illuminated screen states. The metonymic extension of the term "mark" for things closely related to marks is not one that I have to defend; it is already embedded in technical and semitechnical usage.

Next, images. We make *images* by making marks on surfaces, and images are destroyed as these marks are effaced, but it would be a mistake to think of an image simply as a kind of mark. What is the relationship? Clearly, *unmarked* parts of surfaces make up parts of images. Therefore we should think of images, in many cases, as the marked surfaces themselves, or parts of them. Not every such surface constitutes an image, however; marked surfaces abound in the universe, but few of these would be considered images. Perhaps we can find a hint for picking out images from among these by considering some surface-marking technologies. Movable type is one of the most important—indeed, one of the most important of all modern technologies. Yet typesetting and typewriting are not usually considered imaging technologies, whereas xerography, the copying of typeset or written surfaces, is.[5] One reason seems to be that photocopying is responsible for the entire field of the marked surface, taken as a unit: what we call "the overall image." This is our usual way of thinking about images as they appear on cinema, television, and radar screens, for example, when we are concerned about such image qualities as contrast or brightness. Although the physical states that constitute cinema and TV images are in strictly sequential, even digital, series, as images they are considered to be global states of screen surfaces through short periods of time. Let us take this global conception of "mark" and "surface" to suffice for one general conception of "image." We will later have to extend it to cover three-dimensional (3D) images as well. But the general conception we have before us should also now be made rather more specific, through attention to the sorts of cases most relevant to our project.

[5] Sturge, Walworth, and Shepp, *Imaging Processes and Materials.* This is not to deny that makeup editors treat printed pages as images, for they clearly do. See, e.g., in *New Yorker,* June 10, 1985, p. 142, the obituary for Carmine Peppe, fifty years its makeup editor: he "had the hands of a master craftsman, and he had the eye and the soul of an artist. . . . He did not read much, but as he laid out our pages he seemed to see through the type and words to the essential meaning of what he was physically occupied with. . . . His aesthetic instinct for what drawing should appear on what page and what its size on the page should ideally be was faultless. If, say, a drawing was an eighth of an inch too wide, he saw it as jumping off the page, and he was right. . . . In the last analysis, it was Carmine who determined, early in our history, how the pages of *The New Yorker* should look."

Display Marking

We can get closer to *photographic* images by considering the overlap of the large class of images we have just set out with another large class of what might be called displays: for example, in the current sense of electronic displays on CRTs (cathode-ray tubes) such as TV monitors.[6] Most of the image marks that concern us in a treatment of photography might also be called *display markings*. That is, they are produced or presented for the purpose of being perceived, or otherwise taken in cognitively—whether there are technologies for doing so or not. In these cases we are particularly interested in *visual* display marking, so in most of the following contexts I use the expression "display marking" or a further abbreviation, the noun "display," simply to indicate this visual kind.

There are two points to be made about displays, concerning not only the visibility of the mark but its visual purpose. Display markings are not accidental; they are "designedly traced." That is, they have the immediate function of being perceived, which is usually the basis for other functions. Of course, many of the visible, purposive markings we make are not displays. Anthropologists looking at a group of incisions in rock or bone may determine that they were made by humans (or some ancestral stock) and that they were made on purpose. The question then arises whether they were made for anyone to look at. They may, for example, have been merely a series of parallel marks made in the process of sharpening an implement, or scorings done to provide better grip. I say "merely" because it will be a recurrent theme here that markings put down intentionally on surfaces can and often do serve multiple functions. False oppositions there have caused many mistakes.

In working toward an understanding of images and thereby of photography in terms of display functions, we are making a slightly stronger claim than that they have to be visible to do their jobs. Consider, by analogy, weight. Physical implements and goods all have weight, and their functions usually require (approximately) a given weight. A sofa should weigh more than a few pounds and rather less than a ton, but twenty pounds or so either way makes no difference, whereas it does for our drinking glasses, spectacles, contact lenses. Yet having weight (even within a certain range) is not itself a function of these things. It is, rather, necessary to their function. Some things do have as part of their standard function that they have weight, however,

[6] See, e.g., Steven W. Depp and Webster E. Howard, "Flat-Panel Displays," *Scientific American*, March 1993, 90–97.

even a certain weight; some of these are called "weights." By analogy, visi-bility is good in sofas but not a function of sofas, although, like weight, it is prerequisite to their fulfilling their functions, whereas with glasses and contact lenses the case is more complex. There are things whose function is to be vis-ible but for which we lack a convenient term like "a weight." I am suggesting here that we coin the term "(visual) display" for these. Next, I am suggesting that for present purposes we think of images more specifically as such displays, and photography as (mainly) a technology for producing visual displays.

A ready correlate of the display markings that interest us are natural dis-plays, on which there exists a large amount of study. Often, as in the patterns on animals' bodies, markings exist without any process of marking. Such nat-ural markings provide an abundance of fascinating (and well-researched) analogies to visual display markings, and these are not technological—un-less we want to number them among a creature's biological or "first" tech-nologies. We can offer a modest contribution to such studies through our distinction between mere markings and image markings. Occasionally, but not always, natural markings may approximate what we have called image markings: unities comprising both the marked and unmarked parts of the surface in a single overall appearance. Thus, the flicker of ultraviolet mark-ings on the surface of a flower detected by a passing insect, though invisible to us, may serve simply as a honey guide signal—as flashing red lights can be signals to us—and not constitute an *image*. The marking and surface of a swallowtail butterfly caterpillar, however, might together form, for a bird, the image of the head of another sort of creature. Notice how "image" here cannot mean "picture," for birds do not see pictures as pictures, and it would not be very useful to the larvae if they did.

The point of introducing natural analogues here is to bring out another very important feature of the display markings that interest us. Like natural displays, artificial display markings may have simply the function of making themselves visible. Still, they may also have the function of making visible the surfaces on which they lie—or the *objects* of which those are the surfaces. They may even have selective groups of these functions. Natural camouflage displays abound with vivid examples of visual markings that make them-selves, their surfaces, and the surface bearers highly visible—or, of course, make their surfaces and bearers *in*visible. Nature thus provides important analogues for art; marking technologies may be designed to enhance, to ef-face, or to do nothing with surfaces and their bearers; they may or may not be "decorative," may or may not have "location" on things.

It is high time to treat ourselves to an image, to consider some examples of markings as we find them in one photograph by Walker Evans (Figure 1). The picture or "photographic image," as it appears here, like the text around it, is what I am calling *a display* on the page. It is made visible there

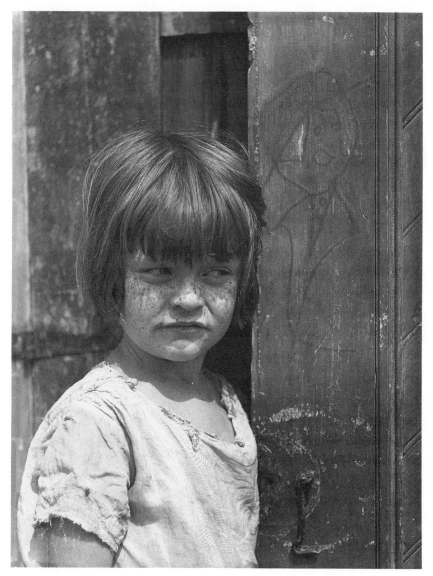

Fig. 1. Walker Evans, "Backyard, 1932." © Walker Evans Archive. All rights reserved, The Metropolitan Museum of Art.

by a marking technology for the immediate purpose of being seen, which seeing then serves other purposes. More particularly, it is a halftone photo reproduced in ink. Its original book appearance in Evans's *American Photographs,* 1938, was in "letterpress printing, the dominant photomechanical technology at the time," a monotype or single-impression method now virtually extinct, whereas its latest reprint manifestations are in offset lithographic duotone.[7] That is what the image is. But what the image *shows* includes a number of marks and markings, as well. The girl's face, for example, is naturally marked with freckles, but not for display (although this opens the interesting topic of how accidental markings may be turned to display). Were her dress of a printed material, that would provide another kind of display marking, as do the boards that are marked with decorative grooves.

The details of marking most likely of interest here are the graven, rather than the pigmented, ones. There are technologies, ancient and new, for scoring wooden surfaces, but some of the markings on the boards are not technological—certainly not industrial. They are in fact on surfaces finished to resist such marking. They also tell a great deal, for as Lady Eastlake wrote, "Though the faces of our children may not be modeled and rounded with that truth and beauty which art attains, yet *minor* things . . . are given with a strength of identity which art does not even seek."[8] For some they may constitute what Barthes calls "the punctum," the poignant details of a historical photograph which make it so memorable—or, in the more direct terms of the photographer Dorothea Lange, make a photo "a second looker." As we shall later consider, such *contact markings* or traces have from the very first been topics of intense interest in photographic images, and the photographic literature of the nineteenth and twentieth centuries contains many appreciations of them. Perhaps the most familiar is from Holmes: "What is the picture of the drum, without the marks on its head where the beating of the sticks has darkened the parchment?"[9]

As we look more closely at the marks in our example, they appear to be of two kinds: inadvertent, like the drumhead marks, and purposeful. Among humanmade markings, the former are by far the more numerous and, again,

[7] Peter Galassi, "A Note on the Fiftieth-Anniversary Edition," in Walker Evans, *American Photographs* (New York: Museum of Modern Art, 1988), pp. 200–202.
[8] Eastlake, "Photography," p. 94.
[9] Holmes, "Stereoscope," p. 59. Holmes comments that "distinctiveness of lesser details . . . often gives us incidental truths which interest us more than the central object of the picture" (p. 58).

raise a topic for later inspection. For example, the latch markings, like most footprints, may be given purpose and may be eloquent in what they reveal—like footprints on the moon—but were not put on the surface for such purposes. Neither are they displays; one might say that they were not *put* there at all. Inadvertent latch traces, or marks on the moon, should also remind us that when it comes to technology and markings, a great human occupation is the removal of marks. As we make our way around this planet's surface, and now beyond, graffitificient *Homo sapiens* marks up surfaces. Occasionally, like those who clean the counter, rake the gravel or the beach, harrow the sand arena, resurface the ice, we see fit to clean, scrape, smooth, or paint over them—having often, as just noted, first constructed or treated surfaces to resist such markings.

The drawing marks are different. Like the halftone photo reproduction dots before us, they are willful marks, put on the surface with a purpose—as we said, display—if only to the drafter. While they, like the photo itself, constitute display markings, they do not seem to *depict* any display markings (as they might have if the drafter had chosen to decorate the hat or blouse with fabric markings). Again, these marks, unlike the milled grooves on the boards, do not appear to be decorative in the sense outlined above. That is, they do not appear to be for the purpose of making the surface or some feature of it more visible. Moving up a level, this is a feature that they share with the photograph itself—at least as it appears here. A more positive common feature shared by the drawing in the photo and the photo itself is that both sets of marks function not only to make themselves visible but also to show *that* they have this function. This, after all, is a connotation of the everyday word "display." As that broaches a point important to the topic of art and photography (Part Three) we need to consider this additional connotation of "display" a little more before we treat photo processes—whether those used by the photographer or by the book publisher—among modern *display technologies*.

The idea of a display that has the function not only of making itself (and perhaps its bearing surface) visible or more visible but, simultaneously, of making visible that this, precisely, is its function may appear complicated or paradoxical.[10] There may be theoretical difficulties in working out a specific formulation for this situation and generalizing it into a theory; that need

[10] I am undecided what relation these observations have to the views of H. Paul Grice on meaning; see Grice, *The Way of Words* (Cambridge: Harvard University Press, 1989).

not detain us here. The phenomenon in question is perfectly familiar, and it works not only for babies but also for animals and insects. You wave to get someone's attention, but you also need to show that this is *why* you are waving. It is essential to the basic success of any such acts—and they fill our social lives—that both parts are discharged, that the movement and its doer are noticed (hence must be visible) but also that it is understood for what it is: namely, an effort to be noticed and, moreover, an effort to be noticed *by these very means.* Both tragedies and comedies can be based on such mixed signals, and they can be missed in either or both ways. Here one might enter into a study of a vast field of human behavior, since we make displays not only by doing such a thing but by modulating other actions using display features. Someone says something and we laugh, sometimes a little louder or more readily than necessary, not only to ensure that the laugh (and perhaps the laugher) is noticed but also that our willingness to make it noticed should be apparent.

Back to display marking. Even the simplest visual-display markings do more than that. Roadway markings, for example, sometimes discharge their functions simply by being noticed, but they normally have also to be interpreted, and the first stage of interpretation is to see them for what they are: roadway markings, things put there for a certain purpose. It is important that road crews not only make such markings visible but also visible *as* road markings (under certain weather conditions, it may be perilously difficult to distinguish lane markings from inadvertent wheel markings on a road surface.) This requirement holds for many of the marks we purposely put on surfaces. The measure mark on the board we want to cut must be not only visible but recognizable, so as not to be mistaken for an inadvertent scratch. Waves, winks, laughs, intonations—or, among visible displays, road markings, goal lines, signature lines, measure marks—are all like drawn and written marks in basic ways. But some are also unlike them in other ways, and that brings up a point of potential confusion that should be dealt with here. The arm wave and some highway markers have a function of being visible because their first office is to be noticed for what they are. For a display to have the function of being visible, however, it is not necessary that it draw attention to itself. The intent to be visible and the intent to be noticed are not the same: all drivers want their cars to be visible; only some wish them to attract attention, to make a display of themselves.

Whether or not one agrees with the further thesis that displays can or do

display their own display functions, the most basic meaning of visual "display," and all we need for present purposes, is the function of making itself visible. The overlap between the idea of a display and that of an image marking, as defined above, picks out a familiar class of visual images. We can say that in the Evans photograph we have a number of surface markings (marks plus surfaces) but that of these only three sorts would normally be considered images in the familiar, narrower sense of the term. The first is the photograph by Evans itself (which we might consider as a latent image made by him, its developed negative and its prints, and any copies of either). The second is the product of the photomechanical processes of producing it, in his book or in this one or elsewhere, and these processes turn out to have an interesting history. The third is the child's drawing incised in the wood. All these are images, according to our first treatment of the word. They are units of marks and surfaces, including unmarked bits of surface. They are also visual displays in the more specific sense now defined. Because they are images and not just visual displays on surfaces, however, they belong to a species of mark that as a whole, writing, postage cancellations, dotted clipping lines, polka dots on fabrics, and road lane markings do not.

Early History of Photographic Images

Some Surface History of Photography

This chapter began from the common idea that photography is to be understood through a sort of thing, the images that it produces, which are often taken to be unusual in their nature, production, or use. I have been willing to go along with this "thing-mindedness" so long as we could avoid the premature narrowing of the approach to photography and loss of order recorded in the first chapter. Therefore I have treated "imaging" in the relevant sense (of that which "photography" produces) as a certain kind of purposive surface marking, and have also been at pains to keep surface marking before us as a very broad arena of human activity. None of this was to deny that there are other kinds of images, such as mental images or sculptural ones, any more than it was to deny that there are other kinds of marks, such as boundary stones or actions indicating esteem. We are at the point now of getting even more specific about the kind of displays here called images—particularly, photographic images—so that we may connect them to our gen-

eral technological approach. By now the strategy should be clear. We shall be investigating photography as a kind of technology for visual display: that is, surface-marking with visual intent.

The oft told but still fascinating story of the first inventions of photography concerns exactly what we are treating here: ways to make permanent, controlled surface marks, toward displays, by means of sunlight. From the point of view of the inventors or first technologists, the whole problem was how to direct sunlight—a constantly renewed, free resource—to produce controlled physical markings on photosensitive materials. In order to produce pictures, the inventors had to produce images, and in order to produce controlled images, they had to produce marks on surfaces by the agency of light. In the beginning the problem was not basically one of optics; the challenge was to prepare sensitive surfaces that could be so marked. This mini-history will here be retold in terms of the general differences among kinds of sensitive surfaces. In each case the visual properties of the surfaces depend upon their physical properties, and we should thus be insistent in the following brief historical survey to keep the physical topic central. The use of physical properties for producing photo displays will be seen to exceed even direct visual use.

Photography, like all surface-imaging technologies, is based upon the fact that our acute powers of extracting information from fine visual differences on surfaces—extremely slight and fragile states of surfaces, produced by tiny physical energies—can be very *meaningful.* Given sufficiently photosensitive surfaces, solar markings on them can be far more minute than our eyes, even with optical microscopes, can detect. For example, the physical bloblets of mercury amalgam on a silver surface which produce the daguerreotype image are usually less than a micron (or micrometer: one-thousandth of a millimeter) wide and high—often only a tenth of that.[11] For comparison, this sheet of paper might be one hundred microns thick, a human hair fifty, a bacterium five. Although discrete surface features of such tiny sizes are invisible, the optical effects of arrays of them are detectable. By a quirk of history, the first practical photo system was also the finest in detail and resolution. Fascination with the apparently miraculous optical fact that relevant information on the very first successful photo surfaces seemed a nat-

[11] See the thorough account of measurements in M. Susan Barger and William B. White, *The Daguerreotype: Nineteenth-Century Technology and Modern Science* (Washington, D.C.: Smithsonian Institution, 1991), chap. 8, "The Daguerreotype Image Structure."

ural phenomenon, well beyond the finest hand or mechanical control, was significant in forming attitudes toward this whole family of images and in setting the direction of its technological growth.

The tale of photography's first invention nearly included pottery as among the first surfaces addressed—unsuccessfully, it turned out. Thomas Wedgwood was a trained draftsman, and at his father's famous pottery firm he had used the camera obscura, a familiar drawing aid by that time, to assist in the delineation of buildings for decoration of its wares. Decorated Wedgwood ware had already had great success via the eighteenth-century transfer process involving three "images"—only the last being, in our terms, *display.* By applying paper to them, wet ceramic paint patterns were lifted off copper engraving plates, then transferred to pottery surfaces. Had the younger Wedgwood succeeded in making these engravings by means of photography, we would have had a modern story to tell of a yet another combination of two of the oldest technologies. Historically, pottery surfaces have usually been decorated. Fired pottery has in fact provided the earliest, most widespread, and most durable of display surfaces. Long subject to the marking techniques of pigment and incision, it tells the most about the greatest number of surface-marking activities in the most societies. Wedgwood did not get that far. Having learned of the newly discovered sensitivity of silver salts to light, he had hoped, as he wrote in a formal paper (with Humphry Davy), to "copy" the "images formed by means of the camera obscura."[12] But since the feeble filtered light of the camera was not sufficient to affect his preparations, his first experiments had to be more modest (though still of technological importance): he succeeded only in solar printing contact traces of leaves, insect wings, and the like onto prepared paper and leather in a way now familiar to schoolchildren. Wedgwood was unable to preserve even these as permanent markings, since they progressively darkened into the ground with subsequent exposures to indirect sunlight.[13]

In their written report, Wedgwood and Davy recorded their aims in terms that became standard and that I later consider at some length. Here are a few.

[12] Thomas Wedgwood and Humphry Davy, "An Account of a Method of Copying Paintings upon Glass and of Making Profiles by the Agency of Light upon Nitrate of Silver . . . ," *Journals of the Royal Institution of Great Britain 1* (1802): 170–74, rpt. in Newhall, *Photography: Essays & Images,* p. 16L.

[13] Helmut Gernsheim, *The Origins of Photography* (London: Thames & Hudson, 1982), p. 27, thinks that Davy could have done so fairly easily if he had set his mind to it, since the chemical evidence was available to him and to Samuel Wollaston from Karl Wilhelm Scheele's work.

Following a line of eighteenth-century experimentation, they observe that their chemical receptor is differentially sensitive to light: more sensitive to blue or short wavelength light, insensitive to red.[14] This is the basis for the important technique of photometry. As their countryman Talbot would note about forty years later, the existence of invisible, very short, rays of sunlight was proved by photosensitive surfaces: these came to be distinguished as "chemical rays," their power called "actinism."[15] Next, they think of the optical camera image on the projection surface as an already existing thing that might be "copied" by means of photosensitive treatment. They refer to the photographic traces of natural objects through direct contact with the photographic surface as "representations—not as "pictures"—of the originals (raising an issue treated at more length in Chapter IV). This is reasonable because, as the paper's title announced, Wedgwood (and probably Davy) also reproduced line drawings and cutout silhouettes by the same method of superposition, but these would not be pictures of their originals. Although they were unsuccessful in their attempts to capture camera images, their efforts to do so had another most important implication: they were perhaps the first to realize that the silver reaction to light is a thing of rather smooth, or "analogue," gradations, making silver capable—unlike printing ink—of presenting halftones directly, through its differential response.[16] The problem by the end of the century would be how to get such analogue images back into digital ink representation, to combine with letterpress.

At all these points shadows figure prominently in their thinking: "When the shadow of any figure is thrown upon the prepared surface, the part concealed by it remains white, and the other parts speedily become dark" (15). We can note here (in preparation for Chapter VI) that the linkage of shadows to photographs is enduring. Shadows, as observed above, are not really

[14] Already in 1839 John Herschel had noticed that the longer waves even *inhibited* the photochemical effect of the shorter ones. See Larry Schaaf, "Herschel, Talbot, and Photography: Spring 1831 and Spring 1839," *History of Photography* 4 (July 1980): 191.

[15] Herschel used the former term in his Royal Society paper of 14 March 1839, "Note on the Art of Photography, or the Application of the Chemical Rays of Light to the Purposes of Pictorial Representation," rpt. in Larry Schaaf, "Sir John Herschel's 1839 Royal Society Paper on Photography," *History of Photography* 3 (January 1979): 47–60. In his journal entry of 13 February 1839 he is already writing: "Fine Sunny day. At work already with great interest & success at the Photography & Chemical Rays. 1. Discovered Fox Talbot's secret, or one equivalent to it" (quoted in Schaaf, "Herschel, Talbot, and Photography").

[16] This perception is due to Joseph Maria Eder, *History of Photography*, trans. Edward Epstean (New York: Dover, 1978), p. 203.

marks but are very like marks, as they too are discontinuous, two-dimensional physical states of surfaces. Shadows are often very difficult to distinguish from marks. (The Evans photo, for example, begins to show that freckles on skin are sometimes hard to tell from shadowing.) There has been some psychological research about how we manage to distinguish shadows, which we do not consider properties of a surface, from surface marks, which we do.[17] Another close connection is causal: we think of shadows as "producing" marks on surfaces, as when dew or frost on the ground is preserved just where the shadow of a building falls and matches its projected outline.

Following Wedgwood, the usual story of the success of photography's first inventions runs through the second to fourth decades of the nineteenth century, focusing on the famous names of Joseph Nicéphore Niépce, Louis Jacques Mandé Daguerre, and William Henry Fox Talbot. My purpose here is to represent that tale briefly from the perspective of photographic surface marking for display. That approach puts Wedgwood in a prominent position; indeed, Lady Eastlake's "stain" quotation derived from her appreciation of Wedgwood. Johann Schulze is usually given credit for the chemical discovery, in the early eighteenth century, of the darkening of silver salts by light. But Schulze's silver went purple in bottles, and there is no evidence that he attempted to spread the salts on surfaces. This Carl Scheele did and reported in 1777, though without indicating uses for the resulting markings.[18] For many, Niépce's efforts from at least 1816 earn him the title of first inventor, because he succeeded where Wedgwood and Davy had failed: not only did he fix photochemical images on surfaces; he produced them there by means of a camera obscura, with clear indication of display use. Niépce's work sprang from standard graphic surface-printing technologies. Although "copying" the images in the camera obscura had been "the first object" of Wedgwood's researches, as it was to be for Niépce, Daguerre, and Talbot, all but Daguerre pursued other uses as well and correctly saw their importance.

Reproduction was one of these, and it is important to place the invention and use of photography in historical continuity with older methods of con-

[17] See, e.g., Patrick Cavanagh and Yvan G. Leclerc, "Shape from Shadows," *Journal of Experimental Psychology: Human Perception and Performance* 15, no. 1 (1989): 3–27.

[18] This effect was rediscovered in 1834 by Professor John William Draper, who went further and applied it to surfaces for photometric studies of solar spectra. He was unsuccessful with camera images. See Beaumont Newhall, *Latent Image: The Discovery of Photography* (Garden City, N.Y.: Doubleday, 1967), pp. 76–78.

tact surface-mark reproduction. Perhaps the oldest are molds and seals, whose great advantage is mechanical reproducibility. Next come pigment-transfer methods, such as Chinese wood-block fabric patterning. Thereafter, a famous story of reproducibility leads up to movable type in the early fifteenth century. Then we have woodcut, engraving, etching, and (at the time of Wedgwood) lithography. All these methods reproduce and multiply not only pictures but also words, designs, patterns, and other marks of a wide variety of uses. Niépce's researches underscore this continuity: the process and uses of his first photographic—or, as he eventually called it, "heliographic"—success were based on the older methods. So were his very materials. Niépce conceived of heliography as a kind of graphic process in which the action of the sun was to substitute for hand work.

Although, apparently, Niépce had earlier attempted, like Wedgwood, to make camera images chemically, his first actual successes at heliography were spurred by the widespread interest in France, around 1813, of the newly invented "planographic" process of lithography, valuable for reproducing pictures but also for reproducing other patterns of marks such as musical scores. Lithography is based on the mutual repulsion of oil and water: a form of grease is used to mark a stone (or other suitable surface, such as zinc), whose surface is then dampened in all but the marked parts, which repel the applied water. When a greasy printing ink is rolled over the stone, its oil is in turn repelled by the damp parts of the surface but accepted by the greasy— hence dry—ones, where it stands, ready for *transfer* (usually by use of a "scraper press") to as many receiving paper surfaces as are pressed against it, so long as one re-inks it as necessary. For Niépce, as for Talbot twenty years later, graphic ineptitude was the mother of invention. Wishing to try other surfaces than heavy, expensive stones for lithographic transfer, and wishing to get something interesting on his plate but not being able to draw, Niépce sought a *second* laborsaving device. Aloys Senefelder's lithography was already an important breakthrough in the mechanical reproduction of complex displays—perhaps the first since the sixteenth century. Niépce had the idea of augmenting this new process with a *second* mechanical procedure: the ink-receptive marking of the printing surface itself, which, like the traditional processes, was up to that point still done by hand. It is important to notice that he never gave up this motive, even after he had shifted his interest from lithography to the earlier intaglio processes of etching and engraving.

Niépce first attempted (unsuccessfully) to transfer translucent drawings to pewter printing surfaces by coating the pewter with light-sensitive varnishes. He followed this with the first successful attempts to get—though not to preserve—negative camera images by using silver chloride on paper. Both these paths of research continued along graphic printing lines, for Niépce's initial success with stabilized camera images came through his combination of the two. He first had to succeed in permanently fixing an image to a graphic reproductive plate by the action of light. This he had accomplished by 1822, when he found that a bitumen etching "resist" for graphic plates—that is, the material cut through by the etcher's needle, but repelling the acid bite everywhere else—was light-sensitive. Just in the places on the surface of the glass (then on more durable zinc or pewter) where sunlight was kept from it by the marks on the translucent original laid against it, the resist would not be hardened by light. Therefore, it could be washed away with a turpentine concoction, leaving bare patches on the surface (usually lines) subject to the acid. The acid would bite intaglio grooves at those points, producing an etching surface, which when inked produced multiple paper copies. As developed by his cousin Claude Abel Niépce de Saint-Victor in 1853, this is the basis of the much-used "asphalt process" of photogravure.[19] As we shall see, it also founded the technological line that produced the computer microchip.

Within two years, Niépce also produced the world's first stable camera photographs, but not by means of silver chemistry. Rather, he put one of his etching plates into a camera for a period of about eight hours. Since the sunlight hardened the more exposed areas, he was able to wash out the rather more shaded, softer areas in his usual way. The mirrorlike surface of the earliest extant heliograph, from about 1826, might qualify as a *barely* marked surface. Helmut Gernsheim, whose efforts rescued it, had to know how to look for the marks on it: seen from an angle of about thirty degrees and in extreme raking light, what Niépce called a *point de vue* positive image from

[19] Newhall, *Latent Image*, p. 26. The intaglio process specifically termed "photogravure" was invented in 1879 by Karl Klic: "A copper plate, grained with resin dust, is etched through a gelatin relief image prepared photographically" (Brian Coe, *The Birth of Photography: The Story of the Formative Years 1800–1900* [New York: Taplinger, 1976], p. 138). Newhall uses the term generically to cover gelatin processes proceeding from Talbot's "photoglyphic" ones. See Beaumont Newhall, *The History of Photography from 1839 to the Present*, 5th rev. ed. (New York: Museum of Modern Art, 1982), pp. 142, 251.

his window is faintly visible, through differential contrast of the darker parts of the bared metal with the bleached and hardened asphalt parts.[20]

Still, in his earlier report of success to his brother Claude in 1824, Niépce restated his conception of camera heliography as a graphic printing process. For example, he wrote of camera successes on lithographic stone and glass, reported that he had "wanted to let the stone dry before I placed it in the acid bath to etch it" and ruined one of his first photos "because I tried to etch it before the stone was quite dry,"[21] and spoke of his photographs as "counterproofs." Perhaps, better than many thinkers long after him, the first inventor of photography perceived its greatest uses and personal rewards in terms of inked surfaces—though it was not until the first decades of the twentieth century that these turned out to lie in letterpress, relief processes. For as Niépce continues in that letter to his brother, "it is good to occupy ourselves a little with the idea of reaping ready cash. I do hope that this time you will not refuse your share in the honour and financial recompense that may result from this." Financially, alas, only the reverse happened, and honor went to the name of Niépce's later partner, Daguerre, whose rather different and more sensitive silver-chemical process yielded more detailed and beautiful results in a shorter time.[22]

Like heliographs, daguerreotypes were at first latent images that became true display images only when made visible by further treatment. They too depend upon the angle of illumination, since, like heliographs, daguerreotypes present displays by the working of two familiar surface reflection properties: specular (or mirror) and diffused reflection. If this is a "mirror with a memory," it is a dark mirror. The bare mirror-silver looks dark as the viewer blocks most of the light that might be specularly reflected to the eyes, while

[20] Helmut Gernsheim opened a valuable new scholarly journal on the history of photography by relating the drama of the rediscovery of the plate and its visual appearance: "The 150th Anniversary of Photography," *History of Photography* 1 (January 1977): 3–8.

[21] Trans. in Gernsheim, *Origins,* p. 33. Of Niépce, Gernsheim writes: "Prints were the desired end product for all his heliographs: ("The 150th Anniversary," p. 3). Another sign of the bond between the reproduction of prints and camera heliographs is that Niépce early copied, and thereby reduced, a print 75 cm (two and a half feet) long with a camera; see R. C. Smith, "Nicéphore Niépce in England," *History of Photography* 7 (January 1983): 48.

[22] Some hold that Arago's championing of Daguerre was a heavily political act: "Scientific objectivity had subsided into political necessity. . . . Talbot was duly swept aside, Niépce was reduced to the lowest terms, and Bayard was overlooked," according to André Jammes, "'A Glaring Act of Scientific Piracy?'" in *Photography: Discovery and Invention,* ed. Weston Naef (Malibu, Calif.: J. Paul Getty Foundation, 1990), p. 67.

the material on the surface (the mercury particles mentioned above)—adsorbed in the post-exposure process rather than being taken off, as in heliography—appear, by diffused reflection, lighter than the underlying mirror. Here we have good confirmation of our earlier decision not to limit "image" to the physical marks on the surface. Daguerre was content with the great pictorial achievement of his invention; he promoted it and retired. As Talbot, his worried rival, correctly observed to John Herschel, although daguerreotypy produced exquisite camera images, unlike graphic procedures it provided no technique for reproduction: "To obtain a second copy of the same view, Daguerre must return to the same locality and set up his instrument a second time."[23] Talbot's waxed paper transmission surfaces, however, allowed multiple prints, with what Herschel first termed "negative/positive" reversal and "re-reversal."

In the Field of Paper

"The French method, which has received the name of the Daguerreotype," wrote Talbot in June 1844 (advertising the publication of the first part of his *Pencil of Nature*), "is executed upon plates of polished silver, while paper is employed in the English process."[24] Because Talbot approached the project of inventing photography from the perspective of individual pencil drawings on paper, rather than from that of tough metal plates for graphic multiple reproduction, he was led to a series of remarkable technological initiatives. Ironically, it was his method that proved more fertile for reproduction of images, although, as remarked before, in the twentieth century metal plate surfaces reasserted themselves for ink transfer with letterpress. With our approach to photography in terms of physical surfaces, we observe that Talbot's were semitransparent surfaces. Unlike Niépce's and Daguerre's, they

[23] Talbot, letter of 27 April 1839, quoted in Schaaf, "Herschel, Talbot, and Photography," pp. 200–201.

[24] Talbot, "Just Published. Part I. of *The Pencil of Nature,* by H. Fox Talbot, Esq.," loose sheet in Talbot, *The Pencil of Nature* (London: Longmans, Brown, Green, & Longmans, 1844–46). This book is cited hereafter in the reprint edition by Beaumont Newhall (New York: Da Capo, 1968). Talbot refers to "the English art (called PHOTOGENIC DRAWING, or the CALOTYPE)," avoiding "Talbotype." As to nationality, the daguerreotype was more popular commercially in England than "the English art," and soon became a North American specialty. The first great calotypes were made by Scots, though it was the French who took to the process with industrial enthusiasm.

provided *filters,* allowing reproduction by the action of light. Early on, Talbot consoled himself with the supposition that only his method allowed contact reproduction of engravings by means of light, and so had the greater potential for use: "Although Daguerre is said to succeed so admirably with the Camera, it does not follow that he can copy an engraving, a flower, or anything else that requires *close* contact."[25] Consolation was in order. In Talbot's first exhibit of paper "photogenic drawings," following the scientific notices of Daguerre's process in January 1839, some barely qualify as displays. His materials were disarmingly simple, including, as he reported, "paper of a good firm quality and smooth surface. I do not know that any answers better than superfine writing paper."[26] Talbot's first processes provided not very sharp images, as his table salt and nitrate of silver coating somewhat penetrated the surface of his paper into the fibers. Besides, his negative camera images were at this point far too weak to print through their paper support, and the camera-free reproductions of etchings, which could be so printed, tended to be rather blurry. Talbot's camera negatives were also very small, and his "close contact" superposition "copies" of flat objects such as leaves and pressed flowers looked positive against their dark backgrounds only when the objects themselves were very light, such as samples of lace (Figure 2), since white is a common lace color.[27]

Herschel, as a good scientist but not an entrepreneur, was more interested in the photochemistry of the situation than in its uses. Accordingly, few of his important experiments involve cameras at all, and, as for images, most of his correspondence with Talbot concerned—sometimes contained, as these were on paper—the stronger, simpler, camerafree examples accomplished by superposition and direct sun. Among his discoveries was pro-

[25] Talbot, letter of 11 February 1839, quoted in Schaaf, "Herschel, Talbot, and Photography," on which Schaaf comments: "It is apparent that Talbot considered the real strength of his own process to be in the area of copying graphic arts. In the 19th century, this concern was quite understandable, as prints and engravings took on increasing social, educational, and entertainment value in society" (p. 192).

[26] Talbot, "Photogenic Drawing (Further Discoveries)," *Literary Gazette* (London), (23 February 1839), pp. 123–24, rpt. in Newhall, *Photography: Essays & Images,* pp. 30–31.

[27] On Talbot's embarrassment, see Joel Snyder, "Inventing Photography," in *On the Art of Fixing a Shadow: One Hundred and Fifty Years of Photography,* ed. Sarah Greenough et al. (Washington, D.C.: National Gallery of Art, 1989), pp. 12, 36 n 35. The superposition prints also included what came to be known as *clichés-verre.* A third class of photogenic drawings exhibited by Talbot in the library of the Royal Institution on 25 January and at the Royal Society on 31 January were enlargements of small things made on his paper by means of a solar microscope. See Gernsheim, *Origins,* pp. 55–56.

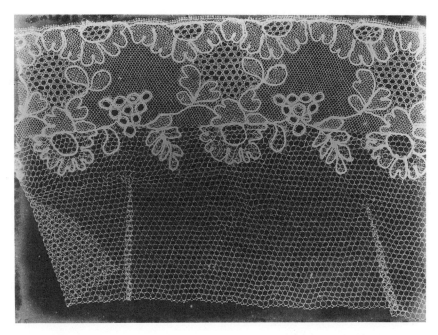

Fig. 2. William Henry Fox Talbot, "Lace." Courtesy of NMPFT/Science & Society Picture Library.

jection printing through glass plates for purposes of enlargement—or reduction—of images, which, when applied to photo negatives, became the basis of modern printing.[28]

By persisting with the advantages of his procedures, however, Talbot provided the basis for modern photography. As the surfaces of his photographs were made visible (like those of most objects in the environment) by relative light absorption and *diffused* reflection, they could be viewed (by several people) from a number of angles, and so were visually more constant through changing light circumstances than daguerreotypy. This important *display* characteristic was greatly enhanced by Talbot's crucial discovery, in September 1840, of the catalytic process of (physical) "development," as he called it. Talbot's invention allowed chemically affected surfaces to develop sponta-

[28] On the prevalence of superposition, see Schaaf, "Herschel, Talbot, and Photography," p. 202: "The reproduction of engravings . . . was seen as an important commercial application." On Herschel's invention of projection printing, see Newhall, *Latent Image,* p. 71. Optical projection, especially for enlargement, is of course a basis of modern applications of photography; consider the movies, for example. Chapter V briefly considers a most important *de*magnification: modern microchip photoengraving technology.

neously into optical displays. This *latent* image he considered to be of first importance.[29] He immediately reported an "acceleration" of sensitivity that allowed him to cut one-hour exposures to a half-hour or even a few minutes and thereby at last to take pictures of people. Such was the essence of his improved (and patented) "calotype" method.

With regard to images, in the sense of surface display markings, comparing the "aesthetic" characteristics of the daguerreotype and the paper print leads to issues much wider than aesthetics. By comparison with its (initially overwhelming) polished silver and mercury amalgam rival, Talbot's writing-paper calotypy had the advantages of lower expense, portability of apparatus, simplicity, and safety of means (daguerreotypists having to deal with mercury vapor). Staying with our perspective of physically marked surfaces for display, however, perhaps we can define these early photographic technologies and their immediate appeals before going further into their functions. The delicate, "jewel-like," expensive, and singular daguerreotype had an appearance and presence that made it precious especially for portraits, especially (after 1851) in North America. Typical descriptions spoke of its "richness and delicacy of execution" (Herschel), its "beauty and sharpness" (David Brewster). The *Edinburgh Review* of 1843 observed that "while a Daguerreotype picture is much more sharp and accurate in its details than a Calotype, the latter possesses the advantage of giving a greater breadth and massiveness to its landscapes and portraits."[30] This was because, by comparison, even Talbot's improved paper print was a very high-contrast image, further blurred in detail by the fibers of the paper, best for what were called "broad effects" and hence for landscape and architecture, in which—especially given their warm brown tones—they rather resemble sepia wash drawings. From 1843, however, David Hill and Robert Adamson, in Scotland, had great artistic success with just these characteristics in candid portrayal of people.[31]

[29] "I don't believe that there is a fact more important and destined to survive than that," Talbot wrote in French in October 1847, defending his patent; see *Selected Correspondence of William Henry Fox Talbot, 1823–1874*, ed. Larry J. Schaaf (London: Science Museum and National Museum of Photography, Film & Television, 1994), p. 53.

[30] *Edinburgh Review*, January 1843, excerpted in *Photography in Print: Writings from 1816 to the Present*, ed. Vicki Goldberg (Albuquerque: University of New Mexico Press, 1988), p. 67.

[31] For the work of Robert Adamson and David Octavius Hill, see, e.g., Gernsheim, *Origins of Photography*, pp. 181–95; Newhall, *History of Photography*, pp. 46–48. Regarding the indistinctness of detail in these pictures, Joel Snyder comments, "Hill and Adamson teach us the first essential lesson of photographic production; objects in front of a camera need not, and most often do not, constitute the subject matter of the photograph" ("Inventing Photography," p. 17).

Significantly, the calotype belonged, in Herschel's words, to "the process-es which have paper as their field of display." Talbot's familiar writing-paper surfaces for photogenic drawings and then calotypes, like the surfaces of drawings and graphic prints, could be written on (Herschel and Talbot did write on them in their experiments) or combined with writing as flexible sheets in books. Talbot did not hang back. His well-named 1844–46 *The Pencil of Nature* is the first book illustrated by photographic processes.[32] Aesthetically, we can say that as part of the chemical penetrates the surface, it seems, like ink, to be part of it. Again, diffused light would be transmitted back through that surface. Unlike the daguerreotype the calotype has the same reflective optical properties as print paper: that is, contrast of absorption and diffusion, with specular or mirror reflection as "noise." Indeed, they have a matte finish, like engravings and wash drawings. It was these surface characteristics that allowed the display success of the famous work of Hill and Adamson in the 1840s. Finally, as noted, the calotype's surface allows it to be used as a transmission filter, carrying information for reproduction to other sheets, with the two very useful *reversals* noted by Talbot: negative/positive and mirror (by turning the sheet over).[33] From this point of photo-surface history several paths diverge, all leading toward familiar modern photo surfaces.

Factory Finish

Talbot's paper method is usually cited as introducing the negative/positive process, the basis for modern photography. Our perspective provides a more comprehensive conception. Through Talbot, gelatin-sized fine writing paper introduced the realm of transparency to photography. The technical film improvements of the 1840s just listed provide reassuring confirmation that this

[32] It is my strong impression that the source of the phrase "have paper as their field of display" is the letter Herschel wrote to Talbot from Paris on 9 May 1839, but I am unable at present to locate the full text of that letter. *The Pencil of Nature* was produced for commercial subscription in fascicles, 1844–1846. Talbot had begun to use the word "photograph" in his notebooks by 27 February 1839, possibly persuaded by David Brewster. See Geoffrey Batchen, "The Naming of Photography: 'A Mass of Metaphor,'" *History of Photography* 17 (Spring 1992): 28.

[33] Part of the importance of the latter feature was that for some years the lenses used by both daguerreotypists and calotypists mirror-reversed their photo images. For example, all the original photographs of Edgar Allan Poe are daguerreotypes, and all are mirror-reversed, making the asymmetry of his face more pronounced. A daguerreotype copy by Albert Sands Southworth "re-reverses" (to use Herschel's term) one of these. The practice of reversing drawings, making transfers, and tracing them is ancient among craftspeople, designers, and drafters of all kinds. Some notable, tireless, artistic examples of the practice are provided by Ingres and Degas.

little "surface history" is not altogether a *superficial* one, for by general historical criteria these improvements represent a crucial point in the history of photography. They also represent a typical situation in technological history, rather like the parable of automatic camera systems with which we began. Part of the impact of daguerreotypes was their submicroscopic information content—people often admired them with magnifying glasses, almost as phenomena of nature rather than as human handwork—and there calotypes did not compete. But as the chemistry and optics of paper photography improved potential detail past the grain limits of Talbot's writing paper, a somewhat *smoother* negative and printing surface seemed in order.[34] The first step, to fill the spaces between the paper fibers, was done by French technicians from the mid-1840s to 1850s. Louis Désiré Blanquart-Evrard and Gustave Le Gray improved the stability, sensitivity, middle tones, and detail of paper photography. Blanquart-Evrard then moved photo printing into modern mass production, which began turning out prints with the machine-finished surfaces that we associate with monochromatic (black-and-white) photography.[35] His immediately visible improvements there exerted pressure to refine optical and chemical sharpness further, and so was started a reciprocal "engine of invention" that has never stopped; it comprehends, for example, recent efforts at high-definition television (HDTV). One could at this point begin a study of the virtue of *resolution* in image-making, with aesthetics as only a single department. Joel Snyder well states these effects in his account of the shifts of the 1850s:

> One way of appreciating how the conflicting values of "transparency" and "artistry" worked themselves out in the 1850s can clearly be seen in what at

[34] The formidable opponent of this tendency in the late nineteenth century was Peter Henry Emerson, who considered it one of the artistic evils of photography: "I feel sure that this general delight in detail, brilliant sunshiny effects, glossy prints, etc., is chiefly due to the evolution of photography: these tastes have been developed with the art, from the silver plate of *Daguerre* to the double-albumenized paper of to-day. But, as the art develops, we find the love for gloss and detail giving way" ("Science and Art," paper read at the London Camera Club Conference, 26 March 1889); rpt. in Peter Henry Emerson, *Naturalistic Photography for Students of the Art* (3d ed.) and *The Death of Naturalistic Photography* [New York: Arno, 1973], 3:77).

[35] See Gernsheim, *Origins*, pp. 237–46, on Louis Désiré Blanquart-Evrard's processes and photo finishing factory in Lille and Gustave Le Gray's waxed-paper process. Blanquart-Evrard's boasting lecture *La photographie: Ses origines, ses progrès, ses transformations* (Lille: Imprimerie L. Danel, 1870), available in Sources of Modern Photography reprint series (New York: Arno, 1979), presents photography in terms of surfaces ("on Plates," "on Paper"), and makes the case from industrial production on the latter.

first might seem to be a trivial matter—the surface structure of photographic prints. . . . The changing surface structure of photographs and the change in the variety of their hues has a dual effect; it draws attention to the photographic origins of the picture—other print forms in this period were rarely glossy—and it produces the impression in the viewer that the prints are machined, exactly reproducible, rather than handmade. It brings photography into a new world.[36]

There are several points to be made about this "new world," beginning with the matter of the factory look. There had already been daguerreotype manufactures, and to produce his *Pencil of Nature,* Talbot set up a system for "the multiplication of positive photographs" on paper—as one of his four patents put it. His production of a thousand prints a month was small, done by a few hands, and hardly uniform, even to the degree that he hoped for. There were and are noticeable color differences between versions of this book, and many prints suffered from "a growing faintness." In short, his results were far from stable. By contrast, Blanquart-Evrard's mass production illustration factory of the early 1850s eventually produced over a hundred paper prints an hour at a much higher level of quality control in their uniformity and permanence. André Jammes observes: "Blanquart-Evrard's innovations can be located at two decisive moments for photography: the creation of stable images and their multiplication."[37] This also marked the beginning of the modern conception of "film" and print surfaces as uniform, dependable, and relatively cheap mass products. It should be kept in mind in considering a period when, toward the end of the century, against criticisms of not following "the nature" of the material, some photo artists attempted to reintroduce individuality of surface and signs of "hand-facture" into the look of their pictures—as well as when, in the 1940s, some dispute broke out between "the fuzzy-wuzzies" and the "sharp and shinies."

The next step was from gloss to glass: from the smooth, processed albumen-finished or waxed printing papers to the negative emulsion on chemically and optically neutral—that is, transparent—glass. That began with

[36] Snyder, "Inventing Photography," p. 22.

[37] Jammes, "'A Glaring Act of Scientific Piracy?'" p. 69, where he further remarks: "Progress from Talbot's brilliant experiments to complete mastery of the process was enormously difficult. . . . With *The Pencil* we are still in the stage of experimentation. With the Lille publications we enter an era of expansion for photography." See Gernsheim, *Origins,* p. 207 for Talbot's print quality, and p. 240 for Blanquart-Evrard's production rates.

Scott Archer's wet collodion method of 1851. It established the modern, stratified structure still in use for both negative and print. We can count the surface layers: a neutral physical support or substratum (flexible "film" since the 1880s), an interface barrier, an emulsion layer (dry gelatin from the late 1870s) carrying the photosensitive receptor grains, a thin protective covering.

Artistic issues abound at each stage of this reciprocal technological action. Although the issue is debatable, Charles Baudelaire's much cited 1859 objection to photography might have been largely an objection not to photography as such but to its daguerreotypy and collodion examples; so might have been, to some extent, Elizabeth Eastlake's. There is evidence, for example, that the seemingly almost immediate "perfection" of daguerreotypes put artists off, whereas the calotype seemed to leave things open to artistic innovation.[38] As for the later processes, the coming of truly factory-produced prints probably signified an even greater shift in experience. As cheap, processed, standardized *surfaces,* they spelled the end of the popular idea of photographs as unique objects and the beginning of the idea of them as easily reproducible, disembodied, rather unlocated conveyers of information about other things: that is, the normal modern view of photos as objects.[39]

Besides the issues of changed appearance, the shifted amplification of recording and depictive powers of the collodion negative, and the smoother, standardized printing papers, there are others of the greatly increased difficulty and outright cumbersomeness of the processes involved in photogra-

[38] Baudelaire, Salon of 1859 review, titled "The Modern Public and Photography," rpt. in Trachtenberg, *Classic Essays,* pp. 83–89. Differently titled, an excerpt from a different translation is reprinted in Newhall, *Essays and Images,* pp. 112–13, and in Goldberg, *Photography in Print,* pp. 123–26. Regarding Eastlake, John Szarkowski, "Early Photography and Modernism," in Naef, *Photography: Discovery and Invention,* p. 102, suggests how the technological development might have been different: "Lady Eastlake's tone is much more polite than Baudelaire's. . . . But if [the attentive reader] makes allowances for their different rhetorical styles, both she and Baudelaire were saying much the same thing. Lady Eastlake liked the early calotype pictures better than the new collodion sort. With their soft papers and broad, impressionistic indication, the early pictures from Talbot's method resembled prints. . . . Beyond that, their very imperfections had encouraged one to hold high hopes for the future." (Chapter IX, however, looks more closely at Eastlake's stated reasons, which seem rather different.) Another historian provides evidence of the stultifying "perfection" of daguerreotypy and of the advantages of calotypy to artists; see Nancy B. Keeler, "Souvenirs of the Invention of Photography on Paper: Bayard, Talbot and the Triumph of Negative-Positive Photography," in Naef, *Photography: Discovery and Invention* pp. 59 n 7, 55.

[39] This view is eloquently presented in Trachtenberg, "Emergence of a Keyword," pp. 37–43.

phy's next few inventions. From the glass-plate negatives of the 1850s, photography became less like sketching and note-taking. John Szarkowski has likened these wet plates to muzzle-loading rifles[40] and gives a vivid account of the difficulties:

> The development that separated mainstream photography . . . into two camps . . . was the wet-plate process. The wet-plate, or collodion, method came close to matching the daguerreotype in its mindless, hypnotizingly precise description of surfaces. It was also—unlike Talbot's paper negative system—an uncompromisingly conceptual method. [With the calotype] one . . . sets up, makes the exposure on a piece of paper previously prepared, and in ten minutes is again on one's way. Development of the negative can be postponed until evening. The wet-plate photographer knew no such freedom. . . . [He] had first to erect his dark tent and manufacture his plate; after exposure, the plate was developed immediately, before its coating had begun to dry, and then was washed and dried. . . . This method of working encouraged methodical planning and discouraged spontaneity. . . . Calotypes were made by gentlemen amateurs, wet-plate pictures by professionals. . . . It is clear that the advent of the wet-plate system must have resulted in a rapid deterioration of the photographer's social status. The method was notoriously messy, and the photographer's clothes and hands were apt to be marked with black stains. He probably tended to squint in normal light—from spending so much time in the dark—and because his equipment was very much heavier than that of the calotypist, he was often accompanied by a donkey.[41]

We think of the dry-plate technologies two decades later, followed by those of the "rollfilm revolution"[42] and the hand-held or miniature camera, then by the innovations outlined above (Chapter I) as very successful in offsetting most of these limitations. So it might be said that photographic production, having become much more difficult, became in stages more and more easy.

[40] John Szarkowski, *Photography until Now* (New York: Museum of Modern Art, 1989), p. 126.
[41] Szarkowski, "Early Photography and Modernism," pp. 100–101. We may include ladies with the gentlemen calotypists, and Constance Talbot was probably one of these.
[42] See Brian Coe, "The Rollfilm Revolution," chap. 3 in *The Story of Popular Photography*, ed. Colin Ford (London: Century Hutchinson, 1989), pp. 60–89. Coe provides some classic examples of technological interactions here: e.g., there was little point in manufacturing small cameras until higher-sensitivity dry films were invented, to allow exposures short enough for a camera held in the hands.

This is true only as the meaning of "photographic production" itself migrates with technological developments. As Szarkowski remarks,

> It is customary to say that the invention of the dry plate greatly simplified photographic technology. It would be more accurate to say that the dry plate so radically complicated photographic technology that it could no longer be left in the hands of the photographers. In the early 1880s photographers stopped making their own plates; a few years later they stopped sensitizing their own printing papers. The earlier craft technology had been replaced by an enormously sophisticated industrial technology; in the century since, photographers have worked with those materials that the photographic industry has seen fit to make available to them.[43]

In fact, none of us could make the cameras or films that we now use, and only a tiny minority can develop and print their products. We *take* our own pictures, but we do not *make* them; many more may make their own beer and wine than their own photos. In exchange for increased powers of image acuity and regularity, Talbot's kind of photographic production became increasingly difficult to obtain in an increasingly industrialized context, and control of the materials and processes have largely been taken out of our hands. In the nineteenth century that work was put instead into the "hands" of a factory labor force. Holmes cheerfully observed that workers, "where labor has become greatly subdivided, become wonderfuly adroit in doing the fraction of something."[44]

The "new world" is even wider than that, so wide that we can only indicate it here. Like waxed papers, glass negatives made sharper prints because they were truer filters than paper negatives. Even before photography, optical filters had been used for *projection* (without printing) onto screens. Screen images consist not literally in marks but in greatly magnified cast shadows on surfaces. With George Eastman, in the 1880s, flexible plastic (celluloid) bases, rather than glass, allowed for roll *film* and thereby for mass amateur photography. Also, by the late 1890s it was this flexible plastic roll film that allowed for the projection of *moving pictures*. More needs to be said about

[43] Szarkowski, *Photography until Now,* p. 126.
[44] See Trachtenberg, "Emergence of a Keyword," p. 43, on Holmes's account of his visit to the "alienated labor" of a stereograph factory in "Doings of a Sunbeam," *Atlantic Monthly* 12 (July 1863): 63f, rpt. in Newhall, *Photography: Essays & Images.*

the physical and optical display characteristics of screen surfaces: both (shadow) reflection surfaces of slide and cinema pictures and the subsequently ubiquitous surfaces of CRT screens provide images on physically affected but not literally marked surfaces. We should note that although investigating them would carry us away from the technologies that, as Herschel said, "have paper as their field of display," the need for hard copy versions of their displays has provided a new niche for images on paper, often again produced by means of photo processes.

A Breakfast of Champions

In 1831, the year that Michael Faraday invented the electrical transformer (and Charles Darwin sailed away on the *Beagle*), during what might be called a photo interim—four years after Niépce's unsuccessful effort to promote heliography in England, two years after he formed a partnership with Daguerre, and two more before Talbot thought about inventing photography—Herschel's ever interesting journal carried the following entry for Sunday, 26 June: "Breakfasted at Babbage's—Brewster—Talbot—Drinkwater—Robt Brown."[45] We have already considered Talbot's and Herschel's great contributions to photochemical imaging. It would be a long time before Charles Babbage's lifelong championing of automatic calculation would lead to the digitally generated images that today interact with photographic "taking" devices (and size, scale, and operation would eventually require photo-etched electrical circuitry to replace Babbage's clockmaker's craft), but the connection of Babbage's work to our interests here is not far-fetched. He was motivated in his pioneer project of designing a "Difference Engine" of calculation by the existing state of a technology for marking surfaces—that is, for the printing of mathematical tables. Accurate reproductive marking of codified tables is, after all, one of the oldest kinds of marking associated with civil life: we may think of ancient Sumeria. Its later technologies were essential to industrialized technology and to the development of most modern sciences, as both entailed sharing detailed data at different sites and times. For nineteenth-century tables there were problems not only of erroneous calculation but of faulty transcription. For example, in analyzing printed tabular errors, Babbage was able to deduce where pieces of loose type had fallen out of the

[45] Quoted in Schaaf, "Herschel, Talbot, and Photography," p. 182.

type plates and been inaccurately replaced. When his and Herschel's checks of astronomical tables turned up major discrepancies, he is reported to have exclaimed, "I wish to God these calculations had been executed by steam!"[46] Babbage's computers were automatic mechanisms that would not only save human labor while calculating more quickly and correctly but would also circumvent transcription and typesetting errors by automatically printing out their results, perhaps on metal plates that could be used graphically to make multiple copies.

The phrase "multiple copies" opens the important photographic topic of photomechanical reproduction, which leads on to EO forms of multiplication and transmission: publication, indeed broadcasting, of photo replicas. The briefest of indications must suffice here. Speaking of plates, we might think of *templates:* guides for making multiple reproductions by the physical process of matching copies against their own patterns, often by mechanical action.[47] Photo-technologies play major roles in many of these actions. For photography's widest effects, the metal templates that carry ink are the most important. In the case of cinema, film templates radiate further in the production of other templates like themselves, from which images are projected. With the evolution of television-image transmissions and with EO photography generally—especially where storage and operation are digitalized—the idea of a template becomes increasingly abstract, carrying us away not only from the field of paper but from that of surfaces and physical template operations, into regions too broad to treat here.[48]

In considering not only automatically printed tables but, more specifically, *images* on surfaces, something should be said about the contributions of Herschel's fourth breakfaster, Sir David Brewster, who not only encouraged Talbot's efforts in the decades ahead but produced the popular photographic *stereoscope,* which raises interesting questions for our overall approach.

[46] Doron D. Swade, "Redeeming Charles Babbage's Mechanical Computer," *Scientific American* February 1993, p. 86. See further Anthony Hyman, *Charles Babbage: Pioneer of the Computer* (Princeton: Princeton University Press, 1982).

[47] This use of the idea of templates is due to Noël Carroll, "The Ontology of Mass Art," *Journal of Aesthetics and Art Criticism* 55 (Spring 1997): 187–99, where more distinctions and applications are worked out. See also Noël Carroll, *A Philosophy of Mass Art* (Oxford: Oxford University Press, forthcoming).

[48] On these further abstractions, see Carroll, "Ontology of Mass Art," then Timothy Binkley, "The Vitality of Digital Creation: Refiguring Culture with Computers," also in *Journal of Aesthetics and Art Criticism* 55 (Spring 1997): 107–16.

Stereoscopy, theory and gadget, would be introduced by Charles Wheatstone in 1838, just before photography came onto the public scene. But it was Brewster's inexpensive "lenticular" stereoscope of 1849 that was made to order for photo stereo, and within a year a French firm was producing both the devices and daguerreotype double pictures for it.[49] These were very successful, and important sectors of photography's early history are tied up with stereo. Holmes's "mirror with a memory" phrase, after all, comes from his article on stereo photography, and a year later he produced the familiar compact viewer, immediately more popular in the United States than Brewster's.[50] Turn-of-the-century developments in popular photography included stereo variations of amateur cameras, as stereo became even more popular in the active "taking" form.[51] Since then stereo has vibrated periodically in and out of style. As it produces a 3D image, it may be considered a forerunner of hologrammic photography as well as "virtual reality" (VR) imaging—all of which raise questions about our account of photo images as marked surfaces treated in a certain way.

In the 3D examples, whether in printed materials, conventional cinema, or VR displays, all that we actually see is—as with other photographs—a marked surface: "marked," that is, in the extended sense of being physically affected in a discontinuous way. Seeing stereographically here does not mean seeing something that *is* 3D (that reverses the effect of some camera focusing-screens, which are designed to make a three-dimensional scene look like a two-dimensional display). It means seeing two marked surfaces, or physical images, at a time but *experiencing* 3D. One might object at this point that the image is not either, or even both, of the surfaces that we actually see; therefore, since the surfaces are normally flat while the image is not, the image is not a marked surface. This seems correct, and we should be careful not

[49] See Robert J. Silverman, "The Stereoscope and Photographic Depiction in the 19th Century," *Technology and Culture* 34 (October 1993): 729–56.
[50] David Allison, "Photography and the Mass Market," in Ford *The Story of Popular Photography*, pp. 55–56.
[51] The Nimslo camera of the late 1980s failed to be the success it was expected to be. "It took four pictures, each from a slightly different angle. . . . The special processing involved dividing each picture into strips, then printing them on special paper that incorporated minute . . . ridges. When you looked at the picture, one eye saw one side of each ridge and the other eye saw the opposite side," with 3D effect (Wade, *The Camera,* p. 143). By this time holograms were being incorporated in credit cards, and shortly thereafter painted "one-picture" stereo books, following the ideas of psychologist Bela Julesz, became a fad.

to try to define all images of the sort we understand as "photographic images" to be marked surfaces, even though all are derived from marked surfaces. Photographic holography provides a more radical exception to the treatment of photo images as marked surfaces. Holograms, too, are of course photographs: photo records of interference patterns. But in a hologrammic image, unlike the 3D examples, we do not even see the marked surface that produces it. The relation of marked surfaces to images is therefore diverse. Most of the time the images treated here are of the sort that you could fingerprint or spill a cup of coffee on, but some are only *generated* by things you could fingerprint or spill a cup of coffee on. Of the latter sort, there will be cases where, to access the image, we must actually see the producing surface, and there will be cases where we need not.

Images and Abstentions

Now that we have accounts of images and of display images, we are set to treat "photography" in a more systematic manner as one diverse class of imaging technologies, members of which have important relations to non-photographic imaging technologies with which they typically combine. When the nineteenth-century artist Edwin Landseer's brother spoke of "foe-to-graphic-art," he made a witty but not an entirely accurate point.[52] Photo-technologies did displace some hand and mechanical occupations in the nineteenth century, but a truer account—as suggested in our history—is that they grew directly out of and redefined these occupations as they intertwined with them. All the basic graphic technologies of the time have important use today. As for *art,* it should be remembered that Delaroche's much quoted exclamation of 1839, "From today painting is dead," was uttered only months after the birth of Cézanne, in the same year as the birth of Sisley and—to stay within his own country—a year or two before the births of Monet, Rodin, Renoir, Bazille, and Morisot, and thirty years before Matisse. These are among the more popular picturemakers in history, and today photographic reproductions of their drawings and paintings grace more home and office walls than do the works of any photographers.

Such photo-reproductive processes are usually in two stages, a silver image mediating a final one in *ink.* Photography in ink, available during the

[52] Quoted in Pat Gilmour, *Modern Prints* (London: Studio Vista, 1970), p. 76.

second decade of the twentieth century, is perhaps photography's greatest reinvention, thanks to ink's permanence, its combination with letterpress technology, and its powers of cheap and wide distribution. In similar ways, the development of electronic imaging systems in the last quarter of the twentieth century—photography's latest reinvention—begin to change but not to *usurp* the work of photochemical photography on paper.

Before I go on to consider technologies more generally and certain photo-technologies more particularly, a summary of my approach so far may be in order. In defining imaging and display imaging I have made no reference to likenesses or counterparts: indeed, no reference to "reference." "Image" I take as basic to "photography," and I have tried by progressive formulations to establish in this chapter that "image" names a certain kind of marked surface, and "imaging" any method for producing it. We will continue to think in terms of physical states of surfaces and of the actions of altering those states as among the many ways in which people address the surfaces of the world, including their own. We see and touch physical surfaces; some philosophers insist that we see and touch only surfaces. We form and alter them; we mar, wash, smooth, burnish, paint, finish, adorn; we set, toss, smash things, walk, sit, sleep, and work on them. This is very much intended to be an investigation of "working" surfaces, and the next chapter discusses technological systems that help us do such work.

Some may consider it eccentric to approach photography in terms of technologies for affecting the surface states of physical objects, given that several quite different conceptions prevail. The immediate reply is that as other construals have failed to provide a framework for understanding one of the most important technologies, perhaps we might try doing the job without them. Consider, very generally, marking (or display-marking) technologies. The category, if very wide, is far from careless; if obvious, far from well-observed. That can be seen by contrasting it with more familiar categories applied to photography: for example, "communications" and "information" technologies. Indeed, someone challenged about the importance, generally, of surface-marking technologies in history and wishing to answer in the one word "writing" (or "Gutenberg") would probably invoke just these associations.

There is something to be grateful for in the classifications that seem forced upon us by recent technological and economic developments. Only a few decades ago the term "technology" had the proper implication of work, but

"work" had a strong connotation of physical action, especially of motive power: the ages of wind, steam, combustion; the "nuclear age." Despite the development of true communications technologies such as telegraphs, telephones, and transportation systems, "technologies" tended, at least in popular thought, to be associated with harnessing the forces of nature. A few technological theorists such as Lewis Mumford spoke against this association, complaining that the "quiet" container, or storage and transport, technologies so essential to human life at any level and especially the symbolic technologies that he called "tools for living" all tended to be slighted in popular thought, in research, in general appreciation.[53] The development of television and then computing, however (including our own topic of image production and display), has since shifted this bias to "the information age."

The link of photo-technology to communications is not altogether new. After all, Elizabeth Eastlake called photography, with perceptive emphasis, "a new means of communication." Following my physical surface-action approach, however, I will avoid the idea of "communications technology" here, for it tends to be misleading in two ways. As another technology critic, Ursula Franklin, has argued, most of the so-called "communications" technologies and "media" are designedly nonreciprocal and would thus be more justly labeled "noncommunications" technologies.[54] Some of the most powerful are correctly called "broadcasting," signifying not point-to-point reciprocal exchange but single point to many (noncommunicating) points unidirectional transmission of increasing volumes of data, with all the implications of authority, control, and passivity that modern culture critics have attacked.[55]

My account may allude to communications theory (though the treatment in Chapter V could be improved by someone with more expert knowledge than I), but as a general label for our topic the term "communications" seems

[53] Lewis Mumford, "Technics and the Nature of Man," in *Knowledge among Men*, ed. Paul H. Oehser (New York: Simon & Schuster, 1966); rpt. in *Philosophy and Technology: Readings in the Philosophical Problems of Technology*, ed. Carl Mitcham and Robert Mackey (New York: Macmillan, 1983), pp. 77–85.

[54] Ursula Franklin, *The Real World of Technology* (Toronto: House of Anansi Press, 1992), p. 48: "In general, technical arrangements reduce or eliminate *reciprocity.*"

[55] Mumford had hopes for electronics. Some argue that personal computing, linked to the World Wide Web, will provide defense of Marshall McLuhan's idea of an electronic "global village" against sharp criticisms such as those leveled in James W. Carey and John J. Quirk, "The Mythos of the Electronic Revolution," *American Scholar,* Spring 1970.

to beg too many questions at the outset—even in suggesting that whoever takes a photograph does so in order "to communicate." Such a use, even where it does importantly occur, gives little guidance for a philosophical inquiry into photography. "Information technology" is a slightly better term but has defects parallel to those of its older relative and perhaps too strong overtones of high-tech developments. Its advantage over "communications" is that it has a more squarely cognitive connotation, and photo-technologies are—by contrast with, say, food-production, medicinal, or reproductive technologies—cognitive: that is, their outputs feed directly into cognitive systems, notably (though not exclusively) through visual perception.

These are some of the reasons why I consider it more helpful to approach photography simply as one kind of marking technology rather than as a medium of communication. Success in this project might serve a little to encourage the greater one of treating human efforts at marking as a distinctive category independent of communication. That such a resource does not already exist is owing partly to the modern history of the historical study of technology itself, partly to the numbing grip of "communications technology." As far as I know, there is no accepted "surface-marking" category in the history of technology. It is typical that a previous, indispensable effort to "find a pattern of significance in the story of prints" in Europe, from woodcuts to photographic reproductions, was titled *Prints and Visual Communication,* as though the printing in medical illustrations, fine art reproductions, and paper money have some common *function* called "communicating."[56] Whatever the varying uses of the *products* of such technologies, and obviously these uses (plural) shape the "significance" of the procedure, the story that the author, William Ivins, relates (and has the expertise to relate) is of the development of a series of techniques for repeatable, sometimes mass-repeatable, printing of prepared surfaces in ink—notably as visual display markings.

I cannot attempt to produce here an analytic history of the technologies of putting marks on surfaces, but I hope we can keep in mind the multitude of diverse interests people have in marking. In a very broad sense of "mark," all painting of surfaces—walls, fabrics, implements, human bodies—would be involved. So would such operations as incising. Mark-related technolo-

[56] William M. Ivins Jr., *Prints and Visual Communication* (London: Routledge & Kegan Paul, 1953).

gies would include, for example, the industries of dye manufacture—which are, historically, deeply implicated with the photographic. Most such marking would be for the purpose of being seen. But not all—and it is important to notice that this exception flows from marks right down through images in general to photographic ones. Many of our marks, the superficial changes we make in the surfaces of things, have no function, or serve nonvisual functions. As physical states of surfaces, marks have many foreseeable consequences besides that of affecting light receptors fixed to our heads. For example, microchip circuits are made through silver-based photolithography on the order of less than one micron; to make such lines even barely visible to the unaided eye would require expanding a quarter-inch chip to the area of a small farm. A great deal of important and useful research exists on all such singular processes and their histories. What is lacking is a *general* perspective on surface-marking technologies.

Likewise, the literature on *perception* of markings is on the one hand overwhelming, on the other remarkably sparse. To encounter the overwhelming aspect, suppose we decided to pursue the following plausible line. Since most of our interest is in markings as visual objects (especially as that interest runs here toward marks that define images), it would seem reasonable to consult research on such perception. And since seeing marks is seeing surfaces, it would seem reasonable to consult research on that wider topic, as well. Unfortunately, to consult that is to consult a good deal of modern perceptual psychology, which for centuries has been largely about vision, about visual space perception, indeed about seeing surfaces. The perception of marked surfaces has come into all that centrally, but not in the general way we need. Consider the testimony of an influential modern theorist in that field, James J. Gibson: "The perception of surfaces, I argue, is radically different from the perception of *markings* on a surface. The former kind of perception is essential to the life of animals, but the latter is not. The former is presupposed when we talk about the latter, and we cannot understand the latter unless we understand the former. But we have been trying to do it the other way round."[57] Gibson's complaint was that research in visual perception had for various reasons followed *picture* perceptual models. Whether or not we agree with Gibson's influential approach either to perception or to pictorial per-

[57] J. J. Gibson, foreword to *The Perception of Pictures,* ed. Margaret A. Hagen (New York: Academic Press, 1980), 1:xi. If we include, as above, natural markings, we might dispute Gibson's idea that their perception is not "essential to life."

ception, we must admit that since at least the seventeenth century, vision theory has been both conceived and experimented with, heavily, in terms of markings on surfaces, notably with *pictures of* things and related displays. Although that mass of work contains valuable research on marks themselves, it is usually in the name of pictorial perception. Once again, this would too early divert our discussion into the wrong channels.

"Signs"

A last abstention is significant enough to warrant a separate section. Here is the first occurrence of the word "sign" in this book—and even now I am citing, not using it. There has been no need for it; there will be only little need for it in what follows. Indeed, in discussing image and imaging we needed to avoid using it. The terms "sign" and "symbol" are unnecessary to our line of inquiry. They would likely get in the way of both its philosophical presentation and its application, for at least two reasons.

First, these terms are relatively harmless so long as one means very little by them. For example, suppose one says something like the following: "What we really encounter while looking at a photograph is a two-dimensional sheet of paper, with a surface marked by shapes and tones that function as signs and symbols. This is our actual experience. The ambiguity between the vicarious and the first-hand creates a tension in the viewer that gives photography its mystery."[58] Mostly, what "function as signs and symbols" means here is that photographs are not the things they are photographs of—or the things they depict, if what they depict is different from what they are photos of. The danger is in thinking that the terms "signs" and "symbols" explain the functions of being a photograph of something, or of pictorially depicting it, as though we had an articulated understanding of them. Rather like a soiled cloth, sign theories, inevitably based on linguistic theories, spread their own difficult problems of semantics—that is, of linguistic meaning and reference—across other fields of surface marking. In the course of doing so they exhibit annoying dualistic tendencies to separate the mark—the physical bearer—from the meaning, treated as something cognitive. This proves a disaster for any account of the arts of marking.

[58] James Borcoman, *Magicians of Light: Photographs from the Collection of the National Gallery of Canada* (Ottawa: National Gallery of Canada, 1993), p. 104.

The second main reason, more specific to the continuing concerns of the first chapter, has to do with essentialism. It is very important at this point to insist on the extremely wide and unsystematic, even random, scope of the *uses* of visual displays. A word like "sign" is certain to obscure this point, suggesting a mythical common function for all such markings. It would involve us in a morass of theories, themselves beset with settled fallacies that we must avoid if we are ever to secure the grasp of photographic phenomena that still eludes us, even as they develop at faster pace. The history of theories of signs, as far back at least as the ancient Roman encyclopedists, is as full of simple error as it is widespread through most disciplines. One error is that of common function, the idea that the objects of our examination all do the same thing. This is usually said to be one or both of two things. The first is "bringing to mind what is not present." The second is, as mentioned above, "referring."

Many markings do have a function of bringing to our minds things not present. Maybe one function of the Evans photo (Figure 1) and much documentary photography is precisely that—as some of our sources insist. For example, the Farm Security Administration project in which Evans and Dorothea Lange were involved was supposed to bring voters to consciousness of social and economic conditions not present to them. Whether this is also true of trade-marks and grade marks, watermarks and voters' marks, may be debated. A "calling to mind the absent" function no doubt picks out an important class of displays, but for the one that interests us here it provides a very bad model. For example, pavement markings are not there to put us in mind of things not present; they are there to make clearer to us things that are present. This is often true of display markings, whose function, as already noted, can be to bring *themselves* to mind. This is true, for example, of all displays that are self-referential.

The more ubiquitous term "referring," though it also picks out an interesting class of displays, fails our purposes just as miserably—even as the name of a general function for displays that might quite reasonably be called "signs." Many displays do have referential *use:* for example, some written words or groups of words. Many words and diacritical marks have no reference, however, actual or intended. Neither do boundary marks or lane marks on sports fields, and—to stay with *line* marking, leaving out all manner of other forms—neither do quantity lines on measuring cups, ledger lines in account books, outlines in clothing patterns, cancellation lines across

stamps, lines on graph or writing paper, pinstripes on shirts, the dotted lines
we sign on. (In Chapter IV we shall see that the same holds even for many
pictures drawn with lines.) Although many marks and images do refer, we are
well rid of any *theory* of reference here, as it is one of the most difficult and
contentious areas of semantics. To be more sympathetic, the desire for a high-
er functional category for visual and other displays, a category such as "com-
munication," "information," or "signs," may be owing to the reasonable
assumption that display would hardly ever be *just* for "the sake of display."
That is, where visibility has further purpose, the purpose for something's be-
ing visible would hardly ever be, simply, visibility.

No doubt the general function of visual display usually does serve further
functions, maybe even other cognitive ones, but this fact should not tempt
us to suppose that all these cognitive functions are of one general kind. If it
is common for display itself to serve other purposes, it does not follow that
all cases of display share *common* purposes—any more than that technolo-
gies for bonding surfaces would inevitably serve some common further func-
tion beyond bonding them. Many of the classifications that we ordinarily
make, whether we have settled labels for them or not, derive from practical
purposes—sometimes vitally important ones—but reveal little of the nature
or purposes of the things classified. "Just be sure to lock up all blunt instru-
ments and throwable objects," says the playwright in Joseph Mankiewicz's
1950 film *All about Eve.* Anyone who has looked after young, mobile chil-
dren knows how fast one's visual classification system can be shaped toward
a relative sense of breakable or dangerous objects and edges. Similarly, when
we look for something of the right shape or weight to fill in for a certain job,
a *function* may link the thing and the situation, but it is accidental to the *na-
ture,* including the *functional nature,* of the item selected: wire hangers are
not designed and sold for service as grappling hooks; newspapers are not
printed and bought for wrapping fish or making papier-mâché figures for
parties; toilet plungers are not manufactured to serve as mutes for jazz trum-
pets. Some everyday groupings are not even exactly functional in the first
place. The familiar, serviceable category of "pocket-sized" or "pocketable"
items, for example, shows little of the nature of stamps, acorns, pins, leaves,
paperclips, frogs, which fall into it, though rather more of the nature of coins,
tissues, keys, pens, watches, penknives, hairpins, dice. It would be very mis-
leading to try to understand such items under the essence of the pocketable,
with "pocket theory."

It is equally vain to seek a common function served by the diverse visual purposes of visual displays and images. Visual display of surface markings, with great open-endedness of future functions, is exactly what we need as a theoretical basis. It is important to preserve that basis as we move down specific lines of surface-marking technologies—including photography.

ℨ❧

Visualizing Technology

Gathering Steam

I f, as we have been considering, not only are there technologies of pho-
tography, but photography is itself a technology, the following proce-
dure would seem to be in order. Given the amount of critical attention
technology has received over the last few decades, we should be able to
apply at least a few of the resulting well-grounded conceptions of technolo-
gy to photography and thereby to place what have seemed to be local pho-
tographic issues in broader perspective, revealing neglected connections with
other processes. In giving photography the philosophical perspective it has
sorely lacked, we might expect that terms and distinctions—the very for-
mulation of photo issues—should be transformed, familiar problems recast,
some even solved.

It is remarkable how little the many excellent histories of photography
make of the connections between photographic inventions and other tech-
nologies that developed adjacent to them by nature, historical setting, or
causal relation.[1] Though broad allusions are made to photography's link with
a new industrial age in the early nineteenth century, there are scant details,
for example, of its kinship to the great technologies of its earliest days, which
it frequently recorded: the technologies of steam power and the intersecting

[1] An exception is Vicki Goldberg's editorial introduction to the anthology *Photography in Print*,
p. 19.

textiles system. One even looks in vain through modern accounts about photography of the late 1870s to late 1880s—when the dry gelatin process first appeared, then opened up popular photography and cinema by means of celluloid roll films—for any connection with the origins of *sound recording* during exactly that period, in the same society, with similar motives. This is less surprising when we notice how infrequently the standard histories of photography include the photographic aspects of cinema. The photo establishment of Lumière *père* might be given closer connection to the famous cinematic work of Lumière *fils*.[2] As so often, nineteenth-century writers seem to have had a better grip on the situation than have later commentators. Already in 1843 the *Edinburgh Review* (opposing patenting of the daguerreotype in Britain) remarked that "the art of Photography . . . is indeed a great step forward in the fine arts, as the steam engine was in the mechanical arts; and we have no doubt that when its materials have become more sensitive, and its processes more certain, it will take the highest rank among the inventions of the present age."[3]

The period of the 1820s and 1830s during which the first photo-technologies were developed coincides with what may be counted as the last major part of Britain's industrial revolution. By the 1830s steam-powered looms were common. The great photographic year of 1839 featured production of the first propeller-driven steamship, the first steamship crossing of the Atlantic Ocean, and the invention by Charles Nasmyth of the steam hammer. The period of Talbot's perfection of his calotype (1840–41) coincided not only with British deployment of steam warships (see Figure 3) but with the development of the portable steam engine, "entirely self-contained including boiler, mounted on wheels, primarily for agricultural use"—mainly threshing, but also sawing and pumping once these devices were hauled into position by horses.[4] "Traction engines" that could go "under their own steam" had seen real practical use from about 1812, and the first intercity steam train line (between Manchester and Liverpool) was under construction during the

[2] That might be assisted by publication of the family letters dealing with the detailed and fascinating technological, as well as business, affairs, in Auguste and Louis Lumière, *Letters: Inventing the Cinema,* ed. Jacques Rittaud-Hutinet, trans. Pierre Hodgson (London: Faber & Faber, 1995).
[3] *Edinburgh Review,* January 1843, in Goldberg, *Photography in Print,* p. 52.
[4] Lyndon R. Shearman, *Portable Steam Engines* (Aylesbury: Shire Publications, 1986), p. 4. For a full study of stationary steam power that says much about self-propulsion as well, see Richard L. Hills, *Power from Steam: A History of the Stationary Steam Engine* (Cambridge: Cambridge University Press, 1989).

Fig. 3. R.W., "H.M. Screw Liner Hogue Towing H.M.S. Caledonia 1850." Courtesy of M. Phillips.

years when Niépce was making his first camera heliographs and then forming his 1830 partnership with Daguerre (Figure 4). The coming of the railroads coincided with the great era of the rival daguerreotype and calotype in Europe (up to the hegemony there of the collodion glass negative of 1851); during the 1840s thousands of miles of track were laid throughout Europe.

Steam and photo technologies are of course very different. These differences, quite as much as the likenesses that obtain despite them, are instructive. Though there is a mountain of literature on the economic and social effects of steam inventions, considered *as* technologies, the growing body of writing on photography still treats photographic technologies without viewing photography itself as technology. More obviously, steam technologies are physical power technologies, central to the economies of the nations that developed them. In the latter nineteenth century their coal-fired engines consumed large masses of that fuel. They reorganized labor forces—indeed, populations. They were housed in buildings or impressively powerful iron and steel machines, or worked along steel tracks that further transformed landscapes. Their science was thermodynamics, which they pushed along,

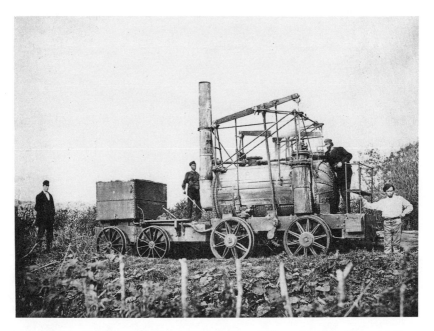

*Fig. 4. Anon., " 'Puffing Billy' Locomotive, Wylam Colliery, Northumberland." Cour-
tesy of The National Gallery of Canada, Ottawa.*

and they were realized through famous, ingenious feats of engineering and
capitalism. The general nature of these feats is instructive about the produc-
tion technologies involved. Because steam mechanisms were so large and
powerful and housed such dangerous energies, a main engineering challenge
from their beginnings in the eighteenth century was to develop the highest
possible levels of automatic control to work and to contain them. As these
engines were designed to magnify in speed and power traditional mecha-
nisms of work, including animal and human bodies, they could develop no
faster than the rate of their own "self-acting," or feedback, controls.

Although the steam engine was an external combustion engine—the eigh-
teenth- and nineteenth-century firebox being located outside the compres-
sion cylinder—its engineering led by the end of the century to the internal
combustion engines and use of oil products which strongly shaped twenti-
eth-century economics and politics. Among several serious nineteenth-cen-
tury attempts to design internal combustion engines, two were made by
Nicéphore Niépce and Henry Talbot. It was the development and promo-
tion of their "pyréolophore" boat engine, more than of heliography, that ex-

pended the finances of the Niépce brothers in the 1820s.[5] Talbot's patent application for an engine design was presented in the fall of 1840, just as he was discovering the latent image. Its title would serve as a good subtitle for this chapter: "Obtaining Motive Power."[6]

By contrast, since photo-technologies came about as cognitive or "information" technologies, they required only small amounts of material. Their science was chemistry; their engineering was chemical and optical.[7] Aside from the optics, the mechanisms involved were extremely simple by the standards of their day or of the several preceding centuries. Compared with traditional graphic procedures, photography appeared free of hands, but not compared with steam technology. Except for their tangential relation to steam factories in the polishing of photographic plates, there was very little of an automatic nature at any stage of photographic production; handwork was necessary from beginning to end. Thus Talbot himself looked at improvements to his art when, besides knowledge, "more skillful manual assistance is employed in the manipulation of its delicate processes."[8] Next to a steam engine, a loaded nineteenth-century camera was a rather passive, "unintelligent" contraption—essentially a one-way system of simple optical filters, linked to a remarkable photochemical silver amplifier, upon which people had just stumbled.

When we consider the *outputs* of the two machines, the balance of advantage shifts drastically. Since the time of Carnot, Kelvin, and Clausius, we have known it to be in the nature of things that the physical systems into

[5] Eder, *History of Photography*, p. 194.

[6] Talbot was the author of twelve patents, including four under this title (1840, '45, '46, '52) and six in photography (1841, '43, '49, '51, '52, '58). The other two involved plating metals. See Gail Buckland, *Fox Talbot and the Invention of Photography* (Boston: Godine, 1980), pp. 36–37, 200–203.

[7] Since the operators of steam railroads were called "engineers," I should say that I understand "engineering" here in its usual general sense of a kind of practical *design*. Engineers are people who design means of making artifacts function more efficiently. In doing so, modern engineers usually have recourse to *sciences*, often to mathematical sciences, whereas traditional engineers did not. The people who carry out these designs may not be engineers; "carrying out" often entails the financing and organization of production. Still less likely to be engineers are those who *use* the artifacts so designed. The term "technology" is usually ambiguous among these three situations: design, construction, use. For further discussion, see Carl Mitcham, *Thinking through Technology: The Path between Engineering and Philosophy* (Chicago: University of Chicago Press, 1994), pp. 143–54. Most of the technological inventors discussed here stand in all three positions of design, production, and application (as well as in doing the relevant sciences). Talbot provides a clear example, and calling him a "technologist" could signify his having any or all of these roles.

[8] Talbot, *The Pencil of Nature*, p. 4.

which steam engines feed fraction their efficiency drastically at each stage. Even in our time, half the motive power of automobile engines is lost before it reaches the drive train. Fortunately, steam and internal combustion engines do not feed into the human visual processing system. Photographic systems, by contrast, link *two* extraordinary amplification systems, since the first, the photochemical one, need produce only tiny physical changes at surfaces in order to feed into the greatest information-processing pathway yet known, the naturally evolved human eye-brain system. For reasons still not well understood, this link is made only in humans, alone among animals, with effects magnified by cross-connections of perceptual context and memory, involving thought and feeling, stirring will and desire. The results make photography a veritable engine of visualization (as defined in the next two chapters) and of all that proceeds from it.

Applications

Let us now compare photography with some more closely related technologies of the nineteenth century. It is often interesting to compare the terms of formal presentation of new inventions, especially where we have clear documents rather than just general accounts. Not surprisingly, inventors themselves offer many possible practical uses ("applications," as they were called in the nineteenth century) for their inventions. For example, Herschel wondered whether Talbot's initial presentation of his method should not be a longer paper, so as to contain "hints for future wider applications which may advantageously be for a time witheld [*sic*]".[9]

Sometimes inventors' and promoters' priorities are remarkably unprophetic. In the era of "the Second Industrial Revolution," from the 1870s, when photo-technologies suddenly moved into wider popular application, Thomas Edison's presentations of sound recording and, a decade later, of motion picture provide instructive cases. Both inventions are clearly related to photography, the latter forming an essential part of photography's history. Edison came upon the idea of the phonography in 1877 (the year following Nikolaus Otto's internal combustion engine); 1878 might be called Edison's year of the light bulb, when he began thinking about replacing home

[9] Unposted draft letter from Herschel to Talbot, quoted in Schaaf, "Herschel, Talbot, and Photography," p. 186.

gaslight—but the metaphorical one above his head that year, as he wrote his article recommending the uses of his "phonograph" to the public, might surprise us. Edison listed musical recording fourth—after dictation, talking books for the blind, the teaching of public speaking; and just ahead of family oral history, including important family sayings and deathbed pronouncements—and he continued to resist the less serious use of musical enjoyment.[10] During the 1880s Alexander Graham Bell, like Edison, thought of the talking machine ("graphophone") as primarily an office dictating machine. That is, Bell had come to think of that application; he had initially been interested in it as an extension of telephone technology—which Edison had put at the end of his list. Apparently only its failure in the serious stenographic business market (which felt no need for it) shifted its promotion in the 1890s into the area of entertainment, notably the recording of music in coin-slot machines. Those who would attribute the earlier emphasis entirely to a Protestant work ethic should recall (to introduce an analogy to photography that will be useful later) that the popular tape music recording market began only in the 1960s in Japan, following limited successes with it for court proceedings, scientific records, and language instruction (Edison's eighth use).[11] Even in the context of popular music, however, phonography initially lacked what Talbot had provided photography: a mechanical method for the multiplication of copies sufficient to serve a market (a topic to which I shall return). As for motion pictures, Edison's first idea for them, in the late 1890s, was as visual accompaniment to those coin-operated music players.

The technology historian George Basalla has emphasized such examples to underscore the point that technological inventions usually neither arise nor succeed because of any perceived *need* for them. This is an important point for any philosophy of technology. Basalla writes: "The automobile was not developed in response to some grave international horse crisis. . . . National leaders, influential thinkers, and editorial writers were not calling for the replacement of the horse. . . . [In its] first decade of existence, 1895–1905, the automobile was a toy, a plaything for those who could afford to buy one. The motor truck was accepted even more slowly. . . . As was the case with

[10] George Basalla, *The Evolution of Technology* (Cambridge: Cambridge University Press, 1988), pp. 139–40.

[11] See ibid., pp. 139–42, with the account of the transfer of transistor technology (pp. 86–87) as background.

automobiles, the need for trucks arose after, not before, they were invented" (6–7)—and, in the United States, through government lobbying by truck manufacturers. As with photography and phonography, it was invention that proved the mother of "necessity."

This point has been made by a number of historians and philosophers of technology. A classic statement is José Ortega y Gasset's 1939 existentialist essay "Meditación de la Técnica," with its telling section title "Being and Well-Being—the 'Necessity' of Drunkenness."[12] It is perhaps put most clearly and generally in three sentences by a founder of modern historical studies of technology, Lynn White Jr: "Necessity is not the mother of invention, since all necessities are common to mankind living in similar natural environments. A necessity becomes historically operative only when it is felt to be a necessity, and after prior technological development makes possible a new solution. Even then, what seems needed and feasible to one culture may be a matter of indifference to another."[13] The nomadic Berber people and city dwellers a few miles away choose different "necessities," and a multitude of such examples survives the efforts of the modern age. What is involved in making something "felt to be a necessity" is a large and interesting topic, in which photography has played an increasingly important role. Even in consumer societies that partake of what Harold Rosenberg well termed "the tradition of the new," the job of inventors is twofold: first, to invent a technology; second, to invent a need for it. This explains why modern innovators such as Talbot typically provide wide lists of uses: they are not always sure what their inventions are for but are eager to encourage users to find out and let them know. Such case studies open questions central to the philosophy of technology, indeed to some of the most important policy questions confronting us near this millennium, as standard assumptions about technological "progress" are in question.

Chapter I alluded to the mass-market factors implicit in popular camera developments over one decade of the late twentieth century. New photographic inventions since the 1840s have had precedent photo values to build

[12] José Ortega y Gasset, "Meditación de la técnica," trans. and ed. as "Thoughts on Technology," in *Philosophy and Technology: Readings in the Philosophical Problems of Technology,* ed. Carl Mitcham and Robert Mackey (New York: Macmillan, 1983), pp. 290–313.

[13] Lynn White Jr., "Cultural Climates and Technological Advance in the Middle Ages." In a footnote to this passage (p. 222 n18), White finds the earliest source of this "misconception" to be Hugo of St. Victor's remark, "*Propter necessitem inventa est mechanica*" (*Didascalion* 1.9).

on; it has always been possible to claim that a new technique does a job better, or easier, than the one before it. For development and promotion of the first photo-technologies the situation was rather different: though immediately seen to be related to earlier inventions and practices, they were still unprecedented—which was much of their attraction. Chapter II emphasized the diversity of possible uses for photography. On balance, the first promotions of photography look good by comparison with those for phonography and cinema. The first terms in which they were recommended to the public provide data for the more general analyses in the next two chapters.

The two French scientists François Jean Arago and Joseph Louis Gay-Lussac, who spoke for Daguerre before the French Chamber of Deputies and Chamber of Peers in July 1839, to secure government purchase of the invention, stressed not records of business contracts (as an Edison might have) but usefulness to "the Sciences and Arts"—a distinction that, to be sure, would form conceptions of photography for most of the century, but at least a distinction stated between related items. It is notable that these two eminent scientists attempted to embed daguerreotypy as firmly as they could in the most advanced *sciences* of the time.[14] Arago's first ploy of connecting daguerreotypy's use to the Egyptian expedition of the previous generation reads strangely until we realize that that great expedition, and the massive volumes and continuing research that flowed from it, were the basis of modern branches of several sciences—including biology and geology—besides Egyptology.[15] The expedition was an enormous data-collecting, -storing, and -processing enterprise, highly dependent upon accurately detailed, scaled, and annotated graphic surveys of ancient monuments, modern manners, and geographical, topological, geological, and biological features. These were recorded under arduous physical conditions, by procedures of engineering and architectural drafting, to be redrawn as etched plates for lavish publication. In the context of this graphic display of information on surfaces— rather than, as Lady Eastlake was to say, of "a picturesque agent"—Arago's case for the bill of purchase of daguerreotypy plays well on its strengths. He

[14] Eder, *History of Photography*, pp. 232–45. Talbot's gloss on the "celebrity" of Daguerre's announcement credited it in part "to the zeal and enthusiasm of Arago, whose eloquence, animated by private friendship, delighted in extolling the inventor of this new art, sometimes to the assembled science of the French Academy, at other times to the less scientific judgment, but not less eager patriotism, of the Chamber of Deputies" (*Pencil of Nature*, pp. 11–12).

[15] See Charles C. Gillispie, "The Scientific Importance of Napoleon's Egyptian Campaign," *Scientific American*, September 1994, pp. 78–85.

cited Daguerre's invention for extraordinary resolution of detail, continuous tonal recording, and perspective that allowed geometric transformation and measurement according to procedures that were advancing at the time. For the importance of recording display marks, one need only remember that expedition's famous discovery of the Rosetta Stone. Arago argued that the laborsaving "exact and rapid means of reproduction" provided by photography would permit the copying of "millions of hieroglyphics" still unrecorded. (He applied this advantage to monuments of France as well.)

Next, both Arago and Gay-Lussac, seeing daguerreotypy as a *photochemical,* not an *optical,* discovery, emphasized the silver-halide plate's use as by far the most sensitive "reagent" to the action of light ever known. They envisioned the immediate application of the plate as a photometric detecting and storage device, establishing objective comparisons of the weak intensities of stars and planets (including those not observable together in the skies) by quantitative measures of marks left on photo plates, figured with the *times* they took to imprint them via quantified optical filters. Light-gathering would be essential to this, but not necessarily by cameras. Arago compared photography to the two most famous scientific optical extenders of perception, the telescope and the microscope, to emphasize that scientific uses of such devices are not well predictable in the beginning. The chemist Gay-Lussac, who made important contributions to photochemistry and photometry, argued that photography would do for the study of small light intensities what microscopy had done for that of small objects, but he made only passing reference to biological work, and that toward the older taxonomy ("study of the species and their organization") rather than the new morphology. In sum, Kracauer's "recording and revealing" functional conception (Chapter I) is here acute and accurate. Still, it leaves out a third "r," barely alluded to in those legislative deliberations, in connection with Niépce's part of the formal bill. This is "reproducing." (Ironically, Niépce's slighted photogravure would have an important continuing history, while Daguerre's acclaimed method would soon disappear.)[16]

It is interesting that strictly *pictorial* functions were still secondary to the presentation at that early point. Regarding the applied and fine "arts" (as opposed to "sciences"), Arago glossed the "foe-to-graphics" issue with the point that daguerreotypy provides no printing plate and—on the testimony of the

[16] Eder, *History of Photography,* pp. 151, 237–38, 242, 234. Eder gives us the two "Reports," Goldberg gives us the subsequent "Bill."

painter Paul ("from this day forward") Delaroche—that in rendering detail, perspective, and broad effects daguerreotypy was partway to successful art and would reduce the labor of making studies for painting and engraving. Gay-Lussac suggested similar use and foresaw its not yet attained success with portraits. The subsequent brief formal bill before the Chamber of Deputies echoed these arguments and prophetically added the advantage of personal freedom: freedom to produce one's own graphic notes and illustrations without the need of skill or the intervention of professionals.[17]

As Talbot the tortoise, unlike that hare Daguerre, plodded on through decades of determined research, we have more than his initial presentation to consider. Talbot's hastily drawn-up case for precedence, six months before Arago and Gay-Lussac and in ignorance of details of the French process, is not really a fair guide to his subsequent promotions of paper processes but is nonetheless of interest for our purposes.[18] We have already seen that he had at first to play down the pictorial powers of his method, as his camera capability of the time amounted to tiny negatives of inanimate objects. In fact, Talbot's early efforts might be divided between direct shadow and lens-filtered optical processes, the materials being the same. The "first applications," as he termed them in January 1839, gave detailed "representation" of plant structure by superposition printing, silhouette (shadow) portraits, copying paintings on glass. Talbot then stressed the importance of accurate and labor-saving photo-printing of images from solar microscopes, much in usage. The botanical superposition and solar microscope printing differ in their use of contact versus use of lenses, but as two types of surface-to-surface imaging, both might be put into an important wider class of scientific representation which has been called "natural diagrams" (and of which I shall have more to say).[19]

Next, famously, came what Talbot called "the most curious application of this art," the (negative) fixing of camera images, with its advantages for quick, accurate results in field work with "architecture, landscape, and external nature," then "copying" sculpture. Talbot's account closed on perhaps

[17] "Bill Presented to the Chamber of Deputies, France: June 15, 1839," trans. in Goldberg, *Photography in Print,* pp. 31–35.
[18] Talbot, "Some Account of the Art of Photogenic Drawing; or, The Process by Which Natural Objects May Be Made to Delineate Themselves with the Aid of the Artist's Pencil," in Newhall, *Photography: Essays & Images,* pp. 23–31.
[19] See David Phillips, "Patterns in Pictures for Art and Science," *Leonardo* 24, no. 1 (1991): 31–39.

his strongest suit at the time: superpositional copying of drawings, engravings, and facsimiles of manuscripts, with the possibility of negative reversal "multiplying at small expense." For all his and our emphasis on applications, we should notice that Talbot, especially in a section titled "On the Art of Fixing a Shadow," promoted photography in two ways independent of technological use, which we would do well to keep in mind throughout. First came his sensuous appreciation of the looks of the displays themselves—which, though monochrome, had varying hues. More important, he marveled that the photochemical processes should work at all, and work as they did. Rather like the initial "toy" appeal of automobiles, that "magical" element in the products of photo processes was part of at least the initial appeal of both his and Daguerre's inventions. (The first sales of daguerreotype equipment were to people who wanted to see if they could get a result. I shall later consider how, as an ongoing appeal, this remains a resource for photographic meaning.) Thus Talbot's initial technological representation.

In less haste, and after five years of improvements, Talbot was able to make a better case for the *pictorial* uses of his paper processes, while maintaining emphasis on facsimile reproduction of texts and pictures, along with the advantages of the negative/positive process for both image reversal and multiple printing. His basic distinction between superposition and "distant objects," or camera, processes cut across copy work, as he argued for the important application of allowing change of scale from the original. Not only was the process different, and renamed, but both his audience and his aims were more general. As this presentation was not scientific, he downplayed microscopic work, and most of *The Pencil of Nature* consists of camera pictures of genre, sculpture, and architectural views. Like Gay-Lussac five years before, Talbot claimed but could not yet produce full portraiture. Remarkably, though, he foresaw ultraviolet or "invisible rays" photography. John Ward well describes Talbot's appreciation of photo-technologies: "The text of *The Pencil of Nature* proved Talbot to be not only a brilliant inventor but also one of the most perceptive forecasters of the future of photography. Where so many of his contemporaries saw the art as painting in another medium, Talbot saw it as a working tool, a recording system, a means of multiplying and manipulating visual images, a means of providing a different view of the physical world around him. . . . Almost alone, Talbot saw photography as it is practised today."[20] As to the content of his images, Tal-

[20] John Ward, "The Beginnings of Photography," in Ford, *The Story of Popular Photography*, p. 26.

bot like Arago claimed for camera photography those powers of capturing physical detail and incident, including minutiae of light and shade, which have been valued ever since, as well as that of systematic perspective organization (see Chapter VI). He too saw these feats as achievable by photography, without "disproportionate expenditures of time and trouble."[21] Slight as that claim may seem, it positions us again for a general technological overview.

Technologies as Amplifiers

The early claims made for any of the processes reviewed here, whatever their degree of technical insight or historical foresight, share the following characterization: all present their technologies as extensions of our powers. In general, that is what we can say all technologies are, extenders or *amplifiers of our powers* to do things.[22] The nineteenth-century applications are either new things that we can do, such as recording sounds, or things that we can do better, more quickly, with less labor or expense, such as threshing, moving heavy loads, copying prints, depicting buildings. Technologies are often presented as *laborsaving* devices, innovations that tend, in the words of the 1843 *Edinburgh Review,* to "either abridge or supersede labour." Talbot combined this idea of technology with photography's "magical" element in a letter to the *Literary Gazette* concerning his earliest "photogenic" processes: "It is a little bit of magic realised:—of natural magic. You make the powers of nature work for you, and no wonder your work is well and quickly done."[23] As an "information" engineer, he saw that the powers of nature which can be used to extend our own are not all, as might have appeared at the time, *motive* powers.

[21] Talbot, note to Plate X, "The Haystack" (in *Pencil of Nature*), which is counted as one of his aesthetically best pictures.
[22] For this perspective I am indebted to Clifford Hooker; see e.g., Hooker, "Value and System: Notes toward a Definition of Agri-culture," *Journal of Agriculture and Environmental Ethics* 7 (1994): suppl. A similar position, also with reference to consequent filtering or suppression, may be found in Don Ihde, *Existential Technics* (Albany: State University of New York Press, 1983). See also Thomas Levenson, *Measure for Measure: A Musical History of Science* (New York: Simon & Schuster, 1995), p. 13. We need to keep our thesis clear of a different one, that new technologies are to be understood as extensions of previous *technologies,* a position labeled and attacked by Marshall McLuhan as "rear-view mirror" thinking (quoted in Neil Postman, *Amusing Ourselves to Death: Public Discourse in the Age of Show Business* [London: Penguin, 1985], p. 83).
[23] Talbot, letter of 30 January 1839, *Literary Gazette,* 2 February 1839.

We need to combine this simple point with the earlier one that technologies do not always arise as a result of need or as solutions to "problems" but sometimes enter realms already well served—or better not served at all. There are at least two important issues here. The first is that as an extension of powers, a new technology need not initially extend those powers beyond the reach of existing methods. Very new technologies are often considerably less efficient than existing ones. For example, the steam train was at first no match for the recently completed canal system, which it nonetheless occulted. It was some time before steam mills could match the output of water-powered mills, with which they coexisted for decades. George Basalla has argued that hand-set movable type was for some time slower, not faster than woodcut; Europe, unlike China, did not use cut blocks until after Gutenberg, and then for comparatively coarse work.[24] For all the initial excitement, it was not until the end of the nineteenth century that photo processes became simple, reliable, safe, and cheap enough to be worthwhile to most people. Just as nineteenth-century people all around the world tended to have better handwriting than do we, far more of them were skilled in drawing—another topic to which I shall return in Chapter IX. East or West, many travelers like those mentioned by Arago and Talbot had long been capable of producing clear, economical, and still interesting verbal *and* graphic records of their observations.

After new technologies become entrenched, they tend to exhibit absolute advantage over their earlier competitors: thus steam over canal transport and water mill. Their advantage appears more relative when we consider the terms of comparison. First, we know the development of the successful technique but often have less knowledge of its competitor's development to compare with it: thus the gasoline-versus steam-powered cars of the early 1900s.[25] Second, successful technologies inevitably build up contextual supports that make comparisons uneven. The wheel has great advantage over the camel and the horse for transport *if* roads are built with grades, turning angles, and widths that fit axles.[26] Trucking proved more economical than rail in postwar North America (as opposed to Europe, Africa, and Asia) only because an extensive highway system was built for it out of public funds, it received

[24] See Basalla, *Evolution of Technology*, p. 149 regarding water and steam mills, and 192–95 on "xylography" (wood-block text printing).
[25] Ibid., pp. 197–204.
[26] Richard Bulliet, *The Camel and the Wheel* (Cambridge: Harvard University Press, 1975).

tax advantages, and the cost of gasoline was kept low; in those years nothing comparable was provided the railroads.[27] That these contextual supports are often the results, as much as the causes, of success leads to the third point, that amplifiers of our abilities to do things inevitably alter the very nature of the things we do. (It will be important to remember this in Chapter IX, considering issues of photographic art.) As Ursula Franklin remarks, "One has to keep in mind how much the technology of doing something defines the activity itself, and, by doing so, precludes the emergence of other ways of doing 'it,' whatever 'it' might be."[28] For example, once trucking and its road systems are well established, other forms cannot compete because warehouses and stores have been organized around the road system. This leads to another general issue out of the technology-as-amplifier principle: the redefined actions that successful technologies promote may not even be ones we would have originally wished to perform—not counting their often unpredicted and incalculable side effects. The things they do rather poorly soon seem hardly worth doing at all. As in our individual lives, so in our societies, the path "forward" is often made by forgetting quite what we are about.

We can now test some general technological points on photography as a kind of technology. Criticisms of photography often claim that its standard for pictorial accuracy or realism is entirely relative, dependent upon cultural factors, and this point is often the beginning of discourses on photography and "truth" or "reality." Although Chapters VII and VIII deal with this topic at length, here our technological observations should at least put us in position to make the general point more clearly than is usual. Photography comprises an extremely successful set of technologies, partly because (in time) it has come to perform certain preexisting tasks very well. In so doing, it has, naturally, somewhat changed the nature of the tasks and therefore set somewhat new standards for their success. How different are the tasks, and what are the standards? The standards are essentially those listed by the earliest proponents. To cite Arago and Talbot, they include extreme resolution of detail, gradation of texture and shade and light, seemingly nonselective capturing of incident, thoroughgoing perspective (all topics treated at length in subsequent chapters). As for the tasks, they are not so radically different as many claim. The investigations into them should be made in terms of the histories of these technologies—rather like the histories of water mills or

[27] Part of this argument is made in Franklin, *Real World of Technology*, pp. 69, 97.
[28] Ibid., p. 17.

steam engines—free of fashionable epistemological and metaphysical con-
jectures about truth.

Physical Amplifiers and Filters

Although it is a literal, not a metaphorical idea, the guiding principle of
technologies as amplifiers of our powers to do things derives from the idea
of *physical* amplifiers. It is important to keep these two kinds of idea distinct.
Our photochemical account of photography has made, and will continue to
make, much of its origins in a kind of *materials engineering:* a succession of
discoveries, particularly during the first half of the nineteenth century, of the
extraordinary amplifying power of silver salts on the effects upon surfaces of
short wavelength light (this includes Talbot's discovery of "development" of
the latent image). Thereby, these technologies have enormously amplified
our mark-making capacities. Here we have an amplification of our *powers* to
act which is based upon a *physical* amplification of the effects of light on sur-
faces. But we must bear in mind the seeming paradox that just as often, our
powers to do things are amplified by physical *filters* or *suppressors.*

To begin with rather domestic examples, air, oil, and coffee filters, screens,
grates, colanders, sieves, strainers, sifters, and glass jars and windows are fa-
miliar filters that save effort and allow us to do things more easily, or at all.
Static container technologies—an important branch of the technological
family which Lewis Mumford said we tend to overlook in our interest in "dy-
namic" technologies[29]—frequently include filters, whose materials, like our
own skins, are selectively permeable with regard to material and direction of
flow. Barbed wire, deployed in the American West during the 1870s, greatly
increased farmers' abilities to keep grazing animals off their crop lands, while
occupying a minimum amount of the land themselves, and letting air and
sunlight through freely.[30] Our own clothes are examples of complex physi-
cal filter/amplifier systems that extend various of our powers. They serve as
permeable barriers between our bodies and their immediate environments.
They are also selective perceptual barriers—reciprocally. The shod foot feels
less of the ground; the clothed body and limbs feel less of the sun, air, and
objects that the person moves against. From the outside, clothing shields

[29] Mumford, "Technics and the Nature of Man," pp. 77–85, 368.
[30] Basalla, *Evolution of Technology,* pp. 49–55; Henry D. and Frances T. McCallum, *The Wire That Fenced the West* (Norman: University of Oklahoma Press, 1965).

much of the body surface from direct visual and touch perception, while organizing visual perception of its arrangement and motion. The difference in appearance between bodies clad in continuous flowing garments and those in discontinuous belted segments is an obvious example. Even the brim of a hat or bill of a cap not only blocks direct skylight but makes the head motions of the wearer more visible. In thus selectively filtering and amplifying perception of bodily states and motions, clothing has always constituted (to return to the discussion in Chapter II) a central *display technology.* The most familiar uses of photography are also as display technologies.

Such everyday examples suggest how amplification is typically attended by suppression or filtering, and it would be easy to supply many more. Often, in fact, physical amplification not only is accompanied by but *entails* suppression—and vice versa: decreasing the theater population of people who have not paid for their seats is necessary to increasing the number of people who have. In technology as in biology, most pumps are equipped with filters. Herschel discovered a highly relevant example of suppression/amplification in 1839, called "the Herschel effect," when he noted that not only were the silver salts more sensitive to short waves than to long but that the presence of the long wavelength *red* light actually inhibits the action of the very short violet.[31] Therefore, amplification of the silver response to violet, necessary to accelerate the early, very slow, photoreceptors, entailed active filtering of the red. Optical lenses were then converted to be what were termed "chemical lenses" as well. (By contrast, modern lenses dealing with faster films need, like our own eyes, optical filters that suppress rather than enhance the short light report.) Many other examples of linked amplification and suppression can be generated simply by considering magnitudes linked by inverse functions, as in the theater ticket control. An example basic to photographic exposure is length of time of flow (exposure length) and rate of flow (controlled, for instance, by aperture size), where the objective is a constant; this applies just as well to filling a sink with tap water.

Technologies as Suppressors

The common coexistence, indeed mutual implication, of *physical* amplification and suppression provides a strong clue for our technological ap-

[31] See Schaaf, "Herschel, Talbot and Photography," p. 191.

proach. If technologies are amplifiers of certain of our powers, they are like-
ly going to be also suppressors or filters of others. And, as with physical fil-
ters, these two situations may often entail each other. A priori, the case for
the analogy is strong for at least two reasons.

First, when powers in a given domain are selectively amplified, the rest
may thereby be left behind, effectively suppressed, as a purely comparative
matter. Second, as in examples given above, the adoption of a new technol-
ogy will often, though not invariably, suppress its competitors and thereby
the specific powers they had offered. This is what graphic artists immediate-
ly feared in 1839, that their skills and activities would be less in demand. The
building of railroads in Britain and the United States suppressed the use of
canal and other water transport technologies (though that constituted a sup-
pression of *powers* to do things only insofar as the powers of the two systems
can be shown to be significantly different powers). A new, successful tech-
nology may tend to redefine the nature of what we do when using it, but this
is a matter of degree and requires case-by-case examination—typically a very
interesting exercise. Just as American highways did unto railways what the
latter had done unto waterways, personal computers did unto the electric
typewriter what the latter had done unto the manual, and these sets of cas-
es may certainly be compared as to how they allow us to do the *same* actions.
For musical recording, compact disk technology (with the collusion of mer-
chants) suppressed further development of the existing mechanical contact
systems, whereas the video camera did *not* have such an effect on the tradi-
tional photochemical system—partly owing to the latter's extraordinary
physical amplifying powers, emphasized in these pages.

Straightforward technological examples in which the amplification of one
power clearly involves the suppression of another—in either of the two ways
mentioned—abound in what Talbot called "obtaining motive power." It is
typical that as motive power is increased, associated perceptual feedback
powers are suppressed, according to the relevant comparison principle. Rel-
ative to hand tools, we have to be more careful with power tools, which at
the same time make being careful more difficult, partly because they do their
work so fast. But there are other causes. For example, it is natural for people
to lift and carry loads. A modern forklift greatly amplifies our powers to lift
and carry and thus greatly amplifies our powers to do all the things that re-
quire moving fairly heavy loads of certain kinds of materials. It does so, how-
ever, at the expense of sensitivity to several dimensions of the load, including

its density and its shear against the carrying surface.[32] The result can be a dangerous gap between two interdependent areas of our powers. Our normal response to such a gap is to extend our perceptual technology as well— relevant consideration for this inquiry, since it has been a primary reason for the rapid development of *imaging technologies,* including the photographic. "Increased motive power" with resultant decreased sensitivity does not always lead to compensatory efforts, however, and there are both benign and tragic instances where the discrepancy is intentional. An everyday example of desirable suppression appears with the development of steam and internal combustion methods of locomotion.[33] High rates of speed on rough tracks without springs or pneumatic tires proves unendurable for people and their goods, so the tire that increases our road speed is also designed to filter out of perception small variations in the road surface; this, in turn, can lead to new hazards, and automatic feedback engineering attempts to deal with some of these. Sinister examples of desensitization attendant on large increases in motive power fall under the heading "the morality of altitude." High-altitude bombing and long-range missile use are only recent examples of how extreme increases in our powers to do violence entail desensitizing us to the effects of the violence we do. The imaging technology for the rocket strikes against Iraq during the 1991 Gulf War were much discussed at the time for the kind of perception they amplified and the kind they suppressed, especially where this technology was relayed through popular TV.

Much could be said about technology simply as an investigation of the power amplification/suppression phenomenon. Much *needs* to be said—perhaps under the title "At No Additional Cost to You"—given that promoters of new technologies rarely want to admit that there *is* another side to every ledger. If the foregoing discussion of cases has been successful, it should appear to have produced truisms or at least points already well stated, often in the distant past. Indeed, one of the oldest and most famous extended examinations of technology in this way is in the works of Plato, whose many discussions of technology—particularly of the new public speaking technologies called "rhetoric"—make a number of the points set forth here. New rhetorical techniques have powerful effects on people, but unlike philosophy they lack both feedback and user control. Their success displaces the very

[32] This example is due to Clifford Hooker (see note 22).

[33] See Lynn White Jr., "The Origins of the Coach" (1970), in White, *Medieval Religion and Technology,* esp. p. 205.

purposes of public address and the motives of their users in their own direction, making other modes seem inefficient in the new context they establish. They amplify powers of securing immediate motivation to action at the price of suppressing powers for the shared critical assessment of evidence necessary to policy formation, powers that people tend to forget they are sacrificing.[34] Similar points about modern rhetorical devices are made today by cultural critics of the so-called information media, to which photo processes are basic.

As for photography and display marking generally, a general point should, a priori, position us to understand a basic cultural phenomenon of photographic processes. If photography is technology, and if that technology is amplification of our powers through display marking, and if where there is such amplification we should expect *suppression* of related powers, we should expect that the use of photographic technologies will suppress some of our important abilities to do things. We should therefore not be surprised when media and culture critics produce some of these and collateral effects to remind us that we are, willy-nilly, giving up powers that may be valuable. This in itself provides no criticism, since according to our general principles such is the effect of *any* successful technology, not only recently advanced ones. It is equally the effect of our first "technologies": our body systems. As a relevant example, note that the corneal yellow of the human eye cuts out very short violet (ultraviolet) rays, allowing us better general focus, while depriving us of vision we would otherwise have into UV.

Many good general perceptions about technologies have been made in recent decades, by many writers. It would be useful to make a compendium of these, then to see how enlightening they might be when translated to the specifics of photography. For our purposes, however, perhaps the few that we have stated and applied will suffice. It is important at the outset to keep the presentation of technology as *un*technical as we can. With these simple technological observations as guides, the next two chapters examine more closely the *kinds* of powers that photo-imaging technologies typically increase, and what kinds they tend to suppress—given that we are thinking about photography generally in terms of technologies of surface marking.

[34] Plato's concern about the harmful uses of the *technai* of rhetoric, perhaps most famously shown in *Gorgias,* is a central focus of his early period. Plato's similar worries about the *technai* of philosophy may be better recognized in, e.g., *Charmides* and *Republic* 6–7. Book 6 includes a striking passage on the dangers even of the cardinal virtues, understood as *technai,* if badly guided.

ぞ

Imagining Technology

Amplified Imagining

To understand photographic technologies in terms of enhancers of our imagining or visualizing activities, it would be useful first to consider imagining itself as an activity, a thing we do, and the whole issue of its technological extendability. Such a discussion surely would have to include at least an outline of pictorial *depiction* as a general branch of imagining technologies. That accomplished, we should be in position to make a general account of photographic depiction, an account that might begin to dispel standard puzzles about photographic images.

It seems odd to have to argue not only that technologies of imagining exist but that, economically and politically, these have become some of the most important technologies of modern times. A priori, their existence and importance would seem obvious. People not only imagine; they imagine quite a lot. They spend a great deal of their time from early childhood onward imagining, even though the objects, shapes, and—notably for us—the tools or means of their imagining change. Quite a lot of our imagining is dreaming, including daydreaming, but much imagining comes as no such interruption in the course of our daily activities. Kinds of imagining, after all, are frequent constituents of perceiving, remembering, thinking. Often, imagining is a crucial practical skill, and from time to time we all fall into serious difficulties for want of imagining, or vividly imagining, certain like-

ly consequences, some more catastrophic than others. As the poet Ted Hughes remarks, we know that imagination "can vary enormously from one person to the next, and from almost non-existent upwards. Of a person who simply cannot think what will happen if he does such and such a thing, we say he has no imagination. . . . We all know such people, and we all recognize that they are dangerous. . . . Imagination which is both accurate and strong," Hughes continues, "is so rare, that when somebody appears in possession of it they are regarded as something more than human. . . . Normally, it occurs patchily."[1] Whether as an interruption of or adjunct to other activities, much of the imagining we do is imagining *about* what else we are doing at the same time. Indeed, this is one of the ways we have of imagining about our favorite subjects: ourselves and our doings.

Given that people are so much involved in activities of imagining, so involved in what Richard Wollheim has termed "imaginative projects,"[2] often very elaborate ones, it is obvious that *technologies* for doing this would have evolved, just as technologies evolve to help us do everything else. As railroads and then automobiles and airplanes changed our ways of going from place to place and the places to which we go, and as writing changed our ways of recording ideas and the kinds and uses of our ideas, so, from society to society, we should expect imagining technologies not only to have extended but to have shaped our imaginings, their uses and effects. Much of the activity of the people we call artists consists in inventing and sustaining involved and vivid imaginings. When we read novels, see films and other dramas, or simply look at pictures, we are engaging in projects of imagining prepared for us by such specialists. Wanting to imagine, we go to specialists to help us do so. In industrial societies, imagining technologies will evolve imagining *industries,* which is exactly what has happened and what we continue to see happening. In modern times, photographic technology plays a leading role in all that.

[1] Ted Hughes, "Myth and Education" (1976), in Hughes, *Winter Pollen: Occasional Prose* (London: Faber & Faber, 1994), pp. 142–43. A. C. Bradley once held that the usual cases where one is thoughtless, unkind, cruel—even criminal—are due not so much to hard-heartedness as to a failure to imagine; see Bradley, *The Study of Poetry: A Lecture* (Liverpool, 1884), p. 16.

[2] Richard Wollheim, "Imagination and Identification," in Wollheim, *On Art and the Mind* (Cambridge: Harvard University Press, 1974), pp. 74, 78–79. Wollheim's examples are of deep psychological projects (such as Leonardo's alleged identification with his mother). The term, as used liberally throughout the rest of this book, centers on more observable activities but by no means rules out the hidden ones.

According to our philosophy, what this means is that people will have devised various *amplifiers* for their imagining powers—and thereby also will have put *filters* upon them. Merely as technologies, imagining technologies—including photographic ones—would tend to amplify and to suppress our powers to imagine certain sorts of things and situations. They would therefore channel not only *what* we imagine but also *how* we imagine, where "how we imagine" signifies both how the things we imagine are imagined to be and also the means by which we imagine them. This follows from their being technologies. Add another premise, that people's mental states and conceptions are influenced by what they imagine, by what they imagine vividly or repeatedly, and we may deduce from our principles the objects of many pages of what is called cultural and, especially, media criticism and we place it in philosophical perspective. Thus the a priori argument. A posteriori, the same was well expressed by *Vanity Fair* magazine's comment on the announcement by Steven Spielberg and a former Disney head of plans to open a major independent movie studio: "'We want to be the owners of our own dreams,' said Spielberg. Why not?" asked the magazine, "They already own ours."[3]

Given such simple and obvious-seeming points, the question arises why there has never been a sustained study of imagining technologies as such. People produce, transport, trade, and prepare food; therefore, they have technologies for doing such things, and these are well recognized and much studied. The same is true of many of our most characteristic activities, including not only physical ones such as lifting and moving objects, and biological ones such as birth production and control, but also cognitive ones such as gathering and storing information and making it available. The neglect of imagining technologies is probably not so much the fault of students of technology as it is of our conception of the activity of imagining itself. Having in the first place failed adequately to mark out a large sector of human activity, we are in no position to consider what technologies might amplify it. Why we have failed to do this makes a complex story, which it is no part of this project to research. A few general remarks must suffice before we turn to the positive job of doing what has not been done, as opposed to speculating about its neglect.

[3] *Vanity Fair,* December 1994. Spielberg's project with Jeffrey Katzenberg and David Geffen is called "DreamWorks." The blurb began with the comment, "Yeltsin rules only a former superpower; their turf is a superpower culture."

Although an alleged "faculty" of imagination was long identified in Western psychology, in close connection with a faculty of sense perception, it was mistakenly associated with a kind of *thing*, mental images. With the rejection of mental "faculty" psychology, imagining lost its status while retaining its spurious association with mental *images*, which in turn fell from favor in cognitive research. It is arguable that just before this time the study of imagining technologies, as such, had almost begun but then suffered an unrecognized though well-known destruction. After all, the late eighteenth-century *Encyclopédie* of Denis Diderot included two influential presentations: of the new industrial technologies as an important branch of human knowledge, and of what were only then coming to be called "the fine arts" as productive arts linked to that faculty of imagination.[4] Any hope of understanding those arts in terms of the amplification of imagining powers, however, appears to have been dashed by reactions to the industrial technologies of the two following centuries. These, both among theoreticians and in the popular mind, redefined the fine arts precisely by contrast with industrial technologies (quaintly associated with our "needs") and set up imagination as the very antithesis of such production.[5]

This is hardly the time to turn back to "faculty" psychology. We would do well to put aside these historical associations and begin again from our own experience. To present some general ideas about imagining, then about technologies for doing so, this chapter starts some distance away from photography or any form of visual imaging and proceeds with as few theoretical presuppositions as possible. By reflecting on familiar examples from everyday experience and other imagining "media," it approaches photography in a series of steps.

It turns out that we already have a great deal of knowledge about imagining and that for our purposes we need simply to recollect it, to draw it together into something only loosely systematic, staying clear of a number of alleged theories that have obscured our everyday knowledge. Now the easi-

[4] On the *Encyclopédie*'s contribution to the idea of the fine arts, see Paul Kristeller, "The Modern System of the Arts," *Journal of the History of Ideas* 12, no. 4 (1951): 496–527, and 13, no. 1 (1952): 17–46; rpt. in Kristeller, *Renaissance Thought and the Arts* (Princeton: Princeton University Press), pp. 163–237. For further comment on the distinction between "necessities" and the fine arts, see Maynard, introduction to the special issue "Perspectives on the Arts and Technology" of *Journal of Aesthetics and Art Criticism* 55 (Spring 1997): 95–106.

[5] For one account of this, see Raymond Williams, *Culture and Society, 1780–1950* (New York: Harper & Row, 1966), chap. 1.

est things to recollect are things that stick in one's mind, and what could be a better case of that than words from popular songs?

Just My Imagination

Introducing this book with a sample of technological innovations beginning in the late 1970s, at a time when microchip manufacture was first providing fully automatic control for popular cameras, was one way of reminding ourselves how photographic technologies have become a formative part of modern popular culture. Let us consider, say, 1971 (the year that Asahi brought out the first SLR linking an electronic shutter with automatic exposure) and remind ourselves of two popular songs that rather bracketed it: a springtime hit by the Temptations, "Just My Imagination," and a fall number by John Lennon, "Imagine"—both in the top ten for nine weeks—whose common topic is imagining. As my permissions budget allows printing the lyrics of only one of these songs, and as the Lennon is well known, let us draw upon our memory of it and quote only the Temptations' song.

Just My Imagination (Running Away with Me)

The Temptations

Each day through my window I watch her as she passes by.
I say to myself, "You're such a lucky guy.
To have a girl like her is truly a dream come true.
Out of all the fellows in the world, she belongs to you."
But it was just my imagination, running away with me,
It was just my imagination running away with me.
Soon, soon we'll be married and raise a family;
A cozy little home out in the country with two children, maybe three.
I tell you . . . this couldn't be a dream, for to me it all seems
But it was just my imagination, once again, running away with me;
Tell me it was just my imagination running away with me.
Every night on my knees I pray, "Dear Lord, hear my plea:
Don't ever let another take her love from me, or I would surely die."
Her love is heavenly; when her arms enfold me, I hear a tender rhapsody—
But in reality, she doesn't even know me.

Just my imagination, once again, running away with me;
Tell me it was just my imagination running away with me.
I'll never, never, but I can't forget her,
Just my imagination, running away with me

There are enough data here to supply most of the terms, distinctions, and clarifications we need. As quick confirmation, note that the two full-blown and easily recognizable instances of imagining both represent it as an activity, something that we *do,* but neither is based upon or even makes reference to such "things" as mental *images.* We may congratulate ourselves on having already escaped volumes of contentious theorizing. Rather than reading, for example, Sartre's two books on imagination, we can learn more about our topic by consulting this "college of musical knowledge." Before looking closely into these cases we might test how fair they are as samples, how typical of popular songs in English during the latter twentieth century, when broadcast and recording technologies (considered earlier in connection with photography) carried them to mass audiences.

Given the content of most such ballads, it is not surprising that a significant fraction of them explicitly *report* acts of imagining, often in day or night dreams. For example, the popular ballad that is claimed to have "sold more copies of sheet music and records combined (in whatever vocal and instrumental version in whatever language) than any other musical composition ever,"[6] Irving Berlin's "White Christmas," entirely consists in just such a report. Moreover, it explicitly *names* that act of imagining, as do the Temptations' song and others—"I'll Buy that Dream," "I See Your Face Before Me," perhaps "I Hear Music"—in a line leading back to Stephen Foster's nineteenth-century "Jeannie with the Light Brown Hair." We can extend this species further by including songs that consist in acts of imagining without explicitly naming them: "Over the Rainbow," "My Boy Bill," very likely "The Man I Love," and "Some Enchanted Evening" all sustain more or less complex imagining projects, although they do not *say* that is what they do.

The Lennon song, however, is of a radically different kind. It is not a report of an imagining event but rather in title and in verse an imperative prescription *to* imagine: "Imagine there's," "Imagine all," "Imagine no." It might be classed with songs like "Tea for Two" ("Picture you . . . "), "Dream (When

[6] Gerald Mast, *Can't Help Singin': The American Musical on Stage and Screen* (Woodstock, N.Y.: Overlook, 1987), p. 39.

You're Feeling Blue)," "Sweet Dreams," and (if, as seems reasonable, we count *make-believe* as imagining) "Make Believe."

Some popular songs do not demand or even report so much as *describe or invite* imagining projects: "Laura," "Paper Doll," "Standing on the Corner," "Dream," "All I Have to Do Is Dream," "Mr. Sandman." Others feature, in any of the ways just noted, acts of imagining and dreaming while not entirely *consisting* in them. The standard "Irene, Good Night" is an example. We may also recall single lines such as "some day soon I'm gonna tell the moon about the crying game" (preceded by "Secret Love" telling a "friendly star" as "dreamers often do," like Dion and the Belmonts' "Teenager in Love").

So far we have brought to recollection only popular songs whose lyrics are concerned with acts of imagining, just as we might consider songs having to do with, say, *remembering;* readers could supply many more examples of each. Yet important as these types are, they still constitute a minority. After all, such standards as "Melancholy Baby," "Night and Day," and some of the most successful postwar popular songs such as "Rock around the Clock" and "The Twist" are not *about* imagining, in any of the ways listed.[7] Do these, then, mark the limits of imagining data to be drawn from modern pop songs, and should we draw all our data from the earlier group? Hardly, for although the songs just listed do not mention or even represent imagining, their function is nevertheless to *produce* imagining. Because most appeal to the listeners' imaginings, their performances, if at all successful, elicit at least *our* imagining that we are hearing the utterances of speakers. Most singers are actors. We hear the singer sing and imagine hearing someone (who may or may not be imagined to be the singer) express a state of mind. Often, of course, it is we who are the singers. It is not surprising that most popular songs of the genre are of this sort: they are, after all, what we would call, correctly if not colloquially, *representations,* just as pictures are.

To see what that means, consider again the 1971 examples. An obvious contrast between them is that the hit of April is a love song; that of November is not—yet both present what I have been calling imaginative projects. The Temptations song is a musical representation of such a project—a private one—whereas the Lennon song, as already observed, is an imperative to engage in such a project. To whom is this imperative directed? It seems rea-

[7] Sources: Joel Whitburn, *Billboard's Top 1000, 1955–1978* (Menomonee Falls, Wis.: Record Research, n.d. [c. 1984]); Steward Goldstein and Alan Jacobson, *Oldies but Goodies: The Rock 'n' Roll Years* (New York: Mason/Charter, 1977).

sonable to suppose with Kendall Walton that it is directed to all who hear it, and that it *mandates* for them—that is, for us—an act of imagining.[8]

As for the more usual kind of song in the Temptations example, we see now that it has to do with *two* acts of imagining, at two levels: the one it represents (the boy's), and the one it elicits (our own). Our imagining act is, in fact, *about* the boy's. Should we say that it, too, mandates or *prescribes* a quite particular imagining, although not in the categorical, imperative manner of the Lennon "Imagine?" Perhaps one can consider this song a mandate or prescription to imagine overhearing a young man's mental and psychological processes. To distinguish it from the Lennon, we would have to say that this happens *conditionally*, as opposed to *categorically*.[9] After all, nobody actually tells us what to imagine on hearing it, yet given the conditions provided by the song, together with our background for listening to such songs, we certainly do imagine; furthermore, for all the theoretical talk one hears about relativity of response, we usually do so appropriately, in accordance with the song and in wide agreement with one another. The Temptations entice so well that most of the time we cannot help but imagine in accord as we listen, even though nothing in the lyrics actually instructs us to do so. This is just as well. Conditional prescription is in fact the normal method and far more effective than the categorical one. People may enjoy hearing the latter without engaging in the project it urges (for to understand something as an imperative is one thing, to follow the imperative quite another), but the conditional directs skill and talent to making its prescription irresistible and the results enjoyable.

Among reports of imagining and prescriptions that we ourselves imagine, songs like "Just My Imagination" are quite efficient for the purposes of investigating ordinary situations of imagining, because, as noted, they provide imagining data at two levels. This double-data aspect can be confusing to think about, yet it is important that we see it as the everyday stuff of imagining guided by the arts. Such works prescribe *our* imagining, and, as it turns out, what we imagine is someone *else's* imagining. We not only imagine *that* they imagine; we imagine their imagining it. Typically, this imagined imaginer's and our own imagining projects will be rather different, though his or

[8] Kendall Walton, *Mimesis as Make-Believe* (Cambridge: Harvard University Press, 1990), pp. 35–43. As subsequent footnotes make clear, this chapter is largely exposition of parts of Walton's theory of representation.

[9] Ibid., pp. 39–41.

hers will be embedded in ours. Songs have us imagining people doing all sorts of things, love songs a well-known category of things. One begins, "What's playing at the Roxy? What's happening all over?" and the answer— from the Polyphemus of Theocritus, through Dante's *Vita nuova,* on through "The Girl from Ipanema"—is frequently the same: yearning. Eros, as Plato instructs, is a kind of lack, and people who yearn are given to *imagining* what they yearn for. Popular songs have us imagining all sorts of things about people, and since imagining is something people so commonly do, it is not at all surprising that many popular songs would entice us to imagine people in the act of imagining. Although "imagine" does not actually occur in many song titles, that term (and cognates like "dream," "pretend," and so on) figure frequently in their lyrics. Our own imagining about represented imagining provides a kind of nested imagining, and such nestings can be multiple. A popular song of the 1940s, for example, began with the categorical "Imagine you imagining that you love me," and when we hear that, we imagine (though not vividly) someone proposing it.

Let us go back to considering imagining as a *subject* of popular works of art but somewhat broaden our artistic media. Although represented imaginings in modern songs are often driven by romantic love, this is by no means always the case; the imaginative projects of many are not particularly amorous. In considering this point, we can enlarge our study to include musical theater, motion pictures, and dance: "visual" media that will move our treatment in the direction of pictorial representation and photography. A standard premise of many plays and movies is that perhaps, as in the 1939 movie version of *The Wizard of Oz,* the whole thing was a dream—or even, as in the film *Amadeus,* the product of a disturbed mind. Presenting a situation as itself imagined is a standard way of getting by with rather fantastic imaginings. The expensive ballet at the end of the film *American in Paris* is an amorous fantasy in which we imagine the protagonist entering into French paintings by Lautrec, Dufy, and others. But of three imagined sequences (one foreboding dream and two envisionings) in the stage and film productions of *Oklahoma!* the first ("Surrey with a Fringe on Top") is amorous, whereas another ("Poor Jud Is Dead") clearly is not.

These last two songs bring out an important feature of imagining that we have not mentioned so far. Both of these, like the Lennon but unlike the Temptations song, are intentional, guided, *collaborative* imaginative projects of more than one person, projects that would otherwise not be carried out.

In representations as in life, envisaging imagining, even daydreaming, need not be, and frequently is not, solitary.[10] This is a most important point to be kept in mind, especially when we go on to consider pictorial depictions. It is true of the "Greased Lightning" and "Look at Me (I'm Sandra Dee)" songs from *Grease*. The long "Gotta Dance" ballet in *Singin' in the Rain* features a solitary daydream, but one represented as part of a production representation (which the producer fails to grasp). Here we have *double* embedding, as we have with Jerome Robbins's "Small House of Uncle Thomas" dance in *The King and I* and in so many ballet divertissements. Such devices are common and perfectly familiar. We need to remember from the outset that there is nothing tricky, modern, or sophisticated about imaginings that are *about* imaginings, not even where the latter are about *other* imaginings. We will see how pervasive they are.

We noted that one kind of embedded or nested imagining situation provides us with two levels of data about imagining. So far, we have considered our own acts of imagining, and we have considered represented acts of imagining. We have made the simple observation that the latter may well be, very typically are, the topic of the former. With regard to our own, the audience's, imagining, we earlier considered "Just My Imagination" in two typical ways: in terms of *conditional* imagining, cross-classified in terms of *embedded* kinds. Let us continue for a while to set to one side questions of the imagining that the song evokes in *us* and focus instead on the imagining that it *represents,* further to remind ourselves what imagining is like. Once again we can see how rich such everyday cases are for a basic understanding of imagining. In the Temptations song the represented act of imagining is solitary, but as other examples have shown, imaginative projects can be cooperative.

Another important feature of this case may now be brought forward: the yearning, hence the imagining, is here represented as brought on, *caused,* or triggered in a certain way. Now strictly speaking, causes are events or situations: here the boy's longing and the girl's passing by (again, as with Beatrice in the fourth chapter of Dante's *Vita nuova*—from which issued a visionary dream[11]—or the girl from Ipanema). Loosely speaking, however, we can say

<hr>

[10] Ibid., pp. 18–19.

[11] "I returned to the loneliness of my room and began thinking of this most gracious lady. In my reverie a sweet sleep seized me, and a marvelous vision appeared to me. I seemed to see a cloud the color of fire in my room and in that cloud a lordly man, frightening to behold, yet apparently marvelously filled with joy": Dante, *La vita nuova,* trans. Mark Musa (Bloomington: Indiana University Press, 1962), pp. 46–5.

that the girl was the cause. Here is an interesting connection: the *objects* of his imagining and yearning—the things about which the fellow imagines—may include the very causes or *prompters* of his imagining.[12] The girl is an object of imagining, as is the boy himself, and both are causes of it too; more correctly, their situations are. Now it is an important feature of imagining that sometimes these causes and objects will *coincide* and sometimes not. We need to consider such causes a bit more closely in order to turn the discussion toward a general treatment of *technologies* for imagining. This will involve once again thinking about ourselves as imaginers, not just about the people represented in the works.

Imagining Technologies and the Arts

In the Temptations song a striking and important difference between our imagining and the boy's is that although both are caused, ours is mandated and controlled by the very causes that incite it. The song (including its recording production) comes to us as a crafted artifact, made with just that *function.* The song is what we would normally call a representation or a depiction. What set *him* off, however, is no such thing—not even if we consider the girl's walk to be crafted. Such artifacts are familiar in all human societies in the forms of pictures, stories told or written, dances, and—as here—songs. With a bit of background in any society in which we live, we usually know without thinking what sort of imagining these artifacts prescribe. In this case, for instance, we are to imagine that the poor fellow is in love, although he never actually says so. In our imagining we avail ourselves of an imagining technology—in fact, a family of them—for which we pay. The imagined fellow, by contrast, is represented as needing no technological assistance in carrying out his elaborate imagining project. He relies, as we all so often do in real life, on private resources. That is not to say that even our private projects are not heavily influenced by the imagining technologies of our societies; of course they are, and that is often justifiable cause for concern. In the modern world we have enormous industries of imagining. For example, we would not be imagining anything about the boy's act of imagining had we not heard that song, whose production and presentation

[12] Walton, *Mimesis,* pp. 21–28. Relations of objects and prompters may themselves be themes of works of art: "Last night I dreamt I went to Manderley again."

to our senses via tape or disk depend on modern electronic engineering, which is part of the vast industry of imagining that constitutes much of the television, movie, book, and music production and distribution industries. (For example, as I was writing this, the largest recording company, the Warner Music Group, was valued at $5.4 billion, and Disney had bought ABC for $19 billion.) All this is well known. We merely have to put it in the proper perspective, which, strangely, it seems never to receive.

Auto, rail, and air travel have not kept us from walking, running, or horseback riding. Of course, we continue still to imagine (generically) as our imaginer does, awake and asleep, and sometimes quite satisfactorily so. The question arises, why all this imagining and why the appetite for its technological extension? A common answer is "escape," but that seems an exaggeration. "Imagination is funny, it makes a cloudy day sunny," begins a standard of 1940. We should not need to be reminded that, waking and sleeping, imagining typically incorporates real objects—notably, as in the dream, ourselves and our own states—and not only what are usually called "imaginary objects" (that is, nonobjects). We nevertheless do tend, as with the dream, to associate imagining with unreal *situations,* even as they pertain to real things—again, for example, to ourselves. Robert Louis Stevenson remembered "the time when to call [leftover mutton] red venison, and tell myself a hunter's story, would have made it more palatable than the best of sauces."[13] The fellow in the Temptations song imagined, then had to admit that "in reality" things were rather different from what he imagined. That is the "running away" part. Lennon asked us to imagine the world in a different, better state as an inducement to begin making it so, though the subsequent decades confirm Shelley's remark that "we want the creative faculty to imagine that which we know; we want the generous impulse to act that which we imagine."[14] Days may be imagined to be sunny when not; what, one might wonder, would be the point of imagining not only things that are but also things *as* they are or, at least, as we think they are?

This chapter's opening remark from Ted Hughes said generally why, and a moment's thought should provide plenty of examples. It is frequently quite important to us to imagine not only according to fantasy but also according to fact, to imagine things correctly, just as "in reality." It is important to be able to imagine how something is, was, will be—also how it is likely to be or

[13] R. L. Stevenson, "Child's Play," in Stevenson, *Virginibus Puerisque and Other Papers* (London: Chatto & Windus, 1911), p. 153.

[14] Percy Bysshe Shelley, *A Defence of Poetry* (1821, 1840).

counterfactually would have been, *if*. Much of Ignatius Loyola's *Spiritual Exercises* concerns the practice of vividly imagining important situations, including the flames of hell. Many readers will recall how the Loyola-like heroine of that popular hit of October 1847 (just as Talbot was struggling for a wider market) *Jane Eyre*, in chapter 16, used her drawing abilities to depict first her own plain visage and then "the loveliest face you can imagine," so that by looking at the two in contrast she could use "force and fixedness" to stop her imagination from running away with her regarding Rochester's interest—given her inclinations, reported in an earlier chapter, for imagining projects about all she "desired and had not in my actual existence." Less romantically, some people have to move the piano to another room to see how it looks; others are saved the trouble (unless they live with the former) because they can accurately imagine how bad that would be. As Hughes remarked, people often get into trouble because they do not imagine with sufficient accuracy, honesty, or vividness. Much imaginative literature shows how imaginative types get into trouble by letting their imaginations run away with them. But despite the currency of the phrase, "it wouldn't take much imagination to see . . . ," probably rather less of that literature shows how people get into trouble by imaginative dysfunction. One way (metaphorically) to make a cloudy day sunny is by imagining some people or things as they are somewhere, maybe in a sunny place. When we say that we like to imagine what someone is likely doing or saying just about now, or what the expression on a person's face was, we are wishing to imagine "in reality," not simply to fantasize about a real object. The phrase "it is (or is not) as I imagined" has wide use and much point, and it often does refer to acts of imagining, not just of expectation. Again, as we all know, imagining or envisioning a situation is often a necessary motivating factor in trying to bring it about: we visualize. Many graphic technologies, including photographic ones, work to help us imagine things relevantly and correctly to these ends.

If, following our philosophy, imagining technologies amplify (also filter) our imagining powers, we must surely note another kind of power: the power to incite *others* to imagine. Some people have such powers, others lack them. Since the mere imagining of situations can strongly affect human conception, desire, and behavior, those powers lead to wider ones, now much amplified by technologies. Earlier we noticed that imaginative projects are often cooperative, social rather than solitary. We noticed, too, that artworks that have us imagining people as imagining exemplify *both* kinds. Rodgers and Hammerstein's *Oklahoma!* presents both kinds. Curly sings "Surrey with

a Fringe on Top" to Laurey in order (with the aid of Aunt Eller) to induce her to imagine a situation with him, and does so in order to help bring that very situation about. This is a *group* project: Curly imagines only in order to induce Laurey to do the same. Laurey, for her part (though she will have another song, "Out of My Dream"), could not imagine as she does without Curly's storytelling (and singing) powers. The joint venture ends in a familiar way. The dreamer, released from her enchanter by his mischievous remark "I made the whole thing up out of my head . . . dash-board and all," turns on him angrily with the reproach "Tellin' me lies!" His artistic defense "Don't you wish there was such a rig, though?" is unavailing. As it turns out by story's end, however, their joint vision is not only vividly imagined but also true: as he then remarks, "That there ain't no made-up rig. . . . I done hired it"— and (at least in the film version) the story ends with Curly and Laurey riding in it, as vividly foretold.

Our data have been so rich that we must now try to recall part of what we have recollected from these cases. First, imagining can be cooperative, though possibly led by a chief, even professional, imaginer. Next, people's imaginings typically have themselves as objects. Further, what is imagined may not only be real or *true;* the act of joint imagining can be part of what makes it so. Finally, storytellers like Curly are technicians of imagining. They possess techniques of building and elaborating imaginative projects and of presenting these conditionally—not by fiat—in ways that irresistibly entice others to join in. One needs no theory to recognize such people as what we generally call artists.

The last chapter will look further at art in this way. Whether or not art is imagining technology, imagining technologies are important and deserve our attention. A study of imagining would be deficient if it did not go into imagining's technological developments. Here, as in most regions of activity, understanding the activity involves understanding the related technologies and understanding them *as* technologies—that is, as extenders of the original activities. Yet properly carried out, such a study is bound to be revealing about the arts. The extensional overlap between the arts and their products and imagining technologies is so great that it could hardly be accidental; the intensional case for affinity is also forceful. Since its consolidation in the eighteenth century, the notion of the fine arts has relied heavily on that of arts (in an older sense of productive processes) or technologies of imagining. Much of the answer to the question "What is art?" has been, and

still is, available in just those terms and applies as well to the ideas of the popular arts, of modern art, to much of what government bureaus and news media refer to (somewhat misleadingly) as the arts of "entertainment" or, alternatively, as "communication."

The simple and abiding facts are, first, that people imagine—that this constitutes a kind of activity that they do as they perceive, think, move themselves and other things about—and, second, that as in all these other cases, people have constructed multiple extenders of their abilities to do so. One of the first sets of these technologies is what we familiarly call (in the relevant sense) *representations,* upon which the modern notions of the arts, fine and popular, appear to have been created. Despite continual attacks from various quarters, including from within, the basic idea of the arts has remained viable because these technologies, far from withering away, have continued to develop and indeed to accelerate in succeeding centuries. One of the main reasons why we have been in such a muddle about the arts for so long is that we have never quite grasped or retained these simple ideas or seen their implications—one of which is that if we wish to understand art, we must form a basic understanding of technology. Whether constituting fine arts or not, imagining technologies now make up a large sector of the economies of most industrialized nations, including but extending well outside the "entertainment" industries. Almost every picture (photographic or not), every song, every story, novel, play, or dance is a technological means of inducing (and thereby shaping) imaginings. Throughout this presentation and the rest of this work, my emphasis is upon imagining as an activity people do, like walking, food gathering, considering, socializing, cooking, playing, transporting, finding, riding, washing, and so on. That is the context for human technology: human activities, employing tools or amplifiers of those activities. Most of the things called images in these contexts, whether mental or physical, are tools used in those activities and have their identity as images because of their roles in such activities, just as the identities of shoes, food, rackets, cars, soaps, telephones are due to their roles in given activities.

A Map of Make-Believe

If putting into order what we have recollected from popular music has given us enough of a general theory of imagining, we should be able to confirm

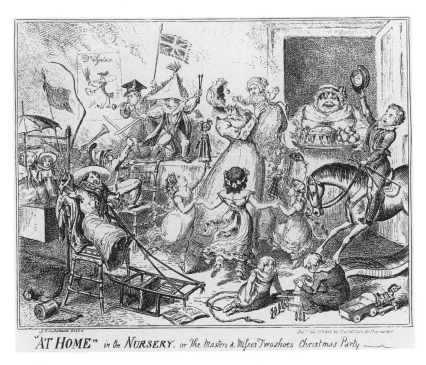

Fig. 5. George Cruikshank, "'At Home' in the Nursery." Source: George Cruikshank,
Cruikshank Prints for Hand Coloring *(nd: New York, Dover Publications, Inc.)*

it by applying the terms, distinctions, and emphases to rather different rep-
resentational media. Moving in the direction of photographically enhanced
imagining, consider a popular *graphic* image that condenses a great deal of
that activity into one lively illustration: "'At Home' in the Nursery" (Figure
5), a popular etching print by George Cruikshank.[15] This was produced in
1835, the year Daguerre made his great photo discovery and Talbot set his
mind to do the same. Cruikshank's lively print makes a claim upon our imag-
ination, especially upon what we imagine seeing, which is different from

[15] Subtitled "The Masters & Misses Twoshoes Christmas Party," "Pubd Augt 1st 1835 by Thos
McLean. 26. Haymarket," from *Cruikshank Prints for Hand Coloring* (New York: Dover, 1978), 18.6
× 24.5 cm. McLean also published the similar work of Cruikshank's contemporary, Seymour Short-
shanks, who, c. 1830, produced a spoof of steam technology called "Locomotion," featuring a cu-
rate "Walking by Steam" boots, two ladies "Riding by Steam" in a kettle fueled by Chinese
"gun-powder" tea, and "Flying by Steam." A "Going by Steam" of another Shortshanks, Robert
(1798–1836), shows an explosion, perhaps by sabatoeurs, of a steam carriage. Steam technology was
for a while treated as a "bubble."

what we *are* seeing. In looking at a marked, inked, surface image on "the field of paper," we are to imagine that we are looking instead at a lively Christmas party from that era. We are therefore once again prescribed to imagine about our own actions. Our own implication in the game is immediate. Just as in the popular songs, we here deal with two levels of imagining: our own imaginings and the imaginative activities of make-believe and play that we imagine seeing. The print prescribes our imagining, but of course we may not follow these prescriptions, and people glancing at it and moving on may not get very far into what it prescribes. Let us go at least a little into it, guided still by Kendall Walton's analysis of imagining situations.

Unlike the musical examples, the print has no dreamers or daydreamers and little of amorous yearning. The reason is clear: it deals with the imagining activities of children, of which the following characteristics are typical. It is the depicted children who are most clearly involved in imagining projects—vigorously so, for they not only imagine situations; they are *physical* actors in them. Therefore, they imagine about themselves, about their own actions, whereas the depicted adults' activities may not be imaginative at all. The children's games—the normal description of their imaginings—are all what we would call games of *make-believe* that use for enhancement physical things and actions: that is, props.[16] Their games, we notice, are more social than solitary, and perhaps number four. Counterclockwise from the upper left, as the composition encourages, there is the military storming of the ramparts, involving four children; then the carriage ride and meeting, with three children, a doll, and a hobbyhorse; next a card castle with two children; finally a sort of Ring-a-Rosie dance of four children with dolls and a baby, using the adult—who may not be imagining at all—as an ad hoc prop. The baby's response to the doll is a good reminder of how early such games get going.

As is frequently true among children, the props in all these entertainments are of two general kinds. Some, such as the rockinghorse, the toy horse and wagon, the toy soldiers, drum, swords, and dolls, were made for that purpose, possibly bought and given as presents by adults. Many others are ad hoc, of the children's devising: the chairs and table, for example, are merely pressed into service as horse, carriage, or rampart. This is a most interesting case of imaginative *transformation,* which most of us can remember well.

16 Walton, *Mimesis,* pp. 11–12, 67.

R. L. Stevenson remarked of childhood, "The things I call to mind seeing most vividly, were not beautiful in themselves, but merely interesting or enviable to me as I thought they might be turned to practical account in play," for when it comes to imagining, the child "works all with lay figures and stage properties."[17] As Doctor Seuss might have remarked, moms are used for make-believe and pops turned into props.

Perhaps this even provides a key to understanding the kinds of imaginings we tend to associate with art. For example, Baudelaire commented on childhood imagining as a path to art:

> All children talk to their toys; the toys become actors in the great drama of life, reduced in size by the *camera obscura* of their little brains. In their games children give evidence of their great capacity for abstraction and their high imaginative power. They play without playthings. . . . But the *diligence* [stage coach]! the eternal drama of the *diligence* played with chairs! the *diligence* itself—a chair; the horses—chairs. . . . The equipage remains immobile—yet with what scorching speed does it devour those fictive spaces! . . .
>
> This ease in gratifying the imagination is evidence of the spirituality of childhood in its artistic conceptions. The toy is the child's earliest initiation to art, or rather . . . the first concrete example of art, and when mature age comes, the perfected examples will not give his mind the same feelings of warmth, nor the same enthusiasms, nor the same sense of conviction.[18]

In this essay praising toys and, above all, children's ad hoc props, and asking if there is not "something here to put to shame the impotent imagination of that blasé public which in the theatre demands a physical and mechanical perfection" (199), Baudelaire neglects to mention a most essential ad hoc prop: the children themselves. Like the dolls and chairs, these "props" too have a double function. Not only do they inspire and prescribe imaginings; they are also the *objects,* indeed the main objects, of those activities of imagining. The gestures of the drummer defending the height, which mandate imagining a sword fight in progress, are themselves the *objects* of that imagining. Both players and we are to imagine of that pose and gesture that it is

[17] Stevenson, "Child's Play," pp. 154, 157. On ad hoc props, see Walton, *Mimesis,* pp. 51–53.
[18] Charles Baudelaire, "A Philosophy of Toys" ("Morale du Joujou," 1853), in Baudelaire, *The Painter of Modern Life and Other Essays,* ed. and trans. Jonathan Mayne (London: Phaidon, 1964), pp. 198–99.

one of heroic defense. If it mandated only that we imagine some soldier doing battle, it would hardly do its job in the game—certainly not for the child. Probably the same is true of the physical sensations and excited feelings of the child, and this is an important aspect of the game.[19] As props in their own games, children are *reflexive* ones, since they mandate imaginings about themselves. Toys are us.

A rough chart in partial summary of our findings from the musical examples as confirmed by the picture may now be made up of dichotomous distinctions regarding the *functions* of real things, the properties of things, events, or situations as props in the games of imagining that we have been considering from popular songs, movies, and pictures.[20] If serviceable, it should apply to a multitude of other practices.

prescribing imagining

categorical prescribing conditional prescribing

external prescribing internal prescribing

(dreams and daydreams)

per function ad hoc

Such props may be reflexive (have themselves as objects of imagining) or nonreflexive. For example, a street photo by Helen Levitt (Figure 6) provides a display marking that is a reflexive prop (though somewhat in need of categorical, verbal prescribing).

We have had examples of each generic and more specific kind, and many more examples for each are easy to find. The two most basic distinctions, between categorical and conditional and (in the conditional) between external and internal prescription, are very important to the nature and complexity of our imagining projects. Having public, physical objects and states of affairs as props greatly enhances the *coordination*, development, and vividness

[19] Walton, *Mimesis*, pp. 209–10.

[20] I stress function because a given thing or state of affairs can have several functions.

Fig. 6. Helen Levitt, "New York, c. 1940." Courtesy of the artist and Laurence Miller Gallery, New York.

of these games, keeping them shared, not solitary.[21] The richness of Cruikshank, like that of the life he so well evokes, would allow us to make further distinctions. We have again, for example, *embedded* imaginings, for we imagine their imagining. And we have embedded *depiction,* for the portrait of "Dr Syntax" on the wall presents a pictorial depiction of a pictorial depiction. This brings us to an early theme of the chapter: the question of what, in general, is pictorial depiction? We need at last to answer that before turning to the specifically photographic kinds.

Depiction: "At Home in the Nursery"

Historically, the question has elicited, still elicits, strange replies. One line is that depictions are artifacts like the peacock feather in the child's hair in the Cruikshank, which sports an "eye": that is, a mark so termed by exten-

[21] Walton, *Mimesis,* pp. 18–19, 21, 68.

sion because it rather *resembles* an eye. Among their other great failings, such accounts fail miserably to help explain our *interest* in and *use* of depictions, let alone our many technologies for producing them. People look at pictures and go to the movies in order to imagine situations vividly, hardly to see what visual resemblances they can observe. "Reference" accounts are even less helpful in illuminating the pervasive human fascination with activities like these and, now, multibillion-dollar industries for producing them. Even E. H. Gombrich's well-known "substitution" approach—from a justly famous essay which, finding the roots of depiction in children's make-believe, rejects the abstraction Baudelaire spoke of (as well as similarity and symbolism)— is hardly adequate. Beginning from a hobbyhorse like the one in the Cruik- shank print, Gombrich's important insight, carried forward in his later work, is that depictions and other representations are to be understood *function- ally*, in terms of their psychological efficacy on our perceptual systems: that is, as keys that turn our psychological locks. In the print, however, the coach driver's clothing, like the soldier's hat and drum, have the same functions as the hobbyhorse, and they are clearly not "substitutes." They are, after all, real things. It takes not much research to discover that children frequently dress up in real clothes as part of their games. Likewise, many of the children's play *actions* are the same as real actions; others are not. We have already seen what the children in at least three of the depicted games imagine about their own actions. The coach driver raises the whip and imagines that act to be the rais- ing of the whip (which it is) and the control of a horse (which it is not). As we noticed before, we often imagine things as they are, as well as things that are not. It is vital to such games that the things the child wears, brandishes, and does incite imagining about these things themselves. Thus banners wave and bugles blow, really and in make-believe. Although Gombrich was right to remark that effective props for visual and other imaginative games need only characteristics suitable for the game, he unfortunately neglected to say what the game was: notably one of *imagining*.[22]

What about specifically pictorial depiction? Depictions in the movies and

[22] It is important to distinguish Walton's approach from that of E. H. Gombrich in his "Medita- tions on a Hobby Horse" (1951), rpt. in Gombrich, *Meditations on a Hobby Horse and Other Essays on the Theory of Art* (London: Phaidon, 1963). See Walton's explicit criticisms in "Make-Believe and Its Role in Pictorial Representation," *Art Issues* 21 (January–February 1992): 22–23. His oversight caused Gombrich problems in the later theoretical development of his insights; ironically, in *Art and Illusion: A Study in the Psychology of Pictorial Representation* (Princeton: Princeton University Press, 1960) he was drawn back to perceptual illusion and linguistic symbolism accounts, which tended to occupy the subsequent literature.

the Cruikshank before us and the picture *in* the Cruikshank are all of a piece with the imagining prescriptions of the songs and musicals considered above. But they are a kind of physical image, marked surfaces that mandate our imagining things. To be more precise, they mandate that we imagine *seeing* things. We would hardly call them pictures otherwise. Indeed, pictorial depictions mandate that our act of looking at them is the act of looking at what they depict. As we look at the Cruikshank we not only imagine seeing Christmas pudding being brought into a roomful of rollicking children; we automatically imagine *of* our act of seeing the picture that *it* is that very act. We could hardly keep from doing so, and we could not access the imagined scene in any other way. This, and not merely the fact that what we do with pictures is look at them, is what makes pictorial depiction visual and distinguishes pictorial depictions from other kinds of representations that make us vividly imagine seeing—such as this later one, so famous that it needs no footnote: "Hallo! A great deal of steam.! The pudding was out of the copper. . . . In half a minute Mrs. Cratchit entered—flushed, but smiling proudly—with the pudding, like a speckled cannon-ball, so hard and firm, blazing in half of half-a-quartern of ignited brandy, and bedight with Christmas holly stuck into the top."

With the picture our visual actions (not just ourselves) work *reflexively:* that is, as inciters and as objects of imagining.[23] Keeping the children's participation in their games in view makes clear that the idea is not that there is some independent visual act, "seeing" the people in the picture (which would still need analysis), *of which* we do something else: that is, imagine about it. By strict analogy, it is not as though the children first move, then take the opportunity to imagine something about what they have done. That would be an absurd account of their game. Their movements are guided by the game and full of the intention of playing it. Similarly, as we look at our marked display surface depictively, our visual activities are guided by the imagining activities that it automatically incites in us. Seeing the image pictorially, as opposed to noticing likenesses between forms in it and forms elsewhere, entails such imaginative seeing, and that entails imagining about ourselves—notably about our visual activity. This last point may seem very subtle; it has certainly eluded enough thinkers on the subject. To Kendall

[23] See Walton, *Mimesis,* pp. 293–96, 303–4.

Walton's great credit, he was able not only to make the point but also to show its *continuity* with other imaginative games we play from early childhood, like the games that Cruikshank shows from one society, games whose variants would be found around the world and through history. Depiction is truly "at home in the nursery."

As we grow up, we may give up such vigorous games.[24] As Baudelaire indicates, there is a history of lament not only for the lost world of child imagining but for full childish *participation* in such imagining. Losing both psyche and physique for such activities, we are reduced to reflexive acts of imagining which flex fewer muscles. We play with the picture as the children do with their props, but our play is largely through our eyes. We imagine things of our seeing of it, rather like the child seeing the card castle being built. The children in the picture, too, play visual games. Are we then restrained to visual ones? Well, we have already been involved in verbal ones, as Baudelaire says children are (perhaps the boy hailing from the horse). For example, we have been discussing what is depicted in the Cruikshank rather as though we were actually looking at the scene. This kind of collaborative imagining is perfectly typical of our descriptions of pictures at least since the Shield of Achilles passage of the *Iliad*'s book 18, which describes a skillfully marked surface in detailed terms of the imagining projects it incited: "Next he depicted a large field of soft, rich fallow, which was being ploughed for the third time. . . . The field, though it was made of gold, grew black behind them, as a field does when it is being ploughed. The artist had achieved a miracle."[25] More could now be said about the subtle cognitive and feeling "games" we do play, but that would take us away from our present purpose: a basic account of imagining and of depiction that will help us better to un-

[24] Ibid., pp. 209, 228.

[25] Homer, *The Iliad,* trans. E. V. Rieu (London: Penguin, 1950), p. 351. On verbal participation, see Walton, *Mimesis,* pp. 220–24. In stressing this common collaborative aspect of pictorial imagining and giving an account of pictorial depiction, I have used all the main observations about imagining save one, drawn from the musical examples. Such depiction is conditional prescription, through marked surfaces with that function (props), of acts of imagining (notably, visual ones). Furthermore, such acts must be perceptual in another sense, for they must at least involve an aspect of reflexive visual imagining: that is, of imagining something visual about themselves. Otherwise we could not distinguish pictures from other prescribers (stories, songs, poems) that produce visual imaginings. It remains only to say what scarcely needs saying, that such pictures may be of real things and accurate.

derstand one of the main functions of photography, among other imagining technologies.

Let us therefore briefly consider pictorial depiction in terms of tools and technologies for prescribing such imagining games, just as we did with the sound-recording examples. Cruikshank's stylus cut his etching resist to instruct one Thomas McLean, of 26, Haymarket, in the production of a quantity of inked surface images, which reach us today in their original forms or in modern photographic line reproductions. Usually our motive in looking at such images is to imagine things as Cruikshank would have us do. As saturated as we are by modern industrial imaging technologies, mainly photographic ones, it is hard even to look upon this image, or at any of the multitude that intrude upon us, without being drawn somewhat into participation, into imagining things of our very act of looking at the marked surface. That is because, as a generic imagining enhancer, depiction features a built-in technological efficiency. If its function is prescription of imagining, and its mode of access is visual inspection of surfaces, it may be thought of as *converting* the latter activity into part of the former. We look at the surface in order to imagine, and immediately imagine about that very looking as well. That is, we imagine it to be the act of looking at children playing games.

Participation: Getting into Pictures

Imagining from the marks, however, including imagining about our very looking at them, usually does not efface our looking at them *as* marks. Indeed, we usually understand them as put there for the very purpose of inciting our imaginings. They are a species of what we earlier called images or display markings. This leads to a second aspect of technological efficiency in depictions. Contrary to popular hyperbole, imaginative participation in works of fiction is not a state of illusionist dementia. The description of the Shield of Achilles in the *Iliad*, for example, mixes, in very familiar ways, imaginative participation with technical admiration: "The artist had achieved a miracle." The Cruikshank print is no miracle and was not meant to be, but it is a lively and comic rendering. As we look at his chair-horse, we see how "no matter what his needle touched, he could give sentient ex-

pression to a barrel or a wig-block, a jug of beer, a pair of bellows, an oyster."[26] As we also know from observing many modern cartoonists, part of the humor of Cruikshank's early work derives from the awkward drawing. Here is Baudelaire again:

> If it was possible to make an unerring analysis of a thing so fugitive and impalpable as *feeling* in art . . . I should say that the essence of Cruikshank's grotesque is an extravagant violence of gesture and movement, and a kind of explosion, so to speak, within the expression. Each one of his little creatures mimes his part in a frenzy and ferment, like a pantomime-actor. The only fault that one might characterize is that he is often more of a wit, more of a cartoonist, than an artist; in short, that he is not always an entirely conscientious draughtsman. . . . The whole of his diminutive company rushes pell-mell through its thousand capers with indescribable high spirits, but without worrying too much if all their limbs are in their proper places.[27]

I remarked above that for imagining, depictive pictures partake of what might be called a basic technological efficiency. Given that we have, in the first place, to look at their marked surfaces in order to be incited and guided to some imagining seeing, pictures of things *convert* that very looking into an object of the imagining. We imagine the represented situation, and also imagine *of* that looking that gives us access to it that it—our own perceptual activity—is seeing what is depicted. This is a striking way in which depictive media gain vividness—and the point can be made regarding dramatic and musical depiction as well.[28]

Now our *second* technological efficiency can be seen to be wrung from this kind of perceptual access. Not always or invariably but very often typically, in fact, with pictures we not only take the marked surface before us as a marked surface—indeed as a drawing, indeed as an etching built up of discrete strokes for the purpose of eliciting our imagining—but *imagine* about these more specific perceptions, too. It is in this way that a Cruikshank imaginative project would be *different* from those by his contemporaries Daumier and Grandville, or by Gillray, Goya, and Rowlandson of the generations

[26] Lost reference: The line is possibly from Dorothy George (see note 29).
[27] Baudelaire, "Some Foreign Caricaturists," in *The Painter of Modern Life*, p. 189.
[28] Walton, *Mimesis*, pp. 333–37.

preceding, even if they had drawn identical things or features of them, even if they did copies of one another.[29] These significant differences might not show up in any verbal descriptions we could make of what things or situations their drawings would have us imagine, but large residual differences would still lie in how we imagine them or, to put the matter another way, in what we have to do perceptually in order to imagine from them. That some of these artists would be more to this or that person's taste than another's does not reduce simply to preferences about what we are imagining, or to matters of the vividness with which we imagine.

Discussing some pictorial traditions of four centuries earlier, Michael Baxandall rightly drew attention to the different perceptual *skills* that differing styles or traditions of picturemaking call for in audiences, and to the way these skills may link to perceptual activities in societies at large: "The beholder must use on the painting such visual skills as he has, very few of which are normally special to painting, and he is likely to use those skills his society esteems highly. The painter responds to this: the public's visual capacity must be his medium." Baxandall links "visual capacity" to "taste": "For it is clear that some perceptual skills are more relevant to any one picture than others: a virtuosity in classifying the ductus of flexing lines—a skill many Germans, for instance, possessed in this period—or a functional knowledge of the surface musculature of the human body—would not find much scope on the [Piero della Francesca] *Annunciation*. Much of what we call 'taste' lies in this, the conformity between discriminations demanded by a painting and skills of discrimination possessed by the beholder."[30] The point is not that such pictures depict different scenes but that they favor different perceptual aptitudes on the part of beholders. Although Baxandall emphasizes differences of "skill" between societies, perhaps regarding taste there is a more basic issue: perceptual activities, whether skilled or not, may vary among in-

[29] Dates: Cruikshank, 1792–1878; Honoré Daumier, 1810–79; Grandville (Jean Ignace Isidore Gérard), 1803–47; James Gillray, 1757–1815; Francisco Goya y Lucientes, 1746–1828; Thomas Rowlandson, 1756–1827. One might compare also William Hogarth (1697–1764) and Baudelaire's choice, Constantin Guys (1805–92). The setting for the English satirists is vividly described in M. Dorothy George, *Hogarth to Cruikshank: Social Change in Graphic Satire* (New York: Walker, 1967). Photography began life during the golden age of popular lithographic satire advanced by Charles Philipon's caricature journal and weekly; see Beatrice Farwell, *The Charged Image: French Lithographic Caricature, 1816–1848* (Santa Barbara, Calif.: Santa Barbara Museum of Art, 1989).
[30] Michael Baxandall, *Painting and Experience in Fifteenth Century Italy: A Primer in the Social History of Style* (London: Oxford University Press, 1972), pp. 40, 34.

dividuals according to temperament. By analogy, ordinary walking is not a matter of skill, yet some people like doing it, some are indifferent, others avoid it whenever possible. By closer comparison, some people are neither good at remembering names nor at keeping in mind complex family relationships; therefore, for them large nineteenth-century novels may be a trial to read.

With regard to looking at pictures, we are now in position to be rather more specific about perceptual activities. Baxandall mentions what sorts of activities may be required without quite telling us what they are required *for.* Where the picture is depictive, these actions will notably include perceiving aspects of the marked surface before us in such a way as to imagine seeing by their means. This entails activities of imagining about our own seeing. One question is whether we wish to "see" something; another is whether we want to do what is involved in "seeing" it. Not only may we wish (or not wish) to imagine what is prescribed, to imagine seeing such things; we may wish (or not wish) to imagine this of our very acts of perception: that it is that seeing. If this last point seems too subtle, all we need do is to look back to our print and consider again how important it is to the children's enjoyment that they not only imagine certain things vividly but that they imagine these things of what they themselves are doing. Likewise, depictive perception, I have argued, already involves a complicity that mere representation does not: that is, participation through reflexive imagining about our own perceptual activities, as with the children at play. When we look at a picture depictively—for example, at a photographic picture of something—we imagine something of our own actual looking, and that is an aspect of our action that we may find fulfilling, enjoyable, uninteresting, unpleasant, distasteful. This is what makes pictures graphic. Thus there can be good reasons of this sort why we prefer to see something in a picture, or prefer rather to follow a detailed, even vivid, verbal account.[31]

Issues of skill do naturally arise from such situations, as they do with most cognitive activities. It is normal for societies, groups, subcultures to define themselves in terms of perceptual discrimination skills—including those that they reject. One of the most familiar objections that people make to kinds

[31] Verbal accounts are also capable of being depictions, however; see Walton, *Mimesis,* pp. 353–54. At this point much could be considered regarding the attractions, as well as the effects, of photo-technologies in "news" media, which I have elsewhere referred to as "medusa media"; see Maynard, "Ravishing Atrocities," *London Review of Books,* 7 January 1988; pp. 17–18.

of pictures, including kinds of photographs, has to do with the sorts of per-
ceptual skill they call for or the skills they frustrate—even demean. More
than subject matter, such is the meaning of *épater les bourgeois,* for it is a sit-
uation common to the arts: music, dance, theater, poetry, and so on. Like
these others, modern pictorial arts frequently confront people with situations
in which they literally do not know what to do or which skills to deploy. A
similar point may be made about distaste for kitsch and some modern mass
arts. Having already drawn on Baudelaire several times, I record his objec-
tion to what he called the "functions" of photo processes. While applauding
their detective, reproductive, and recording functions, he deplored the de-
pictive. He could see no more in what he called "this industry," posing as art,
than encouragement of the masses' appetites for banal recognitions and
pornographic viewing ("no less deep-rooted in the heart of man than the love
of himself"), at the expense of art's concern with "the impalpable and the
imaginary."[32]

What simple aspects of perceptual activity (other than skill) does the
Cruikshank call for, merely to understand its depiction? Here, at least, he does
not draw near the level of the other illustrators mentioned before; this pic-
ture rather looks as if it had been done by a committee—with the vote on
composition not unanimous. But it works, and despite Baudelaire's com-
ments about the "fugitive" quality of art, it is easy to say something not only
about how it does so but also about how it does not. To stay with somewhat
obvious points, the agitation of the left half of the composition is *not*
achieved in the manner of more proficient artists and modern cartoonists:
that is, by the rhythm of the artist's scratching of the polymer surface. Cruik-
shank's way of working here is rather stiff. With other illustrators—Row-
landson, for example—our awareness of the exuberance of the markings
would carry over to our imagining of the exuberance of the scene those mark-
ings evoke. In this reflexive manner, the characteristic "handwriting" of each
illustrator would become *part* of our imagining: that is, we would imagine
of our seeing its liveliness that this is the seeing of a lively scene. But that is
not our illustrator's way of working here.

It is evident at a glance that Cruikshank made his picture by scratching
lines. Although depictive methods are often combined, *photographs* of things
are normally made in ways quite different from such drawings of them, and

[32] Charles Baudelaire, "Photography" (1859), trans. Jonathan Mayne, in Newhall, *Photography: Es-
says & Images,* pp. 112–13; also in Goldberg, *Photography in Print,* p. 125.

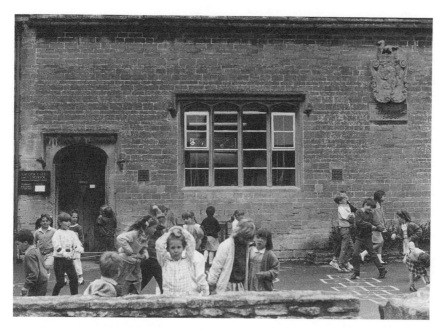

Fig. 7. Lacock C. of E. School.

this is something we all know. Given that part of our perception of depictive display images (a part routinely though not inevitably transformed into imagining material) is our sense of the way in which the picture was put together—broadly speaking, perception of "facture"—we may expect that photographic depictions would tend to present themselves to us depictively in a way different from that of etchings and other drawings. Although we now take this for granted, it was a striking factor for the new medium's audiences, one of the ways in which photographs tended to require different activities of looking. We must not exaggerate this point, however, as has become the modish thing to do, with loose talk about "conventions." Many aspects of the perceptual activity remained the same; otherwise, photographs would not have had the *immediate* success they enjoyed. We can make some simple contrasts by briefly comparing an informal print like Cruikshank's with a photographic snapshot of contemporary children at play (Figure 7). The situations differ in that the latter is not "at home" but in school, not a party but a recess, and the children are rather older. (The school in fact is, as one can almost read in the inscription on the right, one "erected by W. H. F. Talbot, Esq./ 1824" for the village of Lacock.)

Comparison makes clearer how the etching was, literally, *composed* of individual figures, sixteen of them, with a doorway. In the photo, if we take just the large grouping, left, we get near the same number and even a doorway. This is not Cartier-Bresson. Insofar as there is composition here, it will be of a familiar, candid-photo sort. Individual figures will not be as "legible" as in the etching, nor will their activities. (At least one make-believe game is perhaps being played: one girl may be a horse, a skipping rope pressed into service as ad hoc reins.) Where such legibility appears, it will seem to emerge, briefly, from the scene, rather as it would if we were to stand there and look upon it ourselves. In the Cruikshank picture, however, individual activities are clear. Indeed, as Baudelaire remarked in the passage previously quoted, "Tous ses petits personnages miment avec fureur et turbulence comme des acteurs de pantomime." That is not an account of what the picture would have us imagine. The picture does not depict the children as being like a group of mimes. Rather it is an account of Cruikshank's typical *way* of having us imagine the children he depicts. Our action is to view the scene rather as we would a stage with various acts going on. Such, then, are different ways of mandating imagined melees, which transform our somewhat different ways of accessing them into somewhat different ways of imagining them.

Photo Depiction

I chose the Cruikshank print tactically, partly because it represents an important stage in the history of mass image circulation, a time when image-making technologies were becoming industrial in the modern sense and preparing for photography. As one scholar puts it: "New ways of printing in the nineteenth century made good images cheap and cheap images good. Never before in history had the products of highly-skilled draughtsmen been translated with such fidelity into mass-produced form. . . . The proliferation of images in the nineteenth century was only one part of a larger picture of growth and proliferation: words, goods, and people were proliferating at the same rate. Industry, the god or monster that arose to support a new urban population, also created it."[33] Industrial and mass-produced as they were,

[33] Beatrice Farwell, "The Cult of Images (Le Culte des Images): Baudelaire and the 19th-Century Media Explosion (Santa Barbara: University of California–Santa Barbara, 1977), p. 8. About an earlier proliferation of graphics, see Anne Hollander, *Moving Pictures* (New York: Knopf, 1986), chap. 3.

the graphic works of that century were still clearly handworked. It is often said that photography dispensed with such handwork. This is one of the reasons why the photographic industrial image output of the twentieth century dwarfed that of the nineteenth. To the extent that photographs were not handworked, they certainly did provide a new kind of pictorial perception, a kind of imagining that did not work off awareness of the processes of hand-facture—notably in the inscription of lines. That might help account for the frequent, rather misleading, impression that photographic depictions are neutral, or styleless. Yet the facture of snapshot photography, the signs in the image of the processes of making it, as in the Lacock snap—including framing, focus, moment of release, and so on—not only is usually clear as such but also may be imagined into the depicted scene. But before discussing such questions further we need to set out a basic account of *photographic* depiction, which we have been taking for granted. Some may even doubt that such a thing exists.

Again, it is almost embarrassing to have to argue for an imagining technology. Through movies and television, photography has clearly greatly expanded (and channeled) the imaginative activities of billions of people in ways much noted, praised, or condemned by cultural commentators. Like that eighteenth-century medium the novel—which, by tapping the imagining appetites of a fast-growing urban reading public, provided one of its sturdiest roots[34]—and in league with twentieth-century sound recording, motion photography and TV now present vivid and elaborate projects on a mass scale, with enormous social effects.

There can be little question that from the very beginning, long before such images moved, photographic processes were understood largely as pictorial agencies. Camera-obscura optical images, which photography was designed to fix on surfaces, were already sometimes understood pictorially. That means that fugitive as they were, they were treated as images for people to look at, thereby to imagine seeing things, indeed to imagine with reflexive participation that their seeing of those images *was* the seeing of various things, past or present, real or *merely* imaginary. Someone looking at a daguerreotype portrait or an albumen print of Egypt was of course not *directly* seeing such a subject but, rather, looking at a surface marked by photochemical processes—yet imagining directly seeing the subject. As remarked

[34] For figures about the growth of urban literary and artistic markets, and interesting comments on their constitution, see Richard Sennett, *The Fall of Public Man* (New York: Norton, 1974), esp. chaps. 3 and 7.

above, it would surely not be enough to say that such surfaces resembled, referred to, or carried information about their subjects. If they had only done those things without inspiring vivid imagining of direct seeing, with all that this evokes, there might have been many important uses but hardly a popular market for photography, then or now.

These are simple facts framing a complex history of modern technology, and it may well be here that our seemingly endemic confusion about photography begins. Perhaps the most scandalous source of these confusions is a failure to develop a simple terminological distinction between *a photograph of* something and *a photographic depiction of* something: that is, a depiction of something made (largely) by means of photographic processes. Like any other depictive technology, photography provides methods of marking surfaces that entice imagining. Sometimes this is accomplished by photographing what is depicted, sometimes not. Movies provide many routine as well as interesting examples. Although *King Kong* depicts a giant ape climbing the Empire State Building and was made by filming various things, none of them was an ape or the Empire State Building. The photo stills from that sequence are not photographs of what they depict, nor would anyone expect them to be so. Often photographs are taken of merely the same *sort* of thing as they depict. The labels on modern packages frequently depict, photographically, their sort of contents—cereal, bread, soup, pet food—though one trusts that these are not photographs *of* the actual contents. They are merely illustrative, like the nonphotographic package pictures with which they are mixed and continuous. They may be accurate illustrations.

A main feature of photo depiction is how effective, easy, and cheap it has proved to be. The moving picture and advertising industries would hardly exist otherwise. As a result, photographic depiction has become the most prevalent kind throughout the modern world, and the continuous invention of new photo-technologies makes this only more so. If, therefore, as Kracauer and others have thought, there are photographic "affinities"—characteristics generally if not universally shared by photographs—photo-depictive affinities shape the most prevalent depictive characteristics throughout the world. Given that pictorial depiction is one of the central imagining technologies for all peoples, human imagining is now powerfully shaped by such photo-depictive characteristics. Consequently, questions arise regarding what kinds of imagining photo depictions tend to amplify and what kinds they tend to suppress.

These are like the question regarding what kinds of imagining the popular ballads discussed earlier tend to amplify or suppress. They are like it, but far more difficult. We know well that popular songs are quite brief in text and that they typically encourage first-person identification with the reiterated feelings of individuals, feelings characterized by a sense of lack, focused by dreams of happy fulfillment through heterosexual relationship with just one other person; indeed, they typically express low self-esteem in that connection. This accounts for their frequent appeals to forms of imagining. In other words, the Temptations' imagining of 1971 is far more characteristic of the genre than the Lennon song. We also know that with the incursion of other rock influences during the 1950s and 1960s, such songs blatantly took on a physically sexual form, as compared with the preceding romantic ballads, and that the country-and-western genre carried on the mission of romantic yearning. Thus amplification. As to filtering or suppression, very few popular songs had to do with the main concerns of people during those periods: for example, gathering, preparing and eating food. They exclude many themes of the twentieth-century French *chanson*. Also, compared with, say, British broadside ballads of previous centuries, the political content of such songs was remarkably low. By contrast with the songs of other societies, these are almost entirely secular, even where, troubadour style, they transfer spiritual longing into secular form. So we have a story well elaborated by Plato, who in *Symposium* 206–207, was the first to state explicitly that *erōs* is the mortals' desire to live happily ever after.

Photo-assisted imagining is a much less localized phenomenon. Furthermore, photo-technology has developed as a technology of permanent innovation, constantly interacting with other technologies. Pity therefore the media philosopher who wishes to pronounce on its "nature." It is remarkable, for example, how prevalent and influential is the cliché that a photograph depicts things as captured—"frozen" has become the popular term—in a fraction of a second. This is a simple, fallacious attempt to identify the depictive features of photographs with certain features of the causal mechanisms that produce them. Meanwhile, people are perfectly aware that advertising photographs of consumer products, for example, often carry no implication of momentary states or even of time at all. Almost as careless are facile generalizations about "photographic perspective." Many familiar photographs are taken in such a way as to defeat perspective effects, especially of diminution with distance. Popular advertising again provides many exam-

ples. Color photography, for example, has in latter decades taken over the role of oil paint in rendering the surface gloss and tactile allure of portable commodities.[35] As with earlier oil painting techniques, the touch of hands rather than the distant work of spatially estimating eyes is at a premium. This represents a technological extension of the striking characteristics that were commented on from the inception of photo images: a capacity for extraordinarily minute detail and continuous tonal gradation, due to the minute magnitudes of light waves and their silver surface receptors.

Most of this chapter has been about depiction generically, rather than about photography specifically. This is because by far the most important aspects of photographic depiction are those it shares with the multitude of other depictive practices. The best way to understand photography as a picturemaking medium is to place it firmly in the context of other imagining technologies, which entails thinking about imagining itself. In an environment of exaggerated claims about photo processes, we have to realize that picturemaking practices are technologies for amplified imagining, among which photo-depictive technologies take their place. Still, they do have specific characteristics. As marked surfaces, whether permanent or transient (on screens), photographs are physical entities. As depictions, prescribers and enticers of our imaginations, they are functional objects. One of the most striking characteristics of photo depictions, and the source of most confusion about photographs, is due not so much to their physical or depictive characteristics per se as to the combinations of *different* uses that typically, and idiosyncratically, they serve. As I have insisted from the beginning, photographic images have familiar uses other than the depictive, and these uses interact with and affect their depictive uses, just as the depictive affects the others. This is exactly what we should expect. The next chapter is specifically about detection uses and how they combine with those of imagining seeing.

[35] This point is developed in John Berger, *Ways of Seeing* (London: Penguin, 1972), pp. 140–41.

ॐ

Seeing Machines

Interacting Technologies

Photography appears to be a still-developing family of processes for enhancing our powers to do a number of things. We began with its powers to help us mark prepared surfaces for a variety of *cognitive* uses. In that "simple" capacity, let those who relegate to minor or marginal status photography's uses for anything besides pictures of things confront the microprocessor chip. Speak of a "latent image": the rise of computing miniaturization technologies since the 1960s is magnificent vindication of Nicéphore Niépce, lithographer, against the claims made for his partner, Daguerre, impresario of the massive imagining surfaces of his Diorama—hardly exceeded today by the eight-story Imax system. On the grounds that he was throwing in the method of the Diorama, the French government gave Daguerre the greater emolument, while touching lightly on the basic invention of his late partner.[1]

Metal etching and engraving were used for patterning surfaces long before

[1] In the June 1839 bill presented to the Chamber of Deputies, the minister of the interior stressed that Daguerre, "by quite a different course, and by completely laying aside the traditions of Mr. Niépce," made an independent invention "distinct from that of his predecessor, in its course as well as in its effects"—though allowing that one should not infer from the "imperfection" of Niépce's method that "it may never be liable to be improved upon, or to be applied with success in certain circumstances" (Goldberg, *Photography in Print,* pp. 33–34). Neither Arago nor Gay-Lussac made a case for Niépce in the texts of their preliminary reports.

they were adapted to transferring inks from one surface to another by means of presses. Today's micro versions, the so-called "photolithographic" processes that produce silicon solid-state semiconductor chips, are actually micro-etching processes. The microfabricated photoresist is typically a one-micron-thick polymer coating on silicon which catches the lens-reduced image of the drawn circuit as it is cast by ultraviolet light. (Remarkably, Niépce's photoresist of the 1820s was also a polymer, a natural one.)[2] As with traditional photogravure acid etching, either the exposed or unexposed portions of the photosensitive resist are washed away by chemicals, defining the tiny circuit. It is this miniaturization that makes possible large, reliable memory capacity and speedy, powerful processing—thanks to characteristics of photochemistry discovered in the early nineteenth century: the nanometer-scale refinement of light vibrations and of chemical responses to them. Progressively tinier size has also made *industrial* production of computing units possible. The unit cost of memory circuits is at present about one millionth of the original cost, as the density of chips has doubled every year or so for decades.[3] Let those who insist that photography is simply for making depictions pay original prices for circuits! Such chips may go into cameras but also into a host of appliances that bear no particular relationship to pictures or to other enhancers of imagining.

These two uses of photographically marked surfaces—for imagining upon seeing, and for forming invisible semiconductor circuits—are quite remote from each other. Photography would be important for either one, even if the other had never been invented. Such versatility is typical of technologies. For example, the uses of such a material as celluloid thermoplastic—for explosives, for billiard balls, and for the first cinema films—are functionally independent. It is also typical, however, that such distinguishable, even remote, technologies reconvene at some points or even become integral with one another. The results can lead to remarkable further amplifications. It has been

[2] A. B. Cohen and P. Walker, "Polymer Imaging," in Sturge, Walworth, and Shepp, *Imaging Processes and Materials*, p. 226: "Of greatest historic importance, perhaps, with respect to modern polymer imaging processes are the experiments of Joseph Niepce run between 1822 and 1827, wherein he used a natural polymer, Syrian asphalt, to make the first photoengravings on stone, pewter, and copper."

[3] For a simple, graphic presentation of this manufacturing technology, see Gary Stix, "Toward 'Point One,'" *Scientific American*, February 1995, pp. 90–95. That article considers the feasibility of finer records made by X-rays. Further miniaturization has led to rises in cost; see Gary Stix, "The Wall," *Scientific American*, July 1994, pp. 96, 98.

pointed out that in this way technological development is essentially different from biological evolution, because distinct branches of natural evolutionary "trees" cannot interbreed.[4] But independent technological families— computation machines, electronics, photoengraving—are today firmly embedded in one another. For example, electronically and computer-guided photoengraving "step" machines produce the very semiconductor microcircuitry that makes the computers themselves feasible. If such later interaction characterizes the distinct developments represented at Babbage's "breakfast of champions," they would likely also characterize different applications of many common-root technologies. Photography is our case in point.

Referring to the early days of photography, the historian Nancy Newhall remarked that "up to 1853, the photographic image was regarded with the awe and reverence due a miracle."[5] People's puzzlement then about the "magic" of photography should have signaled an already existing unclarity in their understanding of traditional media as well. I have argued that one of the greatest such unclarities concerned the very nature of depiction. Part of the problem about what photographs are is simply inherited muddle about what any kinds of *pictures* are. The advent of photography is not to blame for this, though it might be said to have caused a crisis of confusion: photography's late appearance on the scene made the standing confusions glaringly evident. Alas, this situation led to more muddles rather than to sustained thinking-through of the sources of difficulty. Our job is to continue thinking these matters through from the bases that we have established for photography as a species of imaging technology: the bases, first, of technologies as enhancers (and suppressors) of our powers to do things and, next, of the combinations of these technological functions. My approach will continue to be in terms not so much of things as of our own activities: that is, what *we* do with photo processes and their products, and what functions these have in our activities.

The preceding chapter examined photography as an *imagining* technology, notably as a channeled enhancement of our powers of imaginative visualization: a veritable "engine of visualization" among other engines of imagining. Now we must think of photography in its equally important role as a *de-*

[4] See Alfred E. Kroeber's classic *Anthropology* (New York: Harcourt, Brace 1948), p. 260, and the discussion in Basalla, *Evolution of Technology*, pp. 137–39.

[5] Nancy Newhall, *P. H. Emerson: The Fight for Photography as a Fine Art* (New York: Aperture, 1975), p. 115.

tecting technology. We will not have to wait long before reflecting on familiar *interactions* of these two revolutionary employments of a modern technological family. The most familiar examples of the detective uses of photography are already conjoined with depictive uses, for reasons that will become clear. Computer language provides a phrase that well describes these interactions: "user-friendly interface."

Surface to Surface: "The Philosopher's Meditation"

Two *cognitive* applications of photo imaging typically and familiarly enter into each other in various ways: the imagining or *depictive* function discussed in the last chapter, and this chapter's *detective* function. Although these two basic image functions can exist independently in most contexts, typically they interact. Indeed, "photography" might be most simply characterized as *the site of historically the most spectacular interaction of depictive and detective functions.*

That the fact of such interaction has gone largely unremarked may be more odd than if the combination of the quick, remote communication of telegraphy and the broadcast dispersal of cheap print—that is, the combination that occurred with radio—had also escaped our notice. Yet if such interaction is not explicitly remarked, it is still registered, for example, in the universally used but never analyzed idea of "a photograph of" something—and that is but one of several combinations. As so often, what we overlook lies before us in common experience. This chapter therefore largely consists in a set of exercises whereby we will separate various familiar depictive and detective uses of photography, then show how they fit together in different but familiar ways to demonstrate the variety of their combinations. It is the first step toward a sort of "chemistry" of photo-technologies, showing how the properties of various functional "compounds" are derived from the interactions of a few independent technological "elements." Just as elements do not often occur separately in nature but appear more commonly in compounds requiring analysis, we will most easily find the *detective* element in photographic images in connection with depictive functions. Still, with a little study, it should be possible to find fairly separate detective uses to confirm that we are dealing here with a distinct element.

First, very generally, what do we mean by "detective functions" for pho-

tographs? Detection being so important to us, the photographic would belong to a much wider family of detective technologies. Photo-detective technologies, like other detection technologies, would be prosthetic extensions of what I have called our first technologies: our internal and external organic information-processing systems, by means of which we monitor, regulate, and otherwise interact with environments to advance our purposes. Animals are constantly busy about the task of finding out how it is with the world around them in terms of how it is with them—that is, in terms of how they are *affected* by states of affairs in their environments. The details of our detection systems are the subject of much scientific study. Meanwhile, the overall structure and validity of these systems has long been a topic of philosophical debate. The latter inquiries, like the former, are complex and technical. For our purposes we need merely note how often these come around to our earlier topic of *surfaces.* Specific and general accounts of perception are normally given in terms of surfaces, beginning with the selectively sensitive ones on our own bodies. Since surfaces of all things are normally the boundaries that distinguish them from other things and from whole environments, it is not surprising that significant causal interactions between sensitive creatures and their environments should occur at the surfaces where they communicate. Much has been written about how extraordinary it is that creatures are able to detect so much about their environments simply by monitoring the effects these situations have on tiny regions of their sensitive or "irritable" surfaces. This was not always thought to be the case.[6] Nevertheless, the sciences of perception continue to show how much detection is initiated at surfaces, where receptors are concentrated. For example, Kepler's discovery of the role of retinas in human vision was one stage of this advance; his understanding of the refractive roles of optical interfaces was another.

Environmental surfaces, as boundaries of things perceived, are frequently also the focus of close attention for the perceiver, and just as epistemological issues arise about how we can construe so much from slight differences made at our own surfaces, there are old issues about how we can construe so much from mere differences in surfaces out there. This is particularly so for

[6] This orientation represents a triumph of ancient atomism, which stressed mechanisms of *contact* at superficies of material bodies to explain sensation; e.g., see Lucretius, *De rerum natura.* Plato's and Aristotle's vision theories were extremely interactive, ecological models that put no such emphasis upon organ *surfaces.*

the senses of sight and touch. Not all seeing of things entails the seeing of surfaces, but such an enormous amount of it does that whole branches of visual psychology have been given over to the study of our detection of things, given what their surfaces do to the light that reflects off them to impinge upon our own. The spatial dispositions of surfaces in our environments allow us to locate and to identify them. The states of these surfaces also include traces of their interactions with other things—and this is where photo-detective technologies enter the scene on our behalf. Because of the remarkable sensitivity of photoreceptors, tiny chemical or electrical changes wrought on sensitive surfaces by light emissions and reflections allow us to detect and to record the physical situations of their causes. In this way, some of the abundance of information carried by light can be collected and stored for us. That provides a general way to consider photography. From its beginning, photography has been valued as such a detection and recording device, as an extension of our own organic surface-to-surface powers of detection by means of light.

Consider how a physicist describes photographic receptors from an optical engineering standpoint:

> We may classify detectors in several different ways, and the boundaries will overlap. The main classifications refer to spectral range, temporal frequency response, noise limits, size, and whether the total flux of an image is picked up. . . . The photographic emulsion is the prime example of photochemical detection. It is very nonlinear in response, has very low quantum efficiency, . . . and does not work in "real time." . . . To balance these disadvantages, it has the following great advantages: complete images can be recorded with orders-of-magnitude more pixels . . . than any TV system, and it has the integration property that faint images can be recorded and summed over several hours if necessary.[7]

By contrast, electro-optic (EO) systems typically have, at low illuminations, fifty times the sensitivity (technically expressed as "detective quantum efficiency"). They work in real time; they can be adjusted more cheaply and easily; and they can be compressed and transmitted—indeed broadcast—over great distances at great speeds.[8] Although the word "image" is typically used

[7] Walter T. Welford, *Useful Optics* (Chicago: University of Chicago Press, 1991), pp. 91, 94.
[8] Lawrence A. Maver, John Bisbee, Carey D. Erdman, Larry A. Scarff, James H. Clark, "Aerial Imaging Systems," in Sturge, Walworth, and Shepp, *Imaging Processes and Materials,* chap. 15.

in discussing these trade-offs—"trades"—of detective properties, it is there to be taken in the basic sense established in Chapter II: that is, in terms of physical states of surfaces—especially marks and quasi-marks—and only afterward in terms of their uses, pictorial or otherwise. Now that we have principled accounts of the terms "image" and "picture," or "pictorial depiction," we can note that many important photo-detective functions are by no means depictive. Even where the detection/recording output is a figured image on a surface, that image need not be accessed as a *picture*. Our automatic devices for image scanning, fortunately, do not entail "machine imagining." The pixel quantizing or transmitting devices that monitor phototelemetry reports do not, could not, treat their inputs as pictures: that is, as mandates to imagine. Whether, why, and when their outputs are treated that way by human interpreters is an interesting and complex question. Even when humans read the results, photographic registrations of spectral line intensities, interference fringes, and polarization angles involve images, but not depictive ones. Such important examples therefore illustrate our photo-detective element "neat."

There are famous historical examples as well. It is easy to show that the photographic emulsions and optical systems developed by the middle of the nineteenth century proved of great assistance, independent of pictorial uses, to the physics and engineering that had fixed the new directions of research by the end of that century. All photography, including photographic picturemaking, is based on discoveries about photoreceptors that register the presence of light and related emissions. Given that as early as June 1839 Herschel had discovered ultraviolet radiation by projecting the spectrum on photogenic paper,[9] I may be excused the comment that Daguerre's and Talbot's first developments of photography foreshadowed many important scientific discoveries. Talbot soon realized that his prepared surfaces were sensitive to shorter light rays, and foresaw practical applications of this fact. He would have been gratified to know of the discoveries made by the end of his century, one of which may stand for many. In 1896, the year after Roentgen's discovery of X-rays (partly confirmed by their effects on photographic plates), Henri Becquerel reported his discovery of radioactivity:

A *Lumière* photographic plate having bromide emulsion was wrapped with two sheets of thick black paper, so thick that the plate was not clouded by ex-

[9] Talbot, *Selected Correspondence* p. 25. His letters show how deeply Talbot was involved in optics and photology around that time.

posure to the sun for a whole day. Externally, over the paper sheet, was placed a piece of the phosphorescent substance, and everything exposed to the sun for many hours. Upon developing the photographic plate I recognized the image of the phosphorescent substance in black on the negative. The same experiment can be repeated by interposing between the phosphorescent substance and the paper a thick glass plate; this excludes the possibility of a chemical action resulting from vapors that could be emitted by the substance upon being heated by the sun's rays.

Becquerel then replaced the glass with an aluminum plate:

A *Lumière* plate with silver bromide emulsion was enclosed in an opaque housing of black cloth, closed on one side by an aluminum plate. . . . When the uranium salt was placed on the outside, over the aluminum plate, and again exposed to the sun for many hours, it was observed in developing the plate by the usual procedure that the image of the crystalline material appeared black on the photographic plate.[10]

In this familiar kind of experiment the researcher seeks to detect one phenomenon, radioactive rays, by showing that he is not detecting something else (sunlight or chemical actions), on the grounds that he could not be detecting them. With a lawful relationship established, this radiation was thereafter shaped to many detection technologies. Note that Becquerel speaks, naturally, of an "image" of a thin crust of uranium salt—again, in the most general sense in which I have been using that term. Yet although it happens that Becquerel's chemist father, Edmond, was an important figure in the field of photographic depiction, the son is speaking here not of depiction or even of imagining anything, but simply of detecting (and recording) emission phenomena.[11] The late nineteenth century was a high time for such detec-

[10] Henri Becquerel, "Sur les radiations invisibles émises par les corps phosphorescents," *Comptes rendus de l'Académie des Sciences, Paris* 122 (1896): 420, 501; rpt. in *Great Experiments in Physics*, ed. and trans. Morris H. Shamos (New York: Henry Holt, 1959), pp. 212–13.

[11] Edmond Becquerel (1820–91) was the founding president of *Le Société Héliographique* and a contributor to the chemistry of daguerreotypy and later processes. Becquerel followed up his own father's research in spectra with line spectra recorded by several photographic methods. For influences on photo research, including attempts to derive color photos via the "Becquerel effect," see Barger and White, *The Daguerreotype.*

tions of X-rays and radioactive rays, of light, radio, and sound emissions.[12] Besides Becquerel, the famous names Curie, Rutherford, and Roentgen suggest important discoveries of emissions caught on photographic plates. The technologies these discoveries allowed were immediately put to use to detect features of the sources and other conditions of such emissions, notably in astronomy. Annie Cannon, for example, detected the chemistries of stars by means of spectral lines of photographic plates. In a general account of photography, Paul Valéry asked, "All in all, can one think of a subject more deserving of the philosopher's meditation than the enormous increase in the number of stars as well as in the number of cosmic radiations and energies whose record we owe to photography?"[13] Rather than present a history of similar discoveries, I should perhaps provide a slightly more "philosophical meditation" on the subject.

Source and Channel, Scene and Sensor: "Photography in a Detective Light"

Since Becquerel's classic experiment was a first-time detection, we might say that he was not only displaying natural radiation but also showing that silver emulsions are sensitive to them. Thus Becquerel had claim to two basic discoveries: one about a *source,* the other about a *channel* and a *receiver* for deriving information about that source. Generally speaking, this familiar engineer's distinction between source and channel, or channel and receiver, will prove useful for our purposes. The fact that these labels can mark shifting distinctions makes them all the more interesting, especially for photographic meaning and photo art.

As a physicist, Becquerel was trying to detect states of a *source* on the basis of what he assumed about an existing *channel:* silver bromide photoreceptors and recorders. As a technologist, Edison, by contrast, was interested not in his alleged source (a sound token of "Mary had a little lamb") but rather in the possibilities of his *channel* and *receiver:* the tinfoil phonograph,

[12] See Catherine Caulfield, *Multiple Exposures: Chronicles of the Radiation Age* (Chicago: University of Chicago Press, 1990).

[13] Paul Valéry, "The Centenary of Photography" (1939), in Valéry, *The Collected Works in English,* vol. 11 (Princeton: Princeton University Press, 1970), rpt. in Trachtenberg, *Classic Essays,* pp. 192–98.

which brought that information to Edison in an audibly extractable form in 1877—the year, incidentally, of Talbot's death. In other words, what interested Edison was not the message but the fact that he could hear it; any number of other messages would have served his purpose equally well. We are all *experimenters* when we test a telephone line, television system, tape or video recorder. We look to information about a source in order to see how the channel and the receiver are operating to bring us that information in appropriately amplified and filtered forms. This often entails our keeping that source fairly constant, in order to test fluctuations in the other factors. As *users,* however, we normally have the reciprocal interest of detecting states of the source. It is the channel-receiver conditions that we then seek to keep constant, as variation or modulation in sources is what carries the information that interests us. We do the same in testing eyeglasses, ambient lighting conditions, our eyes, our minds: "Am I seeing things (dreaming) or—?" we test to find whether these entities, including our own systems, are operating well as information channels.

In all such cases, source, channel, and receiver conditions are all among the *causes* of the physical information states that we receive.[14] We seek to distinguish these sets of causes and to make distinctions within them: are the edges of the object not very sharp, or is there vapor in the air, or do our glasses need cleaning, or are we too tired to focus our eyes, or is there too much vibration? With background assumptions about these sets of causes, we derive information about others. Background assumptions are not all *simply* assumed. We know how often monitoring them accompanies detective use of them. That we are getting readings of certain kinds is usually itself confirmation that the channels are operating properly.[15] If the kitchen stove's faulty indicator does not always light when a burner is on but never does when it is *not* on, the fact that one does shine lets us know both that the burner is on and that the indicator channel is functioning, this time. The car radio goes on and off as it overheats; hearing on it one of the "oldies" men-

[14] My use of source/channel distinctions is based on Fred I. Dretske, *Knowledge and the Flow of Information* (Cambridge: MIT Press, 1981), esp. chap. 5, "The Communication Channel." Dretske would separate information connections from causal ones (pp. 26–39) and deny even the necessity of a causal relationship to a communication relationship, where by "causal" he means deterministic. Here I use "cause" in a wider, more general sense (which Dretske mentions, pp. 32–33), one that allows both deterministic and indeterministic causes. Therefore I am obliged to make it clear if at any point my account requires deterministic or regularity conceptions.

[15] Cp. Dretske, *Knowledge and the Flow of Information,* p. 117.

tioned in the last chapter allows us both to hear the song and also to detect that the radio (the channel) is working again—indeed, to tell how well it is working.

Let us apply these familiar observations about sources, signals, channels, and receptors to the narrower realm of images and marked surfaces. Becquerel was able to discover radiation because of a *mark* that it made on his Lumiére glass photo plate. For him the radiation itself was the first information source, from which he could detect its more remote physical source. The fact that it gave him an "image" of a fluorescing crust of bisulfate of uranium and potassium was instrumental to his detecting facts about the radiation (for example, that it penetrated certain substances better than others). But those facts were of secondary interest, for Becquerel was not then seeking information about that salt's shape, size, and location. If we apply all this to what we associate with photography, the many scientific uses of traces on photo emulsions to detect physical facts about the radiations they intercept may appear unrelated to our everyday uses. That such is far from the truth may be appreciated by considering how we examine our own snapshots. We normally look at them to detect things about what we have photographed; that is much the interest of such photos. We also often look at these images to detect causal factors, including the channel conditions, in their production—particularly when something has gone wrong. These are detectable because they are variable. Light conditions vary, notoriously. Camera and film states are also variable. Consciously or not, when we look at such a photo we register a host of things as *detected* which we have not *photographed* and would not consider to be *depicted*—that is, to be what we are to *imagine* seeing when we look at the picture. Most obviously, we note that we used color film, that we focused at certain planes and not at others, that we knelt to take the picture, that we did or did not use a flash, that we tilted the camera down to one side, that we used a certain filter, and so on. We did not, however, *photograph* our using color film, focusing the picture, using a flash, tilting the camera—although another person taking pictures of us as we worked could have photographed these things, and their photos might well depict us doing these things, setting these channel conditions. This is not to imply that channel conditions, or their setting, cannot be part of what we photograph ourselves. Sometimes, by use of mirrors, we photograph our act of taking the photograph; we may even sometimes depict camera motion without photographing it. That is, people take photos in such a way as to compel us

to imagine the camera's position and movement without photographing their moving cameras. We may go so far as to say that photos of things usually depict some of the most important channel conditions for their production, the most important probably being lighting conditions—as, for example, in the Walker Evans (Figure 1). Light is a causal factor that is not only depicted but frequently stressed—we might say thematized—in amateur, professional, and art photography.

It should therefore be clear from our everyday photographing experiences that what a photo depicts and what can be detected from it are far from identical, though significantly overlapping, groups of situations. There should therefore be no objection to the general observation that we can frequently detect from our photos *some* of the things and situations that we have photographed and depicted there, notably features of what is usually called the "subject" of the photograph. That we may be wrong or misled about what we can detect in what we have depicted is no more surprising than that we may be wrong or misled about the detectable causal factors we have not depicted, such as the use of a focus, filter, film. We now have, besides two "elements," the fact that they may occur singly or together. But coincidence is not combination. What is the evidence that they also interact to form "compounds?"

Showing What Shows Up: Photo-Depictive Detection

There are two ways to neglect or to deny the simple fact that "photographs of things" are, as such, both depictions of them and channels for detecting them. One way, challenging the very idea of photo depiction, is an interesting option which, close historical reading may show, has had its attraction for thoughtful people.[16] Photography, wrote Elizabeth Eastlake in 1857, "is the sworn witness of everything presented to her view," recording "facts of the most sterling and stubborn kind," "facts which are neither the province of art nor of description, but of that new form of communication . . . neither letter, message, *nor picture* [emphasis added]."[17] A "new form," not a

[16] Roger Scruton, "Photography and Representation," *Critical Inquiry* 7 (Spring 1981): 577–603, presents a case against photography as "representational" (a view considered in Chapter IX). His sense of "represent" seems to be different from though related to my sense here of "depict" and "represent."

[17] Eastlake, "Photography," in Newhall, *Photography: Essays & Images,* p. 94.

"picture": Eastlake, it appears, drawn by her insistence on photography as a detecting and recording medium, wanted to distinguish its products from pictures of things, was even tempted to deny that photos are pictures at all. Nonetheless, throughout her long essay, she wrote of "photographic pictures." Perhaps, on balance, she thought of them as extending and changing the meaning of the word "picture," as nonfigurative painting was later to do. Yet the case for photos of things as depictions, if not altogether unproblematic, appears to be undeniable. Photographs are clearly used for purposes of depicting things that they are not, or not quite, photographs of. We have overwhelming demonstration of this in movies and television, where one thing or situation has been photographed in order to depict quite another. If photos of things are so often depictions of things they are not photos of, why should they not be sometimes also depictions of what they *are* actually photographs of? Such photos, like any depictions, function to direct us in imagining seeing what they depict: in those cases, what they are photos of. Objects and situations imagined and objects and situations photographed often coincide. We imagine that looking at a photograph of a wedding party is the direct looking at that actual group of people, whereas it is not. Rather, it is the direct looking at a photographic print or a screen.

In the time since Lady Eastlake wrote, more depictions have been made by photography than were ever made by any other picturemaking technology. If we include cinema and television, more time is spent looking at photo depictions than has been spent looking at any other kind of picture—or doing many other important things. So great has the pictorial appeal of photography always been that the more common denial—or, rather, neglect—of its dual function has tended to fall on the other side. Photographs of things, considered just as a kind of depiction of them, turn out to be *not* just another kind of depiction of them. From the start, they have tended to enjoy preferred, though unsettled, status among pictures, largely because of our attempts to comprehend their detective and recording functions under the traditional category of depictive function. Thus the common impression that "photographs do not lie"—meaning that the information they carry about their subjects *is* information and therefore is true—is frequently countered with the easy demonstration that they often *depict* very weakly, inaccurately, incoherently, misleadingly. The mischief increases when it is correctly replied that photographs of things are, often, not only very accurate and effective *depictively*—that is, they have us imagine correctly and in great detail how their subjects are—but are often thus pictorially true in a

distinct way. Since pictorial depiction consists in imagining seeing, it is all
the more effective when that imagining is *vivid*. It appears to be made more
vivid as our activity of looking at pictures mobilizes more of our neural struc-
tures for perceiving real environments. Photo-technologies have continu-
ously amplified our vivid imagining that we are seeing. Photo optics, which
began with perspective and tonal gradation, steadily improved (Chapter VI);
color emerged, then moving pictures, to which sound was added. Whereas
silver imaging features latency, EO photography brings us images in what is
called real time: we imagine seeing things not only as they occur but *while*
they occur, at great gain in vividness. All this adds to the experience of vivid
imagining seeing.

As the pop songs reminded us, imagining is by no means more true or ac-
curate for being more vivid. One might plot veracity of depiction along in-
dependent pictorial axes: accurate depiction (imagining seeing things as they
actually are), vivid depiction (imagining seeing things, exploiting routines
for actually seeing things). If so, *detective* content would require still anoth-
er axis and would be subject to standards of adequacy of its own. Although
we can detect only what is so, we may well assess how important or relevant
are the sorts of things we can detect from a kind of photograph of something,
just as we can assess the same about how things are (rightly or wrongly) de-
picted to be. These dimensions of meaning are radically separate. That we
are prescribed to imagine something—even pretty much as it is—does not
mean that we are able to detect or, indirectly, to see it. Neither does the fact
that we detect something mean that we imagine it accurately, or imagine it
at all. *A fortiori* vivid imagining: the vivacity of hallucination adds nothing
to its detective value; on the other side, the loud signal ring of a telephone
need induce no imagining of a voice, a caller.[18]

The mutual independence of depiction and detection is made more in-
teresting, however, by the very phenomenon investigated in this chapter: the
interactions of these basic dimensions of pictorial use. Briefly stated, depic-
tive use can assist detective use; reciprocally, detective use can enhance imag-

[18] The distinction between photo detection and depiction is clearly and forcefully made by Wal-
ton in "Transparent Pictures: On the Nature of Photographic Realism," *Critical Inquiry* 11 (De-
cember 1984): 246–77, e.g.: "We now have uncovered a major source of the confusion which infects
writings about photography and film: failure to recognize and distinguish clearly between . . . a
viewer's *really* seeing something *through a photograph* and his *fictionally* seeing something directly"
by its means (p. 254).

ining. This should not be surprising when we consider that, generally—not just pictorially—speaking, imagining can assist perceiving, and perception can heighten imagination. My main project in the next sections will be to explore one direction of this interaction: to see how photo depiction can assist detection. We will see that it does so mainly by providing *access* to the existing photo-detective content of images. As remarked above, we are greatly helped in understanding this point in the exposition by the currency of the idea of "user-friendly" interfaces, or modes of access, to computing machines. Although the terminology is relatively recent, the phenomenon is at least as old as photography itself. Indeed, thanks to photography, the interface of these two interacting technological amplifications of our cognitive powers was from the outset so close and ready, and has become so familiar from long use, that the object of the rest of this chapter and much of the next is to tease them apart, allowing their interaction to be better appreciated through recognition of their distinctness.

Interface Imaginings

The user-friendly access role that depictive imagining plays in the extraction of causal information from photographs of things may be clarified by considering recent examples from the wider field of imaging technologies. Graphic displays for detection devices are ancient; depicting pointers (arrows, hands) on gauges such as weather vanes are familiar examples. As highly technical detection devices become more complex and numerous, engineers have found it increasingly necessary to restyle their interfaces in graphic modes, the motive being not to achieve elegance but to avoid perceptual overload as the sources of information multiply. This phenomenon, which applies to airplane controls and to many other high-tech machines, is more generally familiar from controls on home appliances. The movement to graphics is clear in autos, where detection displays have become graphically simple—possibly too much so. An unlocked-door warning detector, for example, will often show a picture of a car with the corresponding door open; and oil, fuel, and light indicators are usually furnished with diagrams that make for easy identification. As personal computing markets expanded and the complexity of features rose competitively, graphics interfaces began to proliferate. These seek to make operation easier by depicting situations—unreal ones—

that "represent" electronic states of affairs. For example, in writing these lines I go through procedures that prescribe my imagining that I move pointers, press buttons, wipe surfaces, and the like, whereas no such mechanical actions are involved in the real working of the system. Few users of such devices would have the remotest ideas about what masses of machine states at dimensions that we have mentioned are being registered. No more do they know what is occurring in their own central nervous systems as they go about their affairs. Nor should they. These displays—"user obsequious," to hackers—work by enticing us to visual and motor instrumental imaginings which, unlike our photographic examples, do not even have the actual states and events they control as objects, much less have us imagine them correctly. Here we imagine mechanical actions not in order to detect them but rather in order to detect (global) electromagnetic machine states. This "world of WIMP (window, icon, menu, pointer) as representation" may well model what some metaphysicians tell us is the difference between sense awareness and reality. With their own bodies and their machine prosthetics, what users detect and act upon is a global situation expressed in familiar perceptual terms for familiar perceptual and motor operations. As enhancers of their users' powers, such machines need to be structured in terms of users' aims and existing capacities. Detections via graphic display states guide them in detecting real, not imagined, states and allow them to work better. Indeed, as computing processes become more numerous and intricate, we may expect the perceptual interfaces to simplify—perhaps becoming directly linked to the users and bypassing much surface display.

Compare such user-friendly devices with computer games, which exploit the same engineering arrangements, run in an opposite direction. There, rather than having a graphic display guide our interactions with an electronic system in order to guide that system toward helping us in some other task, the task loops back to the graphic situation, which is our sole interest in playing the game. All that actually happens is that electronic states and human imaginings change. (If one has doubts about the relevance of self-imagining participation with depictions, the experiences and behavior of players of these interactive games should dispel them.) In such games, detections of graphically imagined states guide us in producing further graphically imagined states, with no other interest directly in view. (Should these serve further functions—for example, by simulating real tasks—they would also serve additional interests.)

We are often free to treat photographs in a similar way. We can sometimes simply use them as depictions and forget that, as photographs, they allow detection of the things that made them. Very often, photography is used just as an efficient technology for producing depictive imagery, stimuli to imagining seeing. One may not know what was actually photographed, or know and not care. Detective values may not matter in much modern de-pictive-image generating, where a number of *non*photographic technologies are combined with photographic ones (and it is typical of imagemakers to combine technologies). One may simply not care what part of a billboard is photographic and what part not.

This investigation being introductory, we must limit ourselves to basic compounds of photo functions, yet we may at least indicate how further complexities of meaning could develop. A subtle chemistry occurs, for ex-ample, where we appreciate the very gap between what was photographed and what we are prescribed to imagine by the resulting image. The very fact that actual, detectable situations should lend themselves to such imagining can itself be meaningful—can indeed be the point of the picture. Humor-ous and satiric effects of the kind are a common currency of press photogra-phy. Photo artists' use of such tensions is also widespread.[19]

Slit Scan

From "elemental" photo detection, followed by the general phenomenon of depictive assistance to detection, we can turn to strictly photographic imagining interfaces, beginning again from pure photo detection and pro-ceeding to some familiar "compounds" of depiction-assisted photo-detec-tive use.

One of the earliest detecting and trace-recording photographic devices is attributed to T. B. Jordan, who, within two months of Talbot's presentation of his first, "photogenic," method, made a device "to record barometric pres-sures on a forty-eight-hour scale—the mercury [barometer] column occlud-ing light entering a window [in the apparatus] and thus resulting in a varying

[19] Barbara Savedoff develops this point with a perceptive use of examples in "Escaping Reality: Digital Imagery and the Resources of Photography," *Journal of Aesthetics and Art Criticism* 55 (Spring 1997): 201–14; and in her book *Transforming Images* (Ithaca: Cornell University Press, 2000).

area of darkening of the [photogenic] paper which was fixed to a revolving drum."[20] This nondepictive graphic arrangement is a forerunner of a very important class of detecting (or "taking") and recording photographic devices, chemical and electronic, which deserve separate attention. Since scanning is a matter of *relative* motion, it can be achieved by movement of either the source or the apparatus or both. As we see things best through motion, our own visual systems scan in all three ways. Our technological prosthetics imitate our own methods in complex ways. For example, aerial EO photo-survey systems may troll the ground below digitally by forward or "push-broom," scans (look ahead to Figure 10 in Chapter VI), but also by side-to-side "whisk-broom" or panning camera movements.[21] Machine vision then builds up a spatial report *sequentially,* rather as we do by touch. Much therefore depends upon powers to integrate such information.[22]

It is good to remember devices like these, based on those for chemical photography, since even thoughtful generalizing on photography (sampled in the first chapter), as well as common conceptions are dominated by the idea of the photograph as an essentially momentary, framed, shutter-controlled product. Early cameras were shutter-free and stood open to the light for hours, then minutes, with many informative and beautiful effects. Even with faster films this long-exposure method is still useful—for example, in astronomy—to detect extremely slow (for us) relative motions. Later nineteenth-century scanning cameras were used for architectural, topographical, and group photography. In another common scanning technique called "painting with light," large interiors can be photographed by playing directed light in scanning paths over the darkened surfaces while the stationary camera's shutter stands open. Looking at such pictures, we are not able to experience them as integrated scanning outputs over a period of time, possibly not even a continuous period. We may even see them without reference to "taking" times or sequences at all, any more than we would see architectural renderings of the same structures in those terms. Taking time and depicted time (if any) are often unrelated.

[20] H. J. P. Arnold, *William Henry Fox Talbot: Pioneer of Photography and Man of Science* (London: Hutchinson, 1977), p. 118.

[21] Maver et al., "Aerial Imaging Systems," pp. 432–33.

[22] Blind people sometimes use canes in the whiskbroom manner as they move along a path. For an introduction to the difference between touch and sight recognition of objects, in terms of sequence and integration, see Oliver Sacks, "To See and Not See," *New Yorker,* 10 May 1993, pp. 59–67, esp. pp. 64–65; rev. in Oliver Sacks, *An Anthropologist on Mars: Seven Paradoxical Tales* (New York: Vintage, 1995), pp. 124–25.

One familiar slit-scan device particularly useful for acquainting us with the interaction of depictive and detective functions of photography is the photo-finish camera, which produces images like that shown in Figure 8.[23] Like Jordan's early barometer recorder, this device traces changes at a source sequentially as these are registered across a moving film strip. Earlier focal-plane camera shutters scanned scenes with a moving exposure slit. Since about 1947 the photo-finish slit-scan has featured a stationary slit; it is the film that moves. The camera lens forms an optical image of the whole area at the finish line of a race, but that falls on a mask through which a narrow slit (typically, .1 or .2 mm wide) allows only the part of the camera image exactly along the finish line to reach the film that is moving behind it. There it produces the chemical image that we see. As racers—or parts of racers—cross that line, they smear their optical imprints on a film strip running smoothly for their average rate behind the mask. Here is a striking example of the important difference between camera optical images and the photo images they are employed to produce (see Chapter VI). In the resulting photo image all that is represented is a sequence of conditions at the finish line. Places along the length of the film represent a sequence of states at that finish line; vertical places on the strip represent spatial positions there at a time. When we look at such images we *detect* the arrival and departure of different parts of racers at the finish line, in an ordered sequence of times. The function of the device, after all, is double. Primarily, it is to register in exact sequence the arrival events of the passing parade. But it must also make this information visually accessible to the judges, projecting it down into their box after quick development. For racing purposes, we do not want to know the relative spatial positions of the racers at any given moment or thin slice of time, as in a flash picture. Our bets are on the relative *temporal* positions of at least three racers at one thin slice of *space*—the finish line.

Should this seem a strange or paradoxical way of photographing, we might make it more familiar by likening the photo-finish image to a bus or rail de-

[23] The example of photo-finish photography works is owing to Joel Snyder and Neil Walsh Allen, "Photography, Vision, and Representation," *Critical Inquiry* 2 (1975): 143–69, esp. p. 157 with fig. 5. I used the example in Maynard, "Talbot's Technologies," *Journal of Aesthetics and Art Criticism* 47 (Summer 1989): 263–76. Technical information about its use was very kindly provided me by Norman Millward of Racetech (Racecourse Technical Services Limited), London, and I am grateful to Justine Phillips of Racetech for much help. Photographic literature is strangely silent about this importantly revealing technology—even literature devoted to sports-timing photography. For a brief interview with Millward, see Tony Lynch, "Photo Finish," *Amateur Photographer,* 4 June 1988.

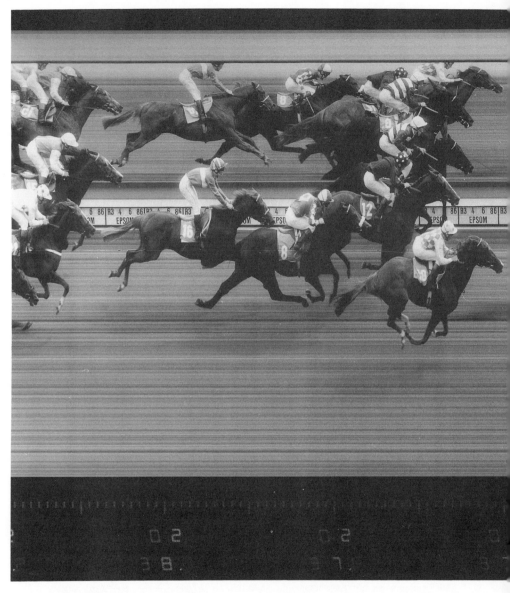

Fig. 8. Racetech, Epsom Derby Race. Courtesy of Racecourse Technical Services Limited.

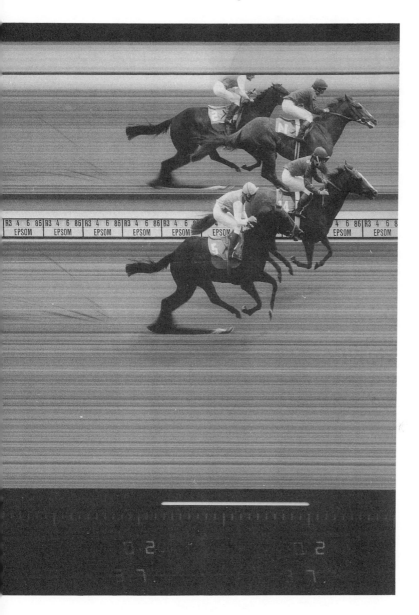

parture board. Reading such a schedule, we have a fixed place (station) and follow a linear sequence of times of departure of different moving objects, just as in the photo-finish picture. Such is the normal mode with such schedules. The public does not usually care to see a schedule that, like the standard photograph, shows different vehicles at different places at a fixed time. What commuter wants to know where all the trains on the line are at eight o'clock? That is a kind of information that only those monitoring the operations would likely need.[24]

Imagine a cartoon film (categorical prescription) in which, horse races being as dependable as trains, a fast horsefly looks at the last race photo finish for those horses as a departure board in order to find precisely when, from the finish line "station," it could hop a ride—and on what sections of its vehicles. Horses being more flexible than trains, some sections will be moving faster than others, relative to the ground and to the prospective passenger. This can be discerned by examining the photo-finish picture. The shorter the horizontal mark a feature makes on the film, the less time it spent at the finish line: hence the faster it was going. The longer the mark, the longer it lingered there. For notable example, a horse's hoof planted on the ground at the line will linger there longer than the leg it supports, thereby producing a wider image. Indeed, a horse's foot may cross the line, return back through it, cross it again. Thus we can detect from such images not only speed but also the direction of motion of parts of racers.[25]

That such visual extraction of information may take study, even laborious inference, brings us back to the general theme of using *depiction* as an access mode to detection. It was the operator's setting of the film's scanning speed that made the runners' optical smears look anything like a *picture* to us in the first place. Film-rolling rate for a horse race might be five centimeters per second, in a mechanism adjustable between one-twelfth and four times that speed. Run the film faster or slower and a funhouse mirror effect emerges—

[24] For a fascinating treatment of such displays, see Edward R. Tufte, *Envisioning Information: Narratives of Space and Time* (Cheshire, Conn.: Graphics Press, 1990), esp. pp. 24–25, 104–5.

[25] Streaks along the ground are caused by dark points at the finish line scoring their images across the moving strip. The continuous repeat of the race place and date is traced flat on the film by print on the circumference of a spinner device turning around the winning post, making its mark in the manner of an ancient cylinder seal. Readers can work out why the more distant horses, as well as the mirror or blind-side reflections of the finishers, are more elongated, while the near horses' images are somewhat compressed.

one that artists have used for their own purposes.[26] Run it still faster or slower and we do not get the picture at all. Why set the speed at the average rate of the objects, when at different speeds the detective information would be much the same? In fact, with sufficient exposure time, a very fast film motion might actually assist computer data analysis. The answer, for the slit-scan photograph as for satellite and rocket telemetry, is that *we* will be able to recognize and judge objects and events better if we can treat the images as depictions of them: that is, if we can access them visually by *imagining* that our seeing of the images is instead a seeing of the represented scenes. As the eye-to-brain channel is the most complex data-processing system we know of, it makes very good sense to mobilize its prodigious abilities by presenting the data to it as though it were seeing the scene.

Thus the peculiar, intriguing "chemistry" of this most revealing photo-technology. Watch now the "chemical" activity of the constituents as our interests change. At the time of a race, economic interests in fast posting of results may push in the direction of less fine electronic recording. After a race, however—even years later—newspapers, horse owners, or track enthusiasts may want photo-finish images as portrayals of the event or of individual horses. Since the middle 1980s, color photography has become the mode, and such interests also push in the direction of nondistorting camera rates.

As it is our general principle that technologies are amplifiers/filters of our powers, and since we are now thinking of photographs of things as, generically, interactive uses of both imagining technologies and detecting technologies, we need to consider not only the enhancements but also the suppressions typically involved. There are many problems inherent in the "imagining seeing" access to visual detection, and popular as well as theoretical criticism of the photograph and its "truth" or "authenticity" would greatly benefit from approaching the subject this way. It would at least provide a structure, and some rudimentary distinctions, to slow the equivocal slides that constitute most such discussions. Perhaps the most common issue is when, and to what extent, the imagining seeing that photographs of things prescribe (or is it the kind we insist on doing?) carries us *away* from the visual detection that they allow. The idea that "photographs never lie," unclear as it is, is probably more a generalization to the effect that they do

[26] See, e.g., *Special Problems,* Life Library of Photography (New York: Time-Life Books, 1971), p. 140.

carry much information about what they are photographs of than it is to the effect that when we look at them pictorially, with any care, we will extract just that information and not be deceived in attempting to do so. The photo-finish example, though unusual in some ways, is quite usual in others. It dramatically demonstrates what we know from many other kinds of photos of things: for example, of the snapshot in which someone blinks, where what is *recorded* on the surface (a blink) may be different from what the picture would have us *imagine* we are seeing (a person of reduced capacities).

With these clear and memorable cases of photo detective-depictive compounds before us, let us return to the wider context of imaging technologies. As I have insisted from the first two chapters on, to be philosophical about photography we must persist in trying to understand it in this wider context. To understand photography as an imaging technology, we must get a better grip on what imaging technologies generally are.

Seeing Machines

Those scanning examples were introduced for several reasons. Perhaps the most important and most familiar scanning technologies today that allow detection via vivid depiction are medical.[27] The computer revolution that made them possible coincided with the popular camera innovations of the 1970s and 1980s (Chapter I). For example, the CT (computerized tomography) X-ray scan came into practical use in the 1970s, and the MRI (nuclear magnetic resonance imagining) in the 1980s. These and a battery of other imaging technologies—including ultrasound, DSA (digital subtraction angiography), radioisotope emission imaging, and fiber optics—provide literally graphic examples of what I mean here by compound depictive detection. It is normal to describe the outputs as "showing in picture form"—that is, as *depictions* and *pictures*—images that allow medical workers to detect, inspect, locate, identify, and study organs, structures, blockages, growths, warning signs. Practitioners and engineers normally speak of these tech-

[27] Among useful popular presentations of these for the late 1980s is Howard Sochurek, "Medicine's New Vision," *National Geographic* 171 (January 1987): 2–41. For a more thorough and technical review at the same time, with emphasis on "trade-offs," see Louis K. Wagner, Ponnanda Narayana, and Robert C. Murry Jr., "Medical Imaging," in Sturge, Walworth, and Shepp, *Imaging Processes and Materials*, pp. 497–566.

nologies as allowing us to look and to see within the body, just as stethoscopes allow us to hear sounds within it. Notwithstanding our emphasis on depiction as access to detecting, the emphasis here on perceiving—albeit indirect perceiving (for one looks *into* a body by looking *at* a surface, screen, display)—may seem inconsistent with depiction; it may seem paradoxical to describe the medical specialist's activity both as seeing an area of soft tissue and also as imagining seeing the area. If one is already seeing it, why also imagine seeing it? A moment's thought should show that there is no paradox. What one sees directly is the image on a screen. One only imagines seeing directly what the screen displays, an organ within the body—imagines that the seeing of the screen *is* the seeing of the organ. Still, one does (indirectly) *see,* not just *detect,* the organ. Reflexive imagining about what one is doing is a common activity, and its purposes may be entirely practical. The product of the activity here is the imagining that an indirect seeing *is* a direct seeing.[28] The whole point of that is to achieve a user-friendly interface for an overwhelming cascade of digital information, most of which would be of no interest. For example, the precession or axial wobble rate of hydrogen nuclei in a magnetic field is not of medical diagnostic interest, nor is the fact that the wobbles produce faint but detectable radio signals. What they show about the location of hydrogen, hence water—hence tissue density, nature, and form—*is* of interest, vital interest.

Such examples have us now speaking of *seeing* things, states, structures, processes by means of imaging technologies, whereas previously we spoke only of detecting them. At what point does visual detection by means of photography, or other imaging technologies, qualify as (indirect) seeing? I find no difficulty in calling such depictive visual detection "seeing"—in saying that by means of the Walker Evans photo (Figure 1) we not only imagine but actually, though indirectly, see a freckled girl leaning against a rough doorway as caught in a shaft of sunlight some decades ago. Seeing things and, as here, events and states of affairs is one kind of visual detection, but not every kind. Often we may see *that* some situation obtains without seeing it or the things it concerns. A technologist looking at an MRI screen can see that pro-

[28] This point was first argued, clearly and systematically, in Walton, *Mimesis*, p. 330. I adapted it to current technologies in Maynard, "Seeing Double," *Journal of Aesthetics and Art Criticism* 52 (Spring 1994): 166 n 18. As remarked in the preface, this chapter owes much to Walton's discussion of photography in *Mimesis* and to his more extended treatment of the topic in "Transparent Pictures."

tons are precessing, that the magnetic field is varying in a certain way, that the radio frequency (RF) coils are sending out pulses at the right frequencies—all without, perhaps, seeing protons, magnetic fields, RF pulses. Still, some things in the situation can be directly or indirectly seen, not just visually detected.

Similarly, by related technologies, some things can be heard. By means of modern technologies it is possible for physicians to listen to, say, heart actions as well as to see them—and we all know from television programs that these sounds may be amplified for operating rooms. Just as events and things from the past can now be seen with photographs and other imaging records, past events and things can now be heard by means of recording technologies. Thanks to the early sound-recording technologies developed by Bell, Edison, and Berliner, we are now able to hear the voices of late nineteenth-century people, to hear them speaking or singing. After several "practical" applications, musical recording by the early 1900s had become a popular form of entertainment. We are therefore today able to hear Enrico Caruso singing in 1902, just as we are able to see him in a variety of photographs (some of which include the Automats he mugged for). In neither case do we perceive him directly: we have not only to hear or see something else to perceive Caruso indirectly but to interpret those perceptions in certain ways. Doing so is normal for much of our perceptual experience. Not being able to see directly a warbler in a tree canopy, we can still see the leaves that obscure it and thereby detect it—that is, indirectly see it and its activity—if we can "read" the characteristic motion in the leaves which carries the specific information of warbler—as opposed to that not only of a tenor but of sparrow or vireo—activity.

We have already noted that the processes of detection by indirect seeing are enhanced by imagination: we imagine *of* our own indirect seeing that it is a more direct seeing. Probably there would not be much popular market for sound recordings if, by their means, we managed only to detect or indirectly to hear people singing—to perceive *that* they were singing certain things in certain ways! As much as in the visual examples described in Chapter IV, the necessary, enfolding act of imagination concerns our favorite objects of imagining, *ourselves*—imagining that our perceptual process is one of hearing Caruso's voice. That act or attitude contains another imagining experience, the dramatic one that he—like the popular singers of later decades—must incite in us. The first act turns out to be easy, thanks to tech-

nology. It is easy because recording engineering has developed these detection and recording devices precisely so that it would be difficult for us to do otherwise, once their signals are delivered to our hearing or to our sight. As we hear the recording or see the photograph, we participate; we imagine about ourselves that our act of perceiving that artifact is the act of perceiving what it depicts. How and how well we hear Caruso on a recording or see him in a photograph is of course a moot question, but one of a different order.

The history of photo-technology, as basically a *materials* technology, differs from that of its younger cousin in having struck on miraculous materials, silver halides, that disclosed their unrivaled image-making powers (the world's largest use of silver is in the photographic industry).[29] Sound recording technology did not share such singular luck.

This discussion of seeing and hearing (or "talking") machines leads into some contentious issues about the nature of photography and about our uses of it. Whatever the other uses of photography, there can be no question that from their inception photo-technologies have been used to produce depictions by means of which we detect and even see things and events—that is, as amplifications of our powers of visual perception. As amplifiers, they are of course filters, suppressors, of various of our powers. Much of the cultural criticism of photo-technological uses can be put in terms of what photography does for us or to us, of what it cannot do or do very well, and the uses that both these characteristics are put to. We have already observed that "photography" or "photographs" as a whole are often set out in these terms (though sometimes one species of photography or of photographic use is so described).

With amplification/suppression in mind, it is useful to compare how the advent of *digital* processing of photographs was greeted, as opposed to processes in medical and engineering imaging. Fears were immediately expressed about the potential manipulation of photo images for news, historical, forensic, political, or advertising purposes, without recourse to a stored original for comparison.[30] By contrast, "image processing" is the routine term for a generally observed *advantage* of electronic-optical imaging over

[29] Arthur Street and William Alexander, *Metals in the Service of Man,* 10th rev. ed. (London: Penguin, 1995), p. 220.
[30] E.g., William Mitchell, *The Reconfigured Eye: Visual Truth in the Post-Photographic Era* (Cambridge: MIT Press, 1992). It would be easy to assemble a file of press clippings on the subject.

the photochemical in the technical literature of engineering. The sorts of medical imaging considered here provide good examples. Conventional chemical film-screen X-rays, with their high spatial resolution (about four to ten line pairs per millimeter), continue to be the basis for this kind of detection. Among their limitations, even suppressions—part, that is, of their "trade"—is the comparative difficulty of processing: that is, enhancing, especially with regard to significant contrast. Whereas film contrasts are relatively fixed, digital displays allow wide latitude for software operations that adjust brightness contrasts between images of neighboring kinds of tissues, making them more accessible to our view.[31] We are not so concerned about the uses of these devices for medical diagnosis, for the same reason that we are not so concerned about the use of Roentgen's rays in the same contexts. One does not claim infallibility for medical diagnostic imaging—or for any process—but still, there is real power of detection, as all the contexts are strictly constrained.

It is important to note that by the very nature of these technologies, background conditions regarding what I have called the source are very well known. The medical specialists who use them are specifically trained as to these sources. Our power to make detections by just looking at photographs and like images—indeed by looking at anything—*always* depends upon background information regarding sources, as well as about our channels of perception. In the austere terms of communication theory, "signals" carry information about sources through their exclusion of some of the relevant states those sources may be in. Given a set of such possible states, the more of these it rules out, the more information a signal carries. Much of the diagnostician's training, then, is technical training in the relevant possibilities. Furthermore, the diagnostician will routinely possess source information based on other procedures, including records from other detection systems. It should also be noted that in diagnostic imaging the often high-tech channel is itself closely monitored, its conditions set and registered by feedback controls. Finally, the image's conditions are usually technically restricted, and more specialized technical training is required for the art of interpreting it to derive very specific kinds of information. Just these conditions, as they exist for medical and other kinds of specialized imaging, stand in marked contrast to our usual fare of detection-directed photography and similar modern im-

[31] Wagner, Narayana, and Murry, "Medical Imaging," p. 505.

age-taking, -storing, and -displaying systems. With such advances in image technology, old worries about photographs of things having, besides the functions of depicting and detecting, a third "d," *deceiving,* are joined by new worries about digital deception—ironically, referred to as "doctoring."

By first separating the depictive and detective functions of photography, then showing some of the familiar ways in which they are combined, we have represented imagining seeing as an amplification of our powers to detect situations on the basis of surfaces we have contrived to let them mark. For strict purposes of detection from images, pictorial access has hazards. Notably, it has its own *momentum,* which may overwhelm and misguide our attempts to extract the information the image contains. The familiar example of editorial cropping and framing shows how characteristically pictorial meanings can control detective use. The expert accounts of such control need to be more widely read and considered.[32]

[32] An excellent treatment by a picture editor is Harold Evans, *Pictures on a Page* (New York: Holt, Rinehart & Winston, 1978); an interesting account of photographic rhetorical effect is Vicki Goldberg, *The Power of Photography: How Photographs Changed Our Lives* (New York: Abbeville, 1993).

PART TWO

❧

PHOTO FIDELITIES

CHAPTER VI

ੴ

In Praise of Shadows

"Fixing the Image"

The idea of marking prepared surfaces with light is clever in several ways (Figure 9). Sunlight need not be produced or extracted. It is ready, abundant, renewed, and free—mischievously effacing all our other markings, as well as its own. Of course, photography makes of light something more than a nanometer-fine grained paint. The flux of light that reaches a surface at any of its regions is already delicately structured, usually carrying inexhaustible analogue fields of environmental information, out of which sentient creatures pick their limited, perhaps digital, reports. On any surface the light may form a real image: a state at that part of the surface which physically affects it. There is little question that the first inventors of photography understood such images as already existing and considered their engineering challenges as finding ways to improve them optically and, especially, finding ways to fix them permanently at those surfaces—for the further uses that we have been considering, though mostly for depiction.

Such is their unanimous testimony, as we can see by running through some of the famous names considered in Chapter II. Wedgwood and Davy reported in 1802 that "the first object" of Wedgwood's researches had been to "copy" the "images formed by means of a camera obscura."[1] The signed

[1] Wedgwood and Davy, "An Account," in Newhall, *Photography: Essays & Images,* p. 16.

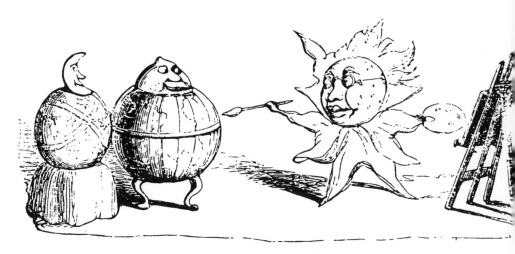

Fig. 9. George Cruikshank, Sun Drawing.

agreement of December 1829 between Niépce and Daguerre formally described the elder partner's discovery as a means for "spontaneous reproduction of images obtained in the camera obscura."[2] Niépce's early advertisement, "Notice on Heliography," described it as a means for "automatic reproduction by the action of light, with their gradations of tones from black to white, of the images obtained in the camera obscura." The bill before the Chamber of Deputies ten years after the agreement claimed that "Daguerre has at length succeeded in discovering a process to fix the different objects reflected in a camera obscura," and Arago's title for the scientific presentation was "Fixation des images qui se forment au foyer d'une chambre obscure."[3] The French press announcements earlier that year regarding the "prodigious" discovery reported that "M. Daguerre has found the way to fix the images which paint themselves within a camera obscura," while the English referred to "fixing images of objects by the camera obscura."[4] As for Talbot, he early described his experiments to Herschel with these words: "Having a paper to be read next week before the Royal Society, respecting a

[2] Quoted in Goldberg, *Photography in Print,* p. 27. The line from Niépce's "Notice" is trans. in Eder, *History of Photography,* p. 218.

[3] Goldberg, *Photography in Print,* p. 32; *Comptes rendus* 8 (7 January 1839), cited in Schaaf, "Herschel, Talbot, and Photography," p. 204.

[4] *La Gazette de France* (Paris, 6 January 1839); and *London Globe,* (23 August 1839), rpt. in Newhall, *Photography: Essays & Images,* pp. 17, 19.

new Art of Design which I discovered about five years ago, viz. the possibility of fixing upon paper the image formed by a Camera Obscura, or rather, I should say, causing it to *fix itself,* I should be happy to show to you specimens of this curious process."[5] The paper he delivered announced that his main object had been to "retain upon paper," as he put it, "the beautiful effects which are produced by a *camera obscura*": that is, "the vivid picture of external nature which it displays."[6]

This way of thinking persisted. The *Edinburgh Review* article of 1843 credited Talbot with having, before 1834, "overcome the difficulty of fixing the images of the camera obscura."[7] In 1871 the famous American daguerreotypist Albert Sands Southworth claimed that prior to Daguerre's success, the artist and inventor Samuel Morse had attempted "to fix the images as seen in the camera obscura."[8] In recent times an eminent photo historian has referred, more circumspectly, to "photography in the established meaning of the word—permanently fixed images of the camera"[9]—presumably meaning by "image" the photographic, notably chemical, state of the surface rather than the optical one. A point about early terminology might further emphasize the important difference between the optical—camera—image and the photochemical one, a difference often blurred in such contexts. Herschel, not Talbot or Daguerre, is celebrated as the discoverer of the standard material for permanent photochemical stabilizing: "hypo" (sodium thiosulphate), which he correctly called a "washing out" agent, as compared with Talbot's far less successful, ultimately discouraging, method of simply stabilizing his halides, which were left in place to do mischief on the photo surface.[10] The image "fixed" here is clearly the photochemical, not the optical one.

[5] Quoted from the Royal Society collection of letters in Schaaf, "Herschel, Talbot, and Photography," p. 185. Herschel replies in the same terms: "your curious process for fixing the images formed by a Camera obscura."
[6] Talbot, *Some Account of the Art of Photogenic Drawing* (London: R. & J. E. Taylor, 1839), rpt. in Newhall, *Photography: Essays & Images,* p. 28.
[7] Quoted in Goldberg, *Photography in Print,* p. 54.
[8] Albert Sands Southworth, "The Early History of Photography in the United States," *British Journal of Photography* 18 (November 1871); rpt. in Newhall, *Photography: Essays & Images,* p. 37.
[9] Gernsheim, *Origins,* p. 6.
[10] This point is emphasized by Larry J. Schaaf, in "Souvenirs of the Invention of Photography on Paper: Bayard, Talbot, and the Triumph of Negative-Positive Photography," in Naef, *Photography: Discovery and Invention,* p. 36. Since daguerreotypes were developed by exposure to mercury vapor, they needed no such "fixing," as those metal vapors are not present in most environments.

Perhaps the best and fullest account of the earlier conception of photography is Talbot's, in *The Pencil of Nature*. Reflecting, as many have, "on the intimitable beauty of the pictures of nature's painting which the glass lens of the Camera throws upon the paper in its focus," Talbot had an idea, his classic statement of which is worth quoting at length:

> The idea occurred to me . . . how charming it would be if it were possible to cause these natural images to imprint themselves durably, and remain fixed upon the paper! . . . The picture, divested of the ideas which accompany it, and considered only in its ultimate nature, is but a succession or variety of stronger lights thrown upon one part of the paper, and of deeper shadows on another. Now light, where it exists, can exert an action, and, in certain circumstances, does exert one sufficient to cause changes in material bodies. Suppose, then, such an action could be exerted on paper; and suppose the paper could be visibly changed by it. In that case surely some effect must result having a general resemblance to the cause which produced it: so that the variegated scene of light and shade might leave its image or impression behind, stronger or weaker on different parts of the paper according to the strength or weakness of the light which had acted there.[11]

There are several steps to this process of thought. The existing camera (optical) image is already understood as a "picture." In order to invent photography, however, one must for a time forget about pictures (one important use of photo images) and think only of a physical, optical image—notably as an array of "light and shade" on a surface. Next, this array must be understood as a causal agency. The differences of light intensity on the surface should be able to produce correspondingly different and "visible" changes on that suitably prepared surface. The result, taken as a whole, would be a photo image, with "a general resemblance to the cause which produced it"—that is, to the optical image on the surface.

It is very important to mark this qualification. The resemblance sought and attained would be only "general," as a two-dimensional structure of dark

[11] Talbot, "Brief Historical Sketch of the Invention of the Art" (n.p.), in *The Pencil of Nature*. Niépce's brief account is also noteworthy: "The invention which I made . . . consists in the automatic reproduction, by the action of light, with their gradations of tones from black to white, of the images obtained in the camera obscura," see "Notice sur l'héliographie" (1829), trans. in Eder, *History of Photography*, p. 218.

and light. This is above all because, as we know, the direct chemical result for Talbot would have been a *negative* image. Talbot acknowledged this but pointed out that for his early superposition photogenic drawings (see Figure 2), structural resemblance was all that was required. "A negative image is perfectly allowable," he wrote, "the object being only to exhibit the pattern with accuracy."[12] The image would also have been lacking in variety of color (another early embarrassment), movement, and fineness of the optical image, and lacking as well the range of brightness differences in the camera image cast on the paper. Furthermore, as earlier remarked, the first inventors soon realized that the "visible rays" by which they saw the camera image (as they peeked into their slow-acting boxes, like someone looking in an oven to see the baking) were not of quite the same class as the short wavelength "chemical" rays that actually did the photographic job. Again, although the brighter and darker parts of an optical image form simultaneously, their photo images do not. Talbot's mild observation that "white china and glass do not succeed well when represented together, because the picture of the china, from its superior brightness, is completed before that of the glass is well begun"[13] might stand for a multitude of important technical challenges that have driven film and filter technologies. Although these improved steadily along technological lines, information "degradation" along every imaginable scale,

[12] Talbot, *The Pencil of Nature*, note to Plate XX, "Lace." Admiration of the optical image seen on the camera-focusing screen is common among photographers. See, e.g., Peter Henry Emerson's remarks excerpted in Newhall, *P. H. Emerson*, p. 28: "This picture [on the ground glass] gives me far more aesthetic pleasure than the final photograph itself" (from "An Ideal Photographic Exhibition," *Amateur Photographer*, 23 October 1885, pp. 461–62).

[13] Talbot, *The Pencil of Nature*, note to Plate IV, "Articles of Glass." Again, if the optical image is formed virtually instantaneously, the photographic image is not. This was particularly true for early processes; thus a fictional but correct account: "I have a print . . . of a photograph of the village street of Thetford, taken in 1868, in which William Smith is not. The street is empty. There is a grocer's cart and a great spreading tree, but not a single human figure. In fact William Smith—or someone, or several people, dogs too, geese, a man on a horse—passed beneath the tree, went into the grocer's shop, loitered for a moment talking to a friend while the photograph was taken but he is invisible, all of them are invisible. The exposure of the photograph—sixty minutes—was so long that William Smith and everyone else passed through it and away leaving no trace. Not even so much of a mark as those primordial worms through the Cambrian mud of northern Scotland and left the empty tube of their passage in the rock" (Penelope Lively, *Moon Tiger* [London: André Deutsch, 1987], p. 13). One finds this effect in photo histories' reproductions of Daguerre's "Two Views of the Boulevard du Temple, Paris" taken in 1838. See these and Samuel Morse's comments on the invisibility of moving objects in Newhall, *History of Photography*, pp. 16–17, and again in "Eighteen Thirty-Nine: The Birth of Photography," in Naef, *Photography: Invention and Discovery*, pp. 24–25.

as an entropy effect, was unavoidable. One might consider much of the subsequent engineering as involving attempts to reduce such degradation.[14]

Even with modern chemical and EO receptors, the brightness ranges of a natural scene and that of a photograph, even a projected one, will differ greatly. As is often pointed out, it is thanks to "constancy" scaling that we can take the lightest place on a printed surface as equivalent to a source many thousand times brighter. Again, we have already seen that camera mechanisms, such as scanning arrangements, can make photo images literally *incongruous* with the camera images from which they are made (Figure 8). Talbot called the chemical, photographic image an "imprint," "impression," "image" of the optical image, like a foot- or handprint on a surface. Such impressions, we know, may also involve not only reversals but also slides and smears due to relative motion. The racing photo finish serves as a good reminder of how misleading it can be to think of photographs simply as fixed camera images.

Though *use* of the 'fixed' images is clearly implied by the context, Talbot correctly omitted mention of it from the long passage quoted above as not being part of the physical process to be effected. At least initially, most people would have had difficulty using Talbot's tiny, negative, mirror-reversed (for want of later optics) camera imprints *as pictures*—that is, for spontaneous imagining seeing. It was some time before he could produce positive prints from them (and thereby also correct the mirror reversal), and he admitted that "the negative images of such objects are hardly intelligible."[15] The camera image should not be identified with the photo image, therefore, either as a physical situation *or* in use as a picture of something; rather, as Talbot says, it is the "cause" of the photo image. Thus we can say, with a recent writer, "The optical image of the physical world imprints itself mechanically upon the sensitized surface,"[16] so long as we clearly distinguish the two images: the optical one and its imprint, both of which are physical states of surfaces, parts of which we can see under certain conditions. Thus if we look to the photo image to detect something about what, in turn,

[14] See John B. Williams, *Image Clarity: High-Resolution Photography* (Boston: Butterworth-Heinemann, 1990), chap. 5, "Theory of Image Degradation."

[15] Talbot, *The Pencil of Nature,* commentary on Plate XX, "Lace."

[16] Rudolf Arnheim, "Melancholy Unshaped," *Journal of Aesthetics and Art Criticism* 21 (1963): 291–97; rpt. in Arnheim, *Toward a Psychology of Art* (Berkeley: University of California Press, 1966), p. 182.

caused the camera or optical image—notably, features of the original scene—
the camera image can be considered part of the optical channel. But if we
look to the photo, as we often do, to detect something about the *camera* im-
age itself (notably, whether it was focused), we consider *that* image as a
source. The "photo" image is therefore different from the "graphic" one, and
in discussing the uses of photography we have been all along concentrating
on the latter. Yet though it is different from the optical image, the latter is
still, as Talbot says, caused by it, and also of "a general resemblance to the
cause." It would scarcely be of use otherwise.

This reminds us that we have a rendezvous with *photo-optics*. No account
of photography—especially none treating it as technology—should leave out
at least an introductory account of photo-optics, and we now have additional
reasons to present such an account. An understanding of photography as an
amplifier/filter of our powers of depiction and our powers of visual detec-
tion would have to include an account of photo-optics—especially an ac-
count that reveals it to be itself essentially a matter of *physical* amplification
and filtering of the light flux. In considering photo-optics we must keep three
orders distinct: first, the real *optical images* in cameras; second, the *photo-
graphic images,* chemical or electronic, that they produce; third, the *photo-
graphic depictions,* if any, that such photographic images are used to present.
The first distinction is much the message of this section; the second has been
a continuing theme of the preceding chapters. Mixing up pairs of the three
is to be avoided. Any unargued slide from the characteristics of one of these
items to those of another should be identified for what it is: an equivocation.
It is only by drawing and maintaining such distinctions that we can keep
clear of the confusions that have long afflicted conceptions of photography.

Shapes and Shades

From their earliest days, photographs have frequently been thought about
in connection with *shadows*. This useful assimilation is worthy of further ex-
ploration. The connection between cast (as opposed to "attached") shadows
and the optical images by which we make photographs is intimate, as has
also been observed from the beginnings of photography. Daguerre promot-
ed his invention in *Magazine Artiste* as follows: "The plate is exposed to light
and at once, whatever the shadow projects on this plate, earth, or sky, run-

ning water, the cathedral lost in the clouds, . . . all things big and little en-
grave themselves instantly."[17] Talbot referred to the darker tones in the cam-
era image as "shadows" (although they would not literally have been, for the
darker parts of a camera image are not formed by blocking out parts of the
projected light). Again, "The Art of Fixing a Shadow" was Talbot's memo-
rable title for a short section of his early account.[18] There, "shadow" could
bear its literal meaning, since the "art" in question at that point of his expo-
sition included only superposition (or contact) printing, whereby the items
photographed do affect the receptor via their shadows. Indeed, his beginning
experiment was "to set the paper in sunshine, having first placed before it
some object casting a well-defined shadow" (23). His first "applications" in-
cluded printing of silhouettes and of slide projections, all of which—like
Niépce's earlier photoengraving and later blueprinting, X-ray imaging, and
so on—work strictly by cast shadow: that is, by filtering projected light. As
direct shadows and camera optical images produce photographs by the same
photochemical or photoelectric processes, their affinity can help us under-
stand photographs, particularly photographic *depictions*.

It seems hardly possible that people would have followed Talbot's direc-
tions for camera photographs and *not* treated the resulting "impression" of a
"variegated scene of light and shade" *depictively:* that is, not spontaneously
imagined the seeing of it as the seeing of a real scene, often of the situation
before the camera that caused the optical image. (I say "people": animals look
at such images uncomprehendingly, but not for lack of visual acuity.) To reaf-
firm our distinction between photographic images as physical existents and
their use as depictions, "pictures of" things, consider their shadow cousins
(Figure 10). Shadows are in many ways like the camera images that produce
photographs, and in many ways like the photographic products themselves.
The edge of an area of unmelted frost or snow on the surfaces of a roof or
lawn will coincide with that of the shadow whose image it is, for shaded and
unshaded areas are real states of light on the surfaces of things, brought about

[17] Quoted in Beaumont Newhall, "Eighteen Thirty-Nine," in Naef, *Photography: Discovery and Invention,* p. 23.
[18] "The phenomenon which I have now briefly mentioned appears to me to partake of the char-
acter of the *marvellous,* almost as much as any fact which physical investigation has yet brought to
our knowledge. The most transitory of things, a shadow, the proverbial emblem of all that is fleet-
ing and momentary, may be fettered by the spells of our '*natural magic,*' and may be fixed for ever
in the position which it seemed only destined for a single instant to occupy" (Talbot, "Some Ac-
count," p. 25).

by the projection of light upon surfaces. Shadows may be still or in continual flux. We think of shadows shrinking and growing as they change direction during the course of the sun's diurnal motion. Shadows flicker, move across surfaces, deepen or darken. They can be colored. They can be solid (though the shadow of a glass on a table reminds us that they need not be); they can cross one another; and lights may be cast on them. They can be sharp or indistinct and are subject to distortion. They may *resemble* the things that cast them as 2D projections from 3D situations. They also clearly fit the two photo functions discussed in the last chapter: detection and depiction. As Dante's words remind us, we can notice objects and detect the sorts of things they are, by looking at their cast shadows:

> I had already parted from those shades [*ombre*]
> and was following the footprints [*orme*] of my leader
> when behind me, pointing his finger, one of them cried out,
> "See, the sun's rays do not seem to shine
> from the left side of the one below,
> and as one who is still alive he seems to carry on."
> I turned my eyes to the sound of these words,
> and saw them gazing at me in marvel,
> at me alone, and at the light that was broken.[19]

There is a similar passage in the *Mahabarata*.[20] By perceiving shadows, we often detect states of the things that cast them. *Occasionally* we use cast shadows for *depiction,* for imagining seeing. Indeed, not just for photography, but for depiction itself, these familiar uses of cast shadows suggest how far one could have gone into the subject of pictures on their very modest budget. If

[19] Dante, *Purgatorio* 5. 1–9, trans. for author by Ausonio Marras, with, for our purposes, a literal rendering of *orme* as "prints" rather than "footsteps." The Italian reads: "Io era già da quell' ombre partito, / e seguitava l'orme del mio duca, / quando di retro a me, drizzando 'l dito, // ua gridó: <<Ve' che non par che luca / lo raggio da sinistra a quel di sotto, / e come vivo par che si conduca!>> // Li occhi rivolsi al suon di questo motto, / e vidile guardar per maraviglia / pur me, pur me, e 'l lume ch'era rotto." The last phrase does not say "shadow," but at line 34 Virgil remarks, "They stopped because they saw his shadow [*ombre*]." As Dante is here being quite explicit about latitude and time of day, we are probably supposed to infer that he is headed west, along the north face of Mt. Purgatory.
[20] Cited by E. H. Gombrich in *Shadows: The Depiction of Cast Shadows in Western Art* (London: National Gallery Publications, 1995), p. 17.

we do not usually treat cast shadows, taken as such, as depictions, then a number of popular and technical accounts of pictures of things may be seen, in a twinkling, to be hopelessly inadequate. Pictures are usually called "likenesses"; shadows are often likenesses, too. The shadow of a tree on the ground can bear clear and useful likeness to the trunk, twisting branches, twigs, buds, and moving leaves that let through sparkles of sun. Such a shadow also lies on a surface, which it frequently describes rather than obscures. This is something that photographers, as much as other artists, must note. As an old drawing book well remarks, "a shadow may be thrown from things hidden from view and thus explain their shape. Or a shadow from some trifling object may bring out the good points, or at least explain the form or surface of the plane it is cast on."[21] Both effects are well illustrated in Figure 10, from "Mystery of the Street," by Umbo (Otto Umbehr). Without the cast shadows, we could not tell that the woman's right foot is raised, or that something dangles from the child's right hand. Shadows are also associated with such surfaces because, unlike mirror images, they are experienced as being *located on* such surfaces, as transient states of them, affecting them but in turn modified by the physical characteristics of the surfaces—their shapes, stability, textures, colors, reflectivities. Shadows may be like pictures in being so "like," and we may experience them so and yet not *treat them* like pictures.

This alone demonstrates the inadequacy of "visual likeness," and also two-dimensional-projection approaches to depiction. Similar inadequacies show up in other approaches and theories of depiction, if we consider them in terms of cast shadows.[22] Shadows are clearly "signs" of things, notably of the things that cast them, signs that work according to likeness. As noted above, we often identify things that we cannot see, or cannot see well, by looking at their shadows, which resemble them. Photographers, like everyone else,

[21] Rex Vicat Cole, *Perspective* (London: Seeley, Service, 1921), rpt. as *Perspective for Artists* (New York: Dover, 1976), p. 185, where Cole also remarks: "The shape of a shadow will at times convey our meaning better than the object itself. Have we not seen pictures of cloaked and hatted conspirators round a table, their guttering rushlight throwing fantastic shadows on the wall that were more expressive of their evil machinations than the plotters themselves?" This means of conveying "meaning" is standard to much black-and-white cinema, which provides a multitude of interesting cases.

[22] The first account criticized here is that of Nelson Goodman, *Languages of Art,* 2d rev. ed. (Indianapolis: Hackett, 1976); the second, that of Flint Schier, *Deeper into Pictures* (Cambridge: Cambridge University Press, 1986). Note: Figure 10 is here printed upside down, in its *taking* position, rather than in its signed *display* position.

Fig. 10. Umbo (Otto Umbehr), "Mystery of the Street." All rights reserved, The Metropolitan Museum of Art, Ford Motor Company Collection, Gift of Ford Motor Company and John C. Waddell, 1987. (1987.1100.49)

take advantage of this (see again Figure 10). Yet these so-called iconic signs are not thereby *pictures of* what cast them. Furthermore, shadows can be put into kinds or systems, the better to understand them as signs, even as analogue ones. As we shall see, sunlight casts shadows in parallel projection, whereas the spreading rays of lamps make shadows smaller the farther off their

sources—or, as Alberti remarked, "The light from the stars makes the shadow equal to the body, but fire makes it greater."[23] Different kinds of shadowing in fact provide effective models for different kinds of mapping and depicting. Yet for all their "syntactic" systematization as analogue signs, shadows seem only on occasion to be understood *depictively*. As signs, kinds of shadows are understood by recruiting the visual-perceptual means by which we recognize the things that cast them. Once we have become acquainted with a certain kind of shadow—cast, for example, by fire or street lights—we call on our regular perceptual resources for recognizing objects in order to extend our recognition of their shadows. This does not make them *depictive*.

What the example of cast shadows shows to be lacking in all such conceptions of pictorial depiction is not some *added* condition but an entirely different dimension of approach. That may be seen more clearly by considering the cases in which shadows *are* treated depictively—in shadow play, shadow puppetry, and also in slides and movies—where shadow-casting filters are placed between light sources and screens and the resulting shadows are *imagined* to be things, though usually not the things that cast them. This does also happen spontaneously with ordinary cast shadows. Children, and adults, can "see" things in such shadows—a feature much exploited in motion pictures, including cartoons—and that experience is quite different from the usual one of seeing things by looking at their shape-resembling cast shadows. Sometimes, however, we imagine seeing cast shadows to be seeing the very things that cast them, though usually with mirror reversal. For example, the shadow of an outstretched left arm against the sunlit wall may be seen as an arm and hand, but then probably as an outstretched *right* one, usually with an imagined spatial depth around it. This difference in experience is represented here as one of *imagination,* and that seems to match well our common conception of these cases. We say that a child sees goblins in cast shadows because the child is imaginative. Such imagination is likely to "run away with" the suggestible child. Now I confess to having printed Umbo's photograph right side up, but—judging from the signature—his artwork upside down. Perhaps when the artwork is righted, readers will find that the cast shadows (say, of the rubble) become strongly depictive, evoking imagining.

[23] Leon Battista Alberti, *On Painting* (1453), trans. John R. Spencer (London: Routledge & Kegan Paul, 1967), p. 50.

We have already considered shadows as a stand-in for optical camera images with regard to some *detective* functions. Consciously or unconsciously, we note the presence of a tree and see many things about it as we look at its shadow on the road before us. Like camera images and photographs made from them, such shadows carry information about other factors, notably ones causally related to them, such as the states of the tree or the source of illumination itself: we often note whether or how clearly the sun is shining, and from which direction, by looking at shadows. For example, we immediately detect in the Walker Evans picture that the sun was shining brightly, almost directly overhead, although we cannot see it. We may confirm the light source of a shadow by noting the direction in which the shadow is cast; Dante is explicit that the "shades" in purgatory noticed that *his* shadow was thrown to his left.

Depiction and detection thus emerge as distinct, sometimes cooperative, sometimes rivalrous, uses of cast shadows, just as they did in our earlier discussion of photography. Historical superposition photos provide further confirmation of the shadow/camera-image association. The first photographs, we recall, because of the weakness of camera images and the initial low sensitivity of photo surfaces, were made by contact superposition. Wedgwood and Davy tried to print slide projections, but also shadows, observing that "when the shadow of any figure is thrown upon the prepared surface, the part concealed by it remains white," and that is where they had their fugitive successes.[24] Talbot referred to his first "photogenic drawings" as well as his later "calotypes" of lace, fern, oats, leaves—made by "intercepting the action of light" on photosensitive paper by placing a flat object directly upon it—as "impressions," "representations," "images," and also "pictures" of those objects.[25] When we look at some such prints—of lace, for example (Figure 2)—we cannot help but take the photograph like a depiction: we imagine seeing some actual lace stretched before us on a surface. But in others the "impression" produced by Talbot—or by a child with a photo printing kit today—no more incites this kind of imagining than do the marks that

[24] Wedgwood and Davy, "An Account," p. 15.

[25] Talbot, *The Pencil of Nature*, note to Plate XX, "Lace;" for the following terms, see Plate VII as well. At the start of "Some Account" (p. 23), Talbot said that his first efforts were to put "before it [a treated paper] some object casting a well-defined shadow. . . . Thus I expected that a kind of image or picture would be produced, resembling to a certain degree the object from which it was derived."

autumn leaves deposit on wet stone or concrete, or the prints of hands, fingers, and feet on surfaces. Photographic or not, *imprints* of many kinds, as surface markings, frequently carry information about the things that made them—including, as with foot and tire tracks, the action of their being made ("following the footprints of my leader")—without thereby inducing us to imagine that seeing them is the seeing of the things or actions that made them. They are veritable paradigms for the one use, the detective use, but not for the other, the depictive.[26] No doubt our prehistoric ancestors in the caves of Gargas, Pech-Merle, and others rightly saw the handprints they made as being *like* hands; they are like hands. Whether they also saw them *as* hands—that is, imagined their seeing of them to be the seeing of hands—is another question. Such prints may have various, sometimes overlapping, functions. An intentional handprint may be placed just as such: to show the presence and identity of a person. Or a handprint on a rock might simply have the significance, "Place your hand here and look out over the valley."[27] The fact that, with a little effort, many such things *can* be treated like depictions (with reversal adjustments) further confirms the difference between noting resemblances and making detections, on the one hand, and imagining seeing, on the other. We can, playfully, turn many of the things we see into foils for such imagining.

Umbra/Penumbra

In their twin functions for detection and depiction, shadows have direct analogy to photographic pictures made by their means, or by cameras. Since we set out in this chapter better to understand photographic images by studying camera or *optical* images, let us return to our original point of comparison between shadows and optical camera images. To understand that shadows bear even closer and more revealing connections with camera images than the early history suggested, we must go a bit more deeply "into the shadows," though without getting lost in them. The title of this chapter is taken from and in homage to Jun'ichirō Tanizaki's classic essay about Japanese aesthetics and the effects of Western technology, in which the novelist as-

[26] This is to be distinguished from a more common experience of vividly and immediately imagining the thing or action upon seeing the imprint: such might not entail the participatory imagining about our own action of seeing, necessary for depiction.
[27] An example I recall from Laurens van der Post.

tutely remarks how differently shaped the same technologies might have been had they been invented by different cultures. For example, he imagines "how much better our own photographic technology might have suited our complexion, our facial features, our climate, our land"[28] (The comment may today seem ironic, considering that the powerful Canon company was founded in Tokyo that very year.)[29] Yet to have invented the camera aspect of photography would have required treating shadows in a way very different from Tanizaki's. "Shadow" for him connoted, as it often does for us all, a *shaded,* protected, indistinct, three-dimensional environment penetrated only by diffused light—which is barred from its deeper recesses—and the soft surfaces that seem to hold it. The presentation of geometric camera optics, however, favors the opposed conception of direct and ordered rays from distinct sources, 2D—often optically hard—surfaces, and often sharp edges.

Now it may seem outrageous to declare, as I have just done, that not only are camera images like shadows of the latter sort but that they *are* parts of cast shadows, yet that is literally the case. This becomes clear when we consider how camera images are formed. *Camera obscura,* after all, means "dark chamber," and the whole point of such a thing is to exclude most of the ambient light. A camera is physical filter system, and a rather strict one at that. It needs to be, for although we rightly think of our cameras as *forming* optical images of things, it is as true to say that they filter or suppress optical images—an uncountable multitude of them—which would otherwise efface one another at every place on the image surface. If we suppose, as is convenient to our purposes, that every luminous or illuminated body casts outward and in all directions, from every point along its surface, a spray of *light rays,* those from various points will meet at every point upon a potential image surface that receives them.[30] For example, rays from every point on the

[28] Jun'ichirō Tanizaki, *In Praise of Shadows,* trans. Thomas J. Harper and Edward G. Seidensticker (Stony Creek, Conn.: Leete's Island Books, 1977), p. 9 *In'ei raisan* was originally published in the December 1933 and January 1934 issues of *Keizai orai.*

[29] Wade, *The Camera,* pp. 110–11, reports that "Kwanon" is a Buddhist goddess of mercy. This is no exception to Tanizaki's position; he holds that the aesthetics he describes is already a thing of the past, because of Westernization. As this is written, Canon is one of the main manufacturers of the lithographic "stepping machines" for making the computer circuits mentioned in the last chapter.

[30] This "punctiform"-radiation way of thinking originates with Johannes Kepler, *Ad Vitellionem Paralipomena* (1604): "Lines [of light] infinite in number issue from every point." See David C. Lindberg, *Theories of Vision from Al-Kindi to Kepler* (Chicago: University of Chicago Press, 1976), chap. 9; and A. C. Crombie, "Expectation, Modelling, and Assent in the History of Optics, II: Kepler and Descartes," in *Science, Art, and Nature in Medieval and Modern Thought* (London: Hambledon, 1996), pp. 329–55.

Diagram 1. Standard pinhole camera obscura.

face of the sun will meet at every point on a wall open to it. Furthermore, rays reflected from points on objects illuminated by the sun, and from the sky, may also reach each point on the surface. The optical result is that no images of any of these light sources will be detectable at any place there—as a sheet of photosensitive paper positioned on such a surface would rapidly show.

The classic recourse is the pinhole camera, into which light is admitted by a very small (theoretically dimensionless or 0D) aperture, as shown in Diagram 1.[31] Its function is to filter out *almost all* the incident light, allowing only (in theory, but not in fact) a *single* light ray from each point of each source to reach the projection surface, or "screen," in an ordered array. The array is ordered if the rays that go through do so relatively unmolested. They are rather like theater customers who not only are filtered through ticketed entry points but also have seats assigned. This occurs spontaneously and naturally—often enough that we have a name for it: "dappled light" in the cast shade of leaves, which are actually pinhole images of the sun's or moon's disks, formed by small spaces between the overlapping leaves that let the rays through. Here nature literally strews the ground before us with shining images of sun and moon: "Coins of sunlight fall down through the trees and lie on feet, on branches, on arms and legs, on the dog's back."[32] A good way to demonstrate that these little pools of light are indeed images of their sources is to note their change of shape with changes in the shapes of their effective sources. This might in some places be visible when moonlight is visible from a moon that is far from full. It is more easily and dramatically visible from the sun's dappling during solar eclipses. Then the pinhole-induced

[31] I will not be accounting for diffraction effects in this simplistic presentation. In practice, the optimal pinhole diameter (D) is figured for the light wave length (λ), as well as for the distance to the screen (f): $D = \sqrt{2\lambda f}$.

[32] Lively, *Moon Tiger*, p. 43.

Fig. 11. Annular Eclipse Shadow, 10 May 1994.

images will clearly and interestingly show (see Figure 11) the effective crescent shape of the partly occluded source.[33]

Many clear and useful explanations of the pinhole phenomenon already exist in print.[34] Approaching from a less usual angle but one constantly familiar from our everyday experience, let us think again about ordinary *cast shadows*. We all know, consciously or not, that all cast shadows are supplied

[33] Some take this as the import of Aristotle *Problemata* 15.11. (912b11–26): "Why is it that during eclipses of the sun, if one views them through a sieve or a leaf—for example, that of a plane-tree—or through the two hands with the fingers interlaced, the rays are crescent shaped in the direction of the earth?" (trans. W. S. Hett in Aristotle, *Minor Works* [London: Heinemann, 1955]).

[34] Two good ones are *Life Library of Photography: The Camera* (New York: Time-Life Books, 1970), pp. 103–05; and Howard F. Hoffman, *Vision and the Art of Drawing* (Englewood Cliffs, N.J.: Prentice-Hall, 1989), pp. 16–18.

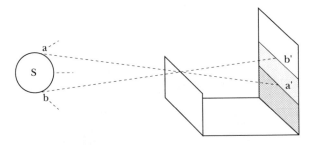

Diagram 2. Generalized umbra/penumbra effect.

with softened edges or fringes, due to *penumbrae* or "almost shadows." Registering penumbral effects carries much information to us about shadow-makers, which we might call "shields," as well as about light sources. The sizes of penumbrae, and changes in their sizes, usually tell us about the shields' distances from the screens—(if we can here restrict the ambiguous term "screen" to the surface that the shield shadows): the ground, walls, stones, leaves against which shadows are cast. The reason for this may be seen in a simple sketch such as Diagram 2, showing a single light source *S*, of extent *ab* (which may be either an original or a reflected-light source), a screen, and between them a shield or light interceptor whose penumbral-edged shadow the source throws upon the screen. Here we see how the width of the penumbra cast on the surface ($b'a'$) is a simple function of several factors. There is, first, the effective *size* of the luminous source *S*; second, its *distance* from the shield. The larger the face of the effective source, the wider the penumbra of the shadow cast on the screen. Thus Ansel Adams wrote that "the quality of the shadow edge [a factor 'less well understood by most photographers'] is related to the effective width of the light source; that is, the angle subtended by its diameter."[35] Also, the greater the source's distance from the shield, the narrower the penumbra. Far short of pinhole-image forming, we can even tell something about the source's *shape* by comparing the penumbrae it casts from different sides of a shield. For example, the eclipse-cast shadow photograph (Figure 11) shows, besides the pinhole crescents just noted, a marked difference in the width of the penumbrae on opposite sides of the hand, an effect perhaps made more explicable by Diagram 3. If we imagine each side of the umbra to be fringed by the overlap of in-

[35] Ansel Adams, *Natural Light Photography* (Boston: New York Graphic Society, 1952), p. 6. He continues: "Sunlight quality is recognized not only by its shadow edge but also by the acuteness of highlights" (p. 7).

Diagram 3. Model of eclipse penumbrae.

numerable pinhole images of the crescent, we can see how the penumbral effects would be wider on one side than the other.

The positioning (and shaping) of the screen also affects penumbral size: the farther it or a part of it is from the shield, the wider the shadow's penumbra—also the more it or a part of it is rotated away from its position directly facing the source. To make a categorical prescription, in Diagram 2 we are to imagine the penumbral part of the shadow as a horizontal band of half-lighted screen—a transition between an unlit (umbral) expanse below and a fully lighted one above. The narrower this transitional zone, the sharper will be the contrast between umbral and fully lit zones. Since our vision is specially adapted to such contrasts, they can seem harsh, even disturbing in certain circumstances. This is why architects and interior decorators try to avoid them: architects, by keeping facade elements from throwing sun shadows into interiors; photographers and decorators, by avoiding small or intense light sources—for example, using "bounce" light illumination, which increases the effective diameter of light sources against light-shielding edges.

Such professionals frequently assume that (in the words of one old drawing book) the sun is "so far distant from the earth that the rays of light coming from it may be regarded as parallel."[36] This, fortunately, is untrue; our

[36] That standard remark about the sun's rays being parallel (I have lost the source of this quotation) conflates two facts. First, the sun being so far from earth, we can say that, for any radiant point on the sun, all rays from it that come to different points on earth, are parallel. This gives us the parallel projections shown in Figure 10 and in Diagram 16. Second, however, for any point on earth reached by rays from different points on the sun, those rays arrive not quite parallel: thus the half-degree penumbral effect shown in the diagrams.

world is by no means so starkly lit. Since the full disks of the sun and the moon are, except during eclipse, of a constant apparent size of about half (.533) a degree in the sky, they conveniently strike a penumbra of exactly that size off the contours of every object they shine upon in the vicinity of the earth. This has two important implications for environmental perception and for pictures, such as photographs, that exploit it. First, the important sense of sunlight illumination, or what Adams called sunlight "quality," as depicted in our faithful Walker Evans, is largely due to it. Even more important, with the full solar penumbral angle forever a fixed quantity, perception of these penumbrae can attend merely to the variables of shield-to-screen distance, and of shield shape and orientation, regarding their rays. This is why we so easily and unthinkingly judge the distance of a shield from a screen by noting the softness of its shadow's edge. Lower bushes, tree branches, and stones cast the sharper shadows on the ground, while the ones higher up cast the softer-edged shadows. The shadow-edge contrasts in the lower left corner of Figure 10, "The Mystery of the Street," for example, clearly indicate farther-off architecture—probably a building—and a closer square form, although we can see neither. Shadows of our own feet have sharper edges upon the pavement than do those of our heads, as we again see in Figure 10. And as we can see by the slight softening of the shadow line of the girl's right sleeve upon her upper arm in the Evans (Figure 1), this can be appreciable, hence descriptive, even over quite small differences of shadow-throw distance from shield to screen.

Where the sun shines to a screen past *opposite* edges of a shield, there will be a penumbra for each edge, with what is called a "core" shadow, or umbra, between (Diagram 4). We know this from familiar eclipse representations such as Diagram 5. As shield and screen retreat from one another, the attenuating tip of this core may even fail to reach the screen, so that all that falls upon it are the joined penumbrae of its opposite sides, producing "the mere shadow of a shadow," as at position 3 in the diagram. The phenomenon of the growing fringes progressively eating away the core may be seen from airplanes as they rise from the ground. Closer to hand, the core shadow of a penny held up to the sun shrinks to a dot at position 2, then disappears at about eight feet (two and a half meters) from a screen, as the featherlike shadow fringes of the fingers holding it overtake their own umbrae.

Photographers must also be acutely aware that the sun is rarely the only light source outdoors. The *sky,* considered as a single source, is one of enor-

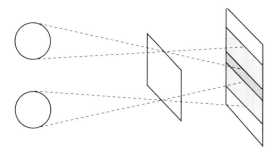

Diagram 4. Core shadow between penumbrae.

mous breadth, making extremely wide penumbra casts, even where objects partially block its light, as one can see by imagining the whole sky as the source *S* in Diagram 2. The Evans photograph, for example, presents the familiar situation of sharply bounded shadow areas from the dominant overhead sunlight, lit by several other lights: general sky light and locally reflected light. For example, the *attached* shadow defining the underside of the girl's face is washed by reflection from her sunlit skin and dress, and this is partly why it appears brighter than (and is thereby distinguished from) her neck, whose shadow does not receive that direct bounce. There is another important factor at work, as well. Our diagrams of cast shadows show that, from the point of view of the receiving screens, the penumbral areas represent positions from which only part of the source could be directly seen. This also holds for the penumbral sectors of what I have been calling "attached shadows": "self" shadows that are on surfaces because they are turned away from

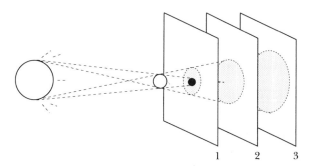

Diagram 5. Schematic eclipse drawing, showing screen positions to intercept umbral and penumbral casts.

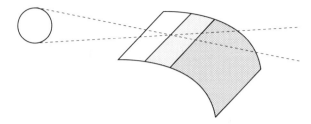

Diagram 6. Penumbral situation for attached shadow on continuous surface.

the light (Diagram 6).[37] Although we tend to understand "shadow" in terms of *cast* or projected shadows, Leonardo counted the attached shadows of objects as "original shadows," and the cast as merely "derived." Of the former, he wrote, "These I term original shadows, because, being the first shadows, they clothe the bodies to which they are attached."[38] E. H. Gombrich has observed that although modeling by the former kind of shadow is definitive of the Western tradition of depiction, that tradition's use of cast shadow in depiction wavers considerably.[39]

As well known as *eclipse* diagrams are, showing umbra and penumbra effects, their commonality with the shade-modeling diagrams that we see in drawing books usually passes unnoticed. The "middle tone" of the so-called side planes between the fully lit and fully shaded sectors in drawing-book diagrams is as important to photographers as to other picturemakers. The penumbral or middle-tone areas on heads, features, hands, and so on, register the rate of *change* in their surfaces as they bend away from the light toward the core shadow. Photographers, among others, study and seek to control these carefully. Here penumbral shadow combines with a distinct *shading* effect which can be difficult to separate, and I know of no treatments

[37] Sometimes these shadows are called "modeling shadows," and the expression "attached" is reserved for a very important class of *cast* shadows—those tangent to the object shield casting them, but stretching out from them. Examples are the shadows of the broom and the lantern in Talbot's Plate VI of *The Pencil of Nature,* called "The Open Door" (see Figure 17 in Chapter IX). Such is Gombrich's usage; see *Shadows,* pp. 37–38. I find this terminology misleading, because of the important role that such cast shadows have in modeling the objects on which they fall. Michael Baxandall, *Shadows and the Enlightenment* (New Haven: Yale University Press, 1995), pp. 3–4, favors the terms "projected shadow" and "self-shadow."

[38] Leonardo da Vinci, *Leonardo on Painting,* ed. and trans. Martin Kemp and Margaret Walker (New Haven: Yale University Press, 1989), p. 97 (from Milan Biblioteca Ambrosiana *Codice Atlantico*).

[39] This is a theme of Gombrich's little catalogue, *Shadows;* e.g., see pp. 19, 29.

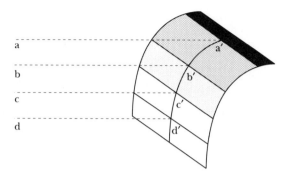

Diagram 7. Slant-shading, or "seasonal effect."

of the subject which explicitly recognize this complication. Unlike attached penumbra, "slant/tilt shading"[40] is a halftone effect along the margins of objects which is independent of the effective size of the source. It exists for point sources, even for parallel sources. Indeed, the rays of sun that fall parallel to the earth provide its most familiar example, and its most dramatic example as well: the seasons of the year—indeed, in Aristotle's theory, the source of all terrestrial change.[41] Diagram 7 shows the effect for a parallel source such as the sun; like diagrams could be drawn for a point source or for effective sources between point and parallel. In this diagram parallel rays of the sun reaching the contour of the earth, or of some object on it, are divided into several unequal horizontal bands by four lines, aa', bb', cc', dd'. If we suppose that equal amounts of light energy are contained in these three bands, then the amount of light falling on contour $a'b'$ is the same as that falling on $b'c'$ and $c'd'$. Therefore, since the former contour segment—because of its tilt or obliquity relative to the rays—is much larger, it will be more feebly lit than $b'c'$, and its "winter" will be $c'd'$'s "summer." The resulting rather darker appearance of contours as they tilt away from light sources is what is usually counted as halflight or halftone. This important angular effect is not a *shadow* effect, however, as there are no "holes in the light flux."[42] One important example of it is the "limb effect" that occurs along the sides of smooth ob-

[40] See Baxandall, *Shadows and the Enlightenment*, pp. 4, 14.

[41] Aristotle, *On Generation and Corruption* 337–38. (Notice that even Cruikshank shows slant shade on Earth in Figure 9.)

[42] For this expression, see Baxandall, "Introduction: Holes in a Flux," in his *Shadows and the Enlightenment*, p. 156 n 1, who derives this nice expression from Lecat (1767): "un espece de trou ou de vuide dans le corps de la lumiere."

jects that have "axis lighting": light that falls along the direction of their fac-
ing axes.[43] This darkening effect allows a smooth, light object such as an egg
to appear rounded, and clearly shaped, even against a light background. It
may also provide a natural basis for the universal technique of contour lines
in drawing.

Our versatile Evans photograph shows a typical mix of attached and cast
shadows, together with slant shade. The child's cheeks look round because
the shadow line on them is so gradual; in other words, because the attached
shadow penumbra there is so large and the slant shade gradual. Indeed, there
is no real "line" at all. Her top lip, by contrast, provides a sharp gradient for
its attached shadow and is defined as a much sharper contour. (This mus-
tachelike cast-shadow "nose" has long been a problem for portraitists of
many kinds; drafters typically cheat on it.) One of the main challenges to
modeling heads depictively by photography, or by other graphic means, is to
understand the relationships of attached and cast shadows upon them, as
parts of them serve as screens for the shadow casts of their own prominences
(the top lip catches the shadow of the nose)—and to understand this not
only for sun but also for *multiple* reflected light sources. Thus the girl's chin,
which has its own penumbra-to-umbra attached shadow, receives a cast shad-
ow from the lips and is also lit by reflections from below.

Returning from the attached-shadow examples to simplified *cast*-shadow
figures, we can see, by consulting Diagram 1 that the pinhole image is *itself*
a shadow—actually the penumbral shadow of the shield around the pinhole
opening. To understand this we need only imagine in Diagram 2 that an-
other shield is brought down from above almost to meet the first one (see *ef*
and *cd* in Diagram 8), thereby shading out the fully lit region of the screen
in Diagram 2. We then see that we have reproduced the pinhole situation
(but only if we imagine also that two additional shields are brought in from
the wings toward the center of the slot). It might appear that bringing the
shield down does not affect the original penumbra in Diagram 2, but a mo-
ment's thought shows otherwise. All that is left then in the camera obscura
is featureless full shadow and penumbral shadow, or halflight. Images are
formed in such cameras because penumbrae are far from featureless: mea-
suring up the screens in the diagrams, no two horizontal sections of penum-

[43] Good photographic demonstrations may be found in Adams, *Natural Light Photography,* pp.
8–9.

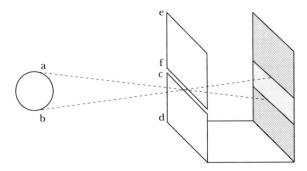

Diagram 8. 1D slit substituted for Diagram 1's 0D pinhole.

bra receive rays from precisely the same group of radiant points along the source. If, as in Diagram 9, we imagine additional sectors on the face of the source, between *a* and *b* (called α, β, γ), rays from the whole series will meet the screen at *g, h, i, j, k.* A penumbral strip between *g* and *h* will be illuminated by only that portion of the source limited by *a* and α, and no light will reach it from any sector of the source below α. By contrast, every region on strip *hi* will be reached by every point of light from α to β, as well as by all light from *a* to α, since it is open to that as well. As we progress up the screen, more and more of the source will affect each point on it until the full face of the source does, at the margin of the fully lit area, *k.* Thus as we move up to the fully lit area, it becomes increasingly ambiguous which points of the source are illuminating any region on it, as it is open to more and more of them. Again by contrast, at theoretical point *g* on the screen, a single ray from the source, issuing from *a,* could illuminate it, so that light at *g* specifies that *a* is shining.

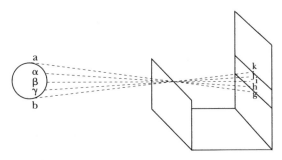

Diagram 9. Fuller version of Diagram 2 indicating grades of penumbra.

Addition of shield *ef* in Diagram 8 would affect this penumbral situation, however, as this shield's penumbra is brought down to overlap that cast by *c*. The screen surface between *j* and *k* in Diagram 9 would be reached only by light from *b*γ, as it would no longer be open to the "confusing" rays from all the other points along the face of the source.

The sun shining between the slats of a blind makes penumbral stripes of this kind on a facing wall, if the slats are close enough together or the wall far enough away. We should not expect to derive penumbral images of the sun's disk then unless we bring in shields from the sides. Actually, a shield from just one side may be sufficient, for as Aristotle (or a follower, in *Problemata* 911b3–5b), long ago asked, "Why is that when the sun passes through quadrilaterals, as for instance in wickerwork, it does not produce figures rectangular in shape but circular?" A little thought, using something like the diagrams here, should show why the penumbral shadow from the meeting corner of just two shields set at right angles should follow the curve of the sun's face. We frequently observe this when the sun, shining through a window, casts the shadow of the angles of the window frame onto a surface such as a wall. If we consider the penumbra, as in Diagram 3, to be an overlap of innumerable images of the source, then we should not be surprised to find (as in Diagram 10) that the brighter, reinforced, overlap of such images at the corner is visible, giving the shadow of the corner a curved appearance, since the round solar disk does not fit the square corner.

"The light filtering through the slatted blinds," wrote Raymond Chandler, "made narrow bars across the floor"[44]—a familiar situation. What is perhaps not so clear is why, when the sun shines through wickerwork, or outstretched fingers, so that there is a combined penumbra on three sides but still an open slot of shade, a *full* image of the sun should readily appear. This can be seen, as well, in the shadows cast on the ground by the notches or embrasures in parapets at the tops of buildings. It is even less clear why the sun should find sufficient excuse to project its full penumbral images where there are only two *parallel* edges (along a blind or between outstretched fingers) and the light is open on two sides—or why it should do so along a *single* shadow edge, so long as there is a slight irregularity. An effective demonstration of these phenomena can again be found when the face of the sun is given striking shape by the occluding moon. Here we see unmistakable

[44] Raymond Chandler, *The Lady in the Lake* (1944; New York: Penguin, 1952), p. 41.

Diagram 10. Aristotle's "wickerwork" effect.

penumbral solar images clinging to the edges of umbral shadows, like chaff to a rod (Figure 11, top).

It should be clear from such examples that it does not require a *camera* to produce a "camera image" of the sun. But the sun's situation here may be generalized for *all* bodies from which light shines. This implies that undetectable images of all sorts of lighted things cling to the shadow edges of most objects—including leaves, branches, stones, grass, animals—cast by the sky, drowned out by the "noise" of a multitude of other images, or by a brighter one of the sun. Images of their environments have always lurked in the attached penumbral halftones on surfaces, which describe them to perceivers. Such images are already present in nature, and keys to finding them lie in isolating them—in excluding or *suppressing* all others that efface them—and in finding means to intensify them where they are very weak. This is the job of the camera obscura and its descendants, by means of which it has become increasingly possible to form optical images of extremely faint, extremely small sources.

Much of the story of camera technology can be told in these terms of optical filtering and amplification. Filtering comes first. We have seen how easily the source images can already exist along the shadow margins. The first step was to eliminate the overlapping, effacing images—the job of the pinhole camera obscura. The next state, pushed along by the invention of photochemical receptors capable of registering, amplifying, and storing the effects, was the widening of that pinhole to admit more light and thereby to obtain stronger images, and then the insertion of *lenses* to resolve the resulting image confusion.

Widening the pinhole to increase the amount of light falling on the screen, however, would simply reverse our discussion of the earlier diagrams. If we

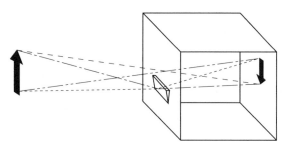

Diagram 11. Pinhole plus prism amplifier.

moved from a (theoretical) oD aperture to a 1D or slit aperture, we would return to the situation of Diagram 8, if we consider *f* and *c* almost to touch. If we opened the slit further to a 2D aperture, we would revert to the Diagram 2 situation: a fully lit and hence imageless center, fringed with the 2D image situation. First the penumbral images would not quite coincide; then the center, like that of an open window, would no longer be even penumbral and would therefore produce no image at all. A better approach is to let more light in by *multiplying* the oD or pinhole situation: that is, by surrounding the original pinhole in Diagram 1 with several more perforations in the light shield, each of which would cast its own pinhole image on the screen. If we could contrive—by, say, putting the right-shaped prism at each of these pinholes—to bend the incident rays so as to bring their images together, exactly to coincide at a place on the screen, this would produce an image bright enough to be effective (Diagram 11). This is the effect of a *lens* (Diagram 12), which may be thought of as a coordinated society of pinholes,[45] a 2D light-gathering window constituted of oD apertures, producing coincident images at a certain distance away from the screen called a "focal length."

This provides a clear situation of amplifying and suppressing trade-offs. The indispensable light-filtering technologies that accomplish lens amplification of the physical signal, and thereby greatly amplify our powers to produce useful images, also thereby suppress some of the powers we have with the single pinhole. Notably, they limit the depth of field for sharpness in the resulting image. The reason for this is that the bending of incident light by

[45] The lens as society of prisms is a standard presentation; see, e.g., Richard L. Gregory, *Eye and Brain: The Psychology of Seeing*, 4th ed. (Princeton University Press, 1990), pp. 32–33. The combination of this with a group of pinholes is due to Hoffman, *Vision and the Art of Drawing*, p. 17.

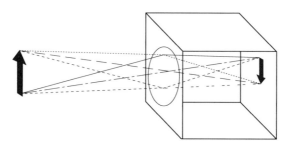

Diagram 12. Lens modeled as a society of pinhole/prisms.

a prism or lens is a function of the angle of incidence with which the rays strike the lens face, and moving the source toward or away from the shield in this diagram would change those incident angles. Unless we reposition the screen, the different pinholes' mini-prisms would no longer bring their various images on it quite into coincidence. Therefore, increased brightness of the overall image would be had for them only at the cost of clarity—like the door behind the child in the Evans photo. Repositioning the screen, as we do when focusing cameras, then puts what was in focus out of focus. This clarity trade is a matter of degree, greater for longer than for shorter focal-length lenses.

It also becomes more difficult to bring images from the outlying "prisms"—that is, from the periphery of a lens—into exact coincidence with those from nearer the center. Most lenses therefore have these peripheries masked. In Talbot's graceful account, "The [camera's] eye should not have too large a *pupil:* that is to say, the glass should be diminished by placing a screen or diaphragm before it, having a small circular hole, through which alone the rays of light may pass. When the eye of the instrument is made to look at the objects through this contracted aperture, the resulting image is much more sharp and correct. But it takes a longer time to impress itself upon the paper, because, in proportion as the aperture is contracted, fewer rays enter the instrument from the surrounding objects, and consequently fewer fall upon each part of the paper."[46] One pays more for wider lenses that are sharp, described in terms of their f-numbers, which express the ratio of the focal length to the diameter of the lens.

We have now witnessed the continuity of camera optics with the optics of common shadow penumbrae. Bringing in the camera to explain penumbral

[46] Talbot, *The Pencil of Nature,* note to Plate III, "Articles of China."

effects, we have discovered that those effects can show how cameras work in photography. In short, camera optical images sufficient to form photographic images require a certain kind of filtering of light, and shadow penumbrae naturally express that kind of filtering.

Tonal modeling and Perspective

One of Talbot's apt descriptions presented early in this chapter made the point that since photos are formed from optical images, they are basically chemical (now, often, electronic) records of intensities (and, we might add, kinds) of incident light, distributed upon surfaces: images or impressions, "stronger or weaker on different parts of the paper according to the strength or weakness of the light which had acted there." This perhaps most strikingly distinguishes photographic depictions—particularly those made by using cameras—from all others. That such images can be so easily used for depiction is owing to the much-researched feature of human visual systems, that they are so well attuned to differences of such intensities. Although we share these capacities with some other creatures, we are perhaps uniquely aware of these differences as they occur on surfaces. Moreover, we are able to *transfer* these sensitivities to *imagining seeing* from surfaces. It is time to focus on these points more closely.

Almost universally, pictorial depictions to a large extent work by Talbot's degrees of "light and shade,"—that is, relatively lighter and darker areas of a marked surface—though "work by" is somewhat ambiguous. It might mean only that shapes discerned because of their relative darkness are the ones whose discerning we imagine to be the seeing of whatever the picture depicts. This is as true of the drawing *in* the Walker Evans photo (Figure 1) as it is of the photo itself, and it is true of the first Cruikshank print (Figure 5): we make all three out by attending to darkness contrasts. But that is as far as it goes with the child's contour drawing. We see it and imagine from it by means of dark and light, yet it has us imagine very little *about* anything's lightness or darkness. In that, it differs from both the Evans and the Cruikshank. Those two are similar, not only in having us imagine that certain things are darker and lighter in their local color (such as the girls' hair versus their dresses in both) but in having us imagine this regarding their color reflections. For example, the top of the hair in the Evans is taken as dark in

pigment but as spectrally reflecting light. The raised sleeve of the rocking-horse boy in the Cruikshank is taken to be reflecting light, not as changing pigment. There is another point to be made in that connection. To a great extent, both pictures would have us imagine not only that things reflect light but also that we are seeing them *by* the lights they reflect, which reflection we also imagine seeing. They both require our imagining that about our seeing of them. They do not do so to the same extent, however; the photo is, typically, more thoroughgoing.[47] In the etching much depends upon contour lines that do not denote darkness. We are not to imagine of our seeing of them that this is the seeing of darker passages; rather we are to imagine that our seeing of that contrast in brightness is the seeing of a boundary of form. As it is often remarked that "there are no lines in nature," there exists a considerable body of speculation and study about why we are so prone to imagine in just this way.

Photographic depiction, still and moving (particularly in monochrome, misleadingly described as "black and white"), inherited from European drawing a set of technical devices whereby the forms and textures of objects are presented to our imaginative visualization in terms only of the shadow features here. As Gombrich noted, such indeed may have become "the distinguishing mark of the Western tradition."[48] We find in that tradition subtle awareness of primary and secondary lights and, for each of these, of cast and attached shadows with umbral and penumbral shadow features. Whole epochs of cinema, for example, are strongly characterized by this, and the advent of color there might be considered as one more typical instance where extending one feature willy-nilly suppresses another. As we approach the closely related topic of linear perspective, let us briefly review this technological adaptation of our powers of environmental perception to depiction on a surface. A continuous history of this subject is yet to be written. Still, by the early sixteenth century Leonardo had systematized the study of depictive shadow toward a treatise on the subject, and his notebooks still provide sharp and beautifully expressed observations on this aspect of pictorial naturalism. "Lights and darks, together with foreshortening, comprise the excellence of the science of painting," he wrote, given that in nature, "shadows and lights are the most certain means by which the shape of any body

[47] This point follows Walton, *Mimesis*, pp. 319–24.
[48] Gombrich, *Shadows*, p. 19.

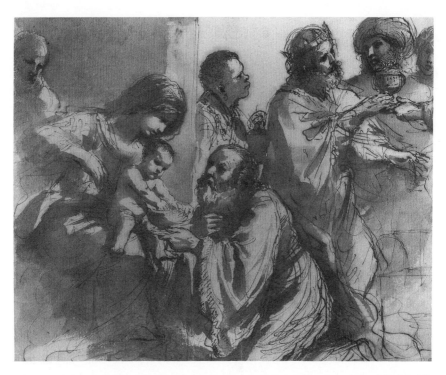

Fig. 12. Guercino (Giovanni Francesco Barbieri), "The Adoration of the Magi." All rights reserved, The Metropolitan Museum of Art, Rogers Fund, 1908. (08.227.30)

comes to be known."[49] Leonardo distinguished cast and attached (or "primary," as he called them) shadows, compound shadows, and—at least in his diagrams—the penumbrae of attached, if not of cast, shadows. Samples from this tradition, as it led to academic teaching, show that by the early seventeenth century these shadow effects had been consolidated into the quick and sure motor actions of an artist.

In such a rendering as Guercino's pen and brown ink "Adoration of the Magi" (Figure 12), we have a clear sense of a main directional source of light, whose shadows are reached by weaker, broader secondary sources, notably that of the sky. A detail such as Mary's head is all we need to show how in a few brush strokes, with more or less water, the shadow effects we have been considering are indicated with assurance. Her forehead is a screen for the shadow cast of her hair, the sharp penumbral edge of which, telling the an-

[49] *Leonardo on Painting,* p. 88 (from Vatican *Codex Urbinas*).

gle of its strong, narrow source, describes the curve of her nose, cheek, and jaw. The lighter wash over the cheek itself describes a very wide, even attached shadow (and slant shade); it is therefore a smooth, rounded feature, contrasting, for example, with the attached shadow on the bony brow of the kneeling king (whose tone suggests light reflected back into it). All these shadows on Mary are still luminous, as they are lit by the sky and by reflection up from around her collar—though the under part of her chin is perhaps not sufficiently light to show that reflection. The back of her head, like her entire back, is lit by still another source, the reflection from the open stable. The far underside of her headdress, like her stomach, is darker than the other shaded places, indicating that it is shaded from some of these diffuse secondary sources, as well. One could go through such a picture feature by feature, noting such effects, exactly those that many photographers (including cinematographers) have to be keenly aware of and that require careful observation and management if, as Leonardo said, the shapes of bodies are to be known by them. Although the term "obscure" has shadow derivation, both attached and cast shadows are often clarifying agents for sight.

After the optical issue of Talbot's "succession or variety of stronger lights . . . and of deeper shadows," one might next consider that the optical images that form camera photographic pictures must be made by filtration if succession and variety are to be distributed meaningfully. Their production, by contrast with that of other pictorial and depictive technologies, is therefore strongly characterized by the trades of such focus-acuity features of the optical images that make them. But besides shadow and issues of resolution, there is a third important optical point to treat here. Photographs from cameras are also characterized by features of *linear perspective,* which they share with a number of other pictorial technologies: recall that Niépce referred to his camera photo efforts simply as *points de vue.* We can avoid many of the problems of pictorial linear perspective if we hold fast to the distinctions reiterated at the start of this chapter among (1) optical camera images, (2) photographs made by their means, and (3) depictive uses of such photographs, and if we also maintain our analogies between these things and shadows. We may go so far as to say that cast shadows upon surfaces prove a much *better* form of exposition than that which has become standard: transparency— things seen through windows. The canonic conception of linear perspective presents a diagram remote from our camera projection (Diagram 13). Here a real or mechanical eye determines the apex of a 3D cone (often called a

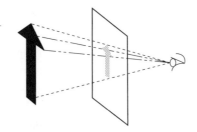

Diagram 13. Standard perspective presentation.

pyramid) of straight lines based on a subject. At some point between subject and eye a projection plane cuts this cone to make a 2D section of it, called a projection of the subject. What this amounts to geometrically is an inverted mirror reflection of Diagrams 1 and 12, with an eye put at the pinhole or lens and the screen placed *between* it and the subject. The geometrical situations for the two screen positions being identical, the question arises why anyone would want to redraw the pinhole or lens situation in this way. We need not go into the historical answer to this question; it is more important to notice why the pinhole-lens model is far *superior* for explaining linear perspective in photography. There are at least three reasons.

The first reason is that our method, abstract as it is, does not involve *needless* abstraction. The standard "window way" of Diagram 13 bears no resemblance to any camera mechanism. Also, whereas in the pinhole-lens diagrams the projection plane is the resulting actual, physical picture plane, for the standard perspective diagram it usually is not—despite the common blithe assumption that it is. Second, the pinhole-lens models avoid *extreme* and confusing abstraction. The window way is usually a *geometrical* diagram, not an optical or an ophthalmological one—a significant difference that its exponents usually overlook. For example, the standard diagram holds as much for things that do not give off light as for things that do, and for blocked (occluded) sources as much as for unoccluded.[50] Third, and most important, our approach proves a far less *misleading* abstraction. Notably, the pinhole-lens models postulate no *eyes;* they do not present themselves in terms of their subsequent *visual displays.* Five centuries of argument have afflicted the theory and practice of pictorial perspective with worries about the eye in Dia-

[50] Michael Kubovy is a rare expositor to favor the pinhole camera, for these reasons, in the exposition of linear perspective; see Kubovy, *The Psychology of Perspective and Renaissance Art* (New York: Cambridge University Press, 1986), pp. 22–25.

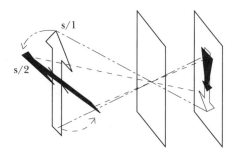

Diagram 14. Perspective effects of rotation on horizontal axis.

gram 13 (standardly, shockingly, called that of "the artist"), because of a pre-sumption that for the projection to work, as a projection or as a depiction (the difference between them being well trampled into obscurity), a viewer's eye(s) must somehow approximate its position. In short, our model is far less open than is the canonic one to what Whitehead called "the fallacy of mis-placed concreteness."[51] So much greater are the virtues of the pinhole-lens approach over the window model—or, at least, so many fewer are its vices—that it is to be recommended for most nonphotographic contexts as well.

Since the camera image is a penumbral, filtered image, we need only look to our earlier figures to read off the main characteristics of perspective, in op-tical images, in photo images that derive from them, and—to a great ex-tent—in the depictions they form. Beginning with (optical) camera images, we may say that linear perspective yields *systematically* three main but dis-tinct features: *occlusion, foreshortening,* and *diminution* of patterns on screen surfaces, all as functions of spatial position. Transferred to photo images, these are also features of the resulting marks on photo surfaces. They are fre-quently characteristics of depicting pictorial surfaces as well. *Occlusion* re-sults when an opaque object between radiant source S and the pinhole prevents some of S's rays from reaching the pinhole, and thereby from reach-ing the screen. To explain *foreshortening,* we need to elaborate our source di-agram as in Diagram 14. Here we are to imagine the sunlike source replaced with a luminous flat arrow. It is clear that in its rocked-back position ($S/2$) the same arrow would produce a narrower penumbral spray through the pin-hole than it does when vertical ($S/1$) and therefore full-face to the pinhole, although its average distance from the pinhole would be the same. It is also

[51] In Alfred North Whitehead, *Science and the Modern World;* the account here follows Maynard, "Perspective's Places," *Journal of Aesthetics and Art Criticism* 54 (Winter 1996): 23–40.

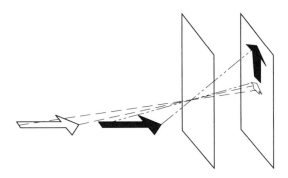

Diagram 15. Perspective effect of advance along same plane.

clear that these variations would occur, systematically and continuously, with the rotation of the face about the source's horizontal axis until, rocked back to horizontal, it would shine no light at all through the pinhole. From that orientation we could still get light to the pinhole if we were to drop the arrow down a bit, and still more if we were to move it toward the shield, as shown in Diagram 15. The same may be said for rotations of this radiant face along its *vertical* axis, as well as along all others between. In any direction and degree of rotation, the source throws a *foreshortened* image (from what it would otherwise make) onto the screen. To consider a concrete case, in the Walker Evans photograph the girl's chest, though broader than her face, is more rotated away from the camera's aperture and is therefore more foreshortened than her slightly rotated face. Finally, we should notice that since the tipped face $S/2$ in Diagram 14 throws a narrower penumbra through the pinhole, it would also make a somewhat smaller obstacle to rays coming to the pinhole from behind it. Therefore, occlusion is affected by foreshortening.

It is important to stress that, so far, pinhole or linear perspective projection is not radically different from some other well-known kinds of shadow, optical, photographic, and depictive projection systems—a point often missed or confused. We can prove the point with a real and very important kind of projection—shadow, optical, photo—what is called "oblique projections."[52] This is perfectly familiar to us all from sunshine. Sun-cast shadows surfaces constitute the *most numerous* class of images that we see, and these are in parallel projection, normally in the oblique form. Examples are

[52] See Fred Dubery and John Willats, *Drawing Systems* (London: Studio Vista, 1972), pp. 10–46.

Diagram 16. Nonperspectival (parallel) projection, as with sun-source shadows.

shown in the Umbo photograph (Figure 10). Although the shadows there are extended on the pavement "screen," because of its rotation away from the direction of the sun's rays, no diminutions occur with distance. (This evidence is also right under our noses, for we see that in the Walker Evans the shadow of the girl's nose is about the same width as the lit part of it.) To explain this phenomenon, it is useful to look at another schematic, Diagram 16. We imagine a translucent box, perhaps of glass or plastic, whose shadow is cast by the sun against a fairly flat screen. The sun's rays come in parallel (subject to the qualification regarding penumbrae). If the box's face f_5 is parallel to the sun's rays, that face will cast no shadow on the screen. Whether it does or not, its four numbered companions will, and the projection lines show where these will be bounded vertically. *Occlusion* occurs: were face f_3 to become opaque, half of f_1's projection (from b to c) would be intercepted by it. So does *foreshortening*: although f_2 is the same size as those other two, its projection, bounded by a and b, is half the length of theirs. Foreshortening will again affect *occlusion,* and everything we noticed about rotation of the source in perspective Diagram 14 will be seen to hold here.

As for practical photography, the method of superposition represents an extreme case of parallel projection, where the object is quite flat and in contact with the screen, minimizing penumbral blur. Talbot's slide projection presents a less extreme case, though the object is still quite flat. Medical radiography normally employs not quite parallel but slightly spreading rays, from an X-ray tube source, to a fluorescent screen which, in turn, exposes the photo film. A lead grid is interposed between the object and the screen to filter scattered rays.

What distinguishes *linear perspective* is that unlike parallel projection it produces a *third* and famous systematic spatial feature: *diminution* with distance. That it should do so is already clear from our discussion of penumbral effects in Diagram 2. We saw that "the greater [the source's] distance from the shield [and thereby the screen] the narrower its penumbra" cast on

the screen. Luckily, this may be expressed by a simple functional relation-
ship: the size of the image is inversely proportional to the distance of the ob-
ject from the pinhole. Move an object twice as far from the pinhole, and its
shadow shrinks by half. Such is not true of parallel projection. Moving the
object in Diagram 16 toward or away from the screen has *no* effect on the
size of the shadows (although it would on the penumbral sizes). As you walk
toward a sunlit wall in late afternoon, your shadow on it becomes sharper
and darker but remains the same size.

If perspective produces systematic diminution, it also shows us how to
control, minimize, or avoid it. A basic method of avoidance is to minimize
differences of distance of objects or their parts from the lens or pinhole, as
with the plane of the boards to the right in the Walker Evans photo. Anoth-
er is to tilt or bend the image screen so as to equalize the image sizes. A third
is to exploit the inverse relationship noted above. Consider an object moved
from two to four, then from sixteen to eighteen units away from the lens or
pinhole. Although the same distance (two units) separates the first pair of
positions and the second pair, because of the inverse relationship the image
ratios of the pairs are quite different. At four units away the image will shrink
to half the size that was projected at two, whereas at eighteen units it shrinks
to only eight-ninths what it was at sixteen units off. With greater distances
a two-unit difference can become so small that a perspective projection could
not be easily distinguished from a parallel projection. This minimizing of
diminution differences is a quite common use of longer—including tele-
photo—camera lenses.

An important feature of perspective is that although the rate of diminu-
tion falls off with increasing distance, the rate of the other variable, fore-
shortening, *increases*. This was already evident in Diagram 15, where the fully
upturned face of the closer arrow throws a far larger-angled image through
the pinhole than does the one farther off—so large, in fact, that for very close
sources "forelengthening" would be a better term. Camera views wide
enough to take in such sources (the depicted angle here is within range of a
standard lens on 35 mm cameras) provide anamorphic shapings of images,
which are sometimes deplored and usually avoided, but often used to good
expressive effect.

Mention of that use brings me to my last point in this elementary treat-
ment of photo optics: the depictive use of photo images. I have insisted all
along on the need to distinguish the optically controlled perspective of a pho-

tographic image from the perspective of a *picture* or depiction for which it might be used. We all know that it is standard practice in cinema production to mix painted backdrops and three-dimensional models with real things—often for the purpose of controlling the perspective to the explicit and usually quite effective end that the optical perspective and the imagined perspectives will be, at least partly, quite *different*. One well-known example will stand for many others.

> *Alfred Hitchcock:* Nowadays, I use magnified props in many pictures. It's a good gimmick, isn't it? The giant hand in *Spellbound,* for instance.
> *Truffaut:* At the end of the picture, when the doctor's hand holds the revolver in the axis of Ingrid Bergman's silhouette?
> *Hitchcock:* Yes: There's a simpler way of doing it, and that's to flood a lot of light onto the set so that the lens [aperture] can be made smaller. We were using George Barnes, a very famous cameraman, . . . and he said he couldn't stop down because that would be bad for Ingrid's face. . . . Anyway, . . . I first tried to get the shot of the revolver by putting Ingrid Bergman on a screen and by placing the doctor's hand, in focus, close to the screen, but that looked fuzzy. So I wound up using a giant hand again, and a gun four times the natural size.[53]

Wanting both the revolver and Bergman's figure in focus so that both would be features of attention in the resulting film, Barnes needed quite a lot of optical depth of field. Therefore, he needed quite a small lens opening, one almost approximating a pinhole's "infinite" depth. This smaller aperture, however, would have required a greater intensity of light reflected through it from the scene being photographed (which would, in turn, have required more light on the set). But as Talbot remarked, "When the eye of the instrument is made to look at the objects through this contracted aperture, the resulting image is much more sharp and correct;" thus Bergman's features would have been too sharply defined, optically and on film. The option was to keep the wider, "softer" aperture and to compensate for resulting loss in depth of field by using a larger foreground prop, closer to the actress. As we have seen, perspective diminution is inversely proportional to distance away. This enlarged prop's four-times-larger projection in the camera would offset

[53] François Truffaut, *Hitchcock* (New York: Simon & Schuster, 1967), pp. 83–85.

the perspective diminution consequent on placing it four times farther from the camera, thereby both simulating closeness to the aperture and the greater distance from the figure that is depicted in the film.

This records a standard set of photographic trade-offs of factors, which should be by now familiar. Optical focus and therefore sharpness through planes of depth, in camera and thereby in photographic images, is played off against aperture size. In this case, so is *depicted* or imagined focus, for here, as several times in this and other Hitchcock films such as *Notorious* and *North by Northwest,* we have a "point of view" sequence of shots. What is projected on the screen depicts the distinctive perspectival, even ophthalmological and psychological, experience of a character depicted in the film. But since the camera focus here serves photographic purposes, it is constrained by the illumination on the set, relative to the type and sensitivity of the film. (That illumination, of course, is often not the same as the illumination *depicted.* For example, "sunlight quality" in shadows and highlights is often simulated by an artificial source of an effective half-degree.) That sharpness (and perhaps the brightness of the set illumination, which alone would increase detail via shadow contrast) might be played off, however, against desired depicted features of a character. As Hitchcock remarks, it might also play off against desired *detected* features in the actor portraying that character. The pleasures of movies include the activities not only of imagining and imagining seeing but also of indirect seeing and detection.

Praising Shadows

Call up library title listings under "shadow" and you will find little but metaphorical mentions (e.g., "in the shadow of"), often with sinister connotations. Yet shadows, if only for their environmental and representational importance to visual perception, deserve much closer examination than they have ever received—a unified and positive treatment. This chapter has attempted in a simple—even naive—manner its own "praise of shadows." If its rudimentary diagrams and their glosses, illustrating schoolchildishly simple shadow phenomena, has been too tedious for some and too trivial for others, there is this to say in their defense. First, encouraged by an early and abiding historical association of shadows with photographs, I have been trying to do what modern writers have lacked either the interest, the insight, or

the patience to do: to stay with the topic and to think through some of its implications at an elementary and everyday level. In this we have the encouragement of Leonardo's "praise of shadows," different from Tanizaki's but complementary to it in sensitive enthusiasm. The scattered pages of Leonardo's notes for his projected treatises on light and shadow, with their beautiful illustrations, set out on a work in seven parts devoted to shadow: about "original" or attached shadows; "derivative" shadow casts through the air; casts upon bodies; their shapes there; lights reflected back into shadow; the colors of this secondary lighting; and its geometry.[54] We might consider our brief treatment as at least a shadow of his plan of praise.

Dividing shadows into cast and attached, and these again into umbral cores and their penumbral edges, we have praised all four kinds, weaving the topics of photography and shadows back and forth in a series of simple but normally overlooked connections. First, shadows are very useful to any understanding of both depictive and detective functions and therefore relevant to what the two preceding chapters presented as the main uses of photography. In both functions, singly and in combination, the information contained in the umbral cores of shadows and in their penumbral halflight margins requires close consideration. Cast shadows from objects onto other surfaces also confirm Chapter IV's imagining-perceiving theory of depiction itself, while refuting most of its current alternatives. Second, we have seen that the strong and longstanding association of cast shadows with photographs is sometimes more than a popular, because evocative, metaphorical association. Some photo processes, early and late, literally work from cast shadows.

We have also seen how cast shadows, umbral and penumbral, recommend themselves to exposition of photographic *optics,* whether in superposition or in photographic camera images. This includes an exposition of linear perspective as preferable to the usual model of projection through theoretical "windows." Surprisingly, the wealth of environmental information contained in the penumbrae of ordinary cast shadows provides a key to understanding the camera as a technology of amplification by means of filtering or suppressing.

I have throughout insisted on distinctions among three phenomena or uses: optical images, notably those formed in cameras; photographic images, chemical or electronic; and the depictive as well as detective uses to which

[54] See *Leonardo on Painting,* pp. 97–98 (from *Codice Atlantico*).

these may be put. Although properties of the later on the list are usually derived from those of the earlier, this is always a matter of contingent fact, physical or perceptual. Among the derived characteristics that often flow down this line are those of shadow modeling and linear perspective in photographic pictures. These we have noted to be continuous with certain older traditions of picturemaking. Further, especially where combined, shadow modeling and perspective are usually thought to permit powerful effects of naturalism or realism in depiction; Leonardo saw them as the chief agents of pictorial fidelity. With our approach, we can treat these techniques as technological innovations long preceding photography, as devices for harnessing the natural powers of environmental perception to imaginative visualization from marked surfaces. It is a fact of human psychology that certain features in marked surfaces can mobilize powerful natural routines of seeing for purposes of imagining seeing. No wonder these technological discoveries have had such widespread and revolutionary effects on pictorial practices. Shadow modeling and perspective are typically factors in photographic "fidelity." But fidelity is not one thing or even a pair. The next two chapters consider quite different aspects of this famous, complicated, and contested feature of photography.

CHAPTER VII

꙯

Photo Fidelities I: "Photographic Seeing"

Photographic Seeing

The software I am using to write this lists among the synonyms for the general term "photographic" the word "detailed" and also "accurate," "exact," "lifelike," "realistic"; many dictionaries would do the same. "Painterly," "draftsmanship," and the like do not receive comparable extension. This small point about the selective migration of one term into extended meanings stands for a great deal, which it would be a labor to review, as the connotation of exactitude is itself far from exact, for it comprises a diversity of photographic features and photographic functions. Besides, we all know of masses of particular exceptions, notably photographs of ourselves and friends (including those on identification cards) which we find to be quite unlike the subjects. This is consistent: "photographic truth" has meaning even where much photography produces the opposite, for the same reason that "surgical precision" has meaning even though some surgery is known to be imprecise, and "philosophical detachment" has meaning despite the lives of the philosophers, and one could go on with "doglike devotion," "businesslike," "aristocratic," "maternal," and other terms. The depictive fidelity standards assumed to be set and maintained by photography are not always approximated by it. That qualification aside, do photographs of things, still or moving, merit such preferential treatment?

One approach to the question which has gained currency would make short

work of it. It is sometimes said that modern people have simply adapted their visual experiences to photography, and that the reason good photographs of things seem to look so much like them is simply that people tend to look at things under the influence of photographs. One of the first statements of this position made was by William Ivins, in *Prints and Visual Communication:*

> At first the public had talked a great deal about what is called photographic distortion. . . . But the world, as it became acclimated, or, to use the psychologist's word, conditioned, to photographic images, gradually ceased to talk about photographic distortion, and today the phrase is rarely heard. . . . Thus by conditioning its audience, the photograph became the norm for the appearance of everything. It was not long before men began to think photographically, and thus to see for themselves things that previously it had taken the photograph to reveal to their astonished and protesting eyes. Just as nature had once imitated art, so now it began to imitate the picture made by the camera. Willy nilly many of the painters began to follow suit.[1]

The wit and brevity of this explanation certainly recommend it, and in a recent climate of relativism it has gained a number of theoretical adherents— including Susan Sontag, who restates it.[2] Photography, it is often said, in a blanket phrase to smother scruple, has changed our way of seeing. It is questionable, however, what this means and, given a meaning, to what extent it is true. It is likewise questionable to what extent photography has, as Ivins and others assert, changed other practices of depiction, notably that of painting.[3]

What does the Ivins claim of adaptation of perception to photographs generally mean, other than that people have come to object (relatively) less

[1] Ivins, *Prints and Visual Communication,* p. 138. Ivins introduced this passage with the comment that "inescapably built into every photograph were a great amount of detail and, especially, the geometrical perspective of central perspective and section."

[2] Sontag, *On Photography,* pp. 97–98.

[3] For arguments against a series of facile, popular assumptions about the effect of photography on drawing and painting, see Peter Galassi, *Before Photography: Painting and the Invention of Photography* (New York: Museum of Modern Art, 1981); Kirk Varnedoe, "The Artifice of Candor: Impressionism and Photography Reconsidered," in *Perspectives on Photography: Essays in Honor of Beaumont Newhall,* ed. Peter Walch and Thomas Barrow (Albuquerque: University of New Mexico Press, 1986), pp. 99–123; and Kirk Varnedoe, *A Fine Disregard: What Makes Modern Art Modern* (New York: Harry N. Abrams, 1990), pp. 42–53. Demurrals include Robert Hughes, "On Lucien Freud," *New York Review of Books,* 13 August 1987, pp. 54–59, esp. 54.

to certain photo peculiarities? These peculiarities might include extreme—even alarming—perspective convergences, surprising momentary attitudes of human forms, exaggerations of tonal contrast, along with "false attachments" in figures, as part of generally muddled and ambiguous compositions—also blurs and abrupt cropping. That wide-angle mirrors at first seem to distort and then, after practice, do not does not indicate change in how things look to us when we look at them *without* mirrors. As for photos revealing things to us, this should, in Ivins's context, mean more than that photography amplifies perception, allows us to see states of affairs that we could not otherwise see; more than that, as Kracauer well remarked, through its "revealing" function it has "considerably enlarged our vision," "has brought a revolution in visual perception," and so on.[4] That we have by now all seen the corona effect of drops of liquid photographed at high speed, the ragged edges of razor blades or the crystal structures of snowflakes under microphotography, or horses with all four feet off the ground does not mean that these subjects appear any different to us when we look at them directly. I doubt that they do.

How different was the visual experience of people in the times before photography from that of people now? Occasionally we get reports of people seeing photos of things for the first time. Edmund Carpenter reports the effect of presenting photographs to people in New Guinea who had never seen them before, people who had never even looked at mirror reflections:

> In one remote village . . . we gave each person a Polaroid shot of himself. At first there was no understanding: the photographs were black and white, flat, static, odorless—far removed from any reality they knew. They had to be taught to "read" them. I pointed to a nose in one picture, then touched the real nose, etc. Often one or more boys would intrude, peering intently from picture to subject, then shout, "It's you!" Recognition gradually came into the subject's face. And fear. . . . When we projected movies of their neighbors, there was pandemonium. They recognized the moving-images of film much faster than the still-images of photographs. . . . The tape-recorder startled them. . . . They understood what was being said, but didn't recognize their own voices. . . . But, in an astonishingly short time, these villagers, including

[4] Kracauer, "Photography," in Petruck, *The Camera Viewed*, 2:169. Cf. Borcoman, *Magicians of Light*, p. 11.

children and even a few women, were making movies themselves, taking Po-
laroid shots of each other, and endlessly playing with tape-recorders. No
longer fearful of their own portraits, men wore them openly, on their fore-
heads.[5]

Carpenter adds, "It's a serious mistake to underestimate the trauma any new
technology produces, especially any new communication technology." Yet
he does not present the trauma in this case as the rapid acquisition of habits
of "photographic seeing," even though he reports that the villagers were soon
running cameras themselves. Rather, the trauma is seeing oneself by such
means. Carpenter relates similar reactions among these people to mirrors:
"They were paralyzed: after their first startled response . . . they stood trans-
fixed, staring at their images, only their stomach muscles betraying great ten-
sion. . . . In a matter of days, however, they groomed themselves openly
before mirrors. . . . When mirrors become a part of daily life, it's easy to for-
get how frightening self-discovery, self-awareness can be" (452–53). Most of
us can recall our own similar responses when we first heard ourselves on tape
recordings. Most of us would no doubt have strange sensations if we were to
see ourselves on large cinema screens; even appearing on television might be
too much. Indeed, some of us retain a "tribal terror" of still photos of our-
selves, and many have not forgotten how frightening self-awareness from
mirrors can be (even leading to the tensing of stomach muscles).

As for "photographic seeing" or "photographic vision," there is nothing
yet in Carpenter's or similar accounts to suggest such a thing. Seeing oneself
in a photo here seems to be basically seeing oneself vividly in a picture, us-
ing, as we usually do, our abilities to see our environments generally. This
also concurs with our experience of photographs in societies which—unlike
the lucky ones in New Guinea—are saturated with photo images. Small chil-
dren take great interest in pictures, still and moving, from very early ages.
Not only do they recognize things there, but their recognition of things *in
general* is often learned first from pictures, then transferred to actual situa-
tions. Largely owing to photomechanical reproductive technologies, these
pictures are a wonderful mix of types and styles. Small children look at pic-

[5] Edmund Carpenter, "The Tribal Terror of Self-Awareness," in *Principles of Visual Anthropology*,
ed. Paul Hockings (The Hague: Mouton, 1975), p. 454. Carpenter filmed these reactions; similar
responses, leading to villager's use of camcorders, have been presented on television. Years earlier,
William Holden showed comparable reactions in Africa, especially to projected film, in his televi-
sion program "Adventures in the Jade Sea."

ture books, magazines, television screens, logos and schemata, and decorative depictions on objects in many scales, along with 3D toys and dolls, all in no particular order and often with no preference. The idea that in so doing, often with an eagle eye that adults have trouble following, the child adapts to and assimilates various so-called conventions of depiction—including photographic ones—seems far-fetched. It appears more so when we recall the childish capacity for projecting—that is, imagining seeing—faces and creatures, in nondepictive arrangements of things such as shadows, a capacity for seeing "faces in strange places" which may abate but never entirely leaves us. Given the mysterious ability of humans to imagine seeing depictively, their ability to do so through great varieties of pictures—for example, those displayed in most newspapers and magazines—seems no more mysterious than their ability to make sense of visual situations generally, across wide optical variations, given that the former capacity most probably *draws upon* the latter.

There is, to be sure, such a thing as development in pictorial perception, as there is development in environmental perception. Many depictive aspects of pictures at first inaccessible to children are later learned, just as many aspects of environmental situations inaccessible to children are later learned. This certainly applies to kinds of photography. People do learn to identify pictures correctly, at a glance, as photographic or not—or at least as basically photographic. That one normally does learn to distinguish different kinds of pictures, and not simply by their subject matters, should not obscure the underlying fact of our impressive general facility with pictures of many sorts. In short, it is easy to make too much of the idea of special kinds of pictorial seeing, as many commentators have done, in their misguided exaggeration of the likeness between understanding kinds of pictures and understanding natural languages or notations.[6]

We have considered the first experiences of photographs among both New Guinea villagers and children in many modern societies. There is also historical evidence of the first experiences of photographs in the places where they were invented. Daguerreotypes were seen to be like other pictures, only far more detailed. Talbot's productions not only looked different from daguerreotypes but looked at first rather like sepia drawings on paper; as late as the improved version in *The Pencil of Nature,* Talbot thought it necessary

[6] For further arguments of this sort, see Richard Wollheim, "Pictures and Language," *Art Issues* 5 (Summer 1989): 9–12, rev. in Wollheim, *The Mind and Its Depths* (Cambridge: Harvard University Press, 1993), chap. 12.

to insert a declaration that the plates were indeed photographs and not (probably aquatint) engravings. As remarked in Chapter II, rather different-looking kinds of photographs ensued within decades, including those of smooth, transparent "factory finish," expressing rather different photographic and aesthetic values. These again suggest easy transitions from previous kinds of pictures and from visual experience generally to new kinds of photos.

Further objections to Ivins's doctrine may be brought to bear on the alleged plasticity of environmental perception under the force of allegedly special pictorial modes. The development of photo-technologies for depiction suggests that, rather than vision adapting to photography, photography has throughout its history adapted to the requirements of vision. After all, Talbot was quite right to be concerned that he could initially produce from cameras only *negative* images: "It is necessary to obtain a *positive* image, because the negative images of such objects are hardly intelligible."[7] After more than a century and a half of use, people overwhelmingly still pay extra to have positive prints made (despite loss of information), and TV's premium cable channels can effectively make their images useless to nonsubscribers simply by color reversal. Again, people did not simply accommodate to the spectral sensitivity bias of silver halides to shorter wavelengths; rather, these have been consistently engineered, at great cost, to approximate human environmental seeing. Color technology has worked along similar lines—particularly favoring human flesh tones—as has lens design. More than sixty years after Moholy-Nagy and others predicted a "new vision" from photography, based upon its revealing capacities and the "vision in motion" mobility of the small camera—a visual attitude by which "everyone will be compelled to see that which is optically true, is explicable in its own terms, is objective" and which "will abolish that pictorial and imaginative association pattern which has remained unsuperseded for centuries," so that "we may say that we see the world with entirely different eyes"[8]—there seems little evidence that people

[7] Talbot—in *The Pencil of Nature*, note to Plate XX, "Lace"—remarks: "In the commencement of the photographic art, it was a matter of great difficulty to obtain good *positive* images"—that is, it was difficult for him, not for Daguerre.

[8] Laszlo Moholy-Nagy, *Painting, Photography, Film* (1927), trans. Janet Seligman (Cambridge: MIT Press, 1969), pp. 28–29. Some observers claim that popular conceptions of photographs rest conservatively on the vision established by previous means of making pictures; see Pierre Bourdieu, *Photography: A Middle-Brow Art* (1965), trans. Shaun Whiteside (Cambridge: Polity, 1990), pp. 73–77, 191–92.

see their environments any differently than they did before. Like cubism, the "new vision" somewhat shifted people's tolerance and expectations regarding *images*—but that is a quite different issue. People still tend radically to underestimate rates of perspective diminution, in tests, in learning to draw—and in the photos they take. As for popular photography, despite general acquaintance with marginal and other perspective distortions of wide-angle views, such lenses have never had a popular market, and closeup use of them in films and television is standard for making human faces look repellently stupid. Despite wide experience with the results and even the use of telephoto lenses, juries in court cases may still be cautioned that in videos taken with such lenses, spaces will appear to them more compressed than they actually are.[9]

Further related evidence against the idea that acquaintance with at least certain kinds of photographic pictures has developed in us a generic way of seeing the environment—a way that typically confirms such photos as "privileged" kinds of depictions of the sorts of things we see—can be found where there *are* straightforward examples of something called photographic seeing. Photographers are frequently instructed about differences between what they will tend to see through the viewfinders of their cameras and what their equipment is likely to register on photo surfaces. For example, the photographer Edward Weston said that one needs to learn "to *see photographically*— . . . to see his subject matter in terms of the capacities of his tools and processes."[10] If people *did* see subjects photographically, they would not take so many bad photographs as they demonstrably do, even according to their own notions of good and bad. It is difficult for even an ex-

[9] Judge Lance Ito's remarks to the jury of the O. J. Simpson trial, Los Angeles, 23 February 1994. Prosecutor Marcia Clark had objected to the use of the videotape as an attempt "to distort [*sic*], confuse, and mislead the jury." (For corroboration, see Jeffrey Toobin, "Annals of Law: Ito and the Truth School," *New Yorker*, 27 March 1995, p. 48.) Again on 6 April 1995, Deputy District Attorney Hank Goldberg, commenting on the "[rate of] foreshortening" and degree of contrast in a telephoto TV view of an item, alleged a "distortion in this [defense] video tape," producing "an artifact" of the process (the appearance of an object at a certain place and time). And on 8 September Marcia Clark commented on the video zoom's "compression of space," with effects "prejudicial to the accurate depiction" of the crime investigation. This trial was one in a recent series making the general public aware of the growing forensic and legal importance of still and moving, chemical and EO, photography done by investigators, news media, private individuals.

[10] Edward Weston, "Seeing Photographically," in *Encyclopedia of Photography*, vol. 18 (New York: Greystone, 1965), rpt. in *Photographers on Photography*, ed. Nathan Lyons (Englewood Cliffs, N.J.: Prentice-Hall, 1966), and in Trachtenberg, *Classic Essays*, p. 173.

perienced photographer to look through a viewfinder and remember that, for example, the picture taken will not appear within the experienced context in which it is taken, will appear no brighter than the paper it is printed on, will not have the range of brightness of the scene viewed,[11] will be flat and static on a surface, related to its corners and edges. The "capacities" of "tools and processes": again, photo-technologies such as slide projection and stereo, and EO machines such as camcorders that record motion as well as sound, find their markets specifically by approximating photo-independent features of environmental seeing.

Yet all these skeptical considerations are consistent with there being some sort of general "photographic seeing" typical of modern populations. Perhaps what such considerations recommend is that we take a little care in specifying what that "seeing" is. Many people have had the experience, after attending exhibitions of pictures of certain kinds, of seeing people, landscapes, and motifs of various kinds under their influence. This is one reason for going to exhibitions. Strong forms in painting may linger in our minds like songs, influencing our experiences for a while. It may be that photos of certain kinds have like effects, and that because we see them so often, we do tend to experience our environments in their terms. It would be useful to have this shown empirically. Until it is, we can at best speculate regarding the depictive characteristics of *certain kinds* of photographs of things, sufficiently familiar to exert such influence. Our historical and causal surveys have given some basis for attempting a plausible list of these characteristics, perhaps guided by Siegfried Kracauer's admonition that "the properties of a medium elude concise definition" but may nonetheless "show certain affinities." Kracauer's four photographic affinities, we may recall from Chapter I, were "for unstaged reality," "to stress the fortuitous," "to suggest the endless (or contents outside the frame)," and "for the indeterminate"—hence "toward the unorganized and diffuse," "suggesting indistinct multiple meanings." This list may be compared with the descriptions of early commenta-

[11] E.g., a leading photo theorist of the nineteenth-century, Peter Henry Emerson, remarked: "The deceptive luminosity of the ground-glass picture must not be allowed to influence our normal mental analysis of the natural scene" (*Naturalistic Photography,* 3:72). In the twentieth century it is common to find admonitions like this: "The unaided eye is not a good judge of the intensity of incident or reflected light. . . . It is necessary to stress . . . that the eye automatically compensates for differences of brightness and color in the subject, perceiving a more refined color range and brightness range than can be registered on any film" (Adams, *Natural Light Photography,* pp. 3, 5).

tors, who would perhaps be more conscious than we of "distinctive charac-
teristics" of photo processes.

Attention to Detail

A first connotation of "photographic," we saw, might be "detailed." As we
noticed earlier, the first admirers of photographs were much struck by the
visual clarity, detail, and perspective of those pictures—features owing to op-
tical and chemical factors, including those reviewed in Chapter VI. Detail
has continued to be a main value of photographic pictures of many kinds,
frequently counted as an aspect of photo fidelity. Photo detail may consti-
tute, as much as perspective and instantaneous effects, what many people
think of as photographic vision. The list of citations about detail, early and
late, is endless. I will consider the topic in two discussions, of detail as visu-
al clarity and detail as incidental representation, before reconsidering their
combination. Following my usual practice, in each case I begin with nine-
teenth-century citations.

Arago's presentation cited Paul Delaroche's report: "What he stresses most
about photographic images is their 'unimaginable precision of detail.'"[12] The
first reviews of the process remarked on the product's "fine detail," "extraor-
dinary minuteness of . . . multiplied details," "every thing . . . reproduced
with incredible exactness" and with "an immense quantity of details, of such
extreme fineness," and the like, as much as they remarked upon the new
process itself.[13] A writer in the 1843 *Edinburgh Review* noted the daguerreo-
type's "minuteness of delineations" and continued: "Every object is seen in
true perspective; and even the aerial perspective is displayed in the diminu-
tion of sharpness which marks the outlines of all objects that recede from the
eye. The combination of these two effects, the last of which is often beyond
the reach of art, gives depth—a third dimension—to the picture"[14] In Amer-
ica three years earlier, Edgar Allan Poe had written with like enthusiasm
about daguerreotypes (the only kind that seems to have been taken of him):
"The Daguerreotyped plate is infinitely (we use the term advisedly) is *infi-*

[12] Arago, "Bill," in Eder, *History of Photography,* p. 235.
[13] *La Gazette de France,* 6 January 1839, and (British) *Literary Gazette,* 13 July 1839, in Newhall,
Photography: Essays & Images, p. 18.
[14] Quoted in Goldberg, *Photography in Print,* p. 56.

nitely more accurate in its representation than any painting by human hands. . . . The closest scrutiny of the photogenic drawing discloses only a more absolute truth, a more perfect identity of aspect with the thing represented. The variations of shade, and the gradations of both linear and aerial perspective, are those of truth itself in the supremeness of its perfection."[15] If such effects were spectacular in daguerreotypes, they were not lacking even in Talbot's paper products, which were often described, relative to daguerreotypes, as lacking in detail. A daguerreotypist, a later collodion professional, or one of our contemporaries might well say that calotypes tended to "suppress surface detail;" this is true, but only comparatively so. The first impressions of Talbot's photogenic drawings register delight in detail, as may be seen by scanning periodicals of the time—for example, this record from *Athenaeum's* "Our Weekly Gossip" column: "The effects produced are perfectly magical. The most fleeting of things—a shadow, is fixed, and made permanent; and the intimate truth of many of the objects, the exquisite delicacy of the pencilling, if we may be allowed that phrase, can only be discerned by a magnifying lens."[16] That account registers a number of our themes: not only the fixing of shadows and the analogy to pencil marks on a surface but also the camera-free superposition images of laces, ferns, and leaves, which would have been the most impressive in this early display.

Talbot could commend his later process for the "multitude of minute details which add to the truth and reality of the representation" as much as for its unflagging rendition of linear perspective.[17] Both features would contribute to what he termed "the character of truth and reality which that art so eminently possesses," wanting even in skillful engravings.[18] The *Art*

[15] Edgar Allan Poe, "The Daguerreotype," *Alexander's Weekly Messenger,* 15 January 1840; rpt. in Trachtenberg, *Classic Essays,* p. 38. Poe's use of "photogenic drawing" is generic; his specific topic is daguerreotypy.

[16] *Athenaeum,* 2 February 1839, p. 96.

[17] On detail, see Talbot, *The Pencil of Nature,* note to Plate X, "The Haystack," and to Plate XIII, "Queen's College, Oxford." On perspective, see note to Plate XVII, "Bust of Patroclus," where Talbot becomes bold: "For there is, assuredly, a royal road to *Drawing.* . . . Already sundry *amateurs* have laid down the pencil [for photography]. . . . Those amateurs especially, and they are not few, who find the rules of *perspective* difficult to learn and to apply—and moreover have the misfortune to be lazy—prefer to use a method which dispenses with all that trouble. And even accomplished artists now avail themselves of an invention which delineates in a few moments the almost endless details of Gothic architecture which a whole day would hardly suffice to draw correctly in the ordinary manner."

[18] Talbot, "Just Published" (notice for Part I of *The Pencil of Nature*), p. 2.

Union review of his *Pencil of Nature* agreed, praising the plates for the way "the minutest detail is given with a softness that cannot be imitated by any artistic manipulation" and "the microscopic execution sets at naught the work of human hands."[19] Holmes claimed that "a perfect photograph is absolutely inexhaustible" and commented on the photo's "exquisitely defined" details,[20] as did Sir William Newton on its "exactitude of delineation."[21] Lady Eastlake praised "correctness of drawing, truth of detail, and absence of convention" as the main virtues of photography in her time. That it also suffered from high contrast and a lack of panchromatic response is, in view of our recent consideration of pressures on photographic technology, worth citing: "The colour green, both in grass and foliage is now his great difficulty. The finest lawn turns out but a gloomy funeral-pall in his hands . . . [and] what with the dark spot produced by the green colour, and the white spot produced by the high light, all intermediate grades and shades are lost."[22] Still, we may emphasize that aside from chromatic response problems, photographs were early remarked on (as in the first news accounts of daguerreotypes) for their "range of high lights, shadows and half-tones"[23]— that is, for what Daguerre advertised as "very fine gradations of tones."[24]

Two decades later the photographer Francis Frith asserted that the distinctive, even "spiritual," characteristics of photographic pictures lie in their detail: "Every stone, every little perfection, or dilapidation, the most minute detail, which, in an ordinary drawing, would merit no special attention, becomes, on a photograph, worthy of careful study."[25] Scott Archer had

[19] *Art Union* reviews of Parts I and II, August 1844 and March 1845, cited in Beaumont Newhall's introduction to *The Pencil of Nature*.
[20] Holmes, "The Stereoscope and the Stereograph," in Newhall, *Photography: Essays & Images*, p. 58.
[21] Sir William J. Newton, "Upon Photography in an Artistic View, and Its Relation to the Arts," *Journal of the Photographic Society* 1 (1853): 6–7; rpt. in Newhall, *Photography: Essays & Images*, p. 79.
[22] See Lady Eastlake, "Photography," in Newhall, *Photography: Essays & Images*, pp. 94–95 for the praise, pp. 92–93 for the criticism. Talbot had commented on the "inconvenient circumstance" regarding trees that "green rays act very feebly" (*The Pencil of Nature*, note to Plate IV, "Articles of Glass"). Another early note of troubles with green versus other colors occurred in the *La Gazette de France*, 6 January 1839, report of Daguerre, trans. and rpt. in Newhall, *Photography: Essays & Images*, p. 18.
[23] Newhall, *Photography: Essays & Images*, p. 17.
[24] Daguerre, "Daguerreotype," rpt. in Trachtenberg, *Classic Essays*, p. 11.
[25] Francis Frith, "The Art of Photography," *Art Journal* 5 (1859): 71–72 rpt. in Newhall, *Photography: Essays & Images*, p. 117.

opened his brief paper on his revolutionary collodion process, which substi-
tuted glass for paper negatives, by stating that the "imperfections in paper
photography, arising from the uneven texture of the material," had induced
him to seek another material that would meet "the necessary conditions" of
"fineness of surface, transparency, and ease of manipulation."[26]

This, our ongoing theme of silver's subtlety and its meanings, carries on
to the twentieth century, where, for example, it provided an aesthetic prin-
ciple for the influential "straight photography" school. The photographer
and teacher Ansel Adams wrote, "Of all the arts, photography encourages ex-
ploration of the minutiae, and in fact is often more convincing in its inter-
pretation of objects of intimate environment."[27] A rather more essentialist
Paul Strand thought that we could "determine what the materials of pho-
tography really are," including the power to "register a scale of tonal values
. . . far beyond the power of the human hand or eye," and to "record the dif-
ferentiation of the textures of objects as the human hand cannot." Such, he
held, are the "strictly photographic" instruments.[28] In that vein, Beaumont
Newhall declared early in his career that "pure photography was the only type
possible"; photographers, he said, were coming to understand "that this is
their only legitimate aesthetic, that the ability of the camera to capture the
utmost possible detail of the natural world is it chief characteristic, and
should be fully realized."[29] Edward Weston also regarded rendering of detail
as the essence of the photographic: "First there is the amazing precision of
definition, especially in the recording of fine detail; and second, there is the
unbroken sequence of infinitely subtle gradations from black to white. These
two characteristics constitute the trademark of the photograph,"[30] he insist-

[26] Frederick Scott Archer, "The Use of Collodion Photography," *Chemist* 2 (March 1851); rpt. in
Newhall, *Photography: Essays & Images,* p. 51.

[27] Adams, *Natural Light Photography,* p. 75.

[28] Paul Strand, "The Art Motive in Photography" (1923 address, Paul Strand Archive), rpt. in
Goldberg, *Photography in Print,* p. 279.

[29] Newhall (quoting an earlier piece of his), "The Challenge of Photography to This Art Histori-
an," in Walch and Barrow, *Perspectives on Photography,* p. 3.

[30] Weston, "Seeing Photographically," in Trachtenberg, *Classic Essays,* p. 172, and Lyons, *Photog-
raphers on Photography,* p. 161. Weston added two other features: "The photographic image . . . con-
tains no *lines* in the painter's sense, but is entirely made up of tiny particles. The extreme fineness
of these particles gives a special tension to the image. . . . Finally, the image is characterized by lu-
cidity and brilliance of tone." In Weston, "Photography—Not Pictorial" (in Lyons, *Photographers
on Photography,* p. 155), the "way of seeing" includes "exaggerating details."

ed, and they roughly correspond to two independent variables: the resolution or fineness of the surface grid of the image, and the contrast subtlety of gradations of light and dark assignable to each component of it.[31] These remain major challenges for contemporary EO technologies.

If we are careful to distinguish the different kinds of photographs, as well as to remember the wide range of particular exemplifications that each allows so as to avoid siding with these last commentators' references to an "essence" of photographic images, we may still talk about what is relatively and notably *easy* for them to achieve. Thus a modern historian can generalize as follows: "To take its technical capacity first: the ability to register with mechanical exactitude and reliability the detailed appearance of things was an astonishing addition to a Western European culture already rich in new technologies."[32] Let us qualify that further by thinking not of "*the* detailed appearance" but of "*a* detailed appearance of things," and inquire into this detail in more detail.

In passages like those cited above, we see that although it usually implies "minuteness," "fineness," tiny scale of features, its meaning—both generally and specifically to photography—is rather wider. Paper negatives, especially when combined with salted paper and the later albumen prints, could never yield the resolution of competent daguerreotypes. This explains why Daguerre's process was at first so much more greatly admired, and why it continued to be the technology of choice in the Americas long after it had lost its dominance in European markets.[33] It is often remarked that the paper method better approximated the painter's and graphic artist's idea of

[31] For similar citations on this theme, see James Borcoman, "Purism versus Pictorialism: The 135 Years War," *artscanada*, 192–95, December 1974, pp. 69–82. Borcoman observes that nineteenth-century writers "were quick to realize that the form the photograph took was an integral part of the whole image and had its own uniquely sensuous nature distinguished by purity of contour, clarity of definition, and infinitely subtle tones that shift from value to value with an exquisite delicacy of which no human hand is capable" (p. 73). Technically, visual clarity in optical and photographic images is a compound of several variables. Among these, we need to distinguish the independent variable of resolution (measured, e.g., by visually resolvable line pairs) from "acutance," a measure of the sharpness of the edges of lines. Contrast affects both, particularly acutance. For a clear, informed account of these factors as applied to photography, see John B. Williams, *Image Clarity: High Resolution Photography* (Boston: Focal, 1990).

[32] Alan Thomas, *Time in a Frame: Photography and the Nineteenth-Century Mind* (New York: Schocken, 1977), pp. 8–9.

[33] Beaumont Newhall, *The Daguerreotype in America*, 3d rev. ed. (New York: Dover, 1976).

"broad handling" of dark and light pictorial masses—for lack of which East-lake and others had pointedly criticized early photography—by suppression of the finer detailed rendering achieved by daguerreotypy. Some photo aesthetics, developing out of the nineteenth and well into the twentieth century, explicitly opposed such values, as did Clement Greenberg's criticism of Weston's pictures: "His camera defines everything, but it defines everything in the same way–an excess of detailed definition ends by making everything look as though it were made of the same substance, no matter how varied the surfaces." Thus, "a nude becomes continuous with the sand, and of the same temperature."[34]

Details, Details

We seem to have another idea and value of photo detail. Fine surface texture and continuous tonal gradation are not all that Talbot pointed to as what we might call details in one of the plates from his *Pencil of Nature* (Figure 13):

> The time is the afternoon. The sun is just quitting the range of buildings adorned with columns: its facade is already in the shade, but a single shutter standing open projects far enough forward to catch a gleam of sunshine. The weather is hot and dusty, and they have just been watering the road, which has produced two broad bands of shade upon it, which unite in the foreground. . . . A whole forest of chimneys borders the horizon: for, the instrument chronicles whatever it sees, and certainly would delineate a chimney-pot or chimney-sweeper with the same impartiality as it would the Apollo of Belvedere.[35]

Normally, as in phrases like "attention to detail," what we mean by 'details' are subordinate parts of wholes, considered separately. Separate consideration tends to give them prominence. This is different from what we mean by "precise detail"—for example, what John Szarkowski referred to as the da-

[34] Clement Greenberg, "The Camera's Glass Eye," *Nation*, 9 March 1946, pp. 294–98; rpt. in *Edward Weston Omnibus: A Critical Anthology*, ed. Beaumont Newhall and Amy Conger (Salt Lake City: Gibbs M. Smith, 1984), pp. 45–48.
[35] Talbot, *The Pencil of Nature*, note to Plate II, "View of the Boulevards at Paris."

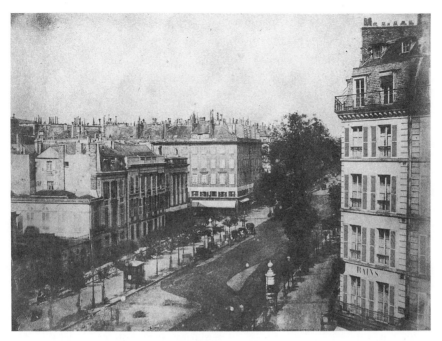

Fig. 13. William Henry Fox Talbot, "View of the Boulevards at Paris." Courtesy of The National Gallery of Canada, Ottawa.

guerreotype's "mindless, hypnotizing precise description of surfaces."[36] Sometimes, as with microphotography (which was practiced very early; indeed, some of the quotations above were about photos made from solar microscopes), small parts are hardly incidental or accidental to our perceptual interests: we take such pictures for that very purpose. This is one way to distinguish optical detail, precision, clarity—what survives levels of magnification—from a kind of subject detail that we usually call *incidental detail.* Comments on daguerreotypy frequently combined the two sorts, as by Arago: "All these pictures [of Parisian monuments] could be examined with a magnifying glass, without losing any precision."[37] Another way would be to consider a large-format photograph—what was once called the f/64 sort, stressing the clarity—of, say, a smooth, evenly lit stretch of metal, porcelain,

[36] Szarkowski, "Early Photography and Modernism," in Naef, *Photography: Discovery and Invention,* p. 100.
[37] Arago, *Comptes rendus de l'Académie des Sciences* 8 (1839), as quoted in Newhall, "Eighteen Thirty-Nine," in Naef, *Photography: Discovery and Invention,* p. 20.

or human nude surface. There may be nothing incidental there, hardly any parts to individuate as details that could be considered incidental, yet the picture would—as, say, Weston wished—carry on the initial qualities of daguerreotypy. By contrast, Talbot's sort of photo detailing in the foregoing passage—stressed also, as we have seen, by Frith, Holmes, Barthes, and others—has to do with what would be counted as Holmes's "incidental," "trivial" features.[38]

Yet if we are to consider the latter kind of detail in connection with the topic of photo fidelities, we must begin with a warning. That detail in representation is no small topic may be indicated by quick consideration of two of the most important works on artistic representation in the last half-century. Erich Auerbach's *Mimesis: The Representation of Reality in Western Literature* opened with a contrast between the *Odyssey* and Genesis, on the following basis: in Homer, unlike the Old Testament, there is "no background."[39] Details there are—vivid, visible, and abundant—but no sense of further, hidden details. Ernst Gombrich's *Art and Illusion* is largely based upon a historical account of European visual representation according to which an interest in "eyewitness" presentation, especially of observable details (probably derived from that very Homeric literature), was the beginning of Greek naturalism and all that followed from it; for Gombrich, this includes the very idea of art.[40] And from World War II on, it has also been much of the attraction of modern news coverage, from radio to television. Even restricting ourselves to photography, such detail, we may say, looms large.

Talbot wrote of "impartiality" in recording the presence of details such as chimneys. What is the meaning of this? It is not Talbot's claim that photographs are impartial depicters or detectors, simpliciter; he is listing the optical phenomena by means of which details appear in his new kind of image. In his picture (Figure 13) one may notice, for example, that the wet part of the road shows specular (mirror) or directional reflecting of light away from the camera position—rather than scattering it, as do the dry parts of the road.

[38] E.g., "This distinctness of the lesser details of a building or a landscape often gives us incidental truths which interest us more than the central object of the picture," "running away with us from the main object . . . they take hold of the imagination." (Holmes, "Stereoscope," p. 58).

[39] Erich Auerbach, *Mimesis: The Representation of Reality in Western Literature* (1946), trans. Willard Trausk (Princeton: Princeton University Press, 1953), chap. 1.

[40] Gombrich, *Art and Illusion*, esp. chap. 4.

Therefore the wet part appears darker in the print. To use Talbot's metaphor, we might even say that there is partiality in what the photo system "sees": the very partialities in which he is instructing his readers. Talbot's own mono-chrome does not record color hue differences, for notable example. Even as monochrome, it blocks greens in his trees, and there may be issues of selec-tive focus, and so on. What Talbot probably means is that there is missing in the physical photo process a *second* order of partiality: the processing, or fil-tering, of what is seen which is typical of pictures made by other means. As a result, the physical processes the photographer invokes, by means of which the things the photographer wishes to depict produce their photographic im-ages, allow other situations to slip through and produce their images as well. Figure 4 also illustrates this effectively.

This is a second order of filtering that we may associate with visual expe-rience and a few other forms of pictorially rendering it. Although it has of-ten been pointed out and strikingly demonstrated how *selective* biological vision is, it is not so often pointed out—at least in the case of human vi-sion—that in a way we are all quite aware of this. Of all that we see at any moment—for example, the multitude of textural details, waves, leaves, blades of grass—we can notice only a little; however, the fact that much must escape our notice does not itself escape our notice. Just as, physiologically, our acute foveal vision works within the wider field of movement-sensitive peripheral vision, we are psychologically well aware that our perceptual ex-perience far outruns our perceptual knowledge.[41] There are traditions of re-marking on this awareness. Perhaps, as has been argued, we are aware that something like a digital filter is being applied on what is more like an ana-logue basis.[42] Simple evidence for this is the amount of energy the wider scan entails, energy that might make us brilliant practitioners of many crafts, or at least idiot savants, if we could but narrow its focus. Yet for normal, re-sponsible adults tunnel vision must be a useful but specialized recourse for emergencies. This awareness of unawareness, as we might call it, contributes to a well-known sense of always missing something that attends our lives (missing either in the sense of not noticing or of noticing but underestimat-ing), a sense that grows more poignant with age and is perhaps keener in modern times. Indeed, the attraction of photography as an instrument of de-

[41] See, e.g., Gregory, *Eye and Brain*, p. 101.
[42] See Dretske, *Knowledge and the Flow of Information*, chap. 6, "Sensation and Perception," for a careful statement of such a distinction.

tective depiction is often attributed to this "rarely conscious fear that we are missing something"[43]—particularly when conjoined with the acquisitive fear of letting go what we did not miss. The familiar "got it" syndrome of picture-snapping may express such anxiety.

Subversion (1): Detail and Displacement

Having made some elementary points about photographic detail, let us return to the general theme of photographic seeing and fidelity—notably, to the idea that a new kind of environmental seeing has been brought on by photography. This idea is sometimes expressed in terms of two photographic *subversions,* through incidental detail, of standard pictorial values. Although these are frequently discussed together, it seems once again useful to observe a simple distinction of two kinds for separate treatment.

A feature that struck people initially about photographic processes, and continues to impress (or oppress) them, is how easily they record that unattended background of perceptual experience, and what efforts it requires to *filter* or to *suppress* that record or to keep it down *as* background. Once such detail is on record, particularly in our first kind of minute detail, we may be able to shift our attention among aspects of it, much as we can—given motive and opportunity—with an environmental scene. We may, that is, if we can make any sense of it.

Striking claims have been made about the effect of this. One interpretation indicates pictorial subversion. In the catalogue for an influential photographic exhibition in the mid-1960s, John Szarkowski quoted Holmes's famous "marks on a drumhead" remark and commented (in a section called "The Detail"): "The compelling clarity with which a photograph recorded the trivial suggested that . . . it was in fact perhaps *not* trivial, but filled with undiscovered meaning."[44] Thus the detail depicted as incidental to the scene may assume greater, and hence not incidental, meaning to the picture. In later writings Szarkowski has interestingly suggested this as the key to photography's influence on modern literature, as well as art. Referring to a nineteenth-century albumen print from a collodion glass negative, he remarks

[43] Richard Hennessy, "What's All This about Photography?" *Artforum* 9 (May 1979): 23.
[44] John Szarkowski, *The Photographer's Eye* (New York: Museum of Modern Art, 1966), n.p. His illustrations of "Detail" are mainly of parts of things and situations; some of these include minuteness, some do not.

that "no humble draughtman would have been so dull as to include in his drawing those irrelevant, extraneous details . . . that [the photographer] Durandelle could not avoid," and continues: "For the most important gift of photography to the traditional arts was not its function as a sketching tool, . . . but as the source of a new sensibility, an expanded sense of the unexpected nooks and crannies in which the seeds of a new visual truth might lie."[45] For a more recent exhibition a like-minded curator, James Borcoman, wrote: "Photographs often contain evidence of how unruly the world is, or, at least, how out of the photographer's control. The refuse between the tracks in the foreground [of a mid-century salt print of a railroad track] is unidentifiable and certainly not of the photographer's choosing. Yet, it sits there, unexplained and apparently irrelevant to the picture's purpose. Such accidental intrusions of the common-place shift the meaning of a photograph and even add to its power to define reality."[46] This oft noted effect of incidental photo detail leads also to the likelihood of *displacement* of attention to Holmes's, Frith's, and Barthes's *significant* incidental details, which Barthes and others say might well be poignant—or which, it is often argued, provide an occasion for surrealism.[47]

Incidental detail need not be *subversive* detail. Talbot, for example, saw it as continuous with the picturesque tradition. "One advantage of the Photographic Art will be," he wrote about one of his calotypes ("The Haystack"), "that it will enable us to introduce into our pictures a multitude of minute details which add to the truth and reality of the representation," and such minutiae "will sometimes be found to give an air of variety beyond expectation to the scene represented" (consistent with "broad effect").[48] The ancient idea of variety in unity was, after all, hardly novel in Talbot's time; we have

[45] Szarkowski, "Early Photography and Modernism," pp. 104–5.

[46] Borcoman, *Magicians of Light*, p. 48, commenting on "The Railroad Station at Clermont" by Édouard Baldus, c. 1855. Regarding an albumen print of a bombed bridge from the Franco-Prussian War, which combines both kinds of "detail," he writes: "Detail is so lovingly rendered in the photograph that we are tempted to question reality. From the rubble in the foreground to the rivets on the girders, . . . everything is so precisely delineated that we find ourselves in world of heightened actuality. . . . The ambiguity between the vicarious and the first-hand creates a tension in the viewer that gives photography its mystery" (p. 104).

[47] See Sontag, *On Photography*, pp. 68–82; and her critic Andy Grundberg, "On the Dissecting Table: The Unnatural Coupling of Surrealism and Photography," in *The Critical Image*, ed. Carol Squires (Seattle: Bay Press, 1990), pp. 80–87. For a fuller, argued account of the surrealism of the small camera, see Peter Galassi, *Henri Cartier-Bresson: The Early Work* (New York: Museum of Modern Art, 1987).

[48] Talbot, *The Pencil of Nature*, note to Plate X, "The Haystack."

seen it in Eastlake's comments about "broad handling." Again, Talbot remarked about perhaps his best-known calotype, "The Open Door" (see Figure 17), that such slight things as a "casual gleam of sunshine, or a shadow . . . may awaken a train of thoughts and feelings, and picturesque imaginings," and he related this effect to "the Dutch school of art." Kracauer thought Talbot was expressing uncertainty about a main property of his medium, but I do not see why this should be so, any more than that his comment should be taken as an inkling of the sublime.[49] Detail can have various effects in different pictures; hence, if photo details are "telling," they need not always tell stories in similar style.

Subversion (2): Whose Mess Is This?

Photography is accident-prone, in several senses. It is accident-prone in the meaningful, mechanical way in which Sitting Bull is alleged to have been the first Amerindian to "take" a photograph when (in 1882) he accidentally released a shutter. It is accident-prone in the related way in which we often photograph details we did not notice, and accident-prone in the sense that such details may be incidental to the scene and to our purposes: as Aristotle would say, *kata symbebekos*.

Successful examples of pictures with *significant* details, such as Talbot's, Szarkowski's, or Borcoman's, should not cause us to forget the overwhelming number of *unsuccessful* examples. Photography automatically amplifies information content in pictures, at least in certain dimensions, while making filtering of that information difficult. The result for most camera users is, relative to other imagemaking technologies, a high degree of *noise*. Most often the incidental detail in our pictures is more muddling than telling, less a "punctum" than a pox. One of the hardest challenges for any of us as photographers is to control a sea of inchoate ephemera. "The camera," Kirk Varnedoe remarked, "though it may be Flemish-Renaissance in detailed surface description, tends to traffic heavily in unfamiliar aspects at the expense of clarity."[50] For as Janet Malcolm had written a decade earlier, "The odds

[49] Ibid., note to Plate VI, "The Open Door." On the Dutch tradition, see Svetlana Alpers, *The Art of Describing: Dutch Art in the Seventeenth Century* (Berkeley: University of California Press, p. 198). On Kraucauer's comment, see "Photography," in Petruck, *The Camera Viewed*, 2:182. I return to this discussion in Chapter IX.

[50] Varnedoe, "The Artifice of Candor," p. 104.

against finding the desired . . . work of art in the mess and flux of life, as op-
posed to the serene orderliness of imagined reality, give a special tense daz-
zle and an atmosphere of tour de force to any photographs that succeed in
the search. These odds are also what give photography its reputation (or for-
mer reputation) for being difficult—more difficult than painting, in the
opinion of some commentators."[51]

The point is an old and abiding one. In Chapter II we found it a theme
of Elizabeth Eastlake's review of the new collodion process. Eugène Dela-
croix, intelligent and articulate, who was born in the same year as lithogra-
phy and saw photography appear long after he was established as a great
painter, wrote as follows:

> The artist is always concerned with a total view of the world. However, when
> the photographer "takes a picture" . . . the edge of his picture is just as inter-
> esting as the middle, one can only guess at the existence of a whole, and the
> view as presented seems chosen by chance. The incidental details become just
> as important as the main theme—they often strike the eye first and confuse
> the whole. In a photographic representation one has to allow far more for
> shortcomings than in a work of the imagination. Photographs that do evoke
> a more powerful impression owe it to the inability of the process to reproduce
> everything absolutely exactly. They leave certain gaps where the eye is forced
> to rest and which restrict the eye to a small number of details.[52]

This distraction and lack of compositional clarity is precisely what the lead-
ing nineteenth-century photographer and teacher Peter Henry Emerson is
perhaps most famous for deploring. According to Emerson, in a discussion
that also relates our two kinds of detail, that of optical clarity and the inci-
dental kind, the amount of scene detail in artistic photographs should be
guided by what would be noticeable in normal environmental vision; there-
fore, optical "sharpness" in such pictures should be controlled so as to allow
this to happen.[53] (As Janet Malcolm remarks, "optical sharpness, after all, is

[51] Janet Malcolm, "The View from Plato's Cave," *New Yorker* (1976), rpt. in Malcolm, *Diana &
Nikon* (Boston: David R. Godine, 1980), pp. 78–79.
[52] Eugène Delacroix, *Les plus belles lettres* (Paris), pp. 325–26, cited in Volker Kahmen, *Photografie
als Kunst,* trans. Brian Tubb as *Art History of Photography* (New York: Viking, 1974), p. 15.
[53] Emerson, *Naturalistic Photography,* 2:71. Emerson wrote of "the great heresy of sharpness" (1:159)
and remarked that the public's interest in photo "clearness" is a throwback to the "powerful vision
of their periscopic ancestors—the Saurians" (3:42).

more an attribute of the buzzard than the human eye.")[54] Emerson distinguished what we normally see "directly and sharply" from what we are visually "conscious of" and argued that the latter should not be brought up to the level of the former, lest to "Where is the picture?" the answer is "Gone! The [subject] is there, but she is a mere patch in all the sharp details; all relief, contrast and modelling are lost. . . . Our eyes keep roving, . . . *there is no rest*, . . . and all the interest is equally divided."[55] Notice that Emerson's objection is neither to the existence of detail (he insistently deplored "fuzziness" in background) nor to the emergence of displacing "significant" detail (which he does not mention) but to loss of composition and therefore loss of a sense of wholeness.[56]

It is interesting that on that score Emerson would probably be in agreement with the "straight photography" of the Adamses and Westons of the 1920s onward, who are normally but not altogether thoughtfully considered antagonistic to his "pictorialist" ideas of camera form.[57] He would also be in agreement with a host of professional photographers working against the nuisances of subject intrusions toward clear and composed pictures of focused subject matter. As for artistic photography, a later anti-craft, small-camera antithesis to *both* "straight" and "pictorialist" aesthetics would set them in synthesis: a school of incidental detail with no orientation toward *optical* detail.

It is clear that our discussion of photo detail has landed us in the history of photo aesthetics, and there we must sojourn briefly. When Borcoman wrote of "how unruly the world is," part of his meaning was how difficult it is for photographers to attain the compositional forms of either the Emerson school or those of Strand, Weston, and so on. Janet Malcolm had already written of the "formlessness, rawness, clutter, accident, and other mani-

[54] Janet Malcolm, "The Dark Life and Dazzling Art of Edward Weston," *New York Times* (1972); rpt. in Malcolm, *Diana & Nikon*, and in Newhall and Conger, *Edward Weston Omnibus*, p. 161.
[55] Emerson, *Naturalistic Photography*, 2:75.
[56] This verges on a large topic for perception generally. E.g., an autistic author, Donna Williams, expresses the experience of autism as "sensory overload" in which "the glue that sticks them all together is not very good." Without optical aids she tends to "see all the little things without the whole"; with optical aids, "like it's all held together" (interview with Paul Kennedy on the CBC *Morningside* radio program, 7 March 1994). Williams is the author of two autobiographical books, *Nobody Nowhere* and *Somebody Somewhere*.
[57] Like most handy oppositions, this one has been challenged by, e.g., Janet Malcolm in an essay on Weston, "Assorted Characters of Death and Blight," *New York Times* (1975); rpt. in Malcolm, *Diana & Nikon*.

festations of the camera's capacity for imposing disorder on reality—for transforming, say, a serene gathering of nice-looking people in pleasant surroundings (as one had perceived it) into a chaotic mess of lamp cords, rumpled Kleenexes, ugly food, ill-fitting clothes, grotesque gestures, and vapid expressions."[58] Malcolm, like others, reported that from this "clutter, accident" there had emerged by the late 1960s (in certain circles) a distinct photo aesthetic—hence her remark about photography's "former reputation." Thus arises an aesthetic of visual noise.

The point is frequently made that this kind of photo "formlessness" was spread through one of the most important streams of development in photo-technology, beginning from the mass marketing of the famous Kodak of the early 1890s, progressing with the rise of 35 mm cameras and "the rollfilm revolution,"[59] through the technologies reviewed at the beginning of this book: that is the snapshot. A dictionary defines "snapshot" as "a causal photograph made typically by an amateur with a small hand-held camera and without regard to technique."[60] That "small hand-held camera" together with fast roll films and lenses, flash attachments, and so on—combined, let us remember, with mass, standardized production and mass marketing services (including development)—made taking pictures of things easy, whereas previous nineteenth-century technologies had made it increasingly difficult.[61]

If we wish to consider parallels between revolutions wrought by photography and writing, we should certainly consider, but not restrict ourselves to, the printing-ink varieties of either. Just as ancient literacy passed from a scribal craft status to a demotic one, so did picture taking, and the numbers, kinds, and uses of marked-surface products increased correspondingly. Among the millions of these, many are of high quality by most standards—as shown by exhibition and promotional contests—but most are not. If photography (of things) is by nature accident-prone, miniature (first "box," then 35 mm) photography is doubly so, thanks to an intentional confluence of technological developments aimed at popular markets. Part of the casualness of the snapshot is due to its social and psychological circumstances. With

[58] Malcolm, "Diana and Nikon," *New Yorker* (1976); rpt. in *Diana & Nikon*, p. 68.
[59] Coe, "The Rollfilm Revolution," in Ford, *Story of Popular Photography.*
[60] *Webster's Ninth New Collegiate Dictionary.* The *Oxford Dictionary* entry reads, "Rapid casual photograph taken with small hand-camera."
[61] Szarkowski, "Early Photography and Modernism," p. 99.

millions of people in different societies and subsocieties taking pictures, the kind and quantities of things and events photographed, and their thematizable aspects, burgeoned enormously. Further, by being quick and easy and allowing multiple exposures, the miniature encouraged casual shots. It did the same by entering into other events as a minor accompaniment—even a filling out—rather than forming picture-taking events of its own. One should remember that the earliest and even some later viewing mechanisms themselves often did not encourage, or even allow, careful composition, control of perspective or lighting, elimination of distracting incidentals.[62] "Previsualization," as it is sometimes called, is hardly likely when one cannot see quite what it is one is photographing. By the sheer numbers of such pictures, the uncontrolled adventitiousness of many snapshots connoted by the dictionary term "casual" came to be generally recognized, then imitated by advertising.[63]

But if the small, mobile camera is an amplifier of noise in images, why work against its grain and attempt to filter that very amplification? Such "accidents" were appreciated by modern artists who were not photographers, and came to be *thematized,* as we might say, by photo artists—in the sense of turning an unintentional or inadvertent aspect of one's activity into something that guides that activity—in the service of pictorial meaning (which may vary considerably among the photographers who feature it).[64] Figure 10, "Mystery of the Street," from 1928, is a composition of what would normally be considered trivial accidents. A surrealist of the 1920s wrote, "The cinema, not because it is life, but the marvellous, chance grouping of elements. / The street, kiosks, automobiles, screeching doors, lamps bursting in the sky. / Photographs."[65]

In a discussion of "photography as a genuinely new way of seeing," Sontag remarks that in the "habit of seeing" it has created one is "charmed by the insignificant detail, addicted to incongruity." And "seeing," she holds,

[62] On early view finders, see Sarah Greenough, "The Curious Contagion of the Camera," in Greenough et al., *Art of Fixing a Shadow,* p. 135.

[63] Examples of advertising simulation from the 1930s are shown in Margaret Harker, "The Inter-War Years," in Ford, *Story of Popular Photography,* pp. 118–19; they are still being produced.

[64] On thematization, a theme of Chapter IX, see Richard Wolheim, *Painting as an Art* (Princeton: Princeton University Press, 1987), p. 20. On the interest of nonphoto artists, see Galassi, *Henri Cartier-Bresson,* pp. 32–33.

[65] Pierre Naville, "Beaux-Arts," *La Révolution Surréaliste,* 15 April 1925, p. 27, trans. Dawn Ades, quoted in Galassi, *Henri Cartier-Bresson,* p. 33.

"tends to accommodate to photographs."[66] Once again, however, we should be skeptical regarding generalizations that from the end of the nineteenth century the small camera brought about a distinctive way of seeing or "new criteria of picture structure."[67] It is one thing to accommodate to a kind of picture, another to accommodate to a way of seeing things around us. As far as I know, no argument has been given that casual snapshooters from the end of the nineteenth century onward have done much more than see something that looks important, interesting, curious, or beautiful and then point a camera (now sometimes a camcorder) toward it to try to "get" it on a film surface.[68] Those same photographers still pay for posed, formal photographs of important ceremonies and family members, which they frequently exhibit in the public rooms of their homes. Their own snapshots typically go in groups into albums and are presented along with memory narratives of the things depicted, the occasions and events of taking the pictures. Most likely, if such photographers could produce miniature versions of Emersons, Westons, or Adamses, they would be delighted, but surprised.

We have already encountered the theory that best comprehends the thematized approach: that of Kracauer, for some cinema also stressed what has been called "open form." In his emphasis on photo affinities for "the unorganized and diffuse," Kracauer too made much of incidental details and "incidental configurations."[69] One could find many other citations for the idea that this constitutes an important dimension of photo fidelity, or photorealism, in which an "unruly" world or the "mess" of life (some would stress modern life) tends to be reflected in photographs, as form follows content. Malcolm's remark about the camera's "imposing disorder" is a necessary caution, however, and if we wish to consider "the mirror with a memory," we

[66] Sontag, *On Photography*, p. 99.

[67] Greenough, "Curious Contagion," p. 129.

[68] Cf. Jerald Maddox, "Photography as Folk Art," in *One Hundred Years of Photographic History: Essays in Honor of Beaumont Newhall*, ed. Van Deren Coke (Albuquerque: University of New Mexico Press, 1975), pp. 104–5: "Instead, the primary interest of this type of photography is simply the making of photographic images as a visual record. . . . If one tries to find an analogy for this photography in the other arts, the closest approximation would be found in folk arts. . . . In folk art and folk photography the use of technology or aesthetics is often only incompletely understood, and this can result in a peculiarity of appearance that many find the most attractive part of folk art" and that "has had a stylistic influence on the work of some creative photographers." My point here is that the folk artists who take these pictures likely cannot see them stylistically and that if they could, they would probably take different kinds of pictures.

[69] Kracauer, "Photography," in Petruck, *The Camera Viewed*, 2:179.

should recall with her the mirror in "The Snow Queen," in which "all good and great things became small and mean, while all bad things were magnified, and every flaw became apparent."[70] Kracauer argued against simple-minded realism, and was well aware of aspects of what I have called photo facture: the signs detectable in the picture of the means of making it. The name "snapshot" connotes not just a picture but a picture that was taken in a certain way. Pictures may look like snapshots, look as though they were taken in this fashion. For example, Figure 7 looks this way, whereas the Evans (Figure 1) does not. The very phenomenon of quick exposures available through fast lenses and miniature cameras, and surprising subjects and angles made possible by their mobility—quite as much as the stolid Indian image resulting from the 19th-century head clamps used for long exposures[71]—should remind us that such pictures are in part artifacts of the procedures for taking them, reflecting as much the film and camera technologies of those different ages as their outlook or pace of life. Emerson's argument for "naturalistic" photography was also an argument for photorealism, based on the view that vision seeks, and finds, hierarchical orders.[72]

There is more to consider on the topic of "intrusions" into photographs; however, as our topic here is photographic seeing in connection with photo fidelity, we should first address a more literal way of seeing that applies to all the kinds of photographs we have considered, and to many more as well.

Seeing with Photographs

We have already considered photographic seeing of a kind that is not only strikingly distinctive and important but also accounts for much of photography's reputation for fidelity: the visual *detective* use. We are in a habit of

[70] Janet Malcolm, "Two Roads, One Destination," *New Yorker* (1978): rpt. in *Diana & Nikon*, p. 114.
[71] "The stoic, hatchet-faced, cigar-store Indian . . . was the product less of a "primitive" society given to unsmiling dignity than of a primitive technology requiring long exposures and rigid poses. . . . After 1888, when Eastman's first box camera made the snapshot possible, we begin to see Indians displaying the relaxed sociability characteristic of their gatherings today" (Ronald Wright, "Chronicles of Loss," *Times Literary Supplement*, 3 March 1995, p. 6).
[72] For a like criticism of Kracauer, see Arnheim, "Melancholy Unshaped," in *Toward a Psychology of Art*. Here we note that some interpreters of the "snapshot aesthetic" denied that it is revelatory of a messy subject matter. A formalist reading of such pictures takes them to be autonomous explorations of a kind of photographic effect, including what Martha Rosler terms "significant pseudojunctures" of chance photo-effects; see Rosler, "Lee Friedlander's Guarded Strategies," *Artforum*, April 1975; rpt. in Petruck, *The Camera Viewed*, 2:100.

looking at many photographs as we look at no other pictures, using them as tools for a certain kind of visual detection and indirect seeing. This is detection of things, events, states of affairs *that they depict.* We have good reason. Photo images of things are (as Talbot remarked of negative images) "produced by" optical images of them, where "of them" implies that the images, in turn, are produced by those things. Lady Eastlake went so far as to take dark and light spots in a positive print to be "produced by" green colors and highlights in a scene. Thereby photos carry information about the optical images and about the things that produced them. In considering shadows and pinhole-camera images (Chapter VI) we saw how—given light source and shield and screen positions—an object produces an image on the screen, and how that image varies with changes in the object. For the simplest cast-shadow examples, not every change in the shield affected the shadow image, only changes of shape and position—and not every change of shape affected it. Theory of geometric projection shows which changes do have an effect, and why, as it does for camera images, where the optical account becomes more complicated. Similarly, for the chemical or electronic images produced by the optical images, known functional relationships obtain. Notably, for chemical images, there are explanations in terms of the "detective quantum efficiency" or sensitivity of the receptor (emulsion system), and in terms of the famous "reciprocity curve," which shows that chemical response to intensities in camera images is nonlinear. Both measures allow for randomness, yet together they describe functional relationships between some states of a subject and the states of the photographic image. These relationships are durable and repeatable under wide variations in other conditions. They establish cause-and-effect relationships between these different sets of factors, just like those that obtain for our much simpler cases of shadow cast.

Indeed, these are relationships we all assume whenever we take or look at photographs—though, for most of us, obviously, not in any technical detail. Our normal working knowledge of these relationships is just that; it is quite approximate and varies among individuals. Only where anomalies appear do we normally seek more details about these variables and the background conditions against which they have correlation. (For example, we might be puzzled that our color film registers the blue chicory flower as a weak pink, and so seek expert advice.) Our understanding need not be otherwise, since much of the purpose of developing photo-technology is, as remarked before, that we need to know less and less in order to do more, and do it more reli-

ably. Also as argued earlier, there are two important, linked advantages of these functional correlations, whether we understand them very generally or quite technically. The first is that photographic images of things, through photochemistry or electro-optics, amplify our *perceptual access* to the shapes, positions, and reflectances or other light modulations of the objects that form them—states that already carry enormous amounts of information about many other states and do so by nonphotographic correlations, directly causal and collateral. Photography, then, like other technologies that greatly amplify our powers, plugs into vast natural resources, just as did steam and, later, combustion engines for producing motive power. The second advantage is that photo images can be so managed as to make our *extraction* and *interpretation* of their information content relatively easy. This, we said, is achieved by the user-friendly strategy of mobilizing our natural perceptual powers in order to retrieve that wealth of information—crucially assisted not only by our ability to work with stimulus reductions but also by the uniquely human capacity to imagine seeing.

Such amplifications of our perceiving make photography and related imaging technologies radically different from drawing, painting, and other methods of visual figuration. This will be a controversial claim. The way in which one image family differs from another needs careful statement, as it is has long been a subject plagued with equivocation and fallacy, often due to the failure to make relevant distinctions. There is no question that drawn and painted depictions *contain* information about the things that they depict and about a number of other matters as well. "Contain information" is an ambiguous expression, however. Design drawings, for example, may be appropriately said to carry important information such as specifications for machine parts which enable engineers to produce, to very exacting standards, components that not only fit and function with great accuracy but are interchangeable. One might even date the beginning of modern industrial technology from the very point at which such representations came into use. Indeed, we might use the advent of such drawings on paper surfaces—say, from about 1800—as the way of separating traditional crafts and "mechanical arts" from what we today consider *technology,* which forms the background to many of the considerations here.[73] Photographs may be used in

[73] See Arnold Pacey, *The Maze of Ingenuity* (Cambridge: MIT Press, 1974), p. 19 (excluded from the 2d ed. in 1992). In accord with the discussions in Chapter IV, such diagrams count as *depictions* only in case their function is to prescribe that we imagine perceiving what they show. They would

the same way. Diagrams are frequently derived from photographs, and photos such as "Puffing Billy" (Figure 4) can themselves be used as diagrams. (The diagrammatic visibility of the gears suggests photographic manipulation.) But this is not the kind of information in question here, as it has nothing to do with whether the object described exists or whether some state of affairs obtains. Design pictures, after all, are necessary to bring nonexistent structures into existence; they provide information about how to construct new things.

In some circumstances, of course, the mere *existence* of such a diagram provides evidence about what it depicts. It may provide historical evidence, for example, about the modes of technical specification of a given period: that is, about the image technologies that served engineering or architecture. With collateral evidence, a diagram might even verify that such an object was manufactured. Many depictions function this way, not just design representations. For example, we derive much historical evidence about the dress, habits and occupations, environments, appearance, and appliances of ancient peoples from depictions that form an important part of the physical evidence they have left behind. Technology historians sometimes argue from such records about the dates of inventions (wheels, harnesses, clocks), dates that have not survived. Figure 3, showing needlepoint presumably executed by a sailor, provides good evidence not only of a technological event but likely also of detailed structures. We look at prehistoric depictions for evidence about which animals were abundant or were of special interest to the people of those remote periods. In general, the existence of surface markings, whether images or not, is an important and sometimes extremely reliable basis of inference. We can say that people would not—sometimes that they could not—have left such images unless what they depicted had indeed obtained. We may argue that artists seventeen thousand years ago could not have depicted the aurochs with such sureness, accuracy, vivid sense of the animals' movement unless they had encountered them, dealt with them often. We might even say that we can *detect* things about the nature of such subjects, at that time—for example, of the nature and abundance of small ancient horses—by the sure markings that depict them. Also we might nat-

do so where they provide user-friendly access to people. Even then, their central use would not be depictive, and they would not always be used so. Diagrams may automatically guide production without ever being understood depictively.

urally say that we can *see* that people were much concerned with a kind of an animal or a hunting activity, judging by the kind and number of their depictions.

Depictive inference of this sort is rather like testimony or descriptive inference. The difference is that depictive inference is inference to the existence of a thing or state of affairs based on the fact that someone made markings that prescribe us to *imagine:* notably—but not necessarily—to imagine what is depicted, as it is depicted. Putting things thus "graphically" alerts us, should that be necessary, to the hazards of this kind depictive inference: we know full well that the mere invocation to imagine something or some state of affairs does not show that such a thing obtains, obtained, or even could possibly obtain. As with popular songs (Chapter IV), part of the function of fictions is to help us imagine what will never be. Among animal depictions we may well list here depictions of unicorns, manticores, sphinxes, chimeras, human-headed winged bulls, senmurvs, ch'i-lins, mermaids, dragons, griffins, and talking mice with four-fingered gloves—many of which are shown repeatedly and with great liveliness. Less fantastically, many architectural and engineering and clothing designs, drawn sometimes with great care and viability, literally never get beyond the drawing board. Sometimes this is regrettable, sometimes not: witness some entries in the nineteenth-century competition for the completion of the Washington Monument.

Treated as a mode of depiction, photography, generally speaking, fares identically with drawing and painting imaging technologies, with which it is routinely mixed. As earlier argued, photographic depiction is often just that: depiction made by a certain process, as is engraving, crayon, or watercolor depiction. That something is depicted and depicted a certain way by a photograph signifies nothing evidentiary in itself, unless this evidence is provided with necessary context. This is something we all know abundantly from movies and television, commercial still photography, and the like. To miss this simple point is to invite equivocation and confusion. As already argued, however, photography need not operate depictively. Even when it does, it often does not operate *simply* depictively; it also works *detectively* and performs this function *independent* of depiction. As we saw, not all the things we detect from photos are depicted by them. Since we have now discussed camera and photo images, we can go back to the Evans picture (Figure 1) and notice the obvious information it carries about the focus of the camera image that produced it. Yet we are not to imagine, and we do not imagine, as

we look at the photo, that we are looking at the camera image. To depict a camera image is not its function—although it could be if, for example, it were embedded in more elaborate versions of Diagrams 1 and 12 (as we can see in illustrated books about photography).

It is important to keep such cases in mind to remind ourselves of the simple but often overlooked point that depiction, invocation of imagining seeing, can be just a user-friendly shaping of the photo information channel, sometimes at the final or "interface" level, to make that information vastly more accessible to human users of it. The physical states—chemical in one kind of photography, electronic in another broad kind—already carry information about what has been photographed and about much else before it is rendered in a form accessible to human perceiving, mediated by imagining perceiving. There is more information in a chemical negative than in prints made from it. Adaptation of the objectively existing information for human consumption involves lengthening the communication channel, thereby losing important information and sometimes adding noise. These are physical facts representing the typical suppressions, necessary to a momentous amplification: an amplification not of information but of the *accessibility* of information to a nervous system of a certain kind.

In this, the family of photography and allied imaging technologies is cognitively distinct from the family of drawing and painting, with which it has rich and ongoing interactions. It is distinct in the kind of information it contains and in the ways we gain access to that information. Photography thereby possesses an important and distinct dimension of fidelity, which must be separated from such other dimensions as depictive accuracy, perspectival consistency, tonal continuity, clarity and intricacy of detail, stereo effects, and moving images, with all of which it is often combined.

"I Am a Camera"?

Having been skeptical about fashionable claims regarding a special kind of photographic seeing, I will now argue for the important distinctness of the kind of photographic seeing, linking detection and depiction, discussed above and in Chapter V. The optical and chemical or electronic account just reviewed could not be given for drawing, painting, and related image-production processes. Could a relevantly *parallel* account be given? If so, we

might be able to narrow the gap between these two broad image families while still recognizing the important technological differences that make photo processes revolutionary. To do this, we would first have to suppose a similar distinction between independent detective and depictive lines for drawing and painting, just as for photography. Equally important, we would then have to show how those two functions may be *combined* in the specific way at issue here. We would have to suppose that states of affairs produce, through graphic materials, images upon surfaces which carry information about them, according to physical laws. This would have to occur, at least in theory and perhaps somewhat in practice, independent of any depictive use that people give them. Nonetheless, we also would need to show how depictive imagining of the states of affairs regarding which they bear information would be an indispensable mode of access to them (as in Chapter VI), in order to make the analogy with photo imaging plausible.

Well, there is no doubt that drawing and painting materials do produce marks on surfaces, and that their doing so is due to a number of causal factors, at least some of which can be detected by examining the marks. As collections of *traces,* drawings and paintings typically show a good deal about their formation, about the processes and materials of their construction, as well as about background conditions necessary for that construction to have taken place. The general term "background conditions" here covers some quite notable items, including the physical and mental abilities of the people who made the drawings or paintings: consider Figure 3. This brings back the topic of *facture* and looks forward to Chapter IX's more extended discussion of it in photography and in drawing. Slightly to anticipate that discussion, we may here say that facture information can be enormously important to our understanding of drawings and paintings as depictions. The terms "drawing of" and "painting of," and their cognates in many languages, express our general interest in facture. Furthermore, idiomatic terms for photography such as "take," "shoot," "snap" suggest one of the chief differences that we mark between our dealings with photos of things and with the products of other methods of imaging. Before we investigate more generally the nature and significance of such facture differences, however, we need to assure ourselves of the present point that the important facture information in drawings of things and paintings of things does *not* play the detective role that it typically does with photographs of things.

It would appear that the following description, of camera and photo ma-

terials, is hardly ever true of drawing and painting materials: that these are deployed so that states of affairs and conditions, working through them, produce surface markings that carry information about them (whether or not such images are used for imagining them). And should such a description ever be true, it is unlikely to provide the kind of analogy we are seeking. For example, ancient people around the world have made "paints" of various sorts so that they might place their hands in it and leave marks, by means of which we can detect the things that made them. That we can do so might often have been the main message of such markings: "I was here and did this." This and like activities of very limited scope and use, however, are not representative of drawing or painting and hence do not provide the analogy we need.

It needs emphasizing that the difficulty in making out a plausible analogy is not due to the presence of agents, skills, or intentions. To deny the analogy nothing should be said or implied to the effect that drawing and painting usually entail such presence but photography does not, for intelligent actions of human agents are involved at many stages in the making of photographs. Yet that in itself is no obstacle to photos' carrying of information about the things photographed—and much else as well. Generally speaking, controlled, intelligent, purposeful human action is in evidence along *all* technological information channels. There is first the technological invention of the channel, next the engineering and construction of it, then its maintenance. Furthermore, people typically monitor and control such channels while they are in use, adjusting them selectively for best performance, given certain uses and values, which can vary among people. Photography itself provides one of the clearest general examples. For all the computing automation installed, the photographic system is still an implement of human use. Normally, one still decides what pictures to take and when, with what instruments, from which angles, and one usually can control to some extent both the disposition of the subject matter and, within certain tolerances, the workings of the photo equipment. None of this interferes with the facts that states of the scene produce optical images in the camera works and that these images, in turn, produce (to use Talbot's term) chemical or electrically stored images. Changing settings along this pathway can radically affect both images, as shown in the discussion of simple shadow figures. There we saw how functional relationships about the shape and size of a light shield and the existence, shape, size (and edge) of its shadow on a screen depend upon other

variables, notably the size, shape, and distance of the illuminating source, and the shape, angle, and distance of the screen. Changes in those factors would produce another set of correlations between a light shield and its shadows. We may imagine these to be made intentionally, with an eye to producing shadows of certain shapes, sizes, edges. With the shadow, as with the photo, all this means is that some functional relationships connecting states of the scene with states of the trace it makes are substituted for others. So the fact that photography is often like drawing and painting in requiring intelligence, skill, artistry, and purposeful intervention does not make it similar in the relevant sense.

In reply to this argument, the following two strategies might be suggested. The first might be inspired by the historical treatment of our themes. It was early perceived that photography, as a nineteenth-century laborsaving device, replaced kinds of human image-making work with machine work, just as did a number of other contrivances of the time: message relay via telegraph, motive power from steam, spinning with automatic machines. In all such cases "operators" (as photographers too were called at first) were necessary, for in none of them could human skill, guidance, and monitoring be dispensed with. We should therefore suppose a *double* role for the skilled person, first as part of the channel, next as channel *monitor.* The earliest photography dispensed with the first role. Since then it has been wearing gradually away at the second role, via automatic controls. The proper drawing/painting correlate to camera, light receptor, and so on in photography would not be pencil, brush, paint, receptive surface—as is so often said— but rather these things *plus* neural systems in human agents. In short, drafters and painters, according to this view, could often be described as autoregulated channels through which things, events, states of affairs produce images on surfaces, or at least significantly shape those images. This version of Christopher Isherwood's "I am a camera" would then imply that part of me can be made to work mechanically to produce images. Let us give this hypothetical position full scope, to see how far it fails to go. Presumably, to maintain the analogy, we would have to suppose that physical surface-marking actions have become in some ways automatic yet—like other trained actions—are still actions of people. For example, accidentally falling against a surface with marker in hand would count as marking it but not as a marking action. Nevertheless, marking actions, like most human actions, will

allow dimensions of accident, as none are *fully* under our control in all respects.

Drafters and painters do indeed train themselves—as do pianists, cyclists, horseback riders, drivers, cooks, runners, swimmers, and countless others—to produce chains of action automatically once they are initiated; there are sciences that study that general phenomenon. In the case of the drafter and painter, this presumably means building up neural patterns governing groups and sequences of muscular actions. To be sure, drafters and painters do have characteristic mark-making routines. Establishing such a routine and then changing it is rather like learning to write in cursive or print and then changing one's habits of so writing. Granting this, for the analogy to work we would still need a link to the situation recorded: presumably a cognitive link. What we need, in particular, is a link between perceptual experience of features of the situation and these sequences of automatic surface-marking behavior. One may expect but should not insist that this be a visual link: it is possible to draw from touch, as do blind people.[74] Drafters sometimes do attempt to train themselves this way. They practice, for example, looking at contours and allowing this visual processing to control their marking activities, sometimes without looking at the results. They may try to imagine that their muscular eye movement entirely steers the marker, with the bodily neural and muscle activity functioning to keep the channel conditions stable. It is consistent with the desired analogy that they should continually *monitor* this process and be able to be intervene in it, even that they may choose among different repertoires of muscular response and among different connections between perceptual and mark-making activity. Photo work, as we saw, involves just such channel switching and adjustment.

Granted all this, the question is where it gets us toward our hypothetical *analogy* between photographing things and drawing or painting them. The answer is, hardly anywhere. On the most charitable construction, we could claim to have established that some aspects of some parts of some drawings and paintings can sometimes be construed as having been made by the features of scene or situations, using the sensory and motor connections of drafters or painters as *channels*. This would be very much like saying that as-

[74] See John Kennedy, *Drawing and the Blind: Pictures to Touch* (New Haven: Yale University Press, 1993).

pects of a musical performance can be construed as having been made by features of a printed score, using the appropriate parts of trained musicians as channels. But such images could provide, at best, weak and fugitive means for detection of scene features, via causal channels. Relatively few aspects of an image could be identified, much less consulted for detection, in this way. The postulated physical channels monitored by the people through whom they run would not provide much independence from other conditions. Functions linking variables of scene and image aspect would be at best very approximate. It is for this reason that although many such images provide important evidence about scenes and situations, we make inferences from them as depictions, rather than using depiction as a way of making inferences from their physical states. Depiction, imagining seeing, plays very different roles in the two kinds of cognitive activities. Photography, which can allow both roles, allows them simultaneously.

A distinct "I am a camera" thesis, also based on real procedures, is easy to construct: we set up a photographic channel and then introduce human operatives as replacements for *parts* of it. One possibility, workable in very simple cases, has recourse to the digital, scanning method discussed earlier. Suppose such a mechanism to be put in place with its usual mechanical, optical, and data-processing connections, except that (as is quite feasible) it reaches an output in printed digits assigned to pixels. Human readers transfer this directly, in tonal gradations, to a surface or direct another mechanism to do so, like someone making a graph. (Given the routine nature of the information transfer, we might combine this case with the previous one and suppose that the operator does these things "automatically.") Such arrangements would be somewhat *analogous* to photography, in that the detective data content would be independent of depiction, but the process might also be so arranged as to entice depictive seeing, even as it facilitates extraction of the scene information at various levels. The operator might well also be the one monitoring and controlling many of the channel settings, as for the photographic and allied imaging techniques used in medical imagining. I doubt that we would actually consider this contrivance to be a way of rigging things so that *features of a scene* were allowed to produce marks on surfaces. We might be so inclined somewhat more than to think the same of drawn or cut cast-shadow silhouettes (for which, incidentally, penumbrae can be a nuisance). I mention that because, for our purposes, the interest of this very unrepresentative case of representation would reside in its extendibility to

drawing and painting generally. We would need next to convince ourselves that in the use of drawing devices such as perspective and pointing machines we are, similarly, using parts of our own systems as such devices. I doubt that we could, and even if we accepted a slippery-slope principle from a charitably granted case, at the bottom of the slope we would still be far short of the goal of showing drawing and painting to be in this way relevantly analogous to photography.

࿕

Photo Fidelities II: Manifestation and Participation

"Curious Self-Representations"

The characteristics of photo and related imaging technologies which we were just attempting to formulate and to defend as unique were among the most striking from the early times of photography. Early reports, descriptions, and estimates of photography not only confirm this but put us in position to clarify those statements in a way that has, perhaps, not been done previously. The usefulness of doing so is more than historical. To the degree that the earliest statements express popular conceptions that have been retained ever after, clarifying them should go some way toward clarifying our own ideas and attitudes, not only at present but for a future that is sure to bring many more technological changes.

An earlier chapter pointed out that a standard way of expressing photo subjects' distinctive relationship to their photo images was to call the latter *shadows* of the former. This way of thinking was common in the first decades of photography, and there are well-known instances of it. Just as we normally think either of things (which we call shields) as casting their shadows on surfaces (screens), or of the light sources as doing so, by analogy there have been ways of thinking of photo channels as means by which things and events delineated images of themselves, or as means by which the sun did so (Figure 9). This way of thinking, though far less common, was not uncommon. Da-

guerre's first public promotion of his invention described it as "not an instrument to be used to draw nature, but a chemical and physical process which gives her the ability to reproduce herself," and the magazine *L'Artiste* remarked, "You can now say to the towers of Notre Dame—Place yourselves there and the towers will obey."[1] Then there was the *Edinburgh Review's* picturesque description of daguerreotypy, "Self-painted by the rectilinear pencils of light, every fixed object transfers its mimic image to the silver tablet,"[2] and Holmes's less picturesque wondering that "a man should paint his miniature by looking at a blank tablet," and that "the astronomer is causing heavenly bodies to print their images on the sensitive sheet he spreads under the rays concentrated by his telescope."[3]

"Curious self-representations" is a phrase from Talbot's description of a photograph of his own house, where he speaks of the picture as having been made by its subject.[4] Yet he also says the same of himself, quoting from his earlier formal presentation of his initial "photogenic drawing" attempts with a camera: "In the summer of 1835 I made in this way a great number of representations of my house in the country, which is well suited to the purpose, from its ancient and remarkable architecture. And this building, I believe to be the first that was ever yet known *to have drawn its own picture.*"[5] The claim to be first turns out not to be true, for Niépce's house beat his by a comfortable margin of nine years. Yet even without the precedence, Talbot has a better case than most to have made photos of his house. First, he invented the photographic process. Next, his little cameras were built to his directions (though he did not grind his own lenses), and having loaded a number of them with handmade photo paper, he deployed them in a battery around the lawn, for an exposure period of about half an hour. He then removed the already visible negative images from the light and fixed them (although, as we observed, he could not for some time print through them).[6] Few proud householders could claim as much. He had discovered the channel, realized

[1] Quoted in Newhall, "Eighteen Thirty-Nine," in Naef, *Photography: Discovery and Invention,* p. 23.

[2] *Edinburgh Review,* January 1843, in Goldberg, *Photography in Print,* p. 56.

[3] Holmes, "The Stereoscope and the Stereograph" and "Doings of the Sunbeam," in Newhall, *Photography: Essays & Images,* pp. 54, 74.

[4] Talbot, *The Pencil of Nature,* note to Plate XV, "Lacock Abbey in Wiltshire."

[5] Talbot, "Some Account," in Newhall, *Photography: Essays & Images,* p. 28.

[6] Ibid. About nine years later, however, in his note to Plate XV, Talbot reported the shortest of those exposure periods to have been "nine or ten minutes."

instances of it, monitored and guided the causal processes. Yet for all that, Talbot could still hold that the *house* made the (fairly) permanent surface marking, which could be used for depiction ("its own picture") once he had arrested it. This is how he thought of it, how he titled for himself a photogenic drawing of May 1839: "Lacock Abbey Self-Represented in the Camera Obscura."[7] He could hold, in other words, that the channel he arranged was one by which a house, for example, is put in position to do such a thing, thought it never would have done so otherwise. Similarly, one could say, of other technologies, that the change of water to steam can produce continuous reciprocal or rotary motions, the movement of large magnets can drive alternating electrical currents for miles, sound waves can score surfaces and would not have done so otherwise. This remarkable situation for picture-making seems to have had several important implications. That this photographic situation would somewhat conflict with the idea of pictorial *art* is a topic for the next chapter. At present two other fidelity issues deserve consideration.

The first issue has to do with photography as an amplifier of our imaging and depiction production powers. It has been a continuing theme here that photos are often used to depict things—to entice us to imagine seeing things—that they are not photos of, to depict things that cannot be detected by their means, to depict things that have no causal influence upon them, things that may not even exist. Moving on to cases in which what is depicted by a photograph is not what was photographed suggests an aspect of photo technologies rather different from what we earlier considered. Here is a way of looking at it: photography may then be thought of not just as an amplifying tool but also as a *tool amplifier* or converter. That is, photography comprises technology that greatly expands the whole realm of tools by which we can do a certain kind of ancient work: marking surfaces for depictive use. Furthermore, photography accomplishes this without changing these "tools" physically. Before the invention of photo processes many kinds of tools were used for surface marking: burins, blowpipes and brushes, pens and inks, earths and plant dyes. We have considered how photography brought in *light*. We could further say that photography converted all things that emit, reflect, or otherwise modulate light, into potential tools for bringing about image states on surfaces. There is perhaps no parallel conversion in all of dy-

[7] Cited in Larry J. Schaaf, "A Wonderful Illustration of Modern Necromancy," in Naef, *Photography: Invention and Discovery,* pp. 33–34.

namic technology. The economic, productive repercussions have been enormous. Photography at first assisted, then greatly augmented, the production of unique images such as portraits and, later, of mass repeatable imagery. The enormous influence of such pictures in modern times can be seen as owing to the greatly expanded scope of the physical tools that can be used to mark images on surfaces.

Photo Manifestation

What should we make of this? We usually note, with interest and delight, conversions of things and processes to depictive image-making tools that are ad hoc and singular. Various traditions provided stories of the kind. According to the ancient skeptics the painter Parrhasios, exasperated by his failure to render foam on a horse's mouth, threw a sponge at his picture, thereby achieving the desired effect. Allegedly, Hokusai astonished the shogun by dipping a rooster's feet in red paint and chasing it across his blue picture, thereby rendering "Maple leaves floating on the Tatsuta River" (though we are not told whether this was achieved on the first trial). We take for granted, however, photography's systematic conversion of conditions, things, and events into surface markers.

There is a further point to make. What the nineteenth-century "self-portrait" metaphor emphasized was not the mere conversion of such items into image-forming tools but the fact that in some cases—unlike the two legendary ones just noted—the resulting image should also *depict* the cause.[8] That converting something into a tool for producing images should be separated from the question of what, if anything, the image is an image of must be kept in mind, for what was photographed needs always to be kept separate from what is thereby depicted.

I suggest, however, that much of the fascination with curious self-portraits

[8] Even then, it may be observed, we have tended to pass over the use, growing since the earliest times of photography, of what might be called natural diagrams, events in nature such as magnetic lines, fluid and electrical flows occurring on surfaces, or intersected by them, whose traces there can be fixed to allow us, in imagination, also to visualize them. The rings of a sectioned plant stem, e.g., can sometimes be used graphically to imagine seeing the events of growing that produce them. It is likely true that many people look in a similar way at states of surfaces with regard to their formative processes. See David Phillips, "Patterns in Pictures for Art and Science," *Leonardo* 24, no. 1 (1991): 31–39.

in photography, which still forms part of our sense of its fidelity, is of *another* sort. That may be presented by quoting a fairly well-known passage from Elizabeth Barrett Browning's response to daguerreotypy: "Think of a man sitting down in the sun and leaving his facsimile in all its full completion of outline and shadow, steadfast on a plate. . . . It is not merely the likeness which is precious in such cases—but the association, and the sense of nearness involved in the thing, . . . the fact of the *very shadow of the person* lying there fixed forever! It is the very sanctification of portraits I think— and . . . I would rather have such a memorial of one I dearly loved, than the noblest Artist's work ever produced."[9] We are not, when looking at most photographs in newspapers or magazines, moved by such sentiments—and perhaps never quite in the terms of another reporter in the same year as Barrett Browning: "The picture is connected with its prototype by sensibilities peculiarly touching. It was the very light which radiated from his brow . . . that penciled the cherished image, and fixed themselves for ever there."[10] Nonetheless, this does not mean that we are never so moved. Barrett Browning's distinction between a photo as a "likeness" and as having an "association" due to experienced "nearness" has been restated, in contested passages, by several theorists since. Sontag, who quotes part of the same passage, herself draws a distinction between a photo "as an image (as a painting is an image), an interpretation of the real," and a photo as "a trace," "the registering of an emanation . . .—a material vestige of its subject in a way that no painting can be." She makes the telling point that to many, a "barely legible" photo of Shakespeare would be more precious than would be a "glorious Holbein" of him. Sontag thinks of photos as being "emitted" from their subjects and adds that a photo, unlike a painting, is "part of, an extension of that subject," "co-substantial" with it.[11] The film theorist André Bazin made a

[9] Letter of 7 December 1843, in *Elizabeth Barrett Browning to Miss Mitford,* ed. Betty Miller (London: 1954), pp. 208–9. Part of this is quoted in Sontag, *On Photography,* p. 183. This and the next section develop ideas first presented in Patrick Maynard, "The Secular Icon: Photography and the Functions of Images," *Journal of Aesthetics and Art Criticism* 42 (Winter 1983): 156–69.

[10] *Edinburgh Review,* January 1843, in Goldberg, *Photography in Print,* p. 65.

[11] Sontag, *On Photography,* pp. 154–55, 180. Earlier, Francis Frith had also had us imagine the value that would be set on photos of "Newton, and Milton, and Shakespeare," distinguishing "this new spiritual quality in Art, a charm of wonderful freshness and power, which is quite independent of general or artistic effect, and which appeals instinctively to our readiest sympathies": Frith, "Art of Photography," in Newhall, *Photography: Essays & Images,* p. 117. But his point seems to be entirely about the merits of photo detail, not at all about *causal* values.

closely related distinction; so did Barthes (as mentioned much earlier) in lines like this: "The photograph is literally an emanation of the referent. From a real body, proceed radiations which ultimately touch me. . . . I am delighted (or depressed) to know that the thing of the past, by its immediate radiations (its luminances), has really touched the surface which in its turn my gaze will touch. . . . [In this way] the photographed body touches me with its own rays."[12] Bazin astutely points out that pictorial realism in the tradition of the West has been developed along two distinct lines, as "two essentially different phenomena": that of perceptual "illusionism" in depiction, and that of forcing us to accept something as real. "A very faithful drawing," he observes, "may actually tell us more about the model but despite the promptings of our critical intelligence it will never have the irrational power of the photograph to bear away our faith."[13] This mysterious photographic appeal continues to seem paradoxical to later writers such as Cavell, who wonders about "the connection" photographs have with "reality" or "the world." For him photography, especially in film, makes the world "present" to us without our being "present" to it. Things photographed contact us without our contacting them, and this cannot be due to depictive *likeness* or vividness or any of the things that painting achieves.[14]

It sometimes appears that what interests such writers is the fact that photographs allow us actually to *see*—or at least visually to detect—indirectly and not in our imaginations things that were photographed. Cavell, for example, feels that "when we look at a photograph: we see things that are not present" (18), which might be glossed by saying that he means indirect seeing, the kind of seeing that, for example, allows us to perceive things past. (One could say, paradoxically, that by seeing through photos we see past things.) This is probably not his meaning, however, or at least not his entire meaning. Whatever his other meaning, and the meanings of the representative testimonies we have sampled, it is far from being a majority view on the matter, as a number of sharp responses attest.[15]

It is understandable that there should be skepticism about so extending

[12] Barthes, *Camera Lucida,* pp. 80–81.
[13] Bazin, "The Ontology of the Photographic Image," in Petruck, *The Camera Viewed,* 2:144, and Trachtenberg, *Classic Essays,* p. 241. Bazin makes several relevant distinctions in this short paper, but it is not altogether clear how these are to relate to one another.
[14] Cavell, *The World Viewed,* pp. 16–23.
[15] See, e.g., Snyder and Allen, "Photography, Vision, and Representation."

these considerations. The photographically made, photo-reproductively printed colored pictures of freshly ground lean beef, seedless grapes, breakfast cereal, hot dog buns, and other edibles on a flyer that may have been stuffed into your mailbox may not seem to convey much of the "presence" of anything. That the "very shadow" of a smiling real estate agent is fixed, though not forever, to the billboard you drive past—a billboard that "registers an emanation" of that person—will likely signify nothing to you. It will be of as little interest if the subjects of a packet of vacation snaps shown to us by an acquaintance "touch us (albeit only transitively) with their own rays." It is understandable that there should be recoil from such convictions. They may seem of a piece with the long history of "apparitional" photography, in which features of photos have been claimed to represent *manifestations* of the spiritual, like voices and table-knockings at seances. Recalling the Chapter I definition that included the phrase "esp. light," we might conjecture that paranormic photography is an even older practice than is panoramic photography, and there exist, in print and on video, interesting and entertaining exposés of claims for it, including those by Arthur Conan Doyle.[16]

"A Parting of Ways": Depiction and Manifestation

If such presence, contact, or manifestation—or even just a sense of it, whether correct or misguided—is very rarely a factor in our use and appreciation of photography, this does not mean that it is never significant to or a significant dimension of photographic fidelity generally. We have seen that pale images issuing through the slightest apertures, sometimes by accident,

[16] Erich Stenger, *The History of Photography: Its Relation to Civilization and Practice* (1939), trans. Edward Epstean (New York: Arno, 1979), contains a short section on "spirit photography," pp. 138–39. A recent video essay on some of these claims is "Fairies, Phantoms and Fantastic Photographs" (*Arthur C. Clarke's World of Strange Powers,* dir. Charles Flynn, Mississauga, Ontario, Marlin Motion Pictures Ltd., c. 1985). I used former photo writer Conan Doyle's gullibility on this matter in Maynard, "Talbot's Technologies." Regarding manifestation, I may be forgiven an example from family history. Once, at my grandfather's dinner table, Conan Doyle declaimed his belief in spiritism to that skeptic by vowing to return to that house the day he died—a promise soon forgotten by his host, but remembered by my father (then a boy), who not many months later was terrified, after noticing the obituary, to lie abed listening to the stairs' sequential creaking upward his room. It was, of course, only the old house cooling off on a summer night—unless this is how supernatural beings manifest themselves: through natural causes.

may form important pictures, and that the seemingly insignificant, fringed, penumbral edges of bright illuminations may be filled with meaning. By analogy, such a little opening might be found in an occasional simile for photographic picturemaking, by contrast with the traditional kinds: "acheiropoietic," or "made without hands." This was the connotation of Holmes's description of a stereo as a "painting not made with hands,"[17] expanded in Barthes's suggestion: "Might one not say of it what the Byzantines said of the image of Christ with which the Shroud of Turin is imbued: namely, that it was not made by human hand, *acheiropoietos?*"[18]

The association of photographs of things with allegedly miraculous objects—objects and relics that go back to ancient times—might not seem to assist the case for a distinct, significant dimension of photographic fidelity. Association with such phenomena and their related attitudes might seem, indeed, to make that idea all the more disreputable. But we should not conflate issues of the validity of a psychological principle with those concerning certain instances of them. David Hume realized this when he wrote lines that might well be applied to the testimonies above:

> Superstitious people are fond of the relicks of saints, . . . for the same reason that they seek after [resembling] types and images, in order . . . to give them a more intimate and strong conception. . . . Now 'tis evident, one of the best relicts a devotee cou'd procure, wou'd be the handy-work of a saint: and if his cloaths and furniture are ever to be consider'd in this light, 'tis because they were once at his disposal, and were mov'd and affected by him: in which respect they are to be consider'd as imperfect effects, and as connected with him by a shorter chain of consequences than any of those, from which we learn the reality of his existence. This phenomenon clearly proves, that a present impression with a relation of causation may enliven any idea.[19]

[17] Holmes, "The Stereoscope and the Stereograph," in Newhall, *Photography: Essays & Images,* p. 59.

[18] Barthes, *Camera Lucida,* p. 82 (I have corrected the loose Richard Howard translation from the French of *La chambre claire,* p. 129).

[19] David Hume, *A Treatise of Human Nature,* ed. L. A. Selby-Bigge (Oxford: Clarendon Press, 1896), p. 101. An example from 1858, of a man bringing his dead wife's clothes to be daguerreotyped ("them's all I've got of the ould woman, they're sure to get scattered about, but when I looks at this, I shall think I see my wife. Thankee Sir"), as related in Richard Rudisill, *Mirror Image: The Influence of the Daguerreotype on American Society* (Albuquerque: University of New Mexico Press, 1971), p. 218, may stand for many cases in which photography has combined these elements.

Hume, here building his famous principles of association—likeness, contiguity, cause and effect—neglects to mention the interest of "superstitious people" in contacting such "relicks" *themselves.* Interest in contact with things, beings, situations, events through having them affect us causally—either directly or by the shortest causal routes, as "imperfect effects"—is closely related but hardly restricted to any interest in *detecting* them or any similar cognitive function. It is a strange creature indeed who would wish only to find out what is happening in its world without being in any way an actual, even passive, part of that world. Participation in events, "being there," is a major motive in human affairs, and not—as some would insist—totally because one wishes to be a shaper of those events. Modern tourist industries prove that being there even long after the events can also be satisfying. As much as being an eyewitness to events is a means of perceiving them for ourselves, reciprocally, perceiving them may be a way of having them actually affect us, so that we are a part of and can experience the total situations. In depictive capacities we have, for example, clear and relevant differences between being in the audience of a theatrical performance and of seeing it—perhaps more fully and in more detail—on a screen, even in "real time." One hardly needs to argue that sports and other events provide similar differences of experience: simply consider the availability and the price of tickets.[20]

It may therefore be that even the "imperfect effects" of photography carried by light transmissions sometimes have meanings for us that other kinds of picturemaking do not supply. One is tempted to say "traditional kinds of picturemaking," and that raises the question of *which* traditions. It is time to raise that question. Modern societies are accustomed to understanding picturemaking primarily in the terms discussed in Chapter IV: that is, as representation, depiction—with other layers of meaning built on them. Yet if we continue to attend to the *functions* of what we would consider to be artistic representations in a wide sampling of societies throughout history, it may emerge that the depictive or imagining function is not the dominant one we tend to assume. Begin with some simple generalizations. On balance, the context of "traditional" works will be rather more what we would call reli-

[20] Stephen Sondheim wittily observes, "That is why you get a standing ovation at every [mega-musical] show. . . . There is a very good reason: the audience wants to feel that it is an event, and they create the event. You always find that a standing ovation starts around the fourth row. One person gets up and what happens is, they do this [*claps*]. They're cuing people, because they're trying to make the evening. . . . It is an event for them, and they are going to the event" ("Sondheim on Sondheim," *The Arts Tonight,* CBC Radio, 5 April 1995).

gious than that of recent times. Also, what are to us settled distinctions between the work, its subject, its maker, and its audience would often appear less clear-cut.[21] A ceremonial or "ritual" dance might be representational, might evoke in us vivid imaginings of various beings, processes, relationships—but that might be only one aspect of its serving its society as a manifestation of such things. Here is an example:

> While the possession dances are being performed, the "horse of the genie" has possession of the code of gestures, attitudes and conduct of the genie, and his acting will ensure that the incarnated spirit is recognized. But the dancer does not know . . . whether he will be possessed or by whom. He must therefore have at his command the complete range of steps and gestures of whatever personality it is who will ride him. . . . It should be noted that although the possession is effective, genuine and violent and is certainly not feigned, . . . it nevertheless has distinctively theatrical features about it.[22]

The dancer knows how to represent the spirit, but in the ceremony that representation will take place only as part of the manifestation of the spirit—if that occurs. The dance of very different traditions, even social dance that is not particularly representational—should there be such[23]—may manifest "spirit" of a different kind: the spirit of the social occasion itself. It is typical of such dances that they are part of wider social events, and that those who take part in them give themselves to the spirit of the occasion—that is, make their dancing exemplary parts of the occasion, thereby manifesting its spirit: "getting into (with it)," as one says. Similar cases could be made for the production of works of visual representation. In some of the most significant examples it is not the act of making the picture but rather entities depicted by the picture that are manifested there: that is, manifest themselves through that image.

In summary, then, people have impulses to imagine things, often for per-

[21] For which, see Meyer Abrams, "Introduction: Orientation of Critical Theories," in Abrams, *The Mirror and the Lamp* (Oxford: Oxford University Press, 1953).

[22] Jean Laude, introduction to Michel Huet, *Danses d'Afrique*, trans. as *The Dance, Art, and Ritual of Africa* (New York: Random House, 1978), pp. 16–17. Our Chapter VI discussion of cast shadows could be developed here in an account of the *wayang kulit,* or ancient Javanese shadow puppet theater, by which audiences can communicate with ancestral spirits through the activities of the puppeteers.

[23] Most styles of ballroom dancing are replete with theatrically representational effects—for example, the popular Latin ones.

ceptual imagining of them; and they have impulses to be in real connection with things, sometimes with the same things that they imagine. Image technologies, including surface-marking ones, can serve, amplify, channel, and suppress such impulses. It is very often observed that Western culture is a culture of images, a culture therefore now firmly in the grip of photo-technologies for producing them. That is the main theme of Sontag's *On Photography*, as well as of certain "postmodern" studies since. Such observations are also by now press clichés. What we have needed all along are rather clearer, complementary sets of accounts. These accounts should tell us, analytically, *what* "images" and "image technologies" are and, historically, *why* these technologies have developed along the lines they have taken—lines that may appear natural or inevitable but upon investigation show the contingency of all modern, developed technologies.

At this point a history of European image-making might be attempted, based on the historical rivalry of the two functions of depiction and manifestation. The history might begin with a "roots" account. Sontag, for example, conjectures that "in primitive societies, the thing and its image were simply two different, that is, physically distinct, manifestations of the same energy or spirit."[24] It would be worthwhile to track that conception through a variety of societies and subsocieties. For our purposes, it will be useful simply to indicate it very generally for *one* broad period of history, beginning with the much researched rift between the Eastern and Western Christian churches from at least the eighth century onward, regarding strategies for accommodating the Second Commandment's unqualified proscription of visual depictions.

Neither storytelling, singing, dancing, acting, building, nor ornamenting are mentioned in the Commandments. Only making "graven" images, "any likeness of any thing that is in heaven above, or that is in the earth beneath, or that is in the water under the earth," is prohibited at Exodus 20:4. Although the object was to avoid idolatry, the command was sweeping: a challenge to all the religions and sects that accept it as law. Historians tell us that after dramatic philosophical, religious, political— even military—conflicts, the Christian East settled on a hard-won status for its icons. They became officially sanctioned objects of veneration, based on the manifestation through them of the spiritual agencies that they symbolized, represented, or

[24] Sontag, *On Photography*, p. 155, I do not agree with her that this appears in Gombrich's accounts of "primitive art."

depicted—as we have distinguished and defined some of those terms.[25] By contrast, the West might be said to have settled on *depiction* as its main pictorial function, depiction precisely as elucidated in Chapter IV: prescription of vivid *sensory imagining* or *visualizing,* which leads to what is usually called naturalism. This Western "mega-style," growing from Hellenistic roots, evolved to include among other factors perceptual devices (Chapter VI), vivid detail (Chapter VII), and eventually photographic depiction itself in all its contemporary forms. Still, one should not infer that the West entirely surrendered manifestation and the function of contact and connection. Such matters are never so simple. The West maintained central positions for the manifestation function, one secular and one theological. Officially, if never quite in fact, it invested the theological manifestation function entirely in that important realm of the *relic,* of which David Hume wrote.

We should not pass so quickly as most general accounts would over issues of function, and the rationalization of functions, from these early times. Our treatment of depiction and representation in Chapter IV was one of use and function—notably the function of prescribing an activity, a thing we do: imagining. But functions, not just things, have histories, and these histories reshape the functions. We are now at a place where, to understand photographic depiction, we should take time to provide that use with some *historical* context not related in Chapter IV, the point being that in this context it was and still is implicated with manifestation. For example, if we consider what a number of historians tell us about the early use of images in the traditions we are considering, we find that prescription to imagine—especially to imagine perceptually—*combines* historically in not one but several ways with the manifestation function lately rediscovered in some photographs. For example, relics had early currency, free of the Exodus ban. Byproducts of relics (*brandea*)—perhaps things that had contacted them or were associated with them in various ways—then acquired some of the function of the originals. These byproducts included surface transfers, where possible, by mechanical means (*acheiropoietos*) such as rubbing, some of which were considered *images* of relics. Then even freehand likenesses came to be

[25] For an argued account of this change of function for icons in the East, see Ernst Kitzinger, "The Cult of Images in the Ages before Iconoclasm," *Dumbarton Oaks Papers* 8 (1954): 85–150; rpt. in Kitzinger, *The Art of Byzantium and the Medieval West* (Bloomington: Indiana University Press, 1976), and Kitzinger, *Byzantine Art in the Making: Main Lines of Stylistic Development in Mediterranean Art, 3rd–7th Century* (Cambridge: Harvard University Press, 1977), pp. 104–5, 118–19.

honored, if done on site; hence, pictures followed.[26] Next, Christians were free to contemplate crosses, and we do not need Jasper Johns to see that it is a nice question when a set of marks exemplifies a cross and when it represents or depicts it. Thus we have a familiar history on Hume's lines—and not just ancient history; cult examples, sacred and profane, abound in our own time as in the lucrative field of "memorabilia."[27] In this way, it has been argued, the function of religious depictions was buoyed up by that of relics, and these combined to serve the same devotional functions.

When we turn from the early Christian use to the philosophical *rationalization* of that use, historians tell us that interpretations of holy images followed different paths. They usually identify a main origin of all paths in the writings of John of Damascus (675–749), accepted by the Second Nicene Council. John appealed to the Christian doctrine of the Incarnation, arguing that when divinity became visible, the old ban against images was lifted and, furthermore, that generations who came too late to see the original were entitled to see artificial images (though not those of what had never been visible).[28] If this is an argument basic to iconodules East and West, the West is normally represented as relying on a much earlier argument—one based on long heuristic practice—made most authoritatively by Pope Gregory the Great (also cited by John), that "a picture takes the place of a book" for the illiterate and indeed that "from the sight of the story described [the faithful]

[26] See Kitzinger, "The Cult of Images," pp. 115–19; and André Grabar, *Martyrium: Recherches sur le culte des reliques et l'art chrétien antique,* vol. 2, *Iconographie* (1946; London: Variorum Reprints, 1972), chap. 8.

[27] Everyone remembers cases of this. Allegedly, bobbysoxers scooped Frank Sinatra's shoeprints from the snow for storage in freezers; John Dillinger's blood was sopped up by bystanders; Travolta's dance costume from *Saturday Night Fever* sold for $103,000; and, as much reported in the news, President John Kennedy's chair, gold clubs, and so on, went for large sums.

[28] Sources are in John's *De Fide Orthodoxa.* His *Orations,* not available until the sixteenth century, feature clear expositions of his views: e.g., "Of old God the incorporeal and uncircumscribed was not depicted at all. But now that God has appeared in the flesh and lived among men, I made an image of the God who can be seen. . . . These injunctions were given to the Jews on account of their [*sic*] proneness to idolatry. We, on the contrary, are no longer in leading strings. . . . When the Invisible becomes visible in flesh you may then draw a likeness of his visible form" (*Orations against the Slanderers of the Images* 1, trans. in Anthony Bryer and Judith Merrin, eds. *Iconoclasm: Papers Given at the Ninth Spring Symposium of Byzantine Studies, University of Birmingham* [Birmingham: Centre for Byzantine Studies, 1977], p. 183). The account here is given in Kitzinger, "The Cult of Images," among others. For a clear summary in the context of Renaissance theology, see E. Ruth Harvey, "The Image of True Love," in *The Complete Works of St. Thomas More,* ed. T. Lawler et al. (New Haven: Yale University Press, 1981), 6.2: 742–48.

should conceive a more ardent" emotion.[29] This is a much-cited passage. Yet it is not usually remarked that when put together—as they were routinely—the Gregorian and the Damascene arguments can both be seen to address the issue from the point of view of the picture's intended *viewers*. Gregory's case is entirely in these terms.

Three related features peculiar to this tradition are now so well entrenched as to be taken for granted in the very idea of a picture of something, out of which photographic pictures were invented. The first is that the *viewer*, not the subject, is the real topic of the account. In complementary fashion, and from independent principles (one that would make the practice lawful, another that would make it useful), both theological arguments present holy images in terms of things that viewers *imagine* seeing as objects of reverence. The second feature is that in its theological context, what was depicted was usually a historical, past, and distant being or occurrence. Other cultures may think of their images as making perceptible that which is already present, or as precipitating into a current event that which is not of any particular time, but Gregory's tradition of images—including those of saints—is in essence historically retrospective. The function of the image, therefore, was to incite one here and now to reexperience vividly what occurred there and then.[30] Third, the account is indifferent to the physical materials and the situation of the image—its decorative function, for example. In short, it leaves the image unlocated.

We should briefly note that the Damascene or Incarnation argument was later developed in the West through the medieval psychology of Thomas Aquinas: our nature is such that the divine—like anything else that reaches our minds—must come to us through our physical senses, notably through sight, and what comes to us in this way is registered as a physical state called an image.[31] There it remains, as a trace, long after its cause has passed. In this late medieval development, which was passed on through the psychologies of the "new learning" of the seventeenth and eighteenth centuries, we encounter a source of the prevalent reified "sign" treatment of imagining which I have scrupulously avoided. This is the approach to imagining in terms of a "faculty" of imagination, understood as a repository of a kind of

[29] Gregory the Great, letter to Bishop Serenus of Marseilles, *Epistles* 9:105.
[30] An important chapter of this story is told in Baxandall, *Painting and Experience in Fifteenth Century Italy,* pp. 40–44. But notice how the relic provides a transition.
[31] Thomas Aquinas, *Summa Theologica* 84.

thing, images, put there by previous sense perceptions. Furthermore, these deposits, since they work rather like words, might be defended that way.

Consider an example. In the sixteenth century Thomas More wrote against those who "gyue honour to yᵉ name of our lorde" yet "dyspyse a fygure of hym carued or paynted whiche representeth hym and his acts." More replied to Renaissance iconoclasts that "all the wordes that be eyther wrytten or spoken be but ymages representyng the thynges that yᵉ wryter or speker conceyueth in his mynde: lykewyse as the fygure of the thynge framed with ymagynacyon and so conceyued in the mynde is but an ymage representyng the very thynge it selfe."[32] This pattern of apology for "graven images," then, is psychological. It deals with the mental activities of the viewers, and to legitimize holy images it frequently likens them to activities with words. It is also rhetorical: it recommends vivid narratives with strong emotional effects. Its usual Incarnation aspect further encourages the presentation of the material, sensory aspects of what is depicted.

If the Orthodox Church was impressed by aspects of the Damascene part of the argument, it may have been less impressed by Gregory's didactic part in it, which fails, in any case, to meet the abiding psychological objection that visual depictions, whatever their intentions, encourage idolatry in a way in which written words do not. Idolatry, after all, was the basis of the Exodus prohibition, as well as of successive waves of iconoclasm. One reason for this concern seems elementary, in terms outlined in Chapter IV: paintings, statues, and the like automatically promote kinds of imaginative participation that even vivid descriptions do not. In the East, although textual evidence to explain it is sparse, there grew up the rather different pattern of function and of rationalization for holy images: that based on manifestation. One scholar has argued that by sharp contrast with the West, the justification of holy images is made "not through their usefulness to, or meaning for, the beholder, but through their inner relationship to their prototypes."[33] Ac-

[32] Thomas More, *The Ymage of Loue,* quoted in Harvey, "The Image of True Love," p. 752.

[33] Kitzinger, "The Cult of Images," p. 136. Kitzinger summarizes (pp. 149–50): "For the first time the Christian artist is exempted by the apologist from the necessity of justifying his work by educating . . . the beholder or by appealing directly to his emotions. The image need not narrate an event or convey a message, nor need the artist make it a primary aim to arouse in the onlooker a particular state of mind, such as awe or reverence, piety or compassion. Instead the artist is charged with the task of creating an image timeless and detached, in contact with heaven rather than humanity . . . capable of mirroring . . . its divine or sainted prototype and . . . of serving as a vehicle for divine forces." See also Peter Brown, "A Dark-Age Crisis: Aspects of the Iconoclastic Controversy," *English Historical Review* 88 (January 1973): 1–34.

cording to one statement of modern doctrine, "An icon . . . does not exist simply to direct our imagination during our prayers. It is a material centre in which there reposes . . . a divine force, which unites itself to human art."[34] The different appearances of the pictures partly reflect this difference of function.[35]

Modern Manifestations

Although the "parting of ways" between Christian East and West is usually marked in art histories, only the latter way is normally followed in telling "the story of art."[36] Furthermore, that story tends to be identified with the story of Western picturemaking as it shifted from devotional to secular imagining functions. There is some justification for this: there simply seems to be more of "story" to tell of the West than is available for the East, a wider social, economic, technological, and political context. This is owing to the relatively conservative nature of the East's history of image-making, compared with the extravagant variation and restlessness that mark the West's. Indeed, the very idea of visual art history was rooted in Renaissance efforts to describe historical and cultural "progress" in European art and became consolidated over the last three centuries as a study related to the dynamics of wider social, economic, and cultural changes. From the point of view of the East, the West's alternative might appear an immature approach, always

[34] Vladimir Lossky, *The Mystical Theology of the Eastern Church* (London: James Clarke, 1957), p. 189. Cf. Leonid Ouspensky, "Icon," in *The New Catholic Encyclopedia* (Washington, D.C., 1967), 7:324: "The icon shares in the sanctity and glory of its prototype. It is a vessel of the grace that the saint acquired during his life. This grace is present and active in his image as well as in his relics."
[35] For discussion of this interpretation, see Leonid Ouspensky, "The Meaning and Language of Icons," in Ouspensky and Vladimir Lossky, *The Meaning of Icons,* trans. G. Palmer and E. Kadloubovsky (Olten, Switzerland: Urs Graf-Verlag, 1952); Roderick Grierson, "The Death of Eternity," in *Gates of Mystery: The Art of Holy Russia,* ed. Grierson (Fort Worth: Intercultura, 1994), esp. p. 20; and Edwyn Bevan, *Holy Images: An Inquiry into Idolatry and Image-Worship in Ancient Paganism and in Christianity* (London: Allen & Unwin, 1940), pp. 143–178.
[36] See E. H. Gombrich, *The Story of Art,* 12th rev. ed. (London: Phaidon, 1972), chap. 6; "A Parting of Ways." Gombrich, like others, exposits the situation as follows: given the Second Commandment's proscription of images of any kind, the Latin West, following Pope Gregory, sanctioned religious ones for *depictive,* visual storytelling purposes: "Why should He not also be willing to manifest Himself in visible images?" Following the iconoclastic controversies (eighth and ninth centuries), Gombrich remarks, "paintings in a church could no longer be regarded as mere illustrations for the use of those who could not read. They were looked upon as mysterious reflections of the supernatural world" (p. 98).

striving for effects but ultimately dissatisfied in its substitution of dream for reality.[37]

Yet even in telling the West's story, it would be a mistake to forget manifestation motives. We can easily list three ways in which they were retained. The first is that under the conception of "art," Western images, religious and secular, did evolve their own manifestation principle and made it central. Here the manifestation is of the *maker,* rather than of the prototype. By the nineteenth century it had become normal under that conception—as also for example in Chinese painting—to think of pictures as manifestations or, as we tend to say, *expressions* of peoples, epochs, mentalities. We are accustomed to look to the style of depiction for manifestation of the mind or psyche of the artist who produced it—even for the historical epoch or culture of the producer. Given the diversity of pictorial practice that creates this kind of history, understanding pictures came to mean appreciating how they differ from historically related works as a result of differences among their makers or their social conditions. In this tradition, each picture tends to be understood as having two topics: the one represented and the one manifested. The main artistic obstacle for photography when it arrived on the scene was whether by its technological nature it could be sufficiently capable of manifesting the artistry, mentality, or depth psychology of photographers: a central topic of the next chapter.

The second way in which the West retained the manifestation function was rather more subversive. Despite its official shunting into the relics channel, undercurrents of *prototype* manifestation remained in Western image-making. Our approach to technology has stressed that it is one thing to pass up an option, quite another to forget its existence. For analogy, let us look back to the options of perspective as illustrated in Chapter VI, and parallel projection systems. All the diagrams in Chapter VI are themselves in parallel projection: most in oblique. It has been effectively argued that although perspective is generally thought to be the ascendant system in the production of works of depictive art, pictures that can be modeled on parallel projection—notably the "oblique" ones—have the longer history and the culturally wider use.[38] These latter systems seem relatively immortal in that they remain both most natural to children and invaluable to modern technical design drawing. They continued to be employed right along and often

[37] Bevan, *Holy Images,* pp. 143–78.
[38] This account of oblique systems and most of the following comments are owing to Dubery and Willats, *Drawing Systems.*

mixed with perspective.[39] We may go so far as to say that modern technology and industry themselves could exist more easily without perspective drawing than it could without orthogonal and oblique drawing. Even within the confines of art history, as it is usually considered, there is the following irony: through general ignorance of simple nonperspectival projection systems, historians and critics of modern visual art are sometimes misled concerning both the nonexistence of perspective in some cultures and its partial abandonment by modern artists in the West, mistaking the latter for abandonment of projective drawing altogether. Closer study shows that many modern artists—some cubists, for example—had reverted to the far older, more "natural," and widely entrenched oblique systems.[40] The analogy is that having set aside the alternative *function* in early chapters of their histories (an alternative that often favors oblique projective systems) in favor of the ascendant vivid, storytelling, depictively visualizing Western alternatives (in which the time, the culture, or the artist, rather than the subject, is manifested), commentators on Western art have not been quite in position to grasp some of its modern developments, despite frequent associations of modern works with "icons." They have therefore been unable to articulate aspects of the efforts in *modern* Western art itself to downplay visualization— indeed, to downplay in various ways mandates to imagine things at all.

The *suppression* of visual imagining through depiction in modern Western art—sometimes by what may be called the "deletion" of that factor,[41] sometimes in favor of manifestation—is a complicated affair that needs to have its own history told. Such a history would have to be fairly complex because, as we saw, pictorial representation is a central pictorial function typically *combined* in various ways, and through *interactions,* with other picture functions. Icons, for example, are certainly depictive—often powerfully, even narratively depictive. They contain, as well, a good deal of naturalistic detail, incident, characterization, and accidental effect. Modes of treatment vary among icons and within the same icon,[42] however, the kinds of imagining participation that they call for and the ways in which these are woven

[39] For architecture, see Robin Evans, "Architectural Projection," in *Architecture and Its Image: Four Centuries of Architectural Representation,* ed. Eve Blau and Edward Kaufman (Montreal: Canadian Centre for Architecture, 1989), pp. 18–35 (and Richard Hemphill's illustration, 178).

[40] See John Willats, *Art and Representation: New Principles in the Analysis of Pictures* (Princeton: Princeton University Press, 1997), pp. 12, 26–27, 275–79.

[41] The idea of deletion in this context is due to Wollheim, *Painting as an Art,* p. 23.

[42] See, e.g., Kurt Weitzmann, *The Icon: Holy Images—Sixth to Fourteenth Century* (New York: George Braziller, 1978), p. 42.

into other kinds of activities are quite different from what became typical of the Western tradition. A chapter in the story of "modern" Western art would certainly include the dramatic playing-down of imagining seeing events and certain situations—or of such visualizing at all—in favor of, say, imagining seeing objects or situations. Another would concern the playing-down of imagining seeing things in certain ways. Perhaps the most famous stage would be that of downplaying *figurative* imagining while still allowing imagining seeing: hence the emergence of what is popularly called abstract art, a general label for types of art that prescribe no (definite) figurative imagining, although they may suggest much other imagining. Ironically, the public, confronted with works that do not mandate the expected kind of imagining seeing, has tended to fall back on the entrenched alternative of artist's self-expression: self-manifestation. If nothing "shows" in the picture, one can still look for what (of the artist) "shows up" in it. Yet often those artists have had religious or metaphysical motivations, rather than self-manifesting ones; one need only consult the example of Mondrian.[43] In this they attempted to put themselves in good company. Ho Shao-chi said of the great seventeenth-century Chinese painter Tung Ch'i-ch'ang, "With every stroke of the brush, Tung transcends imagery and identifies himself with Heaven."[44] The story of imagining-function deletions would not be complete without relating how imagining seeing with pictures, imagining perceiving, even any sort of imagining, can be suppressed *altogether,* despite our tendency to indulge in it at the slightest graphic provocation.[45]

A *third* use of manifestation ideas in Western art brings us back to the topic of photography. Our earlier discussions showed that photographic pictures of things fit firmly into the broad tradition of image function set by the early apologists. First, they are often conceived in terms of their sensory and emotional effects on viewers, using many of the resources of the naturalistic traditions of the West—perspective, shadow modeling, textural rendering—

[43] On another kind of modern nonfigurative painting of sometimes metaphysical purpose—sometimes even likened to icons—see Alwynne Mackie, *Art/Talk: Theory and Practice in Abstract Expressionism* (New York: Columbia University Press, 1989).

[44] Ho Shao-chi (1799–1873), quoted in Stephen Addiss, *The Century of Tung Ch'i-ch'ang: 1555–1636* (Kansas City, Mo.: Nelson Gallery Foundation, 1992), n.p.

[45] For a representational treatment of most nonfigurative art, see Wollheim, *Painting as an Art,* p. 62; and for an interpretation in terms of imagining, see Walton, *Mimesis,* pp. 54–57. On nonfigurative painting that is not representational, see Wollheim, *Painting as an Art,* p. 62, and "Minimal Art" (1965), rpt. in Wollheim, *On Art and the Mind,* chap. 5.

to which they add several more, notably the moving image combined with sound, although their "accident-prone" weakness in clear narrative and "legibility" is often noted. Next, photographic pictures are particularly marked out for their powers to extend sense experiences to past times and distant events, powers assisted by their detective dimension. Third, notoriously dematerialized and unlocated—in their reproductive capacities dematerializing and dislocating other pictures—they have combined well with print technologies. Yet testimonies about "nearness," "contact," "emanation," "vestige," "trace," "co-substantiality," and so on, register a sense that photographs of things can combine with these characteristics a strong *manifestation* function as well. It is important to emphasize that they *can;* not *must;* photographs need no more feature this dimension of fidelity than they need feature the perceptual dimensions: perspective and surface detail. Many of them clearly do not, though many do.

The Western tradition, then, pursuing its projects of vivid sensory imagining, stumbled upon a mechanism of manifestation or contact but, given its historic habits of thought, was not well able to recognize it for what it was. Resultant confusion made ambiguous the term "the authenticity of the photograph." Questions now arise about the *uses* of these various dimensions of fidelity.

A Photo "Chemistry": Fidelities Combined

Our discussion of photo fidelities began with an influential comment about photography by the graphics historian William Ivins. Another of his witty but somewhat misleading lines about photography runs as follows: "The nineteenth century began by believing that what was reasonable was true and it would end by believing that what it saw a photograph of was true."[46] Many hold something similar about the attitudes of the succeeding century. Of course, the situation is not nearly that simple. As I have been arguing at some length, the very idea not only of what is "true" but of what is "in a photograph" is not a simple one, for each of these "whats" is not one but many. It may correctly be said, in an ambiguous phrase, that what one "sees in a photograph" may be what the photograph, as a picture of some-

[46] Ivins, *Prints and Visual Communication,* p. 94.

thing, represents or *depicts,* or how it represents it; it may also be what one can *detect* from the photograph or, again, what seems to manifest itself there, and these factors need not be the same.

We have been at pains to trace some of the multiple dimensions of that ambiguous but indispensable consideration, *fidelity.* There is, first, depictive fidelity in the sense of things being depicted as they are or would be. Next, there is the naturalistic fidelity of their appearing as they did or would, perhaps to an eyewitness. Then there is the fidelity of vivid depiction, such as is provided by the diverse pictorial technologies of shadow modeling, tonal detail, color, and cinematic movement. There is also the entirely different dimension of detective fidelity: the scope that the marked surface gives for actually detecting, or perhaps indirectly seeing, things that may not even be depicted by the photograph, far less depicted accurately or vividly. Finally—if that word could even be appropriate here—there is the "realism" of the fact (or at least the impression) of contact and continuity between viewer and subject. Each of these very distinct dimensions is itself complex, ramified in its kinds and effects and dependent upon wider context. Furthermore, each may be combined with others. In any combination they will likely interact with, change, and sometimes oppose one another. The very fact of the presence or absence (say, by deletion) of any of these may be thematized in a given picture. Photographs are frequently *about* nothing that they are photographs or even pictures *of.*[47]

Given the historical failure to mark out even some of these elementary distinctions, it is no wonder that the ongoing use, experience, conception of and comment upon photography and its fidelities should feature exasperating and often vehement mix-ups of considerations at cross-purposes. I have related each of the various elements of photographic fidelity to fidelity in nonphotographic images, sometimes analytically, sometimes historically. Throughout, I have emphasized how it is as usual for different fields of fidelities to combine and interact as it is for technological functions to do so. Consider a chemical analogy. Suppose that we had, with labor, managed to identify carbon, hydrogen, and oxygen. To consider their combinations would be to begin organic chemistry. Perhaps photographic meaning provides a less daunting prospect. In a few of its "chemical combinations" it is rather like organic chemistry. Rarely do our elements come neat; a complex

[47] This point is made, e.g., in Snyder, "Inventing Photography," in Greenough et al., *On the Art of Fixing a Shadow.* (See p. 44 n 31.)

job of analysis, not synthesis, is usually called for. Besides their complex "molecular" appearances, in the real world they will be much mixed in with other kinds of materials, and those mixtures will greatly affect their nature and working.

We could open a whole book of examples and applications of this sort of chemistry, but fortunately, we do not have to write such a book ourselves. If these efforts have been successful, we should be able to open many books and articles, already written and to be written. That is, in reading any interesting account of photographs, we should be able to make good use of our terms and distinctions. Let us just make do with brief application to one example: Lewis Hine's striking photograph "Top of the Mooring Mast, Empire State Building" (Figure 14), made as part of Hine's project published as *Men at Work*.[48] Taken just as a depiction that happens to be a photo depiction, this image allows us to imagine seeing workers in 1931 completing what was then the highest structure in the world. That is, in looking at the picture's surface we are incited and guided in imagining our very looking to be a looking upon that bygone scene. Furthermore, in the particular context of Hine's other pictures and his essays about them, we are mandated to imagine that what we see is, above all, a kind of *work* from the period of heavy industrial technologies (which in this case, modern engineers inform us, used far too much steel).[49] According to thoughtful interpretations of this set of pictures, this is work as activity, the activity of those industrial builders to whom we owe so much and whom we consider so little.[50] What of its dimensions of depictive fidelity?

One dimension is the group of considerations from Chapter VI. Linear perspective is an important aspect of this picture: for example, what it does for the buildings and for the position of one worker's feet is worth noticing. No less important are the shadows. Cast shadows give us a sense of atmosphere and show the direction of the sun; attached shadows not only define bodies but make the images of the girders into the bold, solid, dark diagonals that so characterize this picture. Aerial perspective is also an effective de-

[48] Lewis W. Hine, *Men at Work: Photographic Studies of Modern Men and Machines* (New York, 1932).

[49] Recent analysis suggests that the Empire State Building had eight times more steel structure in it than was necessary.

[50] The exposition is here dependent upon the researches and quite philosophical interpretations of Alan Trachtenberg, *Reading American Photographs: Images as History, Mathew Brady to Walker Evans* (New York: Hill & Wang, 1989), chap. 4, esp. p. 223.

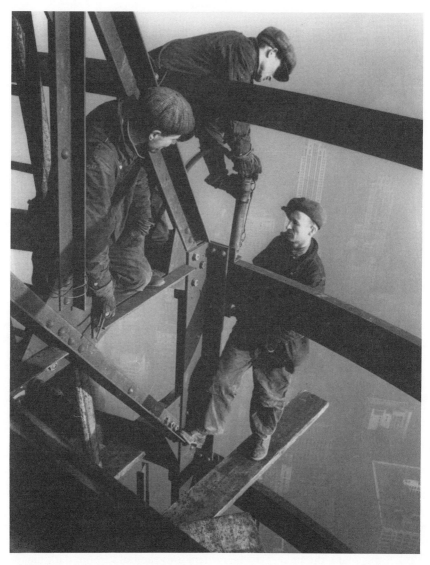

Fig. 14. Lewis W. Hine, "Top of the Mooring Mast, Empire State Building." Courtesy of The National Gallery of Canada, Ottawa.

pictive feature. Another dimension of photo fidelity (the subject of the last chapter) is the typically photographic textural detail important for vivifying the picture's prescribed imaginings: for example, in depicting worn working clothes, and in the contrasts of tangibility between the workers' apparel and the structures they stand upon as they build them. That the well-marked sur-

face of the plank a worker stands on is replete with causal history about its use and portability is part of its depictive meaning.

Another constellation of considerations concerns not so much the vividness of our imaginative perception of the depiction as its depictive accuracy. This may roughly be understood in terms of the information about the subject that could be extracted from the picture and represented in different forms. What sorts of information? As with any other depiction, we would first want to know whether it is what we might call a "representative representation": that is, whether the situation it has us imagine is *typical* of what it depicts—in this case, typical of that kind of work on that kind of building. In this regard, photo depiction is not different from other kinds of depiction. As we all know but often forget, posed, staged, or reenacted scenes are standard in photographic practice, and usually unobjectionable, so long as the situation shown is representative. (We should know this well from newspaper pictures and our own family snapshots.) Besides that accuracy of content, we are also interested in "legibility": the adequacy of this picture to make the relevant information accessible. As this is a depiction of a work action, part of the interest in such a question comes from the fact that action situations always fall under different relevant descriptions. For example, it would be easy to imagine one of these workers observing that the very act of joinery at which they are intent is invisible in this illustration of it, and that their work actions as shown are rather more heroic than they themselves would have experienced them.

This example also makes strikingly clear something that the practice of photographic depiction has brought forward as a strong dimension of picture fidelity. With photography, we often—though by no means always—expect a depiction to be not only representative of the depicted subject but also made from it: in brief, we expect that what is depicted is what was photographed. A kind of *causal,* formative consideration therefore appears: it will matter to us that Hine has made this picture by photographing the workers actually doing the work the photo depicts.[51] I chose the Hine picture because it so dramatically underscores this point. Were an identically depicted scene to occur in a movie, we would expect that what was photographed in

[51] Famous cases include a court's censuring the English philanthropist Doctor Barnardo, in the 1880s, for depicting typical situations of street children by posing other, more photogenic street children in their situations, and Joe Rosenthal's photograph of the flag-raising on Iwo Jima. On the photo-historic Barnardo case, see, e.g., Gillian Wagner, *Barnardo* (London: Weidenfeld & Nicolson, 1979); and Norman Wyman, *Doctor Barnardo* (London: Longmans, Green, 1962), pp. 87–88.

the background was itself a photograph, a rear projection, and not city streets below. Much imaginative vividness might still remain—films often make effective use of rear projection (though even with today's budgets and technologies we sometimes see poor match-ups)—but it is an important aspect of the Hine picture that it not be of that sort. In other words, besides the elements of depictive fidelity listed above, which photo depiction may share with depiction by other means, a certain causal element looms large here. It is a salient aspect of the meaning of this picture that it was formed in a certain way, and our everyday simple way of stating this is that it is a photograph of what it depicts—that is, not just a photographic picture of its subject.

Probably our interest in that element has interrelated parts, including visual indirect perception of a past event, and that great amplification of our ancient eyewitness interests which we associate with photo-technologies. The picture's being made in a certain way affects our activities of actual, not just imagined, perception and detection by its means. Our assumption that it was made in certain ways affects the actions we try to perform, our motives for them, our experiences of them—not only the riveters' actions but our own. Another action that likely interests us in the formation of this image is that of the photographer in taking the picture. It is hard when looking at some photos, this one among them, to avoid wondering and imagining where the camera was and how the photographer was stationed. That, it has been argued, is a "thematized" formative aspect of this picture, whereas its development and printing, its halftone screening and ink reproduction in a book are not.[52] Thus, not only is our empathetic participation with the workers encouraged by the composition; it is easy to think of ourselves in the photographer's position, to consider the precariousness of it—and it was precarious. As Alan Trachtenberg argues, part of the meaning of Hine's photo essay on people at work is the inclusion of photography itself as a kind of work, thus as a kind of participation.[53]

Here, then, are three groups of actions and their interrelationships: the

[52] They well could be, however; all these formative features, and more, have been thematized by photographers themselves (see Chapter IX).

[53] Trachtenberg, *Reading American Photographs:* "Hine's pictures turn back upon themselves, make their own labor of interpretative picturing part of the image" (p. 205); "The book fulfills itself as communication: it creates in the viewer the need to put oneself in the place of the photographer—to place oneself in the picture in the imagined role of the photographer, . . . not as a disembodied eye but as a worker in a medium . . . [in] the labor of photography" (p. 226).

subjects', the photographer's, and our own. By an interacting combination of effective depiction, manifestation, and detective action, we tend, as we look at this marked surface, to be made, ourselves, part of a wider social situation. Although other photographs will have rather different "chemistries," even by different arrangements of the same "elements," Hine's picture is an appropriate example of participation, a main theme of this chapter. And now, following these rather elementary considerations of an effective photograph, we are obliged to think not only about pictorial and photographic meaning but about artistic meaning as well.

PART THREE

❧

PHOTO ART

❧

Art and the "Agents of Apollo"

Survey of Positions

"The Artist's Province"

Given the long and checkered history of wrangles about the aesthetic and artistic status of photography, it is interesting to review how such matters stood at the beginning. In an essay on his calotype paper process, which began "photography" as we have known it (at least up to the time of electronics)—that is, photography as a negative/positive, latent-image, chemical process on flexible surfaces—Talbot made the following observation:

> I remember it was said by many persons, at the time when photogenic drawing was first spoken of, that it was likely to prove injurious to art, as substituting mere mechanical labour in lieu of talent and experience. . . . I find in this, as in most other things, there is ample room for exercise of skill and judgment. It would hardly be believed, how different an effect is produced by a longer or shorter exposure to the light, and also, by mere variations in the fixing process, by means of which almost any tint, cold or warm, may be thrown over the picture, and the effect of bright or gloomy weather may be imitated at pleasure. All this falls within the artist's province to combine and regulate: and if in the course of these manipulations, he *nolens volens* becomes a chemist

and an optician, I feel confident that such an alliance of science with art will prove conducive to the improvement of both.[1]

Thus the historical "perspective" of two whole years. It is clear from his "applications" that Talbot thought photography could be artistic as well as scientific. We recall that his first "philosophical musings" on photo processes issued from frustration with topographical sketching. Although Talbot was neither the drafter that Herschel was nor the photographer that Hippolyte Bayard was, *The Pencil of Nature* is full of comments on artistic composition and is characterized by a meditative regard for photo images. We also know from the early French announcements previously cited that a connection with pictorial art was one of the main talking points for Daguerre's alternative technology. It has been my theme throughout that the applications of these and related processes are of a diversity beyond their early promoters' fondest dreams, even beyond our easy recollection. With regard to the fine arts we also know—although, again, we had to be reminded—that not just one but a number of these technological applications proved at least indirectly fruitful. Photomechanical reproduction provides a simple example, the movies another. Yet just as silver-halide camera depictions of things photographed have continued to be the main stem of interest through many technological branchings and twinings, so have issues about photography and pictorial fine art come down to us much as they were first posed. Although previous chapters have considered some aesthetic and artistic matters, I have so far resisted the tendency of most histories of photography to channel the account progressively toward matters of photo art. Yet even a primer on the subject of photography as technology, such as ours, should suggest what that sort of approach might have to say about these matters.

This chapter attempts three contributions to the topic. First, it sets out a simple way of comparing various opinions about photography and the fine arts. Second, it attempts to identify and to put in philosophical perspective whatever seems the main source of contention. Third, it approaches the issue in ways that might be continued by attention to individual photographs, styles and kinds of photographs: that is, by what has well been termed "substantive" aesthetics. On that protreptic, our primer closes. Throughout, we will again follow the policy of working only from real and interesting exam-

[1] William Henry Fox Talbot, "Calotype (Photogenic) Drawing," *Literary Gazette,* 13 February 1841, p. 108.

ples, read or viewed with efforts at sympathy and understanding, never abandoning the sense of history that has guided the book thus far.

Two preliminary cautions bearing on photo history are in order. First, we must be careful what we imply in saying that issues of photography as art, or photography and art (as in "foe-to-graphic art"), were joined early and continued ever after. We must not imply that these were the main issues occupying the thoughts and deeds of the societies that developed photography's procedures. At any historical point there may have been more pressing and more heatedly debated issues, such as those of our time concerning the insidious effects of imagining projects that are "projected" not to but from screens, the transformation of political debate, and television's powers of persuasion. Still, that there have always been views, attitudes, contention, and puzzlement concerning photographs as works of art is to be expected for at least two kinds of reasons, which I label "aesthetic" and "formative"; these may be distinct but also interact in interesting ways.

Second, we must answer the charge of irrelevance, which will take more space. It will seem to some that to consider ideas about photographs as artworks in expressions coined during the nineteenth century is to encourage an outworn, tiresome exercise. Did not Elizabeth Eastlake, as early as 1857, refer to photography as "a new medium of communication between man and man—neither letter, message, nor picture"? Whatever scruples early commentators may have had (so it will be asserted), they belong to ancient history, to times before modern technologies transformed photographic practice and also to times when now outdated, somewhat quaint, ideas about *art* prevailed. This objection can be run in relay, beginning with the earlier twentieth-century case for the autonomy of photographic media and passing on to what may be seen as its antithesis: a high-tech, "postmodern" dissolution of boundaries between photography and the other arts by the end of the century.

One significant representative for the first (autonomy) leg of the objection is Beaumont Newhall's early version of his history of photography, where he dismissed issues concerning photography as art as outdated or, in any case, "at risk of falling into philosophical quagmires."[2] The better course,

[2] Beaumont Newhall, *Photography: 1839–1927* (New York, 1937), p. 40, cited in Mary Warner Marien, "What Shall We Tell the Children? Photography and Its Text (Books)," *Afterimage* 13 (April 1986): 4–7. The presentation of Newhall's views here is largely based on Marien's critical analysis: "Rather than making it art, Newhall has . . . claimed that photography is a unique, hybrid medi-

he urged, was to treat photography autonomously and, in writing its history, "to construct a foundation by which the significance of photography as an aesthetic medium can be more fully grasped."[3] As to this foundation, Newhall said, "Photographic aesthetics are so closely combined with technique that it is almost impossible to separate the two."[4] Once photography is seen as an autonomous domain parallel to that of pictorial art, it can even be seen as a superior domain, the historical successor to handmade pictures, which have had their day. A more extreme expression of that view might be represented by the constructivist Alexander Rodchenko, or by Moholy-Nagy's "new vision" philosophy (see Chapter VII).[5] According to that artist-theorist, "The old quarrel . . . whether photography is an art is a false problem"; the real issue is to show "that the development of technology out of the industrial revolution has materially contributed to the rise of new forms of optic creation."[6]

Bold words. It seems, however, that with the subsequent technological proliferation of imaging techniques, photography has come to be considered by many as less rooted in any specific technique or kind of vision. This introduces the second ("postmodern") leg of the irrelevance charge. By the

um, with its own aesthetic" (p. 6L). A previous philosophical guide through some of these "quagmires" is John L. Ward, *The Criticism of Photography as Art: The Photographs of Jerry Uelsmann* (Gainesville: University of Florida Press, 1970). Ward distinguishes four special problems about photography for art criticism, addressed here: that it is mechanical, indiscriminate, easy, and of a windowlike nature (pp. 2–3). He also usefully illustrates and criticizes five critical positions—pictorialism, purism, intentionalism, and the "reading" and archetype approaches (pp. 4–18)—before developing his own.

[3] Beaumont Newhall, *Photography: A Short Critical History* (New York, 1938), p. 9, cited in Marien, "What Shall We Tell the Children?" p. 4.

[4] Newhall, *Photography: 1839–1927*, p. 75.

[5] One could make an anthology of examples of these and the other general positions about to be sketched. In handy existing anthologies, note Marius De Zayas's position that as art is dying with religious faith, photography, which "is not art," must take its place in the investigation of forms; see his "Photography," *Camera Work* 41 (1913) and "Photography and Artistic-Photography," *Camera Work* 42 (1913), rpt. in Trachtenberg, *Classic Essays*, pp. 125–40.

[6] Though the precise source of this quotation eludes me, very similar remarks by Moholy-Nagy (pronounced to rhyme with "doughboy-lodge") may be found throughout *Moholy-Nagy*, ed. Richard Kostelanetz (New York: Praeger, 1970), esp. pp. 36, 43, 53–58, 132. Clearly, Moholy-Nagy's ideas about "light modulators" bear on Chapter VI, and his view that art has the social responsibility of integrating modern industrial technology into modern feeling expression addresses the themes of the end of this chapter. Indeed, each chapter of this book could have been developed from interesting statements by that artist and teacher, to be found in that source work.

1980s much photographic practice, theory, criticism, and history (some of it explicitly critical of Newhall) turned away from autonomy and "formalism" toward a kind of photographic picture said to be more "made" than "taken."[7] The newer technologies participated in a cultural tendency toward *hybridization* of forms, which weakened the sense of photography as a domain comparable to but separate from the fine arts. Sometimes this hybrid kind of photography is seen as successor, both to handmade imagery and to earlier photography (including that of the "new vision,"—now, ironically, also considered "traditional"). Sometimes it is suggested that we rewrite photo histories to show that there never were separate domains of photography and other visual arts.[8] This later historical turn is often presented as an antithesis to the earlier formalist one, and on the side of even earlier manipulation aesthetics.[9] Nevertheless, both attitudes share, although with opposed motives, disdain for the kinds of questionings about photographic art that we are to treat in this chapter.

There is a string of reasons for rejecting not the two modern approaches to photography just outlined but their arguments against considering seriously the continual history of questioning whether or not there are photographic arts. After all, the earlier leg of the objection, the photo autonomy view, itself presupposed a strong bond as well as a significant difference between photographic pictures and works of art of other kinds, such that the former could be said to affect, even usurp, the latter. But it is just these similarities and differences that are at issue in the tradition of considering photographic art. Next, recent history shows that approach to have been rather exaggerated. The idea of pictorial art as solidly based upon painting and drawing traditions—especially those running back some centuries and across various cultures—became ever more widely established throughout the world during the last quarter of the twentieth century. This was in part *owing* (as we observed earlier) to contributions of photomechanical processes.

[7] Joshua P. Smith, *The Photography of Invention: American Pictures of the 1980s* (Washington, D.C.: Smithsonian Institution, 1989), p. 10; but see Borcoman, note 9 below. A sampling of slightly earlier views might include Jerry Uelsmann, "Post-visualisation," *Creative Camera*, June 1969, rpt. in Petruck, *The Camera Viewed*, 2:71–75; Duane Michals, *Real Dreams* (Danbury, N.H.: Addison House, 1976).

[8] See Marien, "What Shall We Tell the Children?"

[9] Thus James Borcoman, commenting on early stages of the revival, in 1974: "The recent revival of hand-manipulated photographs . . . has its roots in an older tradition, one in which the picture is made rather than taken" ("Purism versus Pictorialism," p. 73).

Museums and exhibitions of painting thrived during that period, as did the commercial markets for such pictures. Meanwhile, the photographic kinds lagged, harried by theoretical attacks.[10]

Further, it has been argued that the photo phenomena that did burgeon during that period were those of amateur rather than professional photography. Even though most people do not assume their productions to be works of art, we are likely to find the values of amateur photography continuous with the values of painting and drawing.[11] Next, another variety of theoretical and artistic defender of photography insisted on its clear continuity with traditional forms of pictorial art, and that position cannot simply be defaulted without argument.[12] Finally, the content of the postmodern developments that blur the alleged boundaries of photographic art often concerns either the relations of photography to other pictorial methods, or photography as art, or the considerations involved in that issue.

Thus the preliminary comments. Out of the second set of them, a discussion of reasons *not* to consider photo-art questions, there have emerged not simply a pair of opposed views—that photography achieves art or falls short—but rather a range of views regarding the continuity or similarity of photographic pictorial art with other, notably pictorial, kinds of art. One way of thinking about that range might begin by recognizing the generally opposed attitudes that either stress continuity and similarity or emphatically minimize them. Stress on continuity gives us a *first,* familiar kind of view that accepts photographic fine art. The minimizing type, I have already hinted, splits into at least two related views: a *second* one asserting the basic transformation of the concept of pictorial art by these late media, and a *third* proclaiming the abrogation of that concept by those media. These are two versions of the idea of photo autonomy. There remains a *fourth* position, of course: that photographic pictures fail to be art—or, at least, to be represen-

[10] See Richard Bolton, ed., *The Contest of Meaning: Critical Histories of Photography* (Cambridge: MIT Press, 1989).

[11] This is one thesis of sociologist Pierre Bourdieu, who also quotes Pierre Francastel on the topic. See Bourdieu, *Photography: A Middle-Brow Art,* pp. 73–75, esp. "The ordinary photographer takes the world as he or she sees it, i.e., according to the logic of a vision of the world which borrows its categories and its canons from the arts of the past" (p. 75).

[12] On one side there are criticisms such as Marien's; on another, the position of Joel Snyder in papers such as "Photography, Vision, and Representation" and "Aesthetics and Documentation: Remarks concerning Critical Approaches to the Photographs of Timothy H. O'Sullivan," in Walch and Barrow, *Perspectives on Photography,* pp. 125–50.

tational art—but are something else again, only sometimes mistaken for pictorial art on the basis of superficial likenesses. Let us compare these numbered positions by means of a grid showing whether or not they would place photography among the fine arts:

	art	not art
emphasize similarity	1	
emphasize difference	2	3/4

The grid is simple, but the complexity of the situation it represents already shows in the fact that the third and fourth views—which might seem the most antagonistic pair—actually share a quadrant. This list of four kinds of views is provisional. It is neither neat nor exhaustive. The list cannot be neat, because the key terms involved are subject to the trite but relevant qualification "depending on what we mean by 'art'" (a subject we will have to address) and "by 'photography.'"

Where, then, is what Talbot called "the artist's province" in relation to photography? Before addressing that question ourselves, let us, using our grid, survey a few real and interesting views on the subject.

A case in point is the twentieth-century "straight" photographer Edward Weston, who may be taken here, as he often is, to represent a "school." In his many public and private writings, Weston, like P. H. Emerson and Alfred Stieglitz before him, often argued emphatically for our *first* position, the cause of photography as fine art—though not for every kind of still photography that was presented in this way. In his *Daybooks* Weston records that he once set out "to prove [to some painters] by logical deduction that photography could be an art," whereupon "I suddenly realized I did not care how photography was labeled." His reason: "'Art' is considered as a 'self-expression.' I am no longer trying to 'express myself,' to impose my own personality on nature, but . . . to become identified with nature, to . . . *know* things

as they really are, their very essence, so that what I record is not an *interpre-tation—my idea . . .* but a *revelation.*" Yet he had to admit that his pictures were, significantly, interpretations, since he and a commercial photograph-er photographing, say, "a cabbage" might both be said to "present" that sub-ject without self-expression. Weston's reply was that the artist would be able to present it in terms of its significant form; however, he continued: "I will try to prove with logic that, unfortunately, photography can be art . . . in the sense these 'critics' approach art, as a means of personal—very personal—expression." He went on to argue that the photographer "has far more op-portunity for self-expression through material opportunity than is granted the painter."[13] Still, Weston continued the discussion in the direction of nat-ural manifestation: "The mechanical camera, an indiscriminate lens-eye, by restricting too personal interpretation, directs the worker's course toward an impersonal revealment of the objective world. 'Self-expression' is an objecti-fication of one's deficiencies and inhibitions. In the discipline of camera tech-nique, the artist can become identified with the whole of life and so realize a more complete expression."[14] He later argued that in modern times pho-tography had surpassed painting as art: our *third* position.[15]

If we look for consistency in such thoughts, Weston's views might be put as follows. If art entails self-expression, some photographs are art. Yet neither the worse nor the better photographs are art: the worse because they do not achieve self-expression, the better because they transcend it. It might then be that the better photographs are something beyond art (our third view) or that they are "art" of another kind (second view), possibly of a kind to which many other works of art really also belong. In the terms of Chapter VIII's discussion, we recognize Weston to be positing a kind of art that manifests "fundamental forms" in nature, rather than states of an artist's mind—or at least forcefully depicts such manifestation. The physically causal manifesta-tion powers of the process, by which Talbot's house could "draw its own pic-ture," encourage hopes for photography as a channel for more meaningful revelations of nature.

By means of our four categories, Weston's thoughts could then be shaped

[13] Edward Weston, *The Daybooks of Edward Weston,* ed. Nancy Newhall (Millerton, N.Y.: Aper-ture, 1973), pp. 221, 228–29, entries for 14 August and 16 October 1931.
[14] Edward Weston, leaflet for the Los Angeles Museum (1934), excerpt in Goldberg, *Photography in Print,* p. 316.
[15] See Weston, *Daybooks.*

as a recognizable approach—but without forcing his attitudes into any single category. This is also a place to say that, as a general outlook, Weston's would not be peculiar to him among artists, or even among photographers. A number of modern photographers have had similar philosophical inclinations about photography as potentially revelatory of nature: for example, Weston's associates Minor White, Ansel Adams, Wynn Bullock.[16] The practice of nature photography with a large "view" camera, combined with technical craft in printing, does encourage contemplative attitudes. As Sontag remarked, however, in the less contemplative last quarter of the twentieth-century, "darker, time-bound models of beauty have become prominent," and "recent generations of photographers prefer to show disorder, prefer to distill an anecdote, more often than not a disturbing one, rather than isolate an ultimately reassuring 'simplified form' (Weston's phrase)."[17] They have also tended to use smaller cameras, to be more concerned with urban life, and to thematize the appearance of subversive details. We may add that the critique of photo form and beauty exemplified by such photography has been joined by theoretical political movements, suspicious even of efforts to place photographs in picture galleries.[18]

"Philosophical Quagmires"? Emerson

Weston's aspirations to photography as an art beyond the reach of painting probably exceed the normal field of debate—or at least the point for misgivings—regarding photography and art. More familiar, ongoing, seemingly interminable discussions center on the theme of photography as a productive technology, notably as a means for producing aesthetically interesting pictures of things, as compared with "traditional" and "handmade" methods. Various extremes are entertained, stated, possibly sometimes held—including the view that painting and drawing as handcraft techniques

[16] White was an influential photographer, technician, and teacher; see Minor White, *Mirrors/Messages/Manifestations* (Rochester: Aperture, 1969). On Wynn Bullock's philosophy, see Bullock, *Wynn Bullock* (San Francisco: Scrimshaw, 1971).

[17] Sontag, *On Photography,* p. 102.

[18] A number of such papers may be found in Bolton, *The Contest of Meaning.* Perhaps the classic among these (versus Stieglitz) is Allan Sekula, "On the Invention of Photographic Meaning" (1975), rpt. in Sekula, *Photography against the Grain: Essays and Photo Works, 1973–1983* (Halifax: Press of the Nova Scotia College of Art and Design, 1984); abridged in Goldberg, *Photography in Print,* pp. 452–73.

for producing pictures are now made obsolete by image-generating and -modifying photo-technologies. This view is often the changeling issue of crude art-as-manufacture conceptions and high-tech sophistication, characteristic of the modern consumer technological society.

At another extreme it is sometimes said that photography is itself not a fine art (or at least not a major one), and cannot be so, but does contribute to the production of works of fine art and even to the existence of one fine art: cinema. This, the *fourth* of our general positions, is held by many—or at least entertained to varying degrees. A real instance of it may help us understand why, and for this purpose we may do no better than consider the case of Peter Henry Emerson, whom we have already encountered on the topic of photo detail. In a now famous—or notorious—episode in the history of photo aesthetics, Emerson, an outstanding glass-plate photographer and leading theorist and category 1 promoter of photography as a fine art, gave up the claim for photography as a fine art—or, to be more exact, for photography as a major art: as one of *the* fine arts. Earlier, he had argued our *first* alternative, even that photography is second only to painting as a fine pictorial art, notably because of its fine tonality.[19] The recantation occurred most publicly in 1890, when this author of an impressive treatise of the previous year titled *Naturalistic Photography for Students of the Art* recalled its second edition and issued a black-bordered retraction of its main thesis.[20] He maintained this position of renunciation with his revised third edition of 1899 and through his activities and writings up to the 1930s—presumably including his last work, *History of Naturalistic Photography,* the manuscript of which was never found.[21] That Emerson was an outstanding photographer, one of the first to struggle vigorously, supportively, and effectively for recognition of photography as a fine art, the founder of the "pictorial photo-

[19] Emerson, "Photography: A Pictorial Art" (Camera Club address, 11 March 1886), in Newhall, *Photography: Essays & Images,* pp. 159–62.

[20] Emerson reported in *The Death of Naturalistic Photography* (1890; rpt. in Arno ed. of *Naturalistic Photography*), n.p., that his misgivings began with conversations with an artist (probably Whistler) and turned to conviction with his confirmation of the Hurter-Driffield discovery of the "characteristic curve" relating values of exposure, density, and development for emulsion—and a Hokusai exhibition.

[21] The lively and informative source for all this is Newhall, *P. H. Emerson.* Emerson's turnabout actually occurred in the same year as the publication of the first edition of his book and his paper "Photography Not Art," *Photographic Quarterly* 19 (1889), printed as "L'Envoi" to the 3d rev. ed. (1899) of *Naturalistic Photography* (the edition cited here); a tiny excerpt appears in Goldberg, *Photography in Print,* pp. 197–98, and longer excerpts in Newhall, *P. H. Emerson.*

graphic school," an influential theorist, critic, and editor in the field, a hero of the later "straight" school (a name he rejected), something of a curmudgeon and, to many, a crank—all these are facts of interest but of no direct bearing on the present topic. What is of most interest to our purposes are the reasons Emerson gave for reversing himself.

It might appear that neither Emerson's vehemently stated positions nor his statements together with his practice could be consistent. He did not remove the word *art* from the title of his book, even when adding to it the text of a talk titled "Photography Not Art." He campaigned well into the 1930s for "naturalistic photography"—with his penchant for awarding medals—and vigorously attacked other kinds, notably those involving manipulation or "photo-faking" that attempted to imitate drawing and painting. He continued to photograph according to his principles.[22] Emerson's simple and instructive case can be characterized as follows. He did not need to change his photographic *aesthetic* in order to give up his case for photographic art. He held that still photography could never be art—or at best, only a minor one, "the lowest of all arts, *lower than* any graphic art"—even though it "could give a certain aesthetic pleasure."[23] Thus he could announce that "the methods of practice I advised in *Naturalistic Photography* I still advise, and the artists I held up for admiration . . . I still hold up as the best exemplars of their various crafts, but my art philosophy is different as . . . I do not consider photography an *art*."[24] What does it mean to say that Emerson held to his *pictorial aesthetic?* Aesthetically, as opposed to "scientifically" (and he praised scientific photography, including that of great detail resolution),[25] pictures should be true to natural appearance—that is, true to human visual experience, constituted by an interaction of the environment, the light, and human optic physiology—notably as represented by the theories of Hermann von Helmholtz. (One might understand Emerson here alongside philosophers such as John Dewey and twentieth-century phenomenolo-

[22] For an interpretation of the later evolution of Emerson's photography, see Mark Durden, "Peter Henry Emerson: The Limits of Representation," *History of Photography* 18 (Autumn 1994): 281–84.

[23] "Is photography an art?" We answer: 'No,' and . . . agree that 'it can never be an art,'" "Photography Not Art," p. 54; Emerson, *The Death of Naturalistic Photography,* n.p.

[24] Emerson, *Naturalistic Photography,* 2:77; "Naturalistic Photography and Art," *Photographic Journal,* 28 March 1893, rpt. in *Naturalistic Photography,* 1: chap. 4.

[25] See, e.g., Emerson, "Science and Art," pp. 67–87: "We in the photographic world should be either scientists or pictorial photographers." Cf. *Naturalistic Photography,* 1:188–99.

gists.)[26] This aesthetic seems limited and dated now, a "pure" photographic aesthetic only via a conception of nature strongly influenced by a particular *painting* aesthetic. It would be a mistake, however, to reject that aesthetic out of hand, or its versions in Weston and other "contemplative" photographers. Aesthetic views are like many technologies in that rather than being destroyed by new developments, they often continue, unrecognized, in combination with what had seemed to be antitheses. Elements of Emersonian pictorialist photography still hold for some nature photography.

Emerson's general position was made possible by his sharp break between what he called "aesthetic" and "artistic." This view is not unique with him; rather, his is a better-thought-out application than usual of the most normal view of these matters. On this view, something aesthetic is necessary but never sufficient to art. Much that is powerfully aesthetic—notably in natural scenes, in people, in animals—is not art. Emerson applied this distinction specifically to *pictures*. Naturalistic photographs, for example, can be aesthetically valuable without being art.

Let us go further, on Emerson's behalf, and distinguish artistry and the artistic from art. Since artistry requires—though it always exceeds—the practice of aesthetic judgment, artistry may be and usually is important to making aesthetically good photographs; they are unlikely to occur by accident. (It should be added that good photography also requires photographic knowledge. Few painters, Emerson wrote, "can ever make a picture by photography; they lack the science, technical knowledge, and above all, the practice.")[27] Therefore, good photographs, like many other things, can be called artistic without being considered themselves works of art. Thus not all that Talbot thought to be "within the artist's province" need be art. In sum, photography is a "process, whose results are sometimes more beautiful than art, but are never art," although the beauty there will have been found through the practice of artistry.[28]

It was therefore consistent for Emerson to continue to campaign for what he considered artistic values *in* photography while chiding Alfred Stieglitz,

[26] The connection to phenomenologists is made by Durden in "Peter Henry Emerson," although his premise about a "new observer" emerging in the nineteenth century and the phenomenological texts he cites should be examined closely.

[27] Emerson, *Naturalistic Photography,* 3:37.

[28] A naturalistic photograph requires . . . strong artistic sense to produce, and a refined artist to appreciate": Emerson, "What Is a Naturalistic Photograph?" *American Annual for Photography* (1895): 122–25, quoted in Newhall, *P. H. Emerson,* pp. 103, 99.

whom he admired, for promoting what Emerson repeatedly called the "dead cause" of photo *art.* It was reasonably consistent for him, thirty-five years after his recantation, to write of "the most artistic photographers" that "all that concerns me is the *art in the photographs,"* to be composing "a history of art photography," to mention "pure art photography," and to say that "photographs which are art *are rare.*"[29]

What is of most interest and relevance to later times is Emerson's *reason* for maintaining that photography, no matter how good and artistic, cannot be art—because it is "impersonal." It is impersonal because it is "mechanical": a product of nature, not of an artist, even though, as just observed, artistry may be exercised in producing it. Emerson's reasons are interesting because they are still prevalent, and his position, dated as it will seem to many, is in many other ways contemporary. His warnings about photography as false art and suspicions of "scientific" testimony have been restated by social critics since the 1970s. Furthermore, his practice of judging photography on a pictorial aesthetic, separate from issues of art, has been practical policy for some photo collections of the late twentieth century, as the concept of art itself became contested far beyond the debate of Emerson's day. It is not unusual for a curator to say that we would do as well to leave questions of art aside and focus on aesthetics—though, to be sure, with photo aesthetics of much wider latitude than Emerson would have tolerated.[30] Earlier chapters considered several bases for a diversity of photo aesthetics. The daguerreotype versus the calotype, then the combination of gloss, detail, and mass-production issuing from the photo-technologies of the 1850s, provide watersheds for the *appearances* of "photographs"—as do the miniature, amateur film camera of the 1880s, the 35 mm camera, color film, the movie camera, camcorder, and so on. Not only do the products of each of these technologies have a characteristic look, but the activities of looking *at* them differ slightly or greatly from case to case. These differences entail aesthetic differences.

[29] Quoted in Newhall, *P. H. Emerson,* pp. 128–29. Three letters from 1902–3, citing "dead cause" and so on, are deciphered from Emerson's handwriting and printed in Newhall, *P. H. Emerson,* pp. 116–17. In these letters he also remarked, "Photography as an Art is a Strumpet and as a science it must [bear?] . . . *careful watching,*" and wished the embattled Stieglitz "speedy enlightenment so that no more years may be wasted."

[30] "I don't like to use the word art when talking about photographs; it's too confusing": James Borcoman, quoted in David Mattison, "The Magical Eye: Definitions of Photography," *Photo Communiqué* 2, no. 3 (1980): 20.

I have been using the term "aesthetic" in its familiar sense, without ex-
plaining it. At this point we may simply observe that to the extent that ac-
tivities of perceiving things are in themselves interesting, such activities are
candidates to be aesthetic activities. This may not be entirely what we mean
by "aesthetic considerations," but it is always *part* of what we have meant by
it, since the introduction of it (and its cognates in various languages) into
everyday speech in the early nineteenth century. What we normally mean is
a delight (or the reverse) in the very act of perceiving—or even of only con-
ceiving or imagining perceiving—something.[31] Apart from the subsequent
philosophical workings of this idea, the element of "experience of percep-
tion" already suggests that there will be a range of different applications.

Previous chapters have shown that aesthetic issues have in fact been raised
at various junctures in the history of photography, notably in the reserva-
tions of Baudelaire, Newton, and Elizabeth Eastlake during the 1850s. Some-
times the objections were put in *artistic* contexts, yet, it is important to note,
that was not necessarily the case. Before Emerson there were nineteenth-cen-
tury commentators willing to deal with the aesthetics of kinds of photogra-
phy— even the pictorial aesthetics of photography—without raising art
issues; some scrupulously avoided such issues. The simple reason for this, as
we observed, is that not all aesthetic matters, not even all pictorially aesthet-
ic matters, need to be matters of art. We can now add that the complemen-
tary case holds, as well. Some debates about photography as art are not
supposed to involve aesthetic issues, much less to turn on them. Despite the
familiar view that aesthetics is a central component of art, some of the most
influential artists and commentators of the twentieth century forcefully put
forward nonaesthetic—even *anti*aesthetic—views of art, and photography
has played a role in this development. Nor is this altogether a later phe-
nomenon. At about the time of Emerson's third edition, a no less vehement
Leo Tolstoy produced a famous treatise condemning the aesthetic compo-
nent of art as the indulgent hedonism of a privileged class and favoring art
as self-expression, and there are earlier critics, as well, including Hegel and
J. S. Mill.[32]

[31] The history of the term "aesthetic," its evolution out of "taste," and its philosophical develop-
ment have been the subjects of recent research. Computer software now allows us to prove that
writers such as Hume never used the term in its modern sense.

[32] Leo Tolstoy, *What Is Art?* (1899), trans. Alymer Maude (Indianapolis: Bobbs-Merrill, 1960).

Mechanical Misgivings

Mention of self-expression brings us back to Emerson's statement of a perennial case against photography as art. His first reason was what we might call "executive." To Emerson, photographers were discoverers; artists were creators. The artistry around photography, he believed, consists in a few "limited" elements of selection—of view, lens, focus, exposure values, and printing methods—but it is "the machine that draws the photograph," and "The result is *machine-made;* the trapping of a sunbeam": "The photographer does not make his picture—a machine does it all for him." It follows that whereas art is "personal," photographs are "machine-made goods." Owing to this lack of "individuality" or the "personal," which is due to the extremely "mechanical" aspect of photographic technology, photographs lose interest, where etchings and paintings do not.[33]

It would not do to reply (as some did at the time) that most artistic procedures are to some extent technological, using mechanical amplifiers of somatic powers. "Did not this argument hold good just as much with respect to the painter, who uses a brush, if it was to be chiefly a question of the invention of tools?" asked one critic.[34] The answer, clearly, is negative; Emerson never objected to the use of tools in art. A similar reply might be given to Weston's rather better objection to the idea that a "straight photograph was purely the product of a machine and therefore not art." Weston remarked: "Perhaps if singers banded together in sufficient numbers, they could convince [instrumental] musicians that the sound they produced through *their machines* could not be art because of the essentially mechanical nature of their instruments."[35] Such *analogies*—usually similarly rhetorical, and heated—are a familiar mode of response to "mechanical" misgivings regarding photo art. The question, as with all analogical arguments, is whether the analogies are good ones. Usually they are poor, and Weston's is no exception.

For Emerson, "mechanical" is something that admits of degrees and depends upon location within the productive act. He remarks, for example,

[33] Emerson, *Naturalistic Photography,* 1:26, 185; "Photography Not Art," pp. 55–58, 60, 63; *Death of Naturalistic Photography,* n.p. (I omit Emerson's rhetorical italics and capitalizations).

[34] Camera Club discussion note of the Rev. F. C. Lambert, cited in Newhall, *P. H. Emerson,* p. 101.

[35] Weston, "Seeing Photographically"; rpt. in Lyons, *Photographers on Photography,* pp. 159–63, and in Trachtenberg, *Classic Essays,* p. 171.

that rifle shooting and sailing are less mechanical and more personal than photography.[36] Questions of degree and location require separate examination. The mechanical element for Emerson consists in a set of invariant, functional, physical relationships of mechanisms and photochemistry which stretch between the release of the camera shutter and the formation of the photo-image: "In photography man puts the machine under certain physical conditions, and the machine will always (in the same conditions) bring about the same result, therefore the process is logically mechanical. On the other hand, a personal art is one in which the results would differ again and again under the same physical conditions, for the *mind* would work differently on each so-called 'replica' of the original."[37] Some of the main technological advantages of photography therefore suppress its artistic capacities.

Since Emerson's view is fairly precise, it deserves a more than usually precise analogical reply. To say, for example, that painters work with brushes and drafters with pencils, which are both mechanisms that have functional characteristics for surface marking, is not sufficiently precise, as the analogy does not indicate the extent, degree, or relevance of the obtainable physical correlations. Emerson is in position to say that given an unchanged scene, photographic mechanisms, and background conditions, identical photo images will result from any number of photo exposures; he can also say that such conditions are repeatable for photography. But, he holds, we are never in position to say something relevantly analogous with regard to painting, drawing, and similar processes.

Among the array of tactical responses to this argument, several are instructive about contemporary attitudes to photography and to photo art. To defend photography in terms of the other arts, the first option in our diagram, one might attack the functional argument head on. Another reply— and this was Weston's tactic—addresses what might be called the *location* of the mechanical relationship. Weston's musical analogy, however, appears flawed. Musical performances are made of involved sequences of performer operations upon instruments with strong feedback characteristics—indeed, of sequences of interacting elements, since the vibration of even a struck piano wire will be affected by vibrations of later key strikes—whereas the photographer's act that Weston defends is, by his own argument, "instanta-

[36] Emerson, "Naturalistic Photography and Art," in *Naturalistic Photography,* II:187.
[37] Emerson, *Naturalistic Photography,* I:187.

neous." Even if we add later processing stages to it, these do not come near the complexity and performer-instrument interactions of the simplest, most mechanical musical performance. In fact, Weston's own photo aesthetic makes his musical analogy doubtful. This is the view that the location of the artist's act is in the "visualization" of the photograph, and that the rest of the process from the release of the shutter onward *is* essentially mechanical and, as Emerson insisted, not very artistic.[38] Had Weston actually maintained this view, his analogy to musical performance would have evaporated. As earlier indicated, however, our list of alternative positions is intended to be somewhat artificial. It would be unrealistic to expect them to express fully the approaches of those who expound them.[39]

Weston's perceptual, mental location of artistic photographic acts thus turns out to be (generally) one that Emerson allowed ("you selected the view")[40] but held insufficient to make photography a major fine art. Worse for Weston's case, Emerson himself may be considered the first previsualizing, straight photographer, as his unretracted teachings stressed the seeing of natural scenes tonally, in terms of nature and in terms of the finished picture itself, and he opposed photo manipulation at least as much as Weston did.[41] It would be left to defenders of Weston's position to argue that where the right picture ensues, the previsualizing action *is* sufficient for art.[42] No won-

[38] "Since the recording process is instantaneous, and the nature of the image such that it cannot survive corrective handwork, it is obvious that *the finished print must be created in full before the film is exposed*" (Weston, "Seeing Photographically," p. 161). Ansel Adams, also a teacher of visualization, partly through his "Zone System," explained it in 1935 as follows: "The camera makes an image-record of the object before us. It records the subject in terms of the optical properties of the lens, and the chemical and physical properties of the negative and print. The control of that record lies in the selection by the photographer and in his understanding of the photographic processes at his command. The photographer visualizes his conception of the subject as *presented in the final print*. He achieves the expression of his visualization through his technique—aesthetic, intellectual, and mechanical": *Ansel Adams: An Autobiography* (Boston: Little, Brown, 1985), p. 78.

[39] Adams, e.g., insisted upon the specific qualities of Weston's own printmaking; see his *Autobiography*, pp. 253–54.

[40] Emerson, *"Up to taking off the cap, then, nothing is required but artistic knowledge. . . .* All done so far has nothing to do with photography, but with art" ("Photography Not Art," pp. 55–56); "It is not the apparatus that chooses the picture, but the *man* who wields it" (*Naturalistic Photography*, 3:39).

[41] See Emerson, *Naturalistic Photography*, 2: chap 8; and Nancy Newhall's comments in *P. H. Emerson*, pp. 62–63.

[42] Later, more conceptual, photo artists might fault Weston's approach for being, like Emerson's, too perceptual, too aesthetic.

der that Nancy Newhall—who saw Emerson as previsualization's first defender—was moved to term it "the severest challenge in all the arts."[43]

A third general option is an alternative route to those of Emerson and Weston: one that minimizes likenesses between photography and forms of visual art. A noted artist of the 1930s was pleased to take this route, although with an idea of previsualization remote from Weston's. This was Brassaï (Gyula Hálàsz), one among those startled recipients of a medal in the mail from Emerson. Brassaï made little of "photographic seeing" as such. He already had "a proliferation of images to bring to light" from what he saw as he walked about the city, he reported, but had "no method of seizing them other than photography," to which he had "had an aversion" before he took it up, along with his drawing.[44] Before considering Brassaï as an exemplar of the third alternative attitude in our chart, we might note that this remark suggests a still wider construal of the first alternative there. In his engaging comment Brassaï may sound much like the naive photographer who sees an interesting "picture" in the environment and avails him- or herself of a technology for "capturing" it on a surface, bypassing awkward and difficult traditional "hand" methods (Brassaï it should be noted, did not use a miniature camera at that time).[45] To provide such a technology was, indeed, a motive of Edwin Land, the inventor of Polaroid, who thought that many people have artistic perceptions but lack the means for realizing them.[46] For Brassaï, however, who was also a draftsman, the more likely interpretation is the Romantic one that a person of strong artistic temperament can command a variety of media as instruments of expression.

This was, in fact, the view of one admirer of Alfred Stieglitz's photography: according to Paul Rosenfeld, Stieglitz's production of art by means of film and cameras can be understood as the triumph of creative spirit over a machine's "resistant dead eye," after a time when machines had dominated the lives of many.[47] Thus might our four simple charted alternatives begin to become rather less simple. Actually, one of Brassaï's own stated views of

[43] Newhall, *P. H. Emerson,* p. 4.

[44] Nancy Newhall, "Brassaï: 'I Invent Nothing. I Imagine Everything'" (1952), rpt. in Newhall, *Photography: Essays & Images,* pp. 276–81.

[45] According to Colin L. Westerbeck Jr., "Night Light: Brassaï and Weegee," *Artforum* 15 (December 1976): 34–45, in the 1930s Brassaï used a 6 × 9 cm plate camera with tripod, and sometimes magnesium-powder flash (p. 37).

[46] This is the testimony of Ansel Adams, *Autobiography,* pp. 297–98, 306.

[47] Paul Rosenfeld, "Stieglitz"; rpt. in Newhall, *Photography: Essays & Images,* pp. 209–18.

photography is rather like the other option of Weston, our *third* alternative: "I had myself echoed Emerson's view that photography was not an art form, but I had done so without the slightest regret. . . . It is something better than art! It rules out subjectivity, the artist's arbitrariness; through photography it is at last possible to attain divine, total objectivity."[48] This theme from Weston, Moholy-Nagy, Brassaï, and others, of a *tension* between what were awkwardly called the "personal" (Emerson) and "objectivity" (Brassaï) was carried from photography into cinema studies by Siegfried Kracauer, whom we have encountered twice before.

Analyses

"Aesthetic" and "Formative"

We have now considered some real and interesting examples of the first, third, and fourth of our general approaches: that photography is continuous with pictorial arts; that it is different from and beyond them; that it is different from and below them. It remains to find a good example for the *second* alternative: the view that photography, though not sufficiently similar to the fine arts, has nevertheless *extended* the idea of fine art to include itself. Kracauer's position well exemplifies this view, and like Emerson's, it is a thought-out, argued position. Agree with it or not, we are likely to learn by considering it.

Quick access to Kracauer's arguments may be achieved through a useful pair of terms he provides: "aesthetic" and "formative." These stand for considerations with which we should by now be well acquainted. Earlier we considered two bases for objections to photographs as works of art. Elizabeth Eastlake's concerns about the unity or "broad handling" in collodion pictures (Chapter II) were of the first sort, as were some of the worries about photo detail (Chapter VII); Baudelaire's objections concerning "imagination" seemed to be of another order. We have just seen that Emerson's criticism explicitly separated the "aesthetic" issue of how a picture should look from the "formative" one about how it is made. We saw that within his rather limited view of pictorial aesthetics, Emerson was willing to concede that photography is sometimes *aesthetically* superior to painting and graphic art

[48] Brassaï, "My Memories of E. Atget, P. H. Emerson, and Alfred Stieglitz," *Camera*, January 1969; rpt. in Newhall, *P. H. Emerson*, p. 134.

productions, while still failing, because of its formative nature, to be a major fine art.[49]

According to Kracauer, the relationship between the aesthetic and formative aspects of photography would have to be more complex than Emerson had allowed: not only are these different aspects; they are opposed. This is not to say that Kracauer sees the aesthetic and the formative as generally defining opposed poles in the arts. Rather, it is his view that they do in the case of photography (a characteristic inherited, he believes, by cinema) because of the peculiar aesthetic of that medium. That photography produces such a tension is its defining characteristic. The unique aesthetic of photography—that is, the way photographs are best looked at and appreciated, *as* photographs—lies in its *kind* of "realism." This particular kind of realism tends to minimize, though never entirely to eradicate, the formative aspect. The realist photography Kracauer intends is that which for him, as for Weston, is in accord with what he takes to be the medium's "specific nature," and that nature (see Chapter I) lies in what we have called its detective powers: in Kracauer's terms, its "unique ability to record as well as reveal visible, or potentially visible, physical reality." Kracauer's view is thus similar to Newhall's "documentary" approach to what he called "the possibilities and limitations" of photography as a distinct medium. For Kracauer, however, the play of this "inherent realist tendency" of the medium tends to conflict with the normal artistic activity that he calls "formative": that is, the free activity of "shaping the given material" in composing pictures into an "expressive" order. Normally, a strong formative constituent is required for a fine art. Some have tried to realize this for photography, with what are for Kracauer interesting but always marginal results, for the strength of the photo medium lies in an opposed direction. For photographs at their aesthetically most effective Kracauer recommended what he termed a "looser" or "extended usage" of the term "art," to include photographs that "are neither works of art in the traditional sense nor aesthetically indifferent products."[50]

Since Kracauer's case depends upon the controversial term "realism," it is important to stress that his account of it is far from naive. As we earlier saw, his view that photography's "direct recording" of physical reality would not

[49] Its "results are sometimes more beautiful than art, but are never art, just as Nature is often more beautiful than art" (Emerson, "Naturalistic Photography and Art," p. 174).
[50] Kracauer, "Photography," in Petruck, *The Camera Viewed*, 2:187, 162, 165, 171.

entail an uninterpreted recording of it (if that is what Brassaï meant by "divine, total objectivity") and should not, for contrary to what he terms the "naive realism" of the nineteenth century had once assumed, there is no such thing *as* the "uninterpreted." "Photographs," Kracauer insists, "do not just copy nature but metamorphose it." Furthermore, the contexts in which we see photographs of all kinds are radically different from those in which we look at real environments, different in ways that affect how we structure our visual experiences (177). Indeed, Kracauer observes, modern photography has itself done much to promote the relativist view that "reality is as we see it" (168–69). Just because quite different records or revelations of the same situations are possible, photographers are able to follow "the grain" of the medium and form pictures expressively (178). Still, there remains a tension: "Photography, then, is an arena of two tendencies which may well conflict with each other" (173). The conflict would seem to come about in two ways. There is first the photographer's wide but relatively limited scope for producing forms and compositions. Next, there is the often cited tendency of photography to draw perceptual attention toward detecting the situation photographed and away from appreciating the way in which the image was formed by the photographer. This, according to Kracauer, is the basis of photography's aesthetic and the "photo affinities" considered in Chapter VII. He favored allowing a balance point shifted more toward the (shorter) formative end than obtains for other art forms, and carried this forward to his aesthetics of cinema.

Photography and Fine Art

Kracauer's thesis does more than round out an informal survey of positions regarding photography and the arts by exemplifying what I have called the *second* position. It also reflects back on all the general positions considered, set out in our grid according to their emphasis on or denial of sufficient likeness between certain kinds of photography and the fine arts—notably depictive arts. Kracauer's paired terms "aesthetic" and "formative" bring out two different *respects* in which photography might seem to be sufficiently like or unlike such fine arts as drawing and painting. Aesthetic comparisons of photography and visual arts continue to be very important here (in an interesting recent example, the painter David Hockney

has criticized the fixed scale and perspective of photographs).[51] What Kracauer calls formative issues, however, usually predominate in judgments about significant likeness. These issues relate directly to the technological procedures of photography and the fine arts; more specifically, they relate to the procedures for marking surfaces so that they may be used as display images for visualization. We might begin here to consider what a technological approach to photography, such as has been sketched in these chapters, can tell us about formative comparisons. Two matters however, need to be looked into first. Both concern the scope and relationship of aesthetic and formative considerations, and these are not minor matters; one of them is the basic idea of fine arts.

The relationships between the formative and aesthetic aspects look to be more intricate in Kracauer's account of photography than they were in Emerson's. The reason is simple. For Kracauer, the perceptual or aesthetic aspect of photography already involves at least an impression of how its images are formed: the production of the image by the state of affairs photographed and by light. In a more general sense than that in which Kracauer uses the word— he reserves it for "expression" and "personal vision"—this is an aspect of the formative that is *embedded* in the aesthetic, something about how the image was made that is part of the look of the result. Kracauer sometimes calls this the impression of "unstaged reality." The director Michael Roemer, who shows Kracauer's influence, refers to it as "the appearance of an autonomous reality on the screen." (This central part of Roemer's film aesthetic he argues both subtly and bluntly: "When someone dies on the screen and remains in full view, many of us cannot resist watching for the slightest sign of life in the supposed corpse.")[52]

We therefore have two factors on the side of the production of the image: those expressive of the photographer, and also other relevant causal conditions, which, together, we can call formative in a very general sense of Kracauer's term. Do we match this pair against a single factor on the other side—the side of the audience—against the aesthetic appearance of the image? Well, our earlier discussions have emphasized the uses of photographs

[51] David Hockney, *Hockney on Photography: Conversations with Paul Joyce* (London: Jonathan Cape, 1988).

[52] Michael Roemer, "The Surfaces of Reality," *Film Quarterly* 18 (Fall 1964): 20. Some of us also confess wicked enjoyment in noticing that camera rewind cranks are not turning while photographers are depicted feverishly shooting, as in *The Unbearable Lightness of Being*.

for other viewer activities, notably imagining (under an account of representation and depiction) and detecting. Detecting, though a perceptual activity, may not always fall under the rubric of "aesthetic" as that term is normally understood. Now that we have fairly good grip on the idea of "aesthetic," however, perhaps we can stretch the term to include these without detracting from its narrower sense. The result would be a symmetrical array: two groupings of two terms each, corresponding to the production of images, and to their use by viewers. An advantage of this fuller scheme is that it pretty well approximates the idea of fine art to which certain kinds of photography are here being compared. Now that we have once again, as Aristotle said, consulted "reputable opinion," we may be directed by it but should not be bound to it as we work toward a principled understanding of the data. Since the question is whether, in its aesthetic and formative dimensions, photography is sufficiently like other fine arts to be called one, it is time to look more closely into the idea of fine art as it was when photography entered the scene and as it has since developed.

Like photography, the modern idea of the fine arts—the idea, not the arts themselves—has a history that can be studied. In common with photography, that idea not only had a time of first invention but has enjoyed continuous reinvention ever since, which may be a sign that such a conception is itself a technology. It is, after all, a tool of thought with which we attempt to do certain kinds of work and is accordingly subject to certain suppressions and frustrations. In a famous pair of articles, Paul Kristeller showed that the modern list of the fine arts in the West has (like photography and most technologies) a protohistory, a time of consolidation (less than fifty years before photography's), followed by a period of dispersion along identifiable channels.[53] As with photography, the global spread of what appears to many as an inevitable occurrence actually depended upon the existence of other technologies—notably that of the printing press—along with various economic and cultural circumstances.

In Chapter IV we saw that the idea of fine arts was built on that of representation or mimesis, correctly understood as an appeal to imagining. Chapter VIII provided further, very general historical perspective. It is high time to add that this conception was obviously made from—and retains—other constituents as well, numbering at least three. There is the ancient general

[53] Kristeller, "The Modern System of the Arts," in *Renaissance Thought*.

idea of (1) *art* itself as any skilled and teachable body of productive knowledge.

The next constituent needs a bit more introduction. At least since the time of ancient philosophy, where the point was philosophically crucial,[54] few theorists of art (in the basic sense of principled knowledge of how to do things) would have considered a grasp of such principles adequate to good production. It was always clear to theorists, as it is to common sense, that principles are far from sufficient for intelligent action in particular cases in any field, since it requires intelligence to know which principles to apply in particular circumstances or quite how to apply a principle to a concrete instance.[55] To what extent a given activity is an "art" or a "science" is a commonplace of discussion. It is therefore not surprising that by the seventeenth century in Europe, when the idea of fine art was being shaped up, what was termed (2) individual *genius* was already a stated constituent of the general idea of art—just as it had been for centuries with the corresponding conceptions in China, Africa, and elsewhere. There was still the matter of the proportion of these first two constituents; we find the Abbé Batteux and d'Alembert stressing the degree of genius required for the practice of the fine arts.[56]

To "art" understood in this qualified way was conjoined the idea of beauty, which only later came to be called (3) the *aesthetic*. The fine arts were thus first put forward as the beautiful arts (*les beaux arts; die schönen Künste*)—or, as Hume put it, "the finer arts," meaning the arts of producing things (of practical use or not) that were to be understood in terms of their being fine or beautiful.[57] Again in Batteux and d'Alembert, production of the fine or beautiful was linked to the aforementioned (4) *mimesis* constituent by the rather ambiguous notion of "the mimesis of beautiful nature (*belle Nature*)." The idea that there could be bodies of knowledge resulting in such products

[54] Notable examples: Plato's *Euthydemus, Gorgias,* and *Republic* 331b–d, 362bc, 589c; Aristotle's *Nicomachean Ethics* 6.4. As, e.g., Terence Irwin has well argued, a main preoccupation of the early part of Plato's work is the right use of craft principles; see Irwin, *Plato's Moral Theory: The Early and Middle Dialogues* (Oxford: Oxford University Press, 1977), esp. chap. 3.

[55] See Plato's famous treatment of rules of action in *Republic* 1:331–32.

[56] Abbé Batteux, *Les beaux arts réduits à un même principe* (Paris, 1746); Jean le Rond d'Alembert, "Discours Préliminaire des Editeurs" (for Diderot's *Encyclopédie*, 1751).

[57] As a term, "fine art" therefore had the logic of "lawn mower," not that of "power mower"; the adjective *fine* (or *beautiful*) is the objective complement of an implied verb; see Charles Karelis, "An Interpretative Essay," in *Hegel's Introduction to Aesthetics* (Oxford: Oxford University Press, 1979), p. xlix.

is certainly a remarkable one, and has always been open to obvious objections.

If the idea of fine art may therefore be understood as a union of these four factors—art, genius, aesthetic, mimesis—we need to consider what sort of union. Perhaps it should be understood like a federation of Athens, Persia, Sparta, and Thebes, for it never seems to enjoy a time of quiet. Not only is this federation itself always under attack from rivals or what claim to be its colonies, but each is in flux and experiences internecine dynamics of its own. Rivalry among them is endemic. There are always pushes for overall hegemony of individual factors, or leagues of factors with shifting loyalties. Photography has played roles in all these disruptions. The miracle is that the idea still functions, though the same might be said of each of us, genetic federations of discordant parts that we are. Less miraculous is the existence of the four components, as artistry, talent, mimesis, and fineness of work are hardly the inventions of a few eighteenth-century men "in periwigs and silk stockings."[58]

Although for our purposes we are considering the idea of photography and fine art only in terms of these four components, treating that idea as a tool, a fuller account would require studying the history of its use of those ancient components in the wider context of *culture*. Much about this use over the last two centuries may be indicated by a single word: "secular." Alas, its use has also featured from the outset a false but seemingly indelible distinction between the production of "necessities" and of "luxuries," with artworks located among the latter.[59] The place of the practice of photographic arts with-

[58] Perhaps from R. Williams, *Culture and Society* (chap. 2 is influential throughout the present section).

[59] Kristeller, "The Modern System of the Arts," p. 199, attributes "the decisive step" to the system of fine arts as taken in Batteux, *Les beaux arts*. Batteux categorized the main kinds of arts relative to the objects they serve: "We can distinguish three sorts of arts with regard to the purpose proposed. For some, their purpose is the basic needs of mankind. . . . The object of the others is pleasure. They were born only . . . of the feelings that plenty and tranquillity produce: these are called the fine arts par excellence. Such are music, poetry, painting, drama, and the art of gesture or dance" (p. 27); architecture and eloquence he counted as close hybrids. We have already considered the false, abiding idea of "necessity" in the conception of technology. It is interesting to see in Batteux, as well as in d'Alembert's famous "Preliminary Discourse" to the *Encyclopédie* (which, as Kristeller says, did so much to promote the new idea of the *beaux arts*) how the distinction between useful arts and arts of pleasure is substituted for the traditional one between mechanical and liberal arts. D'Alembert attempts to combine these distinctions by placing the *beaux arts* among the liberal but distinguishing them by their alleged pleasurable function, their being even less "necessary," and their requiring genius. The useful/pleasurable arts distinction is an old one; see Aristotle, *Metaphysics* 1.1.981b18, for notable example.

in specific cultures and the efforts to locate them there have been topics of increasingly pointed critical concern since the 1970s.[60] Pursuing them would likely involve, for example, a fuller account of Emerson's or Stieglitz's wider promotional practices, an account of popular photography, and so on. For one photo historian has claimed that "the Pictorialists devoted an amazing amount of work to promotional matters—ultimately, that is, to the manufacture of their own fame."[61]

Now that we have a general picture of our idea of fine art, let us match it again to our broadened aesthetic/formative distinction. The terms "aesthetic" and "formative," we said, represent a simple grouping of the four factors. "Aesthetic," as stressing the perceptual experience of the audience, includes the beautiful or aesthetic artifact component, together with mimesis: art as a tool for imagining, as set forth in Chapter IV. The similarly broadened term "formative" addresses the two components on the side of production: "art" as principled knowledge, combined with the individual intelligence or "genius" necessary to production. Skilled production could be defined only in terms of the materials or media used for production, although contentious issues—those, say, between Weston and Brassaï—concern the degree of dependence. The idea of the fine arts came into popular use as a tool of conception during a period in the nineteenth century when industrial productive technologies were changing the formative processes of many productive activities—among them the production of representations, including pictures. This was likely a main historical cause of the rising prominence of the formative components of the idea of fine arts, at the expense of the aesthetic ones. It would also account for increased sensitivities within the formative realm about what Talbot said might be "injurious to art, as substituting mere mechanical labour in lieu of talent and experience." Deskilling through reengineering was an issue then, as it is now.

It may seem a paradox that rapidly widening audiences for works of fine art during the late eighteenth, nineteenth, and twentieth centuries would favor the side of the formative rather than the audience-based aesthetic or per-

[60] See, e.g., papers in Bolton, *The Contest of Meaning;* and Sekula, "On the Invention of Photographic Meaning." An "anatomy" of fine art and of photo art as offered here is not a rival to but rather a basis for accounts of their *uses.* We should expect these accounts to interact, just as did the general treatments of depiction in Chapters IV and VIII.

[61] Ulrich F. Keller, "The Myth of Art Photography: A Sociological Analysis," *History of Photography* 8 (October–December 1984): 273.

ceptual ones. The air of paradox may seem to increase if we accept the view that, historically, the idea of the fine arts was itself an amateur, audience-based one, rather than one that practitioners of the arts would ever have dreamed up themselves.[62] The paradox is easily solved. It is dispelled when we see that audiences need not prefer a conception of art defined with reference to themselves. "The fine arts," though an audience-centered idea (it might seem plausible only to someone who is neither that what a pianist and novelist do are somehow the same thing), has the producer, not the audience, as its content. There are closely parallel cases: for example, people will always delight in perceiving *skill* in production as well as in action. Furthermore, as has been many times pointed out, the rise of popular ideals of personal liberty, political and other, favored the image of art as a singular sphere for free and fulfilling action. As a result, an idea of artworks as primarily manifestations or expressions of individual (ethnic or national) "genius" tended to override the standard conception of them as manifestations, via individuals, of skill and artistry.[63] As our earlier medical examples should remind us, it is common to admire skilled professions such as medicine generally, not only their practitioners. If the first part of the modern era was characterized by a battle of the individual against craft rules, in the second this shifted to a conflict with mechanical means of production, which steadily threatened to overshadow both: hence Kracauer's idea that in the fine arts (nowadays) the aesthetic/formative combination normally favors the formative. To add that despite its hegemony this latter-day "manifestation" notion is now under attack by a resurgence of audience-based theory is to say relatively little. Each component of fine art, we have said, is always under attack, even when not dominant. (As for the audiences themselves, one must distinguish their conceptions of art from their marked preferences.)

[62] Kristeller's most interesting conclusion in "The Modern System of the Arts," p. 225, is that the *cause* of the system of fine arts in the eighteenth century is largely "the rise of an amateur public to which art collections and exhibitions, concerts as well as opera and theater performances were addressed. . . . The fact that the affinity between the various fine arts is more plausible to the amateur, who feels a comparable kind of enjoyment, than to the artist . . . concerned with the peculiar aims and techniques of his art, is obvious in itself." This idea was further explored by Meyer Abrams in "Art-as-Such: The Sociology of Modern Aesthetics," *Bulletin of the American Academy of Arts and Sciences* 38 (1985): 8–33; rpt. in Abrams, *Doing Things with Texts: Essays in Criticism and Critical Theory* (New York: Norton, 1989), pp. 135–58, where Abrams distinguishes the "maker stance" from the "spectator stance."

[63] See R. Williams, *Culture and Society,* p. 47: "Under pressure, art became a symbolic abstraction for a whole range of human experience."

We should now be in better position to characterize common misgivings about photography's relationship to the fine arts, a puzzlement that does not even rise for photograph*ic* fine arts such as cinema. If we are permitted to broaden the term "formative," beyond Kracauer's restriction to the self-expression of artists, to comprehend all the causal agencies physically shaping the work, our description of the photo predicament will differ from his. Our review has concerned issues of photography's shift of emphasis away from the artist, not directly to the audience and its aesthetic factors but to other formative agencies.[64] Over their first fifty years or so, photographic technologies were understood as dependent on the sun (as Holmes's "Doing of the Sunbeam" and our second Cruikshank drawing in Figure 9 illustrate); the sun, like light, the camera mechanism, or (as we saw) the photo subject, was routinely put in the artist's place.[65]

Seeing Skills

As we have reviewed them, standard art questions regarding photography have scarcely concerned whether it has a discernible formative component, in the general sense; of course it has, as our normal conception of photos as "taken" clearly shows. The issue is whether that component is, as Emerson said, sufficiently "personal"—that is, whether it sufficiently expresses or manifests intentional states of people, rather than other formative factors, so that we might associate it with the arts. We have reviewed a sample of claims that it does and that it does not, and whether this matters or not. What we have not yet considered is the more basic question of why the idea of the arts should have contained such an essential constituent in the first place. Our sources do not tell us *why* this matters to anyone, not even *how* it matters. They only tell us *that* it does—or that it should not. Thus we find Brassaï agreeing with Emerson about the facts of the case ("It required tremendous courage for Emerson to make this dramatic public confession," Brassaï wrote),[66] and simply recommending a different attitude toward them. Kra-

[64] Correspondingly, Kracauer explained the formative factor itself not just in terms of "creativity" but also in terms of an aesthetic product: making "beautiful" forms ("Photography," in Petruck, *Camera Viewed*, p. 165).

[65] See Patrick Maynard, "Drawing and Shooting," *Journal of Aesthetics and Art Criticism* 44 (Winter 1985): 115–29, esp. sec. 2–3.

[66] Brassaï, "My Memories," p. 133.

cauer and perhaps Newhall are a bit more conciliatory; Weston disagrees, then agrees, about the facts themselves.

One main reason why the human formative issue matters should be easy to see. In seeing it, however, we must reject one assumption common to most of our sources. This is the assumption made, for example, by Emerson when he attempted to keep his aesthetic of photography while giving up what he termed his "art philosophy," and retained by Kracauer's subtler and more complex account. It is the view that the formative and aesthetic elements are not only different but independent, art being produced where the two categories overlap. Such a purely extensional thesis is hardly likely to stand up to examination. A priori, it would have little chance of being true, for the simple reason that the audience perspective—called here, generally, the aesthetic factor—is *perceptual.* That allows the immediate implication of formative factors in the aesthetic, because we can see them. This penetration of the perceptual by the formative, of the audience side by the artist's, is therefore of an intentional nature: the perceptual activity is itself relevantly identifiable in terms of its object, which is here a formative element.[67]

By not observing this simple, general fact about perception, we create confusion for ourselves about art. This is by no means a new confusion, or a restricted one. Productive technologies such as photography have simply made old and widespread confusions rather more apparent. Thus the sociologist Pierre Bourdieu sought to express popular misgivings about photographic art:

> The photographic act in every way contradicts the popular representation of artistic creation as effort and toil. Can an art without an artist still be an art? . . . The still life, even if it is unusual, is more readily granted to the painter, because the simple and successful imitation of reality presupposes a difficult art, and thus testifies to mastery. This gives rise to certain of the contradictions in the attitude towards mechanical reproduction which, by abolishing effort, risks depriving the work of the value which one seeks to confer on it

[67] Rejection of sharp process/product dichotomies is a hallmark of the aesthetics of John Dewey; see his *Art as Experience* (New York: Milton, Balch, 1934). Kendall Walton is a recent philosopher who has forcefully refuted what he calls "the cobbler model" of art (which takes this dichotomy for granted). He argues that it is normal, not remarkable, when an understanding of a work in terms of the artist's activities—real or only imagined—is internal to our perception of it; see Walton, "Style and the Products and Processes of Art," in *The Concept of Style,* rev. ed., ed. Berel Lang (Ithaca: Cornell University Press, 1987), pp. 72–103.

because it satisfies the criteria of the complete work of art. . . . The ambigu-
ous situation of photography within the system of the fine arts could lead,
among other things, to this contradiction between the value of the work,
which realizes the aesthetic ideal that is still most widespread, and the value
of the act that produces it.[68]

Where the two kinds of value, aesthetic and formative, are considered to be
separate, they easily fall apart. In consequence, not only are legitimate doubts
about photography made to look like reactionary responses to technological
advance, but our normal understanding of pictures of all kinds is distorted.
Since this is the prevailing attitude, let us work at it in stages, beginning with
a close analogy to aesthetic perception of pictures.

A simple, very relevant, illustration is provided by the common phenom-
enon of admiration of *skill:* skill in all sorts of activities, including those
represented by our first factor, art. Where we can detect the workings of for-
mative factors in products—and usually we can, to some extent—it is not
unusual that we enjoy the perception of skill there. Admittedly, enjoyment
in perceiving something as well made has been made more difficult by mod-
ern industrial-technological societies. For besides featuring enormous vari-
eties of highly technical and mechanized productive processes (often for mass
production of virtually identical and dispensable items), most of which
processes are out of sight and, in any case, too complex for nonspecialists to
understand, these societies are notorious for separating means and ends. Yet
even though this makes many modern peoples strikingly different from all
other peoples in world history, they still enjoy perceiving the workings of
skill and enjoy things as results of skillful action. People continue to admire
skill in the making of representations and, notably, visual depictions, as well
as enjoying the imagining projects these representations incite and sustain
for them.

This brings up a reciprocal point: the complementary implication of the
aesthetic in the formative, represented here by skill in production. Given that
we enjoy the perception of a skill realized, there are, naturally, activities to
serve *that* enjoyment: that is, shows or displays of skill. For example, where
an image is made for "display," as discussed in Chapter II, it may also be

[68] Bourdieu et al., *Photography: A Middle-Brow Art,* pp. 77–78. See also in that volume Robert
Castel and Dominique Schnapper, "Aesthetic Ambitions and Social Aspirations: The Camera Club
as a Secondary Group," pp. 103–28.

shaped to show the skill in making it.[69] Our own experiences, as much as the reports of cultural historians, tell us what different skills different times or cultures or subcultures, may admire and also how shifts, or even reversals, can occur in the fields of admiration. Now seeing, noticing, observing, judging, and appreciating these skills are themselves activities, and they too can be skilled activities. Differences or revolutions in skills on the one side can therefore affect those on the other, back and forth. (Chapter IV prepared us for this in explaining "participation.") We therefore have an iterative principle, since this perception features skills that we sometimes like to *exhibit*— to show off—to ourselves and perhaps to others. The principle holds for all fields of activity. (A ditty occurred to me, working beside a builder: "Not only does this fellow know, he likes to let his knowing show.") Aesthetic ends, then, are often implicit in formative actions. We have therein a collusively intentional situation, typical of human interactions.

Perception of skill provides just one familiar and important way in which formative factors may penetrate aesthetic ones, and vice versa. That point, though trite, is worth emphasizing, because, remarkably, theoretical accounts of aesthetic interest have explicitly denied it. Since such accounts have been applied to photography, it is worth taking a moment to say what these views are, and why they are wrong. The theoretical idea of the aesthetic once seemed to dictate that aesthetic enjoyment is taken only in things *immediately* presented to the senses. This seemed to exclude interest in all aspects of the situation (such as production) that lay outside present sense experience. A strange view was then taken of what was "immediate," or lying within such experience: one's hair or lawn would "directly" appear short, but not recently clipped; potatoes would be of homogeneous aspect, not mashed; sheets of paper might appear to be not flat, but never crumpled. Fortunately, all languages, as well as perceptual experience, present things very differently: in terms of the processes that have brought them to their present "immediate" conditions. It is hardly possible to see many things otherwise; the task of perceiving or describing things in any other way constitutes abstraction from the concrete sense perception that the very idea of the "aesthetic" was intended to celebrate. To appreciate more fully the mischief of this fallacy for pictorial arts, including photographic ones, we need to notice how, histori-

[69] For the view that aesthetic value may itself be grounded in such admiration, see Kendall Walton, "How Marvellous! Toward a Theory of Aesthetic Value," *Journal of Aesthetics and Art Criticism* 51 (Summer 1993): 499–510.

cally, it was turned against depiction—and, with photography, against detection—as aesthetic, and therefore as artistic. Explaining how this occurred requires a brief digression before we return to the skills of seeing skill.

It was once widely believed (at least in theory) that when a marked surface is taken as depicting something, our interest is carried away from that surface to something *else*— even to something purely fictional (nonexistent)—and is in that respect not immediate, therefore not "aesthetic." This view was even taken by some to exclude manifestation, such as self-expression.[70] The muddle was compounded with a second fallacy that we encountered earlier: the "reference" construal of representation. In that view, taking something as a representation consists in following it as a pointer to something else, usually described as "outside" the original something. We can dispel the main error in all this by observing not only that perceiving something depictively is itself a perceptual experience, which we may or may not care to indulge in, but that even taking one thing as pointing to another can be a perceptual experience. It is easy to imagine someone's taking keen aesthetic interest in pointing signs, including arrows, of many sorts.[71] This need not—likely would not—reduce to an interest in their abstract designs; one could take an interest, as we often do with functional objects, in the ways in which they do their pointing jobs. Many of our aesthetically keenest perceptual experiences of things, natural and artificial, derive from functioning objects.

The unlikely theoretical position we have been considering would not have had enduring appeal had it not appeared to deal with incontrovertible data, central to any topic of representation. It is, for example, a common complaint about photographs of things that they tend to be understood in terms of the things of which they are photographs. We have seen the ambiguity, the error, of remarks by Sontag, if unqualified: "In photography the subject matter always pushes through. . . . Hence the formal qualities of style—the central issue in painting—are, at most, of secondary importance, . . . while what the photograph is *of* is always of primary importance."[72] Remembering our distinction between "photo depiction of" and "photo of,"

[70] This fallacy is most clearly and succinctly expressed in Richard Rudner, "Some Problems of Nonsemiotic Aesthetic Theories," *Journal of Aesthetics and Art Criticism* 15 (March 1957): 298–310.

[71] Beautiful examples regarding graphic display may be found in the writings of Edward R. Tufte: e.g., *Envisioning Information*.

[72] Sontag, *On Photography*, pp. 93, 135.

we recall how frequently we neither know nor care what a photograph is of. It is also clear that we frequently do care. Even so, the fallacy is patent. It does not follow from the fact that photo representation allows people to attend to subject matter at the expense of attention to the image itself that it *must* do so. The most important fact about Emerson, Nancy Newhall claims, is that "he was probably the first true photographer-poet—the first to whom the beauty of the image on the ground glass, the moods and emotions it aroused, were more important than the subject, however important in itself"; before him, "for nearly all the subject came first; it had to."[73] Sometimes we are more interested in subject matter, sometimes more in the image, sometimes equally in both—often in their close relationship. In looking at the photograph we are interested in how the image presents the subject *and* in how the subject was used to make the image.

This brings us back to the topic of skill in photography and art, via the aesthetic and formative factors. One kind of interest in images in relationship to subject matter is mediated by interest in the skill, or lack of skill, with which the image has been formed, the subject depicted in a certain way. Photography, by radically affecting formative image-making producers, removed some exercises of skill, transformed or displaced others, left still others unaffected. Two things would seem to follow. First, appreciating skill in photography would entail identifying the relevant areas of skilled, intentional activity involved. Second, doing that would entail identifying *actions:* knowing what kinds of actions are performed, what kinds of things are done, in making various kinds of photographs. We cannot perceive something as skillfully or clumsily done unless we can identify the formative action as an intentional action: that is, know what was done in relation to what happened. The difficulty in identifying formative actions *as* actions in various kinds of photography is a main cause of misgivings regarding photography: hence attempts such as Weston's to describe those actions for certain kinds of photography. Experience is the best treatment for the misgivings; theory can only help to identify the actions.

The skill-enjoyment argument here was based on straightforward general observations about anything that can be done well or ill. These observations were adapted to photographic picturemaking. As for the conclusion of the argument, although it includes matters relevant to our topic, its even more

[73] Newhall, *P. H. Emerson,* pp. 4–5 (all in italics).

general purpose was to provide a simple and familiar illustration of an important "formative" element being inseparable from an important "aesthetic" one. The basic reason was, simply, that we not only can but very commonly do see things "historically"—that is, in terms of how they were produced and affected, in terms of what might be called their "process-histories."[74] For that, we might have argued from a bent and rusty can, from the contact markings on the head of a drum or on a door frame, even from a page of print. To understand the problem of photography's success or failure to implicate sufficiently the formative or "personal" in the aesthetic, we need to argue now from more specific premises.

Rejections Out of "Hand"

Historically, the main source of misgiving about photo art concerns the formative question of whether there is enough of the photographer in the depiction to call a beautiful, powerful, or otherwise interesting photograph a work of art. That raises the more general question of how it is possible for this to obtain with *any* kind of picture, such as a drawing or a painting. If we had a ready answer to that question, the logical thing to do would be to see how far it applies to various kinds of photographs. But here our inquiry into photography confronts a serious problem: this theoretical job seems never to have been done for *any* kind of picture. Indeed, we can feel the lack of conceptual resources whenever we consult efforts by perceptive people to explain their misgivings about photography in comparison with painting. Here are a few of the better samples (some we have met already) from a large collection.

Emerson, as we saw, concluded that the mechanical aspects of photography defeated its claim to being a fine art, not simply because they are mechanical but because they take the place of mental operations. In art, he argued, "everything is done unto one end," whereas in photography, relatively little of what is produced is so directed and controlled.[75] The fact of purposive control over aesthetically relevant aspects of the image is what mattered to Emerson—notably, that artists have their ways with tonal relation-

[74] This term is due to Michael Leyton, *Symmetry, Causality, Mind* (Cambridge: MIT Press, 1990), which argues to a controversial extreme that *all* perception is a matter of recovering the "process-history" of what is before us.

[75] Emerson, *Naturalistic Photography*, 1:185–86.

ships. Yet so sharp was Emerson's separation of aesthetic and formative factors that he made no case for this purposiveness being visible in the pictorial results.

Forty years earlier Elizabeth Eastlake had come to the same conclusion, that photography cannot be practiced as a fine art, although as a new, technological labor-saving device it could be a great help to art. Her reasoning was, like her prose, rather subtler than Emerson's. Art, she stated, requires (chiefly among other things)[76] "the marriage of his [the artist's] mind with the object before him, and the offspring, half-stamped with his own features, half with those of Nature, which is born in the union—whatever appertains to the free-will of intelligent being, as opposed to the obedience of the machine."[77] Photo-technology does not allow this. Thus Eastlake required a good measure of mind—that is, of intentional meaning—in a picture for it to be considered fine art. (That she characterized it in terms of the exercise of freedom, rather than "creativity," is significant.) She did not explain, however, either how mind and its freedom can be present in a picture and how detected there, or why that condition is insufficiently satisfied in photography.

Like-minded people in later ages have tried to be more explicit. For example, Richard Hennessy holds that "the more a given art is capable of making intention felt, the greater are its chances" of being a fine art, and that photography falls far short of painting and drawing in either the degree or proportion of its success. Hennessy attempts to locate why and where intention may be present in a picture, and how we can see it there. Photographic images, he says, "are pitifully limited in sensorial content," because as physically marked surfaces they lack the richness of sensory meaning to be found in paintings and drawings. Notably, they bear no evidence of touch, whereas painting's "mode of existence is produced . . . by its mode of facture. . . . *Through the hand:* this is the crucial point. Painting . . . makes use of all modes of sensorial knowledge—the tactile, oral, auditory, even the olfactory—to supplement the visual. Whereas photography is only able to provide us with information derived from light, painting provides us with an

[76] Eastlake lists a number of photography's "artistic characteristics," including "correctness of drawing, truth of detail, and absence of convention," the possession of which would bring one to "the threshold of art," and says of the "union" here cited, "This, and much more than this, constitutes the mystery called Art, in the elucidation of which photography can give valuable help, simply by showing what it is not" ("Photography," in Newhall, *Photography: Essays & Images,* p. 94).
[77] Ibid., p. 94R.

image of the interrelationship of the senses."[78] Therefore, formative components of mind and meaning are strongly present and aesthetically perceptible in painting and drawing but not in photography, owing to the nature of their respective *surface-marking* procedures. Photo-technology, by "saving the labor" of hand procedures, suppresses one of the most significant means of giving pictures meaning.[79] There is much truth in this view, and the familiar attitude—common to the unlikely trio of modernist, conceptual, and high-tech persuasions—that valuing hand-facture in picturemaking is sentimental nostalgia for "the handmade" per se is a crude distortion of a complex situation.

With regard to mental content in works of art, merely pointing out what photography does not offer artistically leaves open the question of what it does offer. Since intentional meaning and the "personal" exist as much in literature, musical composition, and architecture—with their typical appeals to several senses—as in drawing and painting, it would be as futile to look for the latter's facture there as to look for the corporeality of dance or singing in painting. So much for what we might call an out-of-hand rejection of photo art. It is possible that various kinds of photographs make up in other ways for their inexpressive surfaces; indeed, the works of good photographers are usually distinctive, and their descriptions involve terms implying mental attitudes. As there are witty photographs—which are not simply photographs that depict or allow us to see witty things—so there are arty, trite, charming, biting, brutal, carefully composed, compassionate, probing, and awkward ones (and speaking of evidence of the hand, many of the last variety show the photographer's finger). The task, then, is to identify important formative actions of other sorts that we experience in photographs. Even the colloquial, formative idea of a "snapshot" suggests that there is a world of actions to consider beyond Emerson's "selection" of view, lens, focus, and so on—however relevant these "material opportunities" are, as Weston reminded us. In any case, we still need to know, in a more systematic way, how touch, through facture, could—beyond adding to the sensuous evocation of pictures—also make "intention felt" there.

We had part of an answer in discussing admiration of pictorial skills. We still see pictures, whether by children or adults, amateurs or professionals,

[78] Hennessy, "What's All This about Photography?" p. 23.

[79] For a more extreme expression of this sentiment, John Berger: "The photographic image is produced instantaneously by the reflection of light; its figuration is *not* impregnated by experience or consciousness" (Berger & Mohr, *Another Way of Telling,* p. 95).

very much in terms of the skills exercised in making them. (For example, Jane Austen's Emma was rather pleased with her own.) Generally we enjoy this perception, although— depending on the skills—we may also tire of them, be put off by them, find a picture too show-offish in their regard. The tide of taste that turned from skill to self-expression slued from one form of manifestation to another, and where intention, mind, and the personal are asked for, formative skill alone was found not to satisfy.

To understand either formative component, we still have to understand, generally, how we see pictures at all—in particular, figuratively depictive ones—in terms of formative actions, whether these are skilled and expressive, or not.

Toward Solutions

Seeing Pictures: Reciprocity

Had Talbot been able to draw half so well as John Constable—or even almost as well as John Herschel and Daguerre—he might not have invented photography. Exactly the kinds of pictures he was trying to draw on vacation in 1833 were the sort that not only Constable and other fine British artists (Wilson, Gainsborough, Sandby, and Cozens before him, or his contemporaries Turner, Girtin, Varley, Ward, Cotman, and Sandby) but also many amateurs (such as Heneage Finch, Earl of Aylesford) were producing.[80] The fact is that many amateurs like Talbot did draw well—his wife, Constance, included; drawing, particularly of views and details, had been for at least a century a respected accomplishment in the West. Thomas Jefferson in a letter of 1787 had admonished his fifteen-year-old daughter Martha ("Patsy"): "I am glad to learn that you are employed in things new & good in your music and drawing. . . . it is your future happiness which interests me, & nothing can contribute more to it (moral rectitude always excepted) than a contracting of a habit of industry and activity."[81] Were it not for the "habit

[80] See, e.g., the catalogues of two fine exhibitions: *Landscape in Britain: c. 1750–1850* (London: Tate Gallery, 1973); and Charles Leggatt, ed., *Constable: A Master Draughtsman* (London: Dulwich Picture Gallery, 1994), in the latter esp. Anne Lyles. "The Landscape Drawings of Constable's Contemporaries: British Draughtmanship, c. 1790–1850," pp. 19–44.

[81] Jefferson (who avoided capitalization) continues: "of all the cankers of human happiness, none corrodes it with so silent, yet so baneful a tooth, as indolence. body and mind both unemployed, our being becomes a burthen, & every object about us loathsome, even the dearest. idleness begets ennui, ennui the hypochondria, & that a diseased body. no laborious person was ever yet hysteri-

of industry and activity" involved, which of us would not rather bring back from our travels a drawing book full of crisp, accurate, evocative, handsome, yet lively drawings—perhaps brightened by a few sure though free touches of water color (as by Delacroix in Morocco in 1832)—than several rolls of film which, when developed, will look at best like postcards?

Niépce's and Talbot's houses, said their owners, drew their own pictures. John Constable, who did not quite live to see the age of photography, was obliged to draw all his own—well, really, his father's. Constable, in fact, was in the habit of drawing other people's houses. Figure 15 shows one of those drawings, from his crucial artistic year 1809.[82] Considering it in terms of "touch" as showing mind, individuality, the personal, and also skill should help us understand reservations about photography.

Perhaps the most obvious thing about the drawing at first glance is that it *is* a drawing. One would never mistake it for a house or a person, of course; one would hardly mistake it for a page of writing—or even for a photograph. Therefore, the most obvious thing about it, by its looks—at the level of identification by which we tell that something is a puddle, a car, a tire track—is that it was made by a certain kind of intentional action. A slightly closer look assures that it was not drawn by a four-year-old. Although given the conceptions of the time and the drafter's own motives, Constable himself would likely not have considered it a work of art, it is (to return to the previous discussion), obviously a skillfully made picture of a certain kind.[83] Skill is in action: what are the actions here? These are easy to show from a straightforward description of the picture. With a bit of black chalk Constable has evoked, on a piece of drawing paper the size and shape of a standard four- by six-inch photo print, not only the shape, mass, and disposition of a large house and

cal. exercise & application produce order in our affairs, health of body, chearfulness of mind, & these make us precious to our friends. . . . the future of our lives therefore depends on employing well the short period of youth": Collection of Pierpont Morgan Library, New York City (MA 1029 [1b]).

[82] The following account is based on the exhibition and catalogue of Leggatt, *Constable: A Master Draughtsman*, esp. Patrick Heron's essay "Constable: Spatial Colour in Drawings," pp. 45–50.

[83] Constable seems to have done several views of aspects of this house at that time, some more summary than this. A view from the west is reproduced in Ian Fleming-Williams, *Constable and His Drawings* (London: Philip Wilson, 1990), p. 25, fig. 22. Fleming-Williams, after dividing Constable's landscape drawings into three groups, notes that "if we are prepared to accept these as works of art—of varying quality—they were not intended as such" (p. 24). There is a Constable oil sketch of Malvern Hall from that year at the Tate Gallery, London.

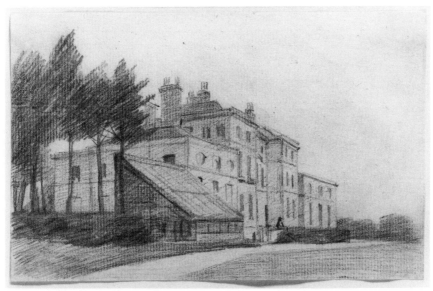

Fig. 15. John Constable, "Malvern Hall and the Conservatory from the South West." Kind permission, private collection.

grounds but also the enveloping light and atmosphere of a time of day in a particular place. Part of the miracle of such an image is that the entirely *unmarked* parts of the picture are hardly less definitive than are the marked ones. Talk about touch: almost half the surface has not a mark on it. It is a good thing we decided early that although marks produce images, those images include the unmarked areas. Yet so deft is the artist's control of tone that we imagine the sky on the right to be a light-filled volume of space that continues in front of the building and the distant trees, which *are* indicated by a variety of marks. Typical of Constable, this, together with the compelling sense of scale, makes us imagine that we see the scene at a precise distance.

Thus the tone; what of the drawing process? That seems evident, also. The tree foliage is done with right-hand slanting scribbles, groupings of free and vigorous continuous strokes defining dark chalked regions, where by "continuous" I mean that Constable has not lifted the chalk very often.[84] This is

[84] See Heron's similar comments on another Constable drawing, in "Constable: Spatial Colour," p. 47. If we were going more deeply into this case in connection with photography, we might speculate whether these regions depict foliage according to varying intensities of light rays as they arrive at a viewing point. For systematic development of this distinction, see Willats, *Art and Representation*, esp. chap. 7.

an easily recognizable kind of marking that we have all done since early child-
hood. We can also see that these masses are rendered tonally: they are not
outlined. The house is done rather differently. The stroke shading there fills
in between the boundaries of one-directional strokes that establish the edges
of bits of architecture. Even the chimneys are put in that way. In all his shad-
ing Constable has taken advantage of the texture of the paper surface. This
is a "laid," not a smooth (wove), paper: that is, it has vertical ridges corre-
sponding to the wires that were used in the papermaking process. On so
small a surface the ridges and valleys are relatively large: for example, the
biggest chimney fits just eight of them.

We find all these features clear, just by looking. The calm and order of the
imagined scene are also obvious. What takes closer inspection are the devices
that make us imagine it this way. One is what we generally call *composition*.
First of all, each individual mark clearly appears to be placed relative to the
edges of the surface and to one another. With such pictures there is always
the matter of the overall ordering of shapes across the surface—what is called
by the ambiguous term *form*.[85] Form (compare "*formative*") is not to be con-
fused with things called forms, or shapes, themselves. Rather, it is the shap-
ing, formative, principle at work to give a whole thing overall character. This
is not a mysterious idea; it is something obvious to sight, if not always to the-
ories. We have seen part of it already, in Constable's clear marking proce-
dures. That is how he formed tree masses, architectural features, and so on.
But form is not restricted to that kind of facture. On closer examination, this
picture, rather like a map, might come with its own sort of legend, in this
case a generative one.

Perhaps the darkest mark on the surface is that defining the facing end of
the shed roof. Although that line stops at the one depicting a tree trunk, the
edge it defines seems to set a measure, which Constable carries across the pic-
ture. For example, that distance measures the base of a square to the left side.
This, perhaps the most emphatic form in the picture, shapes a luminous
"window" through the dark trees on the left. The top of the square is in the
foliage, where a horizontal line can be seen. This is the first of three compo-
sitional squares of the same size, which descend in step fashion to the right.
The second of these, abutting the tree-trunk-defining vertical, locates at its
opposite side the convex corner of the highest part of the facade, where we

[85] I have given a very compressed account of form and its various meanings in Maynard, "Form,"
in *The Dictionary of Art*, Grove's Dictionaries (London: Macmillan, 1996), vol. 11.

can detect one of Constable's little planning marks. The depicted facades of the Hall fall away from that point into distance and atmosphere, caught just within the third descending square. And there are other such spacings, across which Constable set rhythms of verticals and perspectively converging diagonals.

All this has to do with pictorial form, not just depicted forms or shapes. For example, the house is depicted as laid out in a highly symmetrical manner, but the picture that shows it so is not symmetrical. Nevertheless, both the picture and the house as presented by the picture are measured and organized artifacts. Furthermore, the picture's measure marks usually fall along what would be main intervals of the house, regardless of composition and perspective: that is, the corners and ends of walls. These are, after all, depictive marks, marks put down to establish what is to be imagined: here, notably, *outlines*. This is what they are and how they look to be. There would be much to say about outlines, were we to embark on a drawing study at this point; however, we must restrict ourselves to comparison with photography, which is so much noted for not presenting things to our imagining in the efficient outline way known to all peoples.

Three remarks on the Constable are appropriate here, beginning with Ian Fleming-Williams's observation that this is about the time when Constable was giving up lines, "*making shapes* with areas of shading, not, as had been standard contemporary practice, shading within or around previously established outlines. This technique he developed still further, until . . . [in the year of this drawing] outlining is minimalised, and he begins to draw and see tonally," in a revolutionary fashion.[86] The second point is that all of Constable's architecture-defining outlines represent actual *edges,* things one could feel and identify with one's hands. This is by contrast with the *contour* lines of the tree trunks and the ground lines beneath them (forming the base of the first square), which show not true edges but rather what are technically called "occluding contours": that is, places where part of a continuous surface hides other parts of that surface. In other words, Constable's architectural lines marking intervals on the picture surface usually signify the depicted features in particularly objective ways. That leads to another very important dimension of pictorial meaning, further explaining Hennessy's point about the potential richness of "sensorial" appeal in drawings and

[86] Ian Fleming-Williams, "Catalogue," in *Constable: A Master Draughtsman*, p. 112.

paintings. As the foregoing remarks about shading indicate, it is hard to see the lines in such a picture without understanding them as traces of movements. Even the straight outlines appear as directional marks. The direction of their production may not be clear, but they do look drawn, not stamped or pressed. This means that they have the look of being made in a familiar way: the chalk is placed on the paper and moved in a line, then lifted and put down to make another mark elsewhere.[87] A possible representational significance of this is that it mimics the productive process of that which it represents: a building, in which materials were cut and then positioned.

This brief discussion of a Constable drawing is simply to remind us that drawings are (as the word says in English, Dutch, and German) records of intentional *marking* processes, and that they are also (as in Italian, French, and Spanish) things *designed*. It is to remind us that this is exactly how most drawings appear to us, overall and in their parts and aspects. To see them otherwise might be like listening to piano music but not hearing keys being struck and being unaware of phrasing. To carry this discussion through its next steps (continuing the accounts of Chapter II on display marking and IV and VIII on viewer participation) would have further meaning for depiction, since it bears on the very *objects* of our imagining (our acts of seeing the marked surface). For present purposes, however, let us just say that the intentionality in the drawing marks we see exists at the most obvious and also at more subtle levels. One may not need or wish or be able to perceive depictively at all these levels. For all we know, even single perceptions include several perceptual "passes" at them. We can see more and more in pictures as we integrate levels. And of course, a given picture need not be as rewarding at each level as, for example, this Constable is.

We may observe that the efficiency of drawing is rightly accounted for in those familiar terms of its economy of information and its powers of selection. To return to our master theme, however, to say this is to omit the great technological efficiency of turning even the manifestations of the very action necessary to produce the images into means of depiction: for example, turning the spill-over effect of vigorous chalk marking over drawn lines into movement of leaves obscuring architecture. Drawings usually appear to us not simply as marks, even as display markings, but as marks made with the

[87] These comments are inspired by Heron's observations regarding other Constable drawings, in "Constable: Spatial Colour."

intention of indicating shapes and objects, just as we are aware that a speaking voice—whether or not we can hear or understand what is said—is producing speech, not just vocal noise.[88]

We should now be in position to see why photography appears to many people to be at some disadvantage in this regard: a classic case of suppression of one kind of power, consequent upon amplification of others (Chapter III). This is generally to be expected in all the arts—indeed, in all truly cultural practices—where the distinction of means and ends is characteristically so hard to sustain. For obvious example, the photochemical/electronic marking process does not so readily exhibit the intentional direction of marks as do the activities of drawing and painting.

We also touched on the topic of composition in the Constable. Photo composition—design—provides a better opportunity but still not so clear an opportunity as does drawing. For example, where the sorts of measurings just noted occur in a photo, it is usually less clear that they were put there by the photographer. As a result, our imagining seeing of the photo-depicted scene does not work so easily from visible intentionalities. It is normally more difficult for people to see the levels of intentionality in a photo surface than to see it in such drawings. That may even be considered another dimension in the fidelity of photography, besides the ones we have discussed.

Photo Facture

Having seen some of what it might be in drawing, what of "the artist's province"—the intention, the personal—in photography? Having earlier mentioned children's pictures in the context of skill, let us consider a photo of one. A street photo by Helen Levitt (Figure 16) exhibits some of the fidelities discussed in earlier chapters: perspective shaping, different orders of detail (though not subversive detail), with a little shadow. Like the Evans photo (the younger Levitt was at one time a collaborator of Evans), this picture depicts many markings, most notably a fresh sidewalk chalk drawing, palimpsest over earlier efforts. This is probably a three- or four-year-old's job, too young for the depicted boy with the smart look. Demonstrating how easily intentionality and mental acts appear in drawings, it provides another

[88] References here would particularly include writings by Michael Podro cited and developed in Maynard, "Seeing Double."

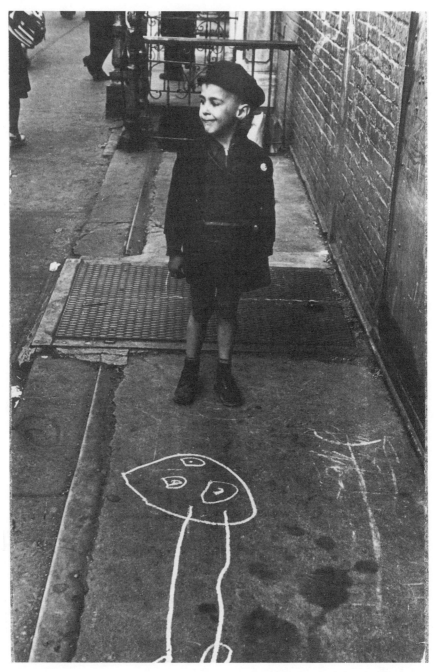

Fig. 16. Helen Levitt, "New York, c. 1938." Courtesy of the artist and Laurence Miller Gallery, New York.

comparison case for photography. That is, having just examined drawing at one of its limits of skill, we can now consider it at its early stage and opposite limit.

Like the Constable, this drawing makes use of markings that we easily distinguish and identify as lines, lines full of facture direction. These produce just three kinds of elements: what might be called points or zero-dimensional pecks, 1D strokes, and 2D enclosure regions. The latter two elements show the significant property of *extendedness,* about which, more in a moment.[89] Recalling the discussion in Chapter VI, we notice that there is no shading at this early stage. Together, the marked regions compose the familiar "tadpole" figure. Notice what "compose" means here. Compared with the multitude of relationships in the Constable, we have just *two* basic kinds of relations. The first relation is *enclosure,* being around (and inside), like the eyes. The second relation is *attachment,* as the legs are fitted to the head-body, and the feet (indicated by closed outlines, probably as round volumes) are fitted to the legs. These attachments show an order. It is not clear, however, whether the attached enclosures themselves show order. These two kinds of relationship in children's early drawings have been observed to be topological: that is, as directed to features which would well survive "rubber-sheet" distortions of the finished marked surface.[90] Mere topological depiction of things has great attractions, even for advanced drafters, just because it allows much rubber-sheet freedom with the lines and regions marked; modern artists—Klee, Picasso, and Dubuffet come to mind, among many others throughout history—have taken rich advantage of just that freedom for other expressive purposes.

Topological representation can also be very practical. Mainly topological drawings are familiar to us all from schematic diagrams, whether for transport routes or electric writing, where the properties of closure, order, and attachment are at a premium. They are also the kinds that we try, for example,

[89] This account, in vocabulary and approach, is based upon the theories of John Willats, as expressed in papers such as "Marr and Pictures: An Information-Processing Account of Children's Drawings," *Archives de Psychologie* 55 (1987): 105–25; "The Representation of Extendedness in Children's Drawings of Sticks and Disks," *Child Development* 63 (1992): 692–710; "Seeing Lumps, Sticks, and Slabs in Silhouettes," *Perception* 21 (1992): 481–96; and in his *Art and Representation,* chap. 3.
[90] This observation is perhaps originally due to J. Piaget and B. Inhelder, *The Child's Conception of Space* (London: Routledge & Kegan Paul, 1956). It is developed by Willats in *Art and Representation.*

to code graphically—more often verbally—when asked for general route directions. Retention of topological features also remains important to drafters as they go on to more developed diagrams and pictures, including those that one would not call topological. Developmental challenges in drawing should be understood, in part, in these terms: developing and *retaining* topological features, while widening one's powers of rendering other relationships graphically. Anyone trying to draw such a complicated scene as a group of trees or buildings, or a nude with arms and legs crossed, finds how easy it is to overlook the basic features of connectedness and order while striving for such higher-level characteristics as contour, proportion, foreshortening, shaded volume. Loss of topological legibility, notably regarding connectedness, is also a familiar hazard of photography. Like the drawing it displays, however, and like the Constable, Levitt's photograph presents important topological features, including all those that we find in the child's drawing within it.[91] It also provides a great many more features, topological or closely related to that, which are out of reach of the young child. For example, it shows the railing as attached to the wall, the coat as around the boy's body, bricks laid upon and beside one another to form a single surface, the hat as on the boy's head, the boy as standing on the sidewalk, the metal doors as covering an opening. The photo also shows the marks as having been put on the sidewalk.

Thus an introduction to "the composition" of the child's picture. The term "compose" also implies the *act* of composing: very much the point at issue. In the child's picture we can see that the large enclosure shape was closed on the left, the marks brought together there for that purpose. By contrast, though we notice also the irregularities in the marks, we do not suppose that the child is yet capable of noting them or of controlling them for depictive purposes. These features would not yet be "thematized" for depiction. That will come in time, as variations in lines and in the 2D enclosures begin to indicate true *edges* or *contours*. They do not do so yet. As for the extended (1D

[91] There is an ambiguity in "topological depiction" among three different ideas: drawing, surface marking that depicts by its topological features; depiction of things predominantly according to their topological features; the obvious combination of the two. Although the child's picture has us imagine a person topologically by being *itself* topologically ordered (as to closure, order, and attachment), topological characteristics may be depicted without the markings themselves being topologically thus. E.g., in the Levitt the metal doors behind the boy's legs are understood to be continuous objects, although the marked regions on the surface portraying them are not *themselves* topological continuities. Several distinct regions of marks have us imagine just one door.

and 2D) markings, it would probably be too much to say at this point that the child has depicted the legs *as* 2D—that we are mandated to imagine them this way: birdlike. We understand, rather, that the child has used such lines to indicate the *predominantly* 2D character of certain 3D shapes: legs. Let us pause with this idea a moment. It is perfectly normal to identify predominantly one-, two-, and three-dimensional objects in terms of those predominant dimensions, even though all are understood to be 3D spatial existents. Some natural languages do this.[92] So does the familiar child's hand game called "knife (or scissors), paper, rock," where the extended digit, flat hand, and fist graphically *display* these extensions of 3D objects. This explanation better suits the case than would one in terms of the overworked and largely vacuous word "convention"—which I have been avoiding. To misunderstand these lines is not to misunderstand a convention. It is to misunderstand a child.

Mental characteristics are manifest throughout the child's picture, as they are in most young children's drawings and in the Constable. This is the way we see them, correctly or not, and the way we tend to value them. Otherwise, parents would not display them so often as they do these days. Furthermore, we need to emphasize again that this is the normal way in which we understand such markings—as Eastlake's "marriage" of mind and object.[93] But what of the Levitt photo itself? Photography, after all, is our subject. The photograph, too, shows many signs of formative action, including the intentional. A first point, so obvious that we tend to overlook it, is that this photo—unlike the Constable and the child's drawing—does not show what we might term *sequence* facture: that is, any traces of the progression of the activities producing it. In this way the photo is less like the Constable than the child's drawing is. Early observers did not tend, as we do, to over-

[92] See Willats, "Marr and Pictures." This aspect of his approach is inspired by J. Peter Denny, "The 'Extendedness' Variable in Classifier Semantics: Universal Features and Cultural Variation," in *Ethnolinguistics: Boas, Sapir, and Whorf Revisited*, M. Mathiot, ed. (The Hague: Mouton, 1978), pp. 24–37.

[93] We are careful here not to attribute to the child mental conceptions of the *thing* drawn. As cautions against that tendency, see, e.g., the writing of Willats cited in note 89; Norman Freeman, "Do Children Draw Men with Arms Coming Out of the Head?" *Nature*, 3 April 1975 pp. 416–17; Freeman, "Process and Product in Children's Drawings," *Perception* 1 (1972): 123–40; and papers in Freeman and M. V. Cox, eds., *Visual Order: The Nature and Development of Pictorial Representation* (Cambridge: Cambridge University Press, 1985). Furthermore, this drawing may in no way *individuate* the child among billions of others who draw similar figures.

look this simple point. Our trusty guide Talbot, for example, remarked more than once that "the Camera depicts them all at once"[94]—one of the most significant facts about photography (though as the slit-scan reminds us, not an essential one). Is there anything here to call "photo facture" (sequenced or not) as there is "drawing facture"? If so, does it function depictively, as the drawing facture does—and function artistically?

Well, the Levitt was taken with a hand-held camera, at a certain moment, with a speed that prevented blurring of the background walkers, with depth of field on a gray day. The exposure was made looking downward from eye, not waist, height; it could not have included the "tadpole" otherwise. The picture is *composed:* boy and chalked picture images are stacked vertically, held between converging lines of perspective. The boy, his head framed by the wrought-iron grill, is placed in the middle of the square of the top two-thirds of the standard two-by-three, 35 mm format, divided by his waist stripe and coat button. The tadpole occupies the bottom third.[95] Levitt also tipped the camera a few degrees left and turned it slightly toward the wall, with the result that the lines "move" more. Emerson spoke only of "selecting a view" with his large cameras and plates, but the framing of photographs frequently suggests a twisting action of hand-held cameras, to lock lines into the corners of the frame, to catch parts of objects, and so on. There are such things as camera angles because photographers angle cameras.

It is thus apparent in many photographs that they are the result of "taking" actions. We see this in snapshots, clearly caught "on the wing," and also in rather different pictures like the Lewis Hine (Figure 14) in the last chapter. In such cases one can scarcely separate in imagination the experience of seeing what was photographed from the experience of photographing it. Often the depicted subject's response plays a larger part in that impression, as in the picture of the Lacock school (Figure 7). Such actions also become clearer to us when we have seen a number of photographs by the same photographer. Levitt, for example, took many pictures of children's chalk drawings on the pavements and walls of the city, from which we can see how she related the framing of her pictures, and their surfaces, to the children's images within them. Coming to understand a kind of action from seeing (varied) repetitions of it is a normal experience. The resulting understanding of

[94] Talbot, *Pencil of Nature,* notes to Plates III and XIV.
[95] It is useful to look at the work of 35 mm photographers this way. Sometimes, as in the case of Cartier-Bresson, we find a centered square bordered by the remaining third of the 35 mm format.

the occurrences usually makes them appear different.[96] If, then, the aesthetic appearance of a picture can include the appearance of the formative act of producing it, and if that is perceptually identifiable in terms of a group of actions to which it belongs, then understanding that group can affect the picture's aesthetic experience. (Thus another black eye for the innocent one. An amateur snap that "looks like" a Bresson actually does not look much like it, because looking at the one is not very like looking at the other.) These are beginning indications of the ways in which formative actions—especially those full of intention—can be manifest in photos. Nevertheless, the technology of photography makes it more difficult to discern the manner and extent in a photo than in a drawing, where, as we saw, it is child's play.

Typically, there will be effects in successful photos that one does not know how to attribute. The left knock-knees of both "people" in the Levitt are probably part of her display image, but what of the curlicue on the curb matching those of the wrought iron? In a drawing, such "rhymes" are more likely to be clear, having been placed there. The issue of photographic detail therefore raises the question of the kinds and proportion of controlled features, relative to uncontrolled ones, as compared with drawing and painting. In art, as Emerson said, not only is much done but "everything is done unto one end": a high proportion of control. Also in everyday drawing: although the amount of control in our child's picture is fairly low, its proportion might be rather high. What of photography? Chapter VII considered the high "noise" level typical of the most familiar camera images—that is, the difficulty of putting a filter on its amplification of information along certain image channels, with its resultant lessening of control.

Artistically, this is an interesting general phenomenon, worth a moment's consideration. The effects of technological advances in musical instruments, for example, are—at least in the opinion of some—a reversal of the photographic situation. The proportion of tone to noise in modern violins is much higher than it was in the eighteenth century; accordingly, a great proportion of the sound is now directly controllable. More dramatically, modern valve-stopped horns allow more range, together with more control and less accident, than did the hand-stopped instruments of that era. Yet some today decry the loss of individuality or personality in individual instruments and

[96] Related arguments appear in Kendall Walton, "Categories of Art," *Philosophical Review* 79 (1970): 334–67.

individual performances, a loss due to the greater control and regularity attending these technological advances.

By contrast, the complaint about photography is that technology has produced *more* noise and less control over the marks produced, thereby suppressing individuality and personal expression. Another photo skeptic argues that with photographs the higher noise levels overwhelm self-manifestation, that "there is no way of determining in advance which detail is relevant to an aesthetic interest: every detail can and ought to play its part. At the same time, the causal process of which the photographer is victim puts almost every detail outside his control." Even where the photographer can achieve control, "there seem to be few ways in which such intentions can be revealed in the photograph. For we lack all but the grossest features of style in photography; and yet it is style that opens the way to the question, Why this and not that?"[97]

These are sweeping claims. The one about style seems easy to refute. Emerson's style and Weston's are still recognizable, worlds away from Levitt's. Levitt's is different even from Hine's and Brassaï's, and Hine's from Bresson's, which itself changed over the years.[98] Such distinctions would seem no harder to draw, illustrate, and defend than distinctions between Constable's, Turner's, and Gainsborough's landscape-drawing styles. What then of the assertion, which has guided this chapter, about lack of intentionality through control? Chapter VII's treatment of detail indicated that photographers such as Bresson have the ability, rather like earlier musical instrumentalists, to exploit the noise elements of their instruments within clear aesthetic forms; 35 mm camera photographers notably differ stylistically precisely in their ways of handling such noise. In general, proportion of control seems problematic regarding art: the drawings of the aged Titian are not valued artistically lower than are those of the younger Titian. All our examples suggest that quantitative measures have sense only in the context of quality. That raises very large questions of artistic meaning.

For example, when speaking of mind, intention, or the personal in art, there is always the question of the depth and quality of mind that can manifest themselves. Constable's and the child's pictures, for example, are not remotely alike in this regard. Similar questions of depth in meaning certainly

[97] Roger Scruton, "The Photographic Surrogate," *Salisbury Review,* January 1987, rpt. in Scruton, *The Philosopher on Dover Beach: Essays* (Manchester: Carcanet, 1990), pp. 175–76.
[98] For details of Bresson's changes, see Galassi, *Henri Cartier-Bresson.*

arise with photography as an artistic medium. The only way to address them is to undertake close examination of cases. Many such examinations already exist, in articles, exhibition catalogues, books on particular photographers and on kinds of photography. My purpose has not been to add to these but rather to provide a philosophical primer that might help us understand and assess such accounts. From that perspective, let us conclude simply by indicating some additional dimensions of meaning in photographs.

This chapter has approached the issue of mind or the personal in photographs largely from the limited but important topic of facture: signs of the physical shaping of marks on a surface. Of course, meaning, even meaning through formative action, exists at many levels beyond this. It is an important feature of many pictures that we simply see a form as having been shaped, whatever the physical process, just as we see a form made in any other artistic medium, whatever the physical action taken. In photography, however, one of the ways in which this can occur is through what I have called the thematization of marking facture. Again, other characteristics of the process or of the materials and their uses, once recognized, can guide further attempts to produce artistic meaning. Let us illustrate this with a small example from the earlier days of photography, one close to the beginning of the processes of photographic thematization. It is fitting that we should conclude by reference to Talbot, this time to one of his pictures rather than to his words. Talbot displayed his calotype "The Open Door" (Figure 17) in *The Pencil of Nature* and described it in terms of "picturesque imaginings." The photo historian E. P. Janis, however, suggests that here the paper process began to assert a characteristic effect that became clearer to later calotypists, who began to *use* it artistically. Due to the physical process, textures in the Talbot are "only visible in discontinuous, unrelated fragments, having been flattened in the process and combined with their own shadows into wholly new 'objects.' The lantern and broom seem almost borne along by shadow appendages, whose insistent black opacity causes them to leap to the surface." The sharp edge of the door shadow, she continues, "denies sentimental attachment to picturesque irregularity and decisively points out the sublime possibilities of photography's radically abstracting mode."[99]

There may be no reason to suppose that Talbot *used* such characteristics,

[99] Eugenia Parry Janis, "Essay on the Origins of an Early Photographic Sensibility," in André Jammes and Eugenia Parry Janis, *The Art of French Calotype: With a Critical Dictionary of Photographers, 1845–1870* (Princeton: Princeton University Press, 1983), pp. 16–17.

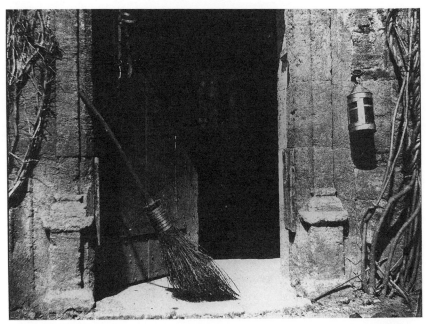

Fig. 17. William Henry Fox Talbot, "The Open Door." Courtesy of The Science Museum/ Science & Society Picture Library.

any more than there is to suppose that the child used the variations in the chalk lines depicted in the Levitt. There may be good reason to suppose such a conscious use, however, in the work of later calotypists such as the landscape photographer Victor Regnault. Overcoming early jingoistic rivalry, we recall, the French soon became expert in "the field of paper" photography. Also, if Talbot, in the opening quotation of this chapter, mentioned "an alliance of science with art," in Regnault we have a good case: a noted physicist turned sensitive photographer.[100] Janis writes of a calotype of the Seine published by Blanquart-Evrard:

> River and river bank collide, light wedge against dark. Along their juncture, three little rowboats cut out crisp silhouettes; the intricacy of each form appears in protruding details along its edge. The boats' cast shadows are insep-

arable from their physical shapes; this new combination of a thing and its shade exaggerates the vessel's lovely crescents. . . . In counterpoint to the black and white forms, houses and trees in a distant horizon cast pale transparent shadows and encircle the perspective with a gentle arm of modulating greys. The footpath on the right echoes the contrasting wedges, but as a transparency. Regnault has combined two contradictory idioms to marvelous effect. Silhouettes and bold orthogonals share space with a transparent horizon that subtly unfolds in the manner of a Chinese scroll. All that is incidental . . . assumes a grandeur of generality, and simplicity reigns.[101]

She is confident in saying what Regnault has *done* here, what he has used the characteristic physical properties of calotypy to produce. One might test these perceptions by looking at his other pictures. Just as Constable's traditional black chalk or graphite has characteristics different from drawing ink and oil paint, so has calotype (thus the argument would go), and it is up to the artist to recognize these and to use them for artistic purposes.

My purpose has been to provide a basis for improved understanding of a number of characteristics of photography as technology, which, with a little study, we can see to be progressively thematized for meaning. That is especially true during a period of increased self-consciousness in all the arts. To begin, the basic fact that photography is technology has itself been a theme of some photographic works. Other thematizations have already included photographs as marked surfaces, as images, as conjoined with ink and print, as depictions, as means for detection, as being shadowlike, as optical and chemical products, as involving projection systems, as showing details, as manifesting, as usable for evidence and for persuasion, as aesthetic, as art. Then there have been thematizations of elements in the causal processes of producing photographs. Photographers have explored, for example, the moment of exposure, the presence of the photographer, the very action of the camera. In many ways they have of course taken as their subject the agency of light in making pictures. This general list already comprehends the work of many serious photographers, and it would be easy to expand, simply

[101] Janis, "Essay," p. 98, on "Victor Regnault, *Sèvres. The Seine at Meudon,* c. 1853 . . . from *Etudes et Paysages,* 1853–1854, published by Blanquart-Evrard." Details of Regnault's scientific career and aesthetics may be found in the "dictionary " part of Jammes and Janis, *The Art of the French Calotype,* pp. 237–41. Unfortunately, I was unable to secure permission to reproduce the picture here and therefore refer readers to the plates in this splendid book.

by another "chemical" or combinatory consideration of them. As photo processes continue to develop through chemical, EO, and digital means, they will no doubt provide many more resources for pictorial investigation. The artistic question will continue to arise concerning the meanings they produce. Just here, where we invite detailed attention to cases for the different pictorial "chemistries" they show, our philosophical primer closes.

References

Abrams, Meyer. *Doing Things with Texts: Essays in Criticism and Critical Theory.* New York: Norton, 1989.

———. *The Mirror and the Lamp.* Oxford: Oxford University Press, 1953.

Adams, Ansel. *Ansel Adams: An Autobiography:* Boston: Little, Brown. 1985.

———. *Natural-Light Photography.* Basic Photo Four. Boston: New York Graphic Society, 1952.

Addiss, Stephen. *The Century of Tung Ch'i-ch'ang: 1555–1636.* Kansas City: Nelson Gallery Foundation, 1992.

Alberti, Leon Battista. *On Painting.* 1453. Translated by John R. Spencer. London: Routledge & Kegan Paul, 1967.

Aristotle. *Problemata.* Translated by W. S. Hett. In Aristotle. *Minor Works.* London: Heinemann, 1955.

Arnheim, Rudolf. "Melancholy Unshaped." *Journal of Aesthetics and Art Criticism* 21 (1963): 291.

———. *Toward a Psychology of Art.* Berkeley: University of California Press, 1966.

———. "The Two Authenticities of the Photographic Media." *Journal of Aesthetics and Art Criticism* 51 (Fall 1993): 537–40.

Arnold, H. J. P. *William Henry Fox Talbot: Pioneer of Photography and Man of Science.* London: Hutchinson Benham, 1977.

Auerbach, Erich. *Mimesis: The Representation of Reality in Western Literature.* Translated by Willard Trask. Princeton: Princeton University Press, 1953.

Auletta, Ken. Annals of Communications (columns). *New Yorker,* 1994–96.

Barger, M. Susan, and William B. White. *The Daguerreotype: Nineteenth-Century Technology and Modern Science.* Washington, D.C.: Smithsonian Institution, 1991.

Barthes, Roland. *La chambre claire.* Paris: Gallimard, 1980. Translated by Richard

Howard as *Camera Lucida: Reflections on Photography.* New York: Hill & Wang, 1981.

Basalla, George. *The Evolution of Technology.* Cambridge: Cambridge University Press, 1988.

Batchen, Geoffrey. "The Naming of Photography: 'A Mass of Metaphor.'" *History of Photography* 17 (Spring 1993): 22–32.

———. "Tom Wedgwood and Humphry Davy: 'An Account of a Method.'" *History of Photography* 17 (Summer 1993): 172–83.

Batteux, Abbé. *Les beaux arts réduits à um même principe.* Paris, 1746.

Baudelaire, Charles. *The Painter of Modern Life and Other Essays.* Edited and translated by Jonathan Mayne. London: Phaidon, 1964.

Baxandall, Michael. *Painting and Experience in Fifteenth Century Italy: A Primer in the Social History of Style.* London: Oxford University Press, 1972.

———. *Shadows and the Enlightenment.* New Haven: Yale University Press, 1995.

Benjamin, Walter. "Kleine Geschichte der Photographie." 1931. Translated by Phil Patton as "Walter Benjamin's Short History of Photography." *Artforum* 15 (February 1977): 46–51.

———. "The Work of Art in the Age of Mechanical Reproduction." Translation by Harry Zohn. In *Illuminations,* edited by Hannah Arendt, New York: Harcourt Brace Jovanovich, 1968.

Berger, John. *Ways of Seeing.* London: Penguin, 1972.

Berger, John, and Jean Mohr. *Another Way of Telling.* New York: Pantheon, 1982.

Bevan, Edwyn. *Holy Images: An Inquiry into Idolatry and Image-Worship in Ancient Paganism and in Christianity.* London: Allen & Unwin, 1940.

Binkley, Timothy. "The Vitality of Digital Creation." *Journal of Aesthetics and Art Criticism* 55 (Spring 1997): 107–16.

Blanquart-Evrard, Louis Désiré. *La photographie: Ses origines, ses progrès, ses transformations.* Lille: Imprimerie L. Danel, 1870. Sources of Modern Photography reprint series. New York: Arno, 1979.

Blau, Eve, and Edward Kaufman, eds. *Architecture and Its Image: Four Centuries of Architectural Representation.* Collection of the Canadian Centre for Architecture. Montreal: Canadian Centre for Architecture, 1989.

Blocker, H. Gene. "Pictures and Photographs." *Journal of Aesthetics and Art Criticism* 36 (Winter 1977): 155–62.

Bolton, Richard, ed. *The Contest of Meaning: Critical Histories of Photography.* Cambridge: MIT Press, 1989.

Booth, Stephen A. "Portraits." *Popular Mechanics,* January 1989, pp. 58–61, 114.

Borcoman, James. *Magicians of Light: Photographs from the Collection of the National Gallery of Canada.* Ottawa: National Gallery of Canada, 1993.

———. "Purism versus Pictorialism: The 135 Years War." *artscanada* 192–95 (December 1974): 69–82.

Bourdieu, Pierre, et al. *Un art moyen: Essai sur les usages sociaux de la photographie.* 1965. Translated by Shaun Whiteside as *Photography: A Middle-Brow Art.* Cambridge: Polity, 1990.

Brown, Peter. "A Dark-Age Crisis: Aspects of the Iconoclastic Controversy." *English Historical Review* 88 (January 1973): 1–34.

Browning, Elizabeth Barrett. *Elizabeth Barrett Browning to Miss Mitford: The Unpublished Letters of Elizabeth Barrett Browning to Mary Russell Mitford.* Edited by Betty Miller. London: J. Murray, 1954.

Bryer, Anthony and Judith Merrin, eds. *Iconoclasm: Papers Given at the Ninth Spring Symposium of Byzantine Studies, University of Birmingham.* Birmingham: Centre for Byzantine Studies, 1977.

Buckland, Gail. *Fox Talbot and the Invention of Photography.* Boston: Godine, 1980.

Bulliett, Richard. *The Camel and the Wheel.* Cambridge: Harvard University Press, 1975.

Bullock, Wynn. *Wynn Bullock.* San Francisco: Scrimshaw, 1971.

Carey, James W., and John J. Quirk. "The Mythos of the Electronic Revolution." *American Scholar* 39 (Spring 1970): 219–41; 39 (Summer 1970): 395–424.

"Carmine Peppe" (obituary). *New Yorker,* 10 June 1985, p. 142.

Carpenter, Edmund. "The Tribal Terror of Self-Awareness." In *Principles of Visual Anthropology,* edited by Paul Hockings, pp. 450–61. The Hague: Mouton, 1975.

Carroll, Noël. "The Ontology of Mass Art." *Journal of Aesthetics and Art Criticism* 55 (Spring 1997): 187–99.

——. "A Philosophy of Mass Art. Oxford: Oxford University Press, forthcoming.

Cavanagh, Patrick, and Yvan G. Leclerc. "Shape from Shadows." *Journal of Experimental Psychology: Human Perception and Performance* 15, no. 1 (1989): 3–27.

Cavell, Stanley. *The World Viewed.* New York: Viking, 1971.

Chandler, Raymond. *The Lady in the Lake.* 1944. New York: Penguin, 1952.

Chew, V. K. *Talking Machines.* 2nd ed. London: Her Majesty's Stationery Office, 1981.

Clarke, Arthur C. "Fairies, Phantoms, and Fantastic Photographs." In *Arthur C. Clarke's World of Strange Powers.* Directed by Charles Flynn. Mississauga, Ont.: Marlin Motion Pictures, c. 1985.

Coe, Brian. *The Birth of Photography: The Story of the Formative Years, 1800–1900.* New York: Taplinger, 1976.

Coke, Van Deren, ed. *One Hundred Years of Photographic History: Essays in Honor of Beaumont Newhall.* Albuquerque: University of New Mexico Press, 1975.

Cole, Rex Vicat. *Perspective.* London: Seeley, Service, 1921. Reprinted as *Perspective for Artists.* New York: Dover, 1976.

Crombie, A. C. *Science, Art, and Nature in Medieval and Modern Thought.* London: Hambledon, 1996.

D'Alembert, Jean le Rond. "Discours préliminaire des editeurs." 1751. Translated by Richard N. Schwab. In *Preliminary Discourse to the Encyclopedia of Diderot.* Indianapolis: Bobbs-Merrill, 1963.

Dante Alighieri. *La Vita Nuova.* Translated by Mark Musa. Bloomington: Indiana University Press, 1962.

Darrah, William C. *The World of Stereographs.* Gettysburg, Pa.: William C. Darrah, 1977.

Daval, Jean-Luc. *Histoire d'un art: La photographie.* Translated as *Photography: History of an Art.* New York: Rizzoli, 1982.

Denny, J. Peter. "The 'Extendedness' Variable in Classifier Semantics: Universal Features and Cultural Variation." In *Ethnolinguistics: Boas, Sapir, and Whorf Revisited,* edited by M. Mathiot. The Hague: Mouton, 1978.

Depp, Steven W., and E. Howard Webster. "Flat-Panel Displays." *Scientific American,* March 1993, pp. 90–97.

Dretske, Fred I. *Knowledge and the Flow of Information.* Cambridge: MIT Press, 1981.

Dubery, Fred, and John Willats. *Drawing Systems.* London: Studio Vista, 1972.

Durden, Mark. "Peter Henry Emerson: The Limits of Representation." *History of Photography* 18 (Autumn 1994): 281–84.

Eastlake, Elizabeth. "Photography." *Quarterly Review* (London) 101 (1857): 442–68.

Eder, Josef Maria. *Geschichte der Photographie.* 4th ed., 1932. Translated by Edward Epstean as *The History of Photography.* New York: Dover, 1978.

Eisenstein, Elizabeth L. *The Printing Press as an Agent of Change: Communication and Cultural Transformations in Early-Modern Europe.* 2 vols. Cambridge: Cambridge University Press, 1979.

Emerson, Peter Henry. *Naturalistic Photography for Students of the Art.* 3rd ed. 1899. Reprinted with *The Death of Naturalistic Photography.* New York: Arno, 1973.

Evans, Harold. *Pictures on a Page.* New York: Holt, Rinehart & Winston, 1978. Vol. 2 of *Editing and Design: A Five-Volume Manual of English Typography and Layout,* edited by Harold Evans. New York: Holt, Rinehart & Winston, 1972–78.

Evans, Walker. *American Photographs.* 1938. 2d (fiftieth anniversary) ed. New York: Museum of Modern Art, 1988.

Farwell, Beatrice. *The Charged Image: French Lithographic Caricature, 1816–1848.* Santa Barbara, Calif.: Santa Barbara Museum of Art, 1989.

——. *The Cult of Images/ Le culte des images: Baudelaire and the 19th-Century Media Explosion.* Santa Barbara: University of California-Santa Barbara, 1977.

Fleming-Williams, Ian. *Constable and His Drawings.* London: Philip Wilson, 1990.

Ford, Colin, ed. *The Story of Popular Photography.* London: Century Hutchinson, 1989.

Franklin, Ursula. *The Real World of Technology.* Toronto: House of Anansi Press, 1992.

Freeman, Norman. "Do Children Draw Men with Arms Coming Out of the Head?" *Nature,* 3 April 1975, p. 416.

——. "Process and Product in Children's Drawings." *Perception* 1 (1972): 123–40.

Freeman, Norman, and M. V. Cox, eds. *Visual Order: The Nature and Development of Pictorial Representation.* Cambridge: Cambridge University Press, 1985.

Galassi, Peter. *Before Photography: Painting and the Invention of Photography.* New York: Museum of Modern Art, 1981.

——. *Henri Cartier-Bresson: The Early Work.* New York: Museum of Modern Art, 1987.

Gassan, Arnold. *A Chronology of Photography.* Athens, Ohio: Handbook, 1972.

George, M. Dorothy. *Hogarth to Cruikshank: Social Change in Graphic Satire.* New York: Walker, 1967.

Gernsheim, Helmut. *Concise History of Photography.* 3d rev. ed. New York: Dover, 1986.

——. "The 150th Anniversary of Photography." *History of Photography* 1 (January 1977): 3–8.

——. *The Origins of Photography.* London: Thames & Hudson, 1982.

Gernsheim, Helmut, and Alison Gernsheim. *The History of Photography from the Camera Obscura to the Beginning of the Modern Era.* New York: McGraw-Hill, 1969.

Gibson, J. J. Foreword to *The Perception of Pictures.* Vol. 1. Edited by Margaret A. Hagen. New York: Academic Press, 1980.

Gies, Frances, and Joseph Gies. *Cathedral, Forge, and Waterwheel: Technology and Invention in the Middle Ages.* New York: HarperCollins, 1994.

Gillispie, Charles, C. "The Scientific Importance of Napoleon's Egyptian Campaign." *Scientific American,* September 1994, pp. 78–85.

Gilmour, Pat. *Modern Prints.* London: Studio Vista, 1970.

Goldberg, Vicki. *Photography in Print: Writings from 1816 to the Present.* New York: Simon & Schuster, 1981. Reprinted Albuquerque: University of New Mexico Press, 1988.

——. *The Power of Photography: How Photographs Changed Our Lives.* Expanded ed. New York: Abbeville, 1993.

Goldstein, Stewart, and Alan Jacobson. *Oldies but Goodies: The Rock 'n' Roll Years.* New York: Mason/Charter, 1977.

Gombrich, E. H. *Art and Illusion: A Study in the Psychology of Pictorial Representation.* Princeton: Princeton University Press, 1960.

——. *Meditations on a Hobby Horse and Other Essays on the Theory of Art.* London: Phaidon, 1963.

——. *Shadows: The Depiction of Cast Shadows in Western Art.* London: National Gallery Publications, 1995.

——. *The Story of Art.* 12th rev. ed. London: Phaidon, 1972.

Goodman, Nelson. *Languages of Art.* 2d rev. ed. Indianapolis: Hackett, 1976.

Grabar, André. *Martyrium: Recherches sur le culte des reliques et l'art chrétien antique,* Vol. 2, *Iconographie.* 1946. London: Variorum Reprints, 1972.

Greenough, Sarah, et al., *On the Art of Fixing a Shadow: One Hundred and Fifty Years of Photography.* Washington, D.C.: National Gallery of Art, 1989.

Gregory, Richard. *Eye and Brain: The Psychology of Seeing.* 4th rev. ed. Princeton: Princeton University Press, 1990.

Grice, H. Paul. *The Way of Words.* Cambridge: Harvard University Press, 1989.

Grierson, Roderick, ed. *Gates of Mystery: The Art of Holy Russia.* Fort Worth, Tex.: Intercultura, 1994.

Harvey, E. Ruth. "The Image of Love." In *The Complete Works of Sir Thomas More,* edited by T. Lawler et al. New Haven: Yale University Press, 1981.

Hennessy, Richard. "What's All This about Photography?" *Artforum* 9 (May 1979): 23–26.

Hills, Richard L. *Power from Steam: A History of the Stationary Steam Engine*. Cambridge: Cambridge University Press, 1989.

Hine, Lewis W. *Men at Work: Photographic Studies of Modern Men and Machines*. New York, 1932.

Hockney, David. *Hockney on Photography: Conversations with Paul Joyce*. London: Jonathan Cape, 1988.

Hoffman, Howard F. *Vision and the Art of Drawing*. Englewood Cliffs, N.J.: Prentice-Hall, 1989.

Homer. *The Iliad*. Translated by E. V. Rieu. London: Penguin, 1950.

Hooker, Clifford. "Value and System: Notes toward a Definition of Agri-culture." *Journal of Agriculture and Environmental Ethics* 7 (1994): suppl.

Hughes, Robert. "On Lucien Freud." *New York Review of Books*, 13 August 1987, pp. 54–59.

Hughes, Ted. *Winter Pollen: Occasional Prose*. London: Faber & Faber, 1994.

Hume, David. *A Treatise of Human Nature*. 1739–40. Oxford: Clarendon Press, 1896.

Hyman, Anthony. *Charles Babbage: Pioneer of the Computer*. Princeton: Princeton University Press, 1982.

Ihde, Don. *Existential Technics*. Albany: State University of New York Press, 1983.

Irwin, Terence. *Plato's Moral Theory: The Early and Middle Dialogues*. Oxford: Oxford University Press, 1977.

Ivins, William M. Jr. *Prints and Visual Communication*. London: Routledge & Kegan Paul, 1953.

Jammes, André, and Eugenia Parry Janis. *The Art of French Calotype: With a Critical Dictionary of Photographers, 1845–1870*. Princeton: Princeton University Press, 1983.

Jefferson, Thomas. Letter. Collection of Pierpont Morgan Library, New York City, MA 1029 [1b].

Jeffrey, Ian. *Photography: A Concise History*. London: Thames & Hudson, 1982.

John of Damascus. *Orations against the Slanderers of the Images*. Translated in *Iconoclasm: Papers Given at the Ninth Spring Symposium of Byzantine Studies, University of Birmingham*, edited by Anthony Bryer and Judith Merrin. Birmingham: Centre for Byzantine Studies, 1977.

Kahmen, Volker. *Photografie als Kunst*. Translated by Brian Tubb as *Art History of Photography*. New York: Viking, 1974.

Karelis, Charles. "An Interpretative Essay." In *Hegel's Introduction to Aesthetics*. Oxford: Oxford University Press, 1979.

Keller, Ulrich F. "The Myth of Art Photography: A Sociological Analysis." *History of Photography* 8 (October–December 1984): 249–75.

Kitzinger, Ernst. *The Art of Byzantium and the Medieval West*. Bloomington: Indiana University Press, 1976.

———. *Byzantine Art in the Making: Main Lines of Stylistic Development in Mediterranean Art, 3rd–7th Century*. Cambridge: Harvard University Press, 1977.

———. "The Cult of Images in the Age before Iconoclasm." *Dumbarton Oaks Papers* 8 (1954): 85–150.

Kristeller, Paul O. "The Modern System of the Arts." *Journal of the History of Ideas* 12 no. 4 (1951): 496–527; 13, no. 1 (1952): 17–46.

———. *Renaissance Thought and the Arts: Collected Essays.* Princeton: Princeton University Press, 1980.

Kubovy, Michael. *The Psychology of Perspective and Renaissance Art.* New York: Cambridge University Press, 1986.

Lacayo, Richard. "Drawn by Nature's Pencil." *Time,* 27 February 1989, pp. 62–65.

Landscape in Britain: c. 1750–1850. London: Tate Gallery, 1973.

Lang, Berel, ed. *The Concept of Style.* Rev. ed. Ithaca: Cornell University Press, 1987.

Laude, Jean. Introduction to Michel Huet, *Danses d'Afrique.* Translated as *The Dance, Art, and Ritual of Africa.* New York: Random House, 1978.

Leggatt, Charles, ed. *Constable: A Master Draughtsman.* London: Dulwich Picture Gallery, 1994.

Leonardo da Vinci. *Leonardo on Painting.* Edited and translated by Martin Kemp and Margaret Walker. New Haven: Yale University Press, 1989.

Levenson, Thomas. *Measure for Measure: A Musical History of Science.* New York: Simon & Schuster, 1995.

Levine, Les. "Camera Art." *Studio International,* July–August 1975, 52–54.

Levitt, Helen. *In the Street: Chalk Drawings and Messages, New York City, 1938–1948.* Essay by Robert Coles. Durham, N.C.: Duke University Press, published for Duke University Center for Documentary Photography, 1987.

Leyton, Michael. *Symmetry, Causality, Mind.* Cambridge: MIT Press, 1990.

Life Library of Photography: The Camera. New York: Time-Life Books, 1970.

Lindberg, David C. *Theories of Vision from Al-Kindi to Kepler.* Chicago: University of Chicago Press, 1976.

Lively, Penelope. *Moon Tiger.* London: André Deutsch, 1987.

Lossky, Vladimir. *The Mystical Theology of the Eastern Church.* London: James Clarke, 1957.

Lumière, Auguste, and Louis Lumière. *Letters: Inventing the Cinema.* Edited by Jacques Rittaud-Hutinet; translated by Pierre Hodgson. London: Faber & Faber, 1995.

Lyons, Nathan, ed. *Photographers on Photography.* Englewood Cliffs, N.J.: Prentice-Hall, 1966.

McCallum, Henry D, and Frances T. McCallum. *The Wire That Fenced the West.* Norman: University of Oklahoma Press, 1965.

Mackie, Alwynne. *Art/Talk: Theory and Practice in Abstract Expressionism.* New York: Columbia University Press, 1989.

Malcolm, Janet. *Diana & Nikon.* Boston: David R. Godine, 1980.

Marien, Mary Warner. "What Shall We Tell the Children? Photography and Its Text (Books)." *Afterimage* 13 (April 1986): 4–7.

Mast, Gerald. *Can't Help Singin': The American Musical on Stage and Screen.* Woodstock, N.Y.: Overlook, 1987.

Mattison, David. "The Magical Eye: Definitions of Photography." *Photo Communiqué* 2, 3 (1980).

Maynard, Patrick, ed. "Perspectives on the Arts and Technology." Special issue. *Journal of Aesthetics and Art Criticism* 55 (Spring 1977).

———. "Drawing and Shooting." *Journal of Aesthetics and Art Criticism* 44 (Winter 1985): 115–29.

———. "The Engine of Visualisation." *Canadian Journal of Rhetorical Studies* 1 (1991): 73–85.

———. "Form." *The Dictionary of Art.* Vol. 11. Grove's Dictionaries. London: Macmillan, 1991.

———. "A Legacy of Light." Review of *Ansel Adams: An Autobiography. Canadian Review of American Studies* 18 (Spring 1987): 127–31.

———. "Perspective's Places." *Journal of Aesthetics and Art Criticism* 54 (Winter 1996): 23–40.

———. "Photo-Opportunity: Photography as Technology." *Canadian Review of American Studies* 22 (Winter 1991): 501–28.

———. "Ravishing Atrocities." *London Review of Books,* 7 January 1988, pp. 17–18.

———. "Real Imaginings." Walton Symposium. *Philosophy and Phenomenological Research* 51 (June 1991): 389–94.

———. Review of *The Contest of Meaning,* edited by Richard Bolton. *Journal of Aesthetics and Art Criticism* 50 (Winter 1992): 68–71; Errata, 52 (Spring 1994): 167.

———. Review of *Deeper into Pictures* by Flint Schier. *Word & Image* 3 (October–December 1987): 325–26.

———. "The Secular Icon: Photography and the Functions of Images." *Journal of Aesthetics and Art Criticism* 42 (Winter 1983): 155–69.

———. "Seeing Double." *Journal of Aesthetics and Art Criticism* 52 (Spring 1994): 155–67.

———. "Talbot's Technologies: Photographic Depiction, Detection, and Reproduction." *Journal of Aesthetics and Art Criticism* 47 (Summer 1989): 263–76.

Michals, Duane. *Real Dreams.* Danbury, N.H.: Addison House, 1976.

Mitcham, Carl, *Thinking through Technology: The Path between Engineering and Philosophy.* Chicago: University of Chicago Press, 1994.

Mitcham, Carl, and Robert Mackey, eds. *Philosophy and Technology: Readings in the Philosophical Problems of Technology.* New York: Macmillan, 1983.

Moholy-Nagy, Laszlo. *Moholy-Nagy.* Edited by Richard Kostelanetz. New York: Praeger, 1970.

———. *Painting, Photography, Film.* 1927. Translated by Janet Seligman. Cambridge: MIT Press, 1969.

Mumford, Lewis. "Technics and the Nature of Man." In *Knowledge among Men,* edited by Paul H. Oehser. New York: Simon & Schuster, 1966.

Murrells, Joseph. *The Book of Golden Disks: The Records That Sold a Million.* London: Barrie & Jenkins, 1978.

Naef, Weston J., ed. *Photography: Discovery and Invention.* Malibu, Calif.: J. Paul Getty Foundation, 1990.

Neblette, C. B. *Photography: Its Principles and Practice.* 2d ed. New York: Van Nostrand, 1930.

The New Catholic Encyclopedia. Toronto: McGraw-Hill, 1967.

Newhall, Beaumont. *The Daguerreotype in America.* 3d. rev. ed. New York: Dover, 1976.

———. *The History of Photography from 1839 to the Present.* 5th rev. ed. New York: Museum of Modern Art, 1982.

———. *Latent Image: The Discovery of Photography.* Garden City, N.Y.: Doubleday, 1967.

———. *Photography: A Short Critical History.* New York, 1938.

———, ed. *Photography: Essays & Images, Illustrated Readings in the History of Photography.* New York: Museum of Modern Art, 1980.

———. *Photography: 1839–1927.* New York, 1937.

Newhall, Beaumont, and Amy Conger, eds. *Edward Weston Omnibus: A Critical Anthology.* Salt Lake City, Utah: Gibbs M. Smith, 1984.

Newhall, Nancy, *P. H. Emerson: The Fight for Photography as a Fine Art.* New York: Aperture, 1975.

"150 Years of Photography: Pictures That Made a Difference." Anniversary Issue. *Life,* Fall 1988.

Ouspensky, Leonid, and Vladimir Lossky. *The Meaning of Icons.* Translated by G. Palmer and E. Kadloubovsky. Olten, Switzerland: Urs Graf-Verlag, n.d. (c. 1952).

Pacey, Arnold. *The Maze of Ingenuity.* Cambridge: MIT Press, 1974.

Petruck, Peninah, ed. *The Camera Viewed: Writings on Twentieth-Century Photography.* 2 vols. New York: Dutton, 1979.

Phillips, David. "Patterns in Pictures for Art and Science." *Leonardo* 24, no. 1 (1991): 31–39.

Piaget, J., and B. Inhelder. *The Child's Conception of Space.* London: Routledge & Kegan Paul, 1956.

Postman, Neil. *Amusing Ourselves to Death: Public Discourse in the Age of Show Business.* London: Penguin, 1985.

Roemer, Michael. "The Surfaces of Reality." *Film Quarterly* 18 (Fall 1964): 15–22.

Rudisill, Richard. *Mirror Image: The Influence of the Daguerreotype on American Society.* Albuquerque: University of New Mexico Press, 1971.

Rudner, Richard. "Some Problems of Non-Semiotic Aesthetic Theories." *Journal of Aesthetics and Art Criticism* 15 (March 1957): 298–310.

Sandweiss, Martha A, ed. *Photography in Nineteenth-Century America.* New York: Harry N. Abrams, 1991.

Savedoff, Barbara. "Escaping Reality: Digital Imagery and the Resources of Photography." *Journal of Aesthetics and Art Criticism* 55 (Spring 1997): 201–14.

———. "Looking at Art through Photographs." *Journal of Aesthetics and Art Criticism* 51 (Summer 1993): 455–62.

———. *Transforming Images.* Ithaca: Cornell University Press, 2000.

——. "Transforming Images: Photographs of Representations." *Journal of Aesthetics and Art Criticism* 50 (Spring 1992): 93–106.

Schaaf, Larry J. "Henry Fox Talbot's *The Pencil of Nature:* A Revised Census of Original Copies." *History of Photography* 17 (Winter 1993): 388–96.

——. "Herschel, Talbot, and Photography: Spring 1831 and Spring 1839." *History of Photography* 4 (July 1980): 181–204.

——. "Sir John Herschel's 1839 Royal Society Paper on Photography." *History of Photography* 3 (January 1979): 47–60.

Schier, Flint. *Deeper into Pictures: An Essay in Pictorial Representation.* Cambridge: Cambridge University Press, 1986.

Schwalberg, Bob. Critical Focus (column). *Popular Photography,* September 1989, 28, 30.

Scruton, Roger. *The Aesthetic Understanding.* Manchester: Carcanet, 1983.

——. *The Philosopher on Dover Beach: Essays.* Manchester: Carcanet, 1990.

Sekula, Allan. *Photography against the Grain: Essays and Photo Works, 1973–1983.* Halifax: Press of the Nova Scotia College of Art and Design, 1984.

Sennett, Richard. *The Fall of Public Man.* New York: Norton, 1974.

Shamos, Morris H., ed. *Great Experiments in Physics.* New York: Henry Holt, 1959.

Shearman, Lyndon R. *Portable Steam Engines.* Aylesbury, Bucks: Shire Publications, 1986.

Silverman, Robert J. "The Stereoscope and Photographic Depiction in the 19th Century." *Technology and Culture* 34 (October 1993): 729–56.

Smith, Joshua P. *The Photography of Invention: American Pictures of the 1980s.* Washington, D.C.: Smithsonian Institution, 1989.

Smith, R. C. "Nicéphore Niépce in England." *History of Photography* 7 (January 1983): 43–50.

Snyder, Joel, and Neill Walsh Allen. "Photography, Vision, and Representation." *Critical Inquiry* 2 (1975): 143–69.

Sontag, Susan. *On Photography.* New York: Penguin, 1977.

——. "Writing Itself: On Roland Barthes." *New Yorker,* 26 April 1982, pp. 122–41.

Special Problems. Life Library of Photography. New York: Time-Life Books, 1971.

Squires, Carol, ed. *The Critical Image: Essays on Contemporary Photography.* Seattle: Bay Press, 1990.

Stalker, Peter, ed. "The Strange World of Photography." Special issue. *New Internationalist* 185 (July 1988).

Stenger, Erich. *Die Photographie in Kultur und Technik.* 1939. Translated by Edward Epstean as *The History of Photography: Its Relation to Civilization and Practice.* New York: Arno, 1979.

Stevenson, R. L. *Virginibus Puerisque and Other Papers.* London: Chatto & Windus, 1911.

Stevenson, Sara. *Hill and Adamson's "The Fishermen and Women of the Firth of Forth."* Edinburgh: National Galleries of Scotland, 1991.

Sturge, John, Vivian Walworth, and Allan Shepp, eds. *Imaging Processes and Materials: Neblette's Eighth Edition.* New York: Van Nostrand Reinhold, 1989.

Swade, Doron D. "Redeeming Charles Babbage's Mechanical Computer." *Scientific American,* February 1993, pp. 86–91.

Swedlund, Charles. *Photography: A Handbook of History, Materials, and Processes.* 2d ed. New York, 1981.

Szarkowski, John. *The Photographer's Eye.* New York: Museum of Modern Art, 1966.

———. *Photography until Now.* New York: Museum of Modern Art, 1989.

Taft, Robert. *Photography and the American Scene: A Social History, 1839–1889.* 1938. New York: Dover, 1964.

Talbot, William Henry Fox. "Calotype (Photogenic) Drawing." *Literary Gazette,* 13 February 1841, p. 108.

———. Letter, 30 January 1839. *Literary Gazette,* 2 February 1839, pp. 74–75.

———. *The Pencil of Nature.* London: Longmans, Brown, Green, & Longmans, 1844–46. Reprint edited by Beaumont Newhall. New York: Da Capo, 1969.

———. *Selected Correspondence of William Henry Fox Talbot, 1823–1874.* Edited by Larry J. Schaaf. London: Science Museum and National Museum of Photography, Film & Television, 1994.

Talbot, William Henry Fox. *Some Account of the Art of Photogenic Drawing, or The Process by Which Natural Objects May Be Made to Delineate Themselves without the Aid of the Artist's Pencil.* London: J. & R. E. Taylor, 1839.

Tanizaki, Jun'ichirō. *In'ei Raisan.* 1933–1934. Translated by Thomas J. Harper and Edward G. Seidensticker as *In Praise of Shadows.* Stony Creek, Conn.: Leete's Island Books, 1977.

Tausk, Petr. *A Short History of Press Photography.* Prague: International Organization of Journalists, 1988.

Thomas, Alan. *Time in a Frame: Photography and the Nineteenth-Century Mind.* New York: Schocken, 1977.

Thompson, Paul, and Gina Harkell. *The Edwardians in Photographs.* New York: Holmes & Meier, 1979.

Tolstoy, Leo. *What is Art?* 1899. Translated by Aylmer Maude. Indianapolis: Bobbs-Merrill, 1960.

Toobin, Jeffrey. "Annals of Law: Ito and the Truth School." *New Yorker,* 27 March 1995, p. 48.

Trachtenberg, Alan, ed. *Classic Essays on Photography.* New Haven, Conn.: Leete's Island Books, 1980.

———. *Reading American Photographs: Images as History, Mathew Brady to Walker Evans.* New York: Hill & Wang, 1989.

Truffaut, François. *Hitchcock.* New York: Simon & Schuster, 1967.

Tufte, Edward R. *Envisioning Information.* Cheshire, Conn.: Graphics Press, 1990.

Turner, Peter. *History of Photography.* New York: Exeter, 1987.

Varnedoe, Kirk. *A Fine Disregard: What Makes Modern Art Modern.* New York: Harry N. Abrams, 1990.

Wade, John. *The Camera: From the 11th Century to the Present Day.* Leicester: Jessop, 1990.

Wagner, Gillian. *Barnardo.* London: Weidenfeld & Nicolson, 1979.

Walch, Peter, and Thomas Barrow, eds. *Perspectives on Photography: Essays in Honor of Beaumont Newhall.* Albuquerque: University of New Mexico Press, 1986.

Walton, Kendall. "Categories of Art." *Philosophical Review* 79(1970): 334–67.

———. "How Marvellous! Toward a Theory of Aesthetic Value." *Journal of Aesthetics and Art Criticism* 51 (Summer 1993): 499–510.

———. "Make-Believe and Its Role in Pictorial Representation." *Art Issues* 21 (January–February 1992): 22–23.

———. *Mimesis as Make-Believe.* Cambridge: Harvard University Press, 1990.

———. "Transparent Pictures: On the Nature of Photographic Realism." *Critical Inquiry* 11 (December 1984): 246–77.

Ward, John L. *The Criticism of Photography as Art: The Photographs of Jerry Uelsmann.* Gainseville, Fla.: University of Florida Press, 1970.

Weitzmann, Kurt. *The Icon: Holy Images—Sixth to Fourteenth Century.* New York: George Braziller, 1978.

Welford, Walter T. *Useful Optics.* Chicago: University of Chicago Press, 1991.

Westerbeck, Colin L., Jr. "Night Light: Brassai and Weegee," *Artforum* 15 (December 1976): 34–45.

———. "Photography Now." *Artforum* 17 (January 1979): 20–23.

Weston, Edward. *The Daybooks of Edward Weston.* Edited by Nancy Newhall. Millerton, N.Y.: Aperture, 1973.

Whitburn, Joel. *Billboard's Top 1000, 1955–1978.* Menomonee Falls, Wis.: Record Research, n.d. (c. 1984).

White, Lynn, Jr. *Medieval Religion and Technology: Collected Essays.* Berkeley: University of California Press, 1979.

———. *Medieval Technology and Social Change.* Oxford: Oxford University Press, 1962.

White, Minor. *Mirrors/Messages/Manifestations.* Rochester, N.Y.: Aperture, 1969.

White, William, Jr. *Close-Up Photography.* Kodak Workshop Series. Rochester, N.Y.: Silver Pixel Press, 1984.

Willats, John. *Art and Representation: New Principles in the Analysis of Pictures.* Princeton: Princeton University Press, 1997.

———. "Marr and Pictures: An Information-Processing Account of Children's Drawings." *Archives de Psychologie* 55 (1987): 105–25.

———. "The Representation of Extendedness in Children's Drawings of Sticks and Disks." *Child Development* 63 (1992): 692–710.

———. "Seeing Lumps, Sticks, and Slabs in Silhouettes." *Perception* 21 (1992): 481–96.

Williams, John B. *Image Clarity: High Resolution Photography.* Boston: Focal, 1990.

Williams Raymond. *Culture and Society: 1780–1950.* London: Chatto & Windus, 1958.

Wollheim, Richard. *The Mind and Its Depths.* Cambridge: Harvard University Press, 1993.

———. *On Art and the Mind.* Cambridge: Harvard University Press, 1974.

———. *Painting as an Art.* Princeton: Princeton University Press, 1987.

Wright, Ronald. "Chronicles of Loss." *Times Literary Supplement,* 3 March 1995, p. 6.

Wyman, Norman. *Doctor Barnardo.* London: Longmans, Green, 1962.

Zwingle, Erla. "Seizing the Light: Photography's First Fifty Years." *National Geographic,* October 1989, pp. 530–46.

Index